DECORATIVE ARTS

AN ILLUSTRATED SUMMARY CATALOGUE OF THE COLLECTIONS
OF THE J. PAUL GETTY MUSEUM

❖

DECORATIVE ARTS

AN ILLUSTRATED SUMMARY CATALOGUE OF THE COLLECTIONS
OF THE J. PAUL GETTY MUSEUM

❖

Charissa Bremer-David

Department of Decorative Arts

WITH

Peggy Fogelman • Peter Fusco • Catherine Hess

Department of European Sculpture
and Works of Art

THE J. PAUL GETTY MUSEUM MALIBU, CALIFORNIA 1993

© 1993 The J. Paul Getty Museum
17985 Pacific Coast Highway
Malibu, California 90265-5799
Christopher Hudson, Publisher
Cynthia Newman Bohn, Managing Editor

J. Paul Getty Trust Publication Services
401 Wilshire Boulevard, Suite 850
Santa Monica, California 90401-1455
Richard Kinney, Director
Deenie Yudell, Design Manager
Karen Schmidt, Production Manager

LIBRARY OF CONGRESS CATALOGING IN PUBLICATION DATA
J. Paul Getty Museum.
 Decorative arts: an illustrated summary catalogue of the
collections of the J. Paul Getty Museum / Charissa Bremer-David.
 p. cm.
 Rev. and expanded version of the 1986 ed.
 Includes bibliographical references and indexes.
 ISBN 0-89236-221-9:
 1. Decorative arts—California—Malibu—Catalogs.
2. J. Paul Getty Museum Catalogs.
I. Bremer-David, Charissa. II. Title.
NK460.M35J25 1993
745'.074'79493—dc20 93-9753

Project staff:

Manuscript Editor
Mollie Holtman

Designer
Leslie Thomas Fitch

Production Artists
Eileen Delson, Marcelo Thomaz

Illustrator
Timothy Seymour

Production Coordinator
Amy Armstrong

Photographers
Donald Hull, Thomas Moon,
Penelope Potter, Jack Ross, and
Charles Passela

Typography
G & S Typesetters, Austin, Texas

Printing
Pace Lithographers, Inc.
City of Industry, California

Previous edition published as
*Decorative Arts: A Handbook of the
Collections of the J. Paul Getty Museum*
(Malibu, 1986), Lynne Dean, manuscript
editor, and Patrick Dooley, designer.

CONTENTS

FOREWORD

Anyone wanting a sample of the Getty Museum's growth in the past decade should put this book next to its predecessor of 1986 and turn the pages.

Between editions there have been 115 additions to the collection of French furniture and decorative arts, a collection that in 1984 was already the glory of the Getty Museum. These acquisitions include material in virtually every category, including objects of a kind conspicuously lacking in the earlier edition: various individual types of furniture not yet represented, a group of especially beautiful and rare French and German porcelain, and a miscellany of fine Neoclassical pieces. This astute purchasing has been the work of Gillian Wilson, who came to the Getty Museum in 1971 to build up the collection and apply a professional standard to its care and publication.

Just as striking in this edition is the addition of entire categories to the Getty Museum collection, accomplished since 1984 by a new curatorial department under Peter Fusco.

Although European sculpture is the main focus of this department, it is also charged with broadening the representation of European furniture and decorative arts. Collections of Italian maiolica and European glass were among its first purchases. Since then Italian furniture, *Kunstkammer* objects, metalwork, and works of art in many other categories have been added. Altogether, these total some 141 acquisitions.

As I write, the foundations are being poured for a new museum that will house these collections. For French furniture and decorative arts there will be some sixteen galleries *en suite*, including five complete paneled rooms—space enough, at last, to exhibit the collection in the style it deserves. In other parts of the building, galleries are being designed for sculpture, glass, maiolica, metalwork, and other works of art outside France; some of this material will be shown in the paintings galleries as well. Since we can exhibit only a mere sampling in Malibu, the opening of the new museum will be an unveiling and celebration of these remarkable collections.

I owe Gillian Wilson and Peter Fusco, whose taste can be detected everywhere in this catalogue, my admiration for what they have brought about. Their staffs, especially Charissa Bremer-David, Peggy Fogelman, and Catherine Hess, have my gratitude for the collaboration that made the book possible.

John Walsh
Director

Preface and Acknowledgments

This book is a revised and expanded edition of *Decorative Arts: A Handbook of the Collections of the J. Paul Getty Museum* (Malibu, 1986). The original volume contained entries on all the objects acquired by the Department of Decorative Arts through the middle of 1984. The growth of the Museum's decorative arts collection since that date and the formation of the Department of European Sculpture and Works of Art in 1984 have necessitated a new edition. The larger part is devoted to objects in the Department of Decorative Arts, which covers the area of Northern Europe from 1650 to 1815, while the remainder of the entries represent the acquisitions of the Department of European Sculpture and Works of Art: European objects to 1650 and Southern European objects (from Italy, Spain, and Portugal) to 1900.

The format remains the same: objects are grouped by country of origin and then arranged chronologically by medium and form. Each object is illustrated. Where appropriate and available, the following information is given: place of manufacture, date, artist or maker, materials, description of marks, measurements, accession number, provenance, exhibition history, and selected bibliography.

Two indexes are provided: the first lists makers with their dates; the second, the previous owners.

It is hoped that this new edition will serve as an interim survey of the Decorative Arts collection, pending the publication of that department's catalogues, as well as an introduction to a portion of the collections in the Department of European Sculpture and Works of Art. Objects which are not displayed in the galleries may be viewed by students and scholars by appointment.

This summary catalogue is based on files created by Gillian Wilson, Curator of Decorative Arts, and Peter Fusco, Curator of European Sculpture and Works of Art. The 1986 edition was compiled jointly by Adrian Sassoon and Gillian Wilson. The present book is largely the effort of Charissa Bremer-David, Department of Decorative Arts, and Peggy Fogelman, Peter Fusco, and Catherine Hess, Department of European Sculpture and Works of Art.

Many others within the Museum have contributed to the summary catalogue: the late David Cohen, Associate Curator of Decorative Arts, provided much essential data and unfailing assistance. Jeffrey Weaver, Assistant Curator of Decorative Arts, and Bernard Jazzar, Intern in the Department of Decorative Arts, contributed information regarding marks, bibliography, and exhibition history. Brian Considine, Conservator of Decorative Arts and Sculpture, and Gordon Hanlon, Assistant Conservator, aided in the identification of materials. Jack Ross, Senior Photographer, was responsible for new photography. Kathleen Ryczek, former Senior Secretary in the Department of European Sculpture and Works of Art, assisted in organizing and typing portions of the manuscript.

A number of colleagues have generously given information over the years: Theodore Dell, New York; Rosalind Savill, Director of the Wallace Collection, London; Sir Geoffrey de Bellaigue, Surveyor of the Queen's Works of Art, London; Patrick Leperlier, Paris; Bruno Pons, Ecole Nationale du Patrimoine, Paris; Alexandre Pradère, Paris; Jean-Nérée Ronfort and Jean-Dominique Augarde, Paris; Anna Maria Massinelli, Florence; Michael Bohor, Florence; John Mallet, London; Kirsten Aschengreen-Piacenti, Palazzo Pitti, Florence; Bertrand Jestaz, Sorbonne, Paris; Leonard Amico, former Assistant Curator in the Department of European Sculpture and Works of Art, J. Paul Getty Museum; Rainer Zietz,

London; Ruth Blumka, New York; and Sheri Bernstein, Amy Lyford, Ken Wayne, Maria de Peverelli, Francesca Bewer, Anna Zagorsky, and Anne Collopy, all former interns in the Department of European Sculpture and Works of Art, J. Paul Getty Museum.

We also wish to acknowledge the contributions of the following: Antoine d'Albis, Manufacture Nationale de Sèvres; Daniel Alcouffe, the Musée du Louvre, Paris; Catherine Arminjon, the Ministère de la Culture, France; Rotraud Bauer, the Kunsthistorisches Museum, Vienna; Christian Baulez, Château de Versailles; Leslie Bowman, the Los Angeles County Museum of Art; Frances Buckland, London; Martin Chapman, the Los Angeles County Museum of Art; Andrew Ciechanowiecki, London; Timothy Clarke, Kent; Howard Coutts, the Bowes Museum, County Durham; Christian Witt-Döring, Österreichishes Museum für ange-wandte Kunst, Vienna; Winthrop Edey, New York; Pierre Ennès, the Musée du Louvre, Paris; Svend Eriksen, Copenhagen; Ronald Freyberger, New York; Peter Frieß, Munich; Carolyn Gay Nieda Gassmann, Paris; Alvar

Gonzáles-Palacios, Rome; Burckhardt Göres, the Kunstgewerbemuseum Schloß Köpenick, Berlin; Michael Hall, London; John Hardy, London; Leslie Harris, Kedleston Hall, Derbyshire; Henry Hawley, the Cleveland Museum of Art; Peter Hughes, the Wallace Collection, London; Anne Ratzki-Kraatz, Paris; Guy Kurasewski, Château de Versailles; Ulrich Leben, Paris; Claire Le Corbeiller, the Metropolitan Museum of Art, New York; Roland de L'Espée, Paris; Jessie McNab, the Metropolitan Museum of Art, New York; Bozenna Majewska-Maszkowska, the Royal Castle, Warsaw; the late Stanley Margolis, the University of California, Davis; Sarah Medlam, the Victoria and Albert Museum, London; Daniel Meyer, Château de Versailles; Jeffrey Munger, the Museum of Fine Arts, Boston; Maria Leonor d'Orey, Museu Nacional de Arte Antiga, Lisbon; Bill Pallot, Paris; James Parker, the Metropolitan Museum of Art, New York; Tamara Préaud, Manufacture Nationale de Sèvres; Peter Pröschel, Munich; Carolyn J. Sargentson, the Victoria and Albert Museum, London; Béatrix Saule, Château de Versailles; Anna Somers-Cocks, London; Edith Standen, the Metropolitan Museum of Art, New York; and the late Sir Francis Watson, formerly Director of the Wallace Collection and

Surveyor of the Queen's Works of Art, England. We are most grateful to Theodore Dell, who kindly reviewed and corrected the manuscript, to Timothy Husband, for permission to use his manuscript for a forthcoming catalogue of the Museum's glass collection; to Leslie Thomas Fitch, for her fine design; and to our patient editor and indexer, Mollie Holtman.

Gillian Wilson
Curator
Department of Decorative Arts

Peter Fusco
Curator
Department of European Sculpture and Works of Art

ABBREVIATIONS

The following abbreviations have been employed in referring to frequently cited works.

"ACQUISITIONS 1982"
Gillian Wilson, Adrian Sassoon, and Charissa Bremer-David, "Acquisitions Made by the Department of Decorative Arts in 1982," *The J. Paul Getty Museum Journal*, vol. 11 (Malibu, 1983), pp. 13–66.

"ACQUISITIONS 1983"
Gillian Wilson, Adrian Sassoon, and Charissa Bremer-David, "Acquisitions Made by the Department of Decorative Arts in 1983," *The J. Paul Getty Museum Journal*, vol. 12 (Malibu, 1984), pp. 173–224.

"ACQUISITIONS 1984"
Gillian Wilson, Charissa Bremer-David, and C. Gay Nieda, "Selected Acquisitions Made by the Department of Decorative Arts in 1984," *The J. Paul Getty Museum Journal*, vol. 13 (Malibu, 1985), pp. 67–88.

GETTY, COLLECTING
J. Paul Getty, *The Joys of Collecting* (New York, 1965).

GETTYMUSJ
The J. Paul Getty Museum Journal

HANDBOOK 1986
The J. Paul Getty Museum Handbook of the Collections (Malibu, 1986).

HANDBOOK 1991
The J. Paul Getty Museum Handbook of the Collections (Malibu, 1991).

HESS, MAIOLICA
Catherine Hess, *Italian Maiolica: Catalogue of the Collections, The J. Paul Getty Museum* (Malibu, 1988).

JOURNAL OF GLASS STUDIES
"Recent Important Acquisitions Made by Public and Private Collections in the United States and Abroad," *Journal of Glass Studies*, vol. 28 (1986).

KJELLBERG, DICTIONNAIRE
Pierre Kjellberg, *Le Mobilier français du XVIIIe siècle: Dictionnaire des ébénistes et des menuisiers* (Paris, 1989).

MORLEY-FLETCHER AND MCILROY, EUROPEAN POTTERY
Hugo Morley-Fletcher and Roger McIlroy, *Christie's Pictorial History of European Pottery* (Englewood Cliffs, N.J., 1984).

OTTOMEYER AND PRÖSCHEL, VERGOLDETE BRONZEN
Hans Ottomeyer and Peter Pröschel, *Vergoldete Bronzen: Die Bronzearbeiten des Spätbarock und Klassizismus* (Munich, 1986), vol. 1.

PALLOT, L'ART DU SIEGE
Bill G. B. Pallot, *L'Art du siège au XVIIIe siècle en France* (Paris, 1987).

SASSOON, VINCENNES AND SEVRES PORCELAIN
Adrian Sassoon, *Vincennes and Sèvres Porcelain: Catalogue of the Collections, The J. Paul Getty Museum* (Malibu, 1991).

SAVILL, SEVRES
Rosalind Savill, *The Wallace Collection: Catalogue of the Sèvres Porcelain* (London, 1988), vols. 1–3.

VERLET, LES BRONZES
Pierre Verlet, *Les Bronzes dorés français du XVIIIe siècle* (Paris, 1987).

VERLET ET AL., CHEFS D'OEUVRE
Pierre Verlet et al., *Chefs d'oeuvre de la collection J. Paul Getty* (Monaco, 1963).

WILSON, "ACQUISITIONS 1977 TO MID
1979"
 Gillian Wilson, "Acquisitions Made by the
Department of Decorative Arts, 1977 to
mid 1979," *The J. Paul Getty Museum
Journal*, vol. 6–7 (Malibu, 1978–1979),
pp. 37–52.

WILSON, "ACQUISITIONS 1979 TO MID
1980"
 Gillian Wilson, "Acquisitions Made by the
Department of Decorative Arts, 1979 to
mid 1980," *The J. Paul Getty Museum
Journal*, vol. 8 (Malibu, 1990), pp. 1–22.

WILSON, "ACQUISITIONS 1981"
 Wilson, "Acquisitions Made by the
Department of Decorative Arts,
1981–1982," *The J. Paul Getty Museum
Journal*, vol. 10 (Malibu, 1982), pp. 63–86.

WILSON, SELECTIONS
 Gillian Wilson, *Selections from the
Decorative Arts in the J. Paul Getty Museum*
(Malibu, 1983).

WILSON, "SÈVRES"
 Gillian Wilson, "Sèvres Porcelain at the
J. Paul Getty Museum," *The J. Paul Getty
Museum Journal*, vol. 4 (Malibu, 1977).

WILSON ET AL., MOUNTED ORIENTAL
PORCELAIN
 Gillian Wilson, F. J. B. Watson, and
Anthony Derham, *Mounted Oriental
Porcelain in the J. Paul Getty Museum*
(Malibu, 1982).

EDITOR'S NOTE: In the provenance sections,
the lack of a semicolon before a sale in paren-
theses indicates that the object was sold from
the collection of that person, dealer, or gallery;
dealers are set off by brackets; and unless
otherwise noted, the year in which an object
was acquired either by the J. Paul Getty
Museum or by J. Paul Getty is reflected in the
first two digits of the accession number.

French
Decorative Arts

*

Furniture

BOXES, CHESTS, AND COFFERS

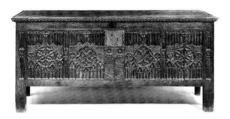

1

1. Chest
Late fifteenth century
Carved walnut
Height: 3 ft. 1⅜ in. (94.9 cm); Width:
6 ft. 10¼ in. (208.9 cm); Depth: 2 ft. 3 in.
(68.6 cm)
Accession number 78.DA.108

PROVENANCE
[Ugo Bardini, 1960]; purchased by J. Paul
Getty for Sutton Place, Surrey; distributed
by the estate of J. Paul Getty to the J. Paul
Getty Museum.

EXHIBITIONS
Woodside, California, Filoli, on loan,
1983–1991.

2. Coffer
Second half of the sixteenth century
Oak and iron
Height: 3 ft. 1¾ in. (95.5 cm); Width:
5 ft. 10¾ in. (179.7 cm); Depth: 2 ft. 5⅝ in.
(75.2 cm)
Accession number 78.DA.124

PROVENANCE
O. V. Watney, Cornbury Park, Charlbury,
Oxfordshire, England (sold, Christie's,
Cornbury Park, May 22, 1967, lot 93); pur-
chased by J. Paul Getty for Sutton Place,
Surrey; distributed by the estate of J. Paul
Getty to the J. Paul Getty Museum.

EXHIBITIONS
Woodside, California, Filoli, on loan,
1983–1992.

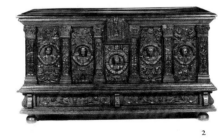

2

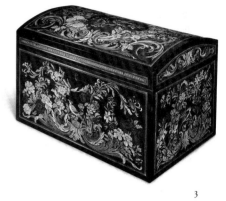

3

3. Box
Paris, circa 1675–1680
Attributed to André-Charles Boulle
Oak veneered with ebony, boxwood, natural
and stained sycamore, mahogany, padouk,
walnut, amaranth, cedar, pear, satinwood,
brass, horn, and pewter stringing
Height: 1 ft. 4½ in. (31.9 cm); Width:
2 ft. 2 in. (66.1 cm); Depth: 1 ft. 5 in.
(43.2 cm)
Accession number 84.DA.971

PROVENANCE
[B. Fabre et Fils, Paris, 1984].

BIBLIOGRAPHY
"Acquisitions/1984," *GettyMusJ* 13 (1985),
no. 46, p. 175, illus.

4. Two Coffers on Stands

Paris, circa 1684–1689
Attributed to André-Charles Boulle
Oak and walnut veneered with plain and
red painted tortoiseshell, blue painted horn,
ebony, amaranth, pewter, and brass; set with
mirror glass; gilt-bronze mounts
One stand stamped *HY.RASKIN* at top of
back for Henry Raskin, an early twentieth-
century French restorer. Some mounts on
each coffer and stand are stamped with
the crowned *C* for 1745–1749.
82.DA.109.1: Overall Height: 5 ft. 1⅛ in.
(156.6 cm); Coffer (*première-partie*):
Height: 2 ft. 2⅜ in. (67 cm); Width:
2 ft. 11⅜ in. (89.9 cm); Depth: 1 ft. 10 in.
(55.8 cm); Stand: Height: 2 ft. 11¼ in.
(89.6 cm); Width: 2 ft. 7⅞ in. (80.9 cm);
Depth: 1 ft. 9½ in. (54.7 cm)
82.DA.109.2: Overall Height: 5 ft. 1½ in.
(156.2 cm); Coffer (*contre-partie*): Height:
2 ft. 2⅜ in. (67 cm); Width: 2 ft. 11¼ in.
(89.4 cm); Depth: 1 ft. 10 in. (55.8 cm);
Stand: Height: 2 ft. 11⅛ in. (89.2 cm);
Width: 2 ft. 7¼ in. (79.4 cm); Depth:
1 ft. 8 in. (50.7 cm)
Accession number 82.DA.109.1.a-.b and
.2.a-.b

PROVENANCE

82.DA.109.1: (?) C. F. Julliot (sold, Paris,
November 20, 1777, lot 706, to M. de
Luneville for 590 *livres*).
82.DA.109.1–.2: Anatole Demidov, Prince of
San Donato (1813–1870), San Donato Palace,
Pratolino (near Florence) (offered for sale
by his nephew Paul Demidoff, Prince of
San Donato [died 1885], San Donato Palace,
March 15, 1880, lots 1421–1422, bought in);

4

Marquis da Foz, Lisbon; Mortimer L. Schiff,
New York (sold by his heir John L. Schiff,
Christie's, London, June 22, 1938, lot 68,
to Gaston Bensimon for 1,080 guineas);
Anna Gould (duchesse de Talleyrand),
Palais Rose, Paris; Violette de Talleyrand
(Mme Gaston Palewski), Château de
Marais, Seine-et-Oise (offered for sale,
Sotheby's, Monaco, May 26, 1980, lot 619,
for 3,800,000 FF, bought in).

BIBLIOGRAPHY

Alfred de Champeaux, *Le Meuble* (Paris,
1885), vol. 2, p. 78, illus. p. 65, fig. 12;
A. Genevay, *Le Style Louis XIV: Charles Le
Brun, decorateur: Ses oeuvres, son influence,
ses collaborateurs et son temps* (Paris, 1886),
p. 241, fig. 31; Henry Havard, *Les Boulle*
(Paris, 1892), p. 40, illus. pp. 41, 45; Emile
Molinier, *Histoire générale des arts appliqués
à l'industrie*, vol. 3, *Le Mobilier au XVII^e et
au XVIII^e siècle* (Paris, 1896–1911), p. 74,
illus.; Gerald Reitlinger, *The Economics of
Taste*, vol. 2 (London, 1963), p. 415; Pierre
Verlet, "A Propos de Boulle et du Grand

Dauphin," *Nederland Kunsthistorisch Jaar-buch 3* (1980), pp. 285–288, illus.; Wilson, "Acquisitions 1982," no. 1, pp. 13–18, illus.; Wilson, *Selections*, no. 6, pp. 12–13, illus.; *Handbook* 1986, p. 143, illus. (one); Pradère, *Les Ebénistes*, p. 68, nos. 131–132, p. 104; illus. p. 68, fig. 14; *Handbook* 1991, p. 157, illus. (one).

─────

5. **Pipe Box**

Lorraine, circa 1710–1715
Bois de Sainte-Lucie (cerasus mahaleb)
Height: 2 9/16 in. (6.5 cm); Width:
1 ft. 10 5/8 in. (59.5 cm); Depth: 8 1/4 in.
(21 cm)
Accession number 88.DA.61

PROVENANCE
[Didier Aaron, Paris].

BIBLIOGRAPHY
"Acquisitions/1988," *GettyMusJ* 17 (1989), no. 69, p. 141, illus.

─────

5

CABINETS

6. **Cabinet**

Burgundy, circa 1580, with late nineteenth-century additions
Based on engraved designs by Jacques I Androuet Du Cerceau (active 1549–1584) and Jan Vredeman de Vries (1527–1604)
Carved walnut set with painted panels
The number *1580* painted on one panel.
Overall Height: 10 ft. 1 1/8 in. (308.3 cm); Width: 5 ft. 5 3/8 in. (166.2 cm); Depth: 1 ft. 10 1/2 in. (57.1 cm)
Accession number 71.DA.89

PROVENANCE
Baron Achille Seillière, Château de Mello, Oise, France (sold, Galerie Georges Petit, Paris, May 9, 1890, lot 540); Gauthiot d'Anchier, Governor of Besançon, France; [Duveen Brothers, New York, 1930s]; Norton Simon Foundation (sold, Parke-Bernet, New York, May 7, 1971, lot 193); purchased by J. Paul Getty.

BIBLIOGRAPHY
Edmond Bonnaffé, "Le Meuble en France au XVI^e siècle," *Gazette des beaux-arts* (1886), pp. 60–63, illus.; Edmond Bonnaffé, *Le Meuble en France au XVI^e siècle* (Paris, 1887), pp. 84–85, 166–167, illus.; Georg Hirth, *Formenschatz* (French ed.: *L'Art pratique*), Munich, 1891, pl. 7; Alfred de Champeaux, *Le Meuble* (Paris, 1906), vol. 1, pp. 198–199, illus. p. 195.

─────

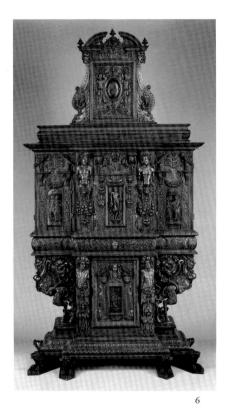

6

7. **Cabinet on Stand**

Paris, circa 1675–1680
Attributed to André-Charles Boulle. Medals after Jean Varin
Oak veneered with ebony, tortoiseshell, pewter, brass, ivory, horn, boxwood, pear, thuya, stained and natural sycamore, satinwood, beech, amaranth, cedar, walnut, mahogany, ash; with drawers of lignum vitae; painted and gilded wood; bronze mounts

Height: 7 ft. 6½ in. (229.9 cm); Width:
4 ft. 11½ in. (151.2 cm); Depth: 2 ft. 2¼ in.
(66.7 cm)
Accession number 77.DA.I

PROVENANCE

(?) William Ward, 11th Baron Ward (born
1817, created 1st Earl of Dudley 1860, died
1885), Witley Court, Worcestershire (house
acquired, with contents, in 1838, from Lord
Foley); (?) William Humble, 2nd Earl of
Dudley (born 1867, died 1932), Witley
Court, Worcestershire, circa 1920 (sold
with the house to Sir Herbert Smith, Witley
Court) (sold, Jackson-Stops and Staff,
Witley Court, September 29, 1938, lot 582);
Violet van der Elst, Harlaxton Manor,
Lincolnshire (sold, Christie's, London,
April 8, 1948, lot 142); John Prendergast,
6th Viscount Gort, Hamsterley Hall,
County Durham (sold by his heirs, 1976).

EXHIBITIONS

Barnard Castle, County Durham, The
Bowes Museum, on loan, 1950s; London,
The Victoria and Albert Museum, on loan,
August 1978–February 1979.

BIBLIOGRAPHY

"A La découverte," *Connaissance des arts* 35
(January 15, 1955), p. 58, illus.; Stéphane
Faniel et al., *Le XVIII^e siècle français*
(Collection Connaissance des arts, Paris,
1958), illus. p. 53; "Current and Forth-
coming Exhibitions," *Burlington Magazine*
120 (December 1978), p. 93, illus.; Wilson,
"Acquisitions 1977 to mid 1979," no. 1, p. 37,
illus.; Marvin D. Schwartz, "Boulle Furni-
ture," *Art and Antiques* 6 (April 1983), illus.

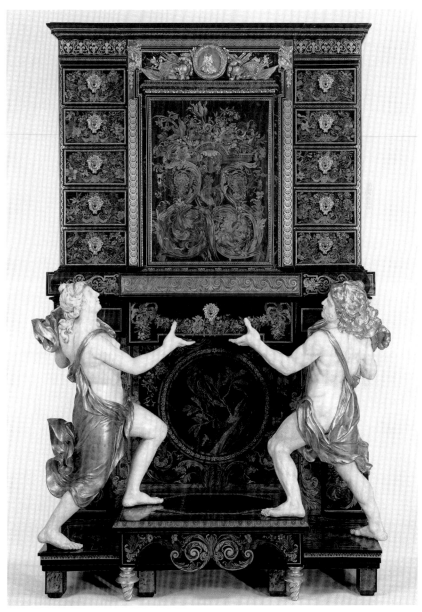

7

p. 72; Wilson, *Selections*, no. 3, pp. 6–7, illus.; Gillian Wilson, "A Late Seventeenth-Century French Cabinet at the J. Paul Getty Museum," *The Art Institute of Chicago Centennial Lecture; Museum Studies* 10 (1983), pp. 119–131, illus.; *Handbook* 1986, p. 145, illus. p. 144; Lorenz Seelig, "Eine Reiterstatuette Kurfürst Max Emanuels von Bayern aus dem Jahr 1699," *Anzeiger des germanischen Nationalmuseums* (1986), n. 34, p. 73; Pradère, *Les Ebénistes*, p. 94; p. 104, no. 103; illus. p. 93, fig. 49; *Handbook* 1991, p. 158, illus. p. 159.

8. **Cabinet (*cabinet des médailles*)**
Paris, circa 1710–1715
Attributed to André-Charles Boulle
Oak veneered with ebony, brass, and tortoiseshell; gilt-bronze mounts; *sarrancolin des Pyrénées* marble top
Height: 2 ft. 8½ in. (82.5 cm); Width: 4 ft. 7¼ in. (140 cm); Depth: 2 ft. 4½ in. (72.5 cm)
Accession number 84.DA.58

PROVENANCE
Suzanne de Launay and Jules-Robert de Cotte, Paris; inventoried after their deaths as one of a pair of medal cabinets on November 20, 1767; by descent to their son, Jules-François de Cotte; inventoried in his collection on May 13, 1782 (sold, Paris, March 8, 1804, lot 34); Baron Gustave Salomon de Rothschild, Paris; Baronne Cecilie de Rothschild (née Ansbach, 1840–1912), Paris; Sir Philip Sassoon, Bt., London, by descent, 1912; Sybil Sassoon

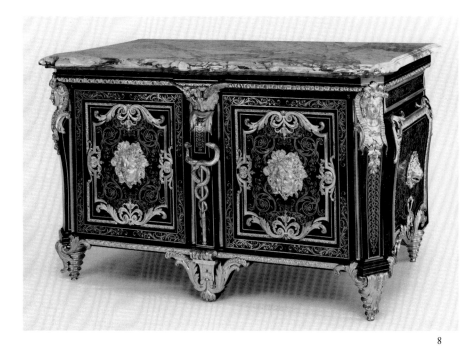

8

(Marchioness of Cholmondeley, wife of the 5th Marquess, married 1913), Houghton Hall, Norfolk, by descent, after 1939 (sold, Christie's, London, April 12, 1984, lot 164).

EXHIBITIONS
London, 25 Park Lane, *Three French Reigns*, February–April 1933, no. 71, illus.

BIBLIOGRAPHY
F. J. B. Watson, "The Marquess of Cholmondeley," *Great Family Collections*, Douglas Cooper, ed. (Zurich, 1963), p. 228, illus.; Pierre Verlet, *La Maison du XVIIIᵉ siècle en France: Société, décoration, mobilier* (Paris, 1966), p. 38, fig. 21; Wilson, "Acquisitions 1984," pp. 67–71, illus.; "Acquisitions/1984," *GettyMusJ* 13 (1985), no. 47, pp. 175–176, illus.; Pradère, *Les Ebénistes*, no. 157, p. 104, illus. p. 109, fig. 65; *Handbook* 1991, p. 162, illus.

9. **Armoire**

Paris, circa 1720–1725

Oak veneered with rosewood and olive;
modern fabric lining

Height: 5 ft. 9¼ in. (176 cm); Width:
3 ft. 2⅜ in. (97.5 cm); Depth: 1 ft. 5¼ in.
(43.5 cm)

Accession number 84.DA.852

PROVENANCE

Private collection, France; [La Cour de
Varenne, Paris].

BIBLIOGRAPHY

"Acquisitions/1984," *GettyMusJ* 13 (1985),
no. 50, pp. 176–177, illus.

10. *Cartonnier* with *Bout de Bureau*
and Clock

Paris, *cartonnier* and *bout de bureau*
circa 1740

Clock, 1746

Cartonnier and *bout de bureau* by Bernard II
van Risenburgh. Maker of the clock case
unknown. The clock movement by Etienne
II Le Noir. The clock dial enameled by
Jacques Decla

Oak veneered with ebonized wood and
painted with *vernis Martin*; enameled and
painted metal; glass; gilt-bronze mounts

Cartonnier and *bout de bureau* stamped
BVRB on the back; *cartonnier* also stamped
with the name of *E.J. CUVELLIER*, who
possibly restored it. Several mounts on
clock case stamped with the crowned *C* for
1745–1749. The clock dial and movement
are signed *Etienne LeNoir AParis*. The spring

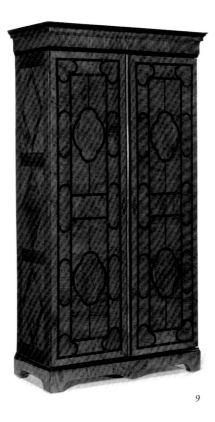

9

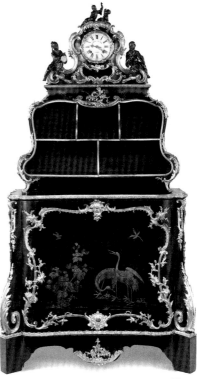

10

of the striking train is dated *1746* and the
back of the dial bears the enameled inscrip-
tion *.decla.1746*. Metal plaque on the rear
of *cartonnier* engraved *Angela's 1835*; also a
torn typed label with *M....xandrine de.....*

Height: 6 ft. 3⅝ in. (192 cm); Width:
3 ft. 4⁹⁄₁₆ in. (103 cm); Depth: 1 ft. 4⅛ in.
(41 cm)

Accession number 83.DA.280

PROVENANCE

(?) Harriot Mellon Coutts (1777–1837?),
widow of Thomas Coutts and later Duchess

of St. Albans; Angela Georgina, Baroness
Burdett-Coutts (1814–1906, stepgrand-
daughter of Harriot, Duchess of St. Albans),
London, probably given to her in 1835 on
her twenty-first birthday; Hon. William
Bartlett Burdett-Coutts M.P. (husband
of Angela, Baroness Burdett-Coutts), by
descent, 1906 (sold, Christie's, London,
May 9, 1922, lot 144, for 4,200 guineas to
H. J. Simmons); Alexandrine de Roth-
schild, Paris; confiscated after the German
occupation of Paris in 1940; Edmond de

Rothschild, Paris, 1972; José and Vera Espirito Santo, Lausanne, Switzerland, after 1972.

BIBLIOGRAPHY

Sassoon, "Acquisitions 1983," no. 6, pp. 193–197, illus.; "Acquisitions/1983," *GettyMusJ* 12 (1984), no. 8, pp. 263–264, illus.; *Handbook* 1986, p. 159, illus. p. 158; Jean-Dominique Augarde, "1749 Joseph Baumhauer, ébéniste privilegié du roi," *L'Estampille* 204 (June 1987), p. 25; Pradère, *Les Ebénistes*, illus. p. 196, fig. 188; *Handbook* 1991, p. 175, illus. p. 174.

11. **Cabinet**

Paris, circa 1745–1750
Attributed to Bernard II van Risenburgh
Oak veneered with tulipwood, *bois satiné*, and cherry; gilt-bronze mounts; *brèche d'Alep* top
Inscribed *DAVAL* twice on the back.

Height: 3 ft. 9⅝ in. (115.8 cm); Width: 15 ft. 4½ in. (468.6 cm); Depth: 1 ft. 9½ in. (54.5 cm)
Accession number 77.DA.91

PROVENANCE

Daval (*marchand-mercier*, died circa 1821), Paris, before 1822; Henri, comte de Greffulhe, Paris (sold by his widow, Sotheby's, London, July 23, 1937, lot 50, to both [Arnold Seligmann] and [Trevor and Co.], for £1,400); [David Drey, London, 1950s]; [Maurice Aveline, Paris, 1950s]; Antenor Patiño, Paris, circa 1957; [Aveline et Cie, Paris and Geneva].

BIBLIOGRAPHY

Charles Guellette, "Les Cabinets d'amateurs à Paris—La Collection de M. Henri de Greffulhe, Part 2: Ameublement," *Gazette des beaux-arts* 15 (1877), p. 466; Gerald Reitlinger, *The Economics of Taste* (London, 1963), vol. 2, p. 426; Wilson, "Acquisitions 1977 to mid 1979," no. 3, p. 37, illus.; Pradère, *Les Ebénistes*, p. 190, illus. p. 185, fig. 168.

12. **Pair of Cabinets**

Paris, circa 1745–1750
By Bernard II van Risenburgh
Oak veneered with *bois satiné*, kingwood, and cherry; gilt-bronze mounts
Each cabinet is stamped *B.V.R.B.* on back.
Height: 4 ft. 10⅛ in. (149 cm); Width: 3 ft. 3¾ in. (101 cm); Depth: 1 ft. 7 in. (48.3 cm)
Accession number 84.DA.24.1–.2

PROVENANCE

(?) Sir John Hobart Caradoc, 2nd Baron Howden, Grimston Park, Tadcaster, Yorkshire, circa 1840; (?) Albert Denison, 1st Baron Londesborough, Grimston Park, 1850; (?) William Henry Forester, created Earl of Londesborough, Grimston Park (sold with the contents of Grimston Park in 1872 to John Fielden); Captain John Fielden (great-nephew of John Fielden) (sold, Henry Spencer and Sons, at Grimston Park, Tadcaster, Yorkshire, May 29–31, 1962, lot 372); [Etienne Lévy and René Weiller,

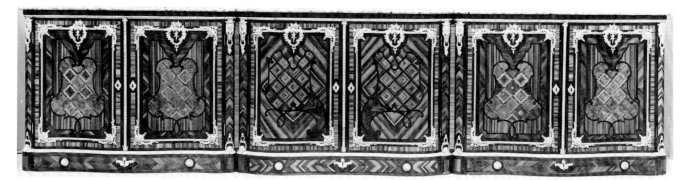

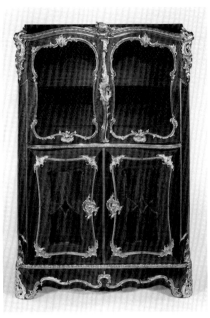

One of a pair 12

Paris, 1962]; [Raymond Kraemer, Paris, 1960s]; [Kraemer et Cie, Paris, 1970s].

BIBLIOGRAPHY

"Acquisitions/1984," *GettyMusJ* 13 (1985), no. 54, pp. 178–179, illus.; *Handbook* 1986, p. 164, illus. (one); Pradère, *Les Ebénistes*, illus. p. 188, fig. 174; Kjellberg, *Dictionnaire*, p. 139; *Handbook* 1991, p. 180, illus. (one).

13. **Cabinet**

Paris, circa 1765
By Joseph Baumhauer
Oak veneered with ebony, tulipwood, and amaranth; set with panels of seventeenth-century Japanese *kijimaki-e* lacquer; gilt-bronze mounts; yellow jasper top
Stamped *JOSEPH* between two fleur-de-lys under the apron.
Height: 2 ft. 11¼ in. (89.6 cm); Width: 3 ft. 11⅜ in. (120.2 cm); Depth: 1 ft. 11⅛ in. (58.6 cm)

Accession number 79.DA.58

PROVENANCE

[Kraemer et Cie, Paris, 1930–1939]; private collection, Brussels; [Lucien Delplace, Brussels]; [Les Antiquaires de Paris, circa 1976]; [Alexander and Berendt, Ltd., London, 1977].

BIBLIOGRAPHY

Wilson, "Acquisitions 1979 to mid 1980," pp. 6–7, illus.; Wilson, *Selections*, no. 34, pp. 68–69, illus.; *Handbook* 1986, p. 171,

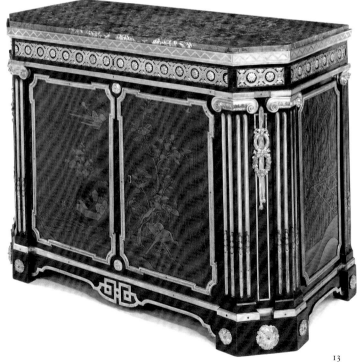

13

illus.; Jean-Dominique Augarde, "1749 Joseph Baumhauer, ébéniste privilegié du roi," *L'Estampille* 204 (June 1987), pp. 15–45, figs. 26, 28; Pradère, *Les Ebénistes*, no. 16, p. 244; Kjellberg, *Dictionnaire*, p. 450; *Handbook* 1991, p. 187, illus. p. 186.

———

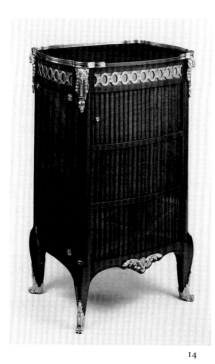

14

14. **Cabinet**

Paris, circa 1765
By Roger Vandercruse Lacroix
Oak veneered with *bois-de-rose*, amaranth, and green stained wood; gilt-bronze mounts; white marble interior shelf

Stamped *RVLC* and *JME* inside the drawer at top right-hand side. Paper label glued underneath printed with a ducal coronet above the typed inscription *CLUMBER*.
Height: 3 ft. 1 in. (94 cm); Width: 1 ft. 11¼ in. (59.5 cm); Depth: 1 ft. 5¼ in. (43.8 cm)
Accession number 70.DA.81

PROVENANCE
Dukes of Newcastle-under-Lyme, Clumber, Nottinghamshire; Henry Pelham Archibald Douglas, 7th Duke of Newcastle (1864–1928), Clumber, Nottinghamshire, by descent (sold by his heir, Christie's, London, June 9, 1937, lot 253); [J. M. Botibol, London]; purchased by J. Paul Getty, 1938.

BIBLIOGRAPHY
Verlet et al., *Chefs d'oeuvre*, p. 125, illus.; Getty, *Collecting*, illus. p. 155.

———

15. **Cabinet**

Paris, circa 1785–1790, with marquetry panels and some gilt-bronze mounts of the late seventeenth century
Attributed to Philippe-Claude Montigny
Oak veneered with ebony, brass, pewter, tortoiseshell, and amaranth; gilt-bronze mounts; *blanco et nero antico* marble top
Height: 3 ft. 5¼ in. (104.8 cm); Width: 5 ft. 4⅝ in. (164.2 cm); Depth: 1 ft. 10½ in. (57.1 cm)
Accession number 72.DA.71

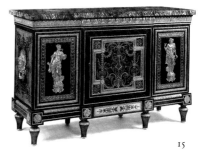

15

PROVENANCE
George Granville Sutherland-Leveson-Gower, 2nd Duke of Sutherland (1786–1861), the Picture Gallery, Stafford House, London, by 1848, and still present in 1895; [Arnold Seligmann, Paris] (sold, Galerie Jean Charpentier, Paris, June 4–5, 1935, lot 192); [François-Gérard Seligmann, Paris]; [French and Co., 1972]; purchased by J. Paul Getty.

BIBLIOGRAPHY
F. J. B. Watson, *Louis XVI Furniture* (London, 1960), no. 236, illus.; Jean Meuvret and Claude Frégnac, *Ebénistes du XVIIIᵉ siècle français* (Paris, 1963), p. 37, illus.; Michael Stürmer, *Handwerk und höfische Kultur: Europäische Möbelkunst im 18. Jahrhundert* (Munich, 1982), illus. pp. 156, 288; Marvin D. Schwartz, "Boulle Furniture," *Art and Antiques* 6 (April 1983), illus. p. 67; Alexandre Pradère, "Boulle de Louis XIV sous Louis XVI," *L'Estampille-L'Objet d'art* 0 (June 1987), pp. 56–57, 118; illus. p. 62.

———

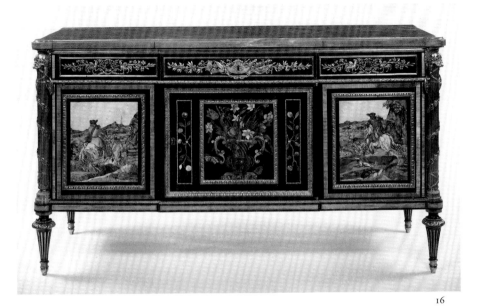

16

16. **Cabinet**

Paris, 1788

By Guillaume Benneman; gilt-bronze
mounts cast by Forestier (either Etienne-
Jean or his brother Pierre-Auguste) and
Badin from models by Gilles-François
Martin, chased by Pierre-Philippe Thomire
and gilded by André Galle; marble top
supplied by Lanfant

Oak veneered with ebony, mahogany, and
lacquer, set with *pietre dure* plaques of
seventeenth- and eighteenth-century date;
gilt-bronze mounts; *bleu turquin* marble top
Stamped *G.BENEMAN* twice on top of the
carcass and stenciled with a partial mark,
possibly for the Château de Saint-Cloud,
on back.

Height: 3 ft. ¼ in. (92.2 cm); Width:
5 ft. 5⅛ in. (165.4 cm); Depth: 2 ft. 1¼ in.
(64.1 cm)
Accession number 78.DA.361

PROVENANCE

Louis XVI, one of a pair costing 5,954 *livres*
in the *Chambre à coucher du Roi*, Château
de Saint-Cloud, from October 4, 1788,
until at least *an* II (1793–1794); Earls of
Powis, Powis Castle, Wales, by 1848 (sold,
Sotheby's, London, May 11, 1962, lot 262,
for £33,000); John Allnat (sold, Sotheby's,
London, June 21, 1974, lot 109, to Didier
Aaron, Paris); [Aveline et Cie, Paris and
Geneva].

EXHIBITIONS

London, The Victoria and Albert Museum,
on loan, 1969–1974.

BIBLIOGRAPHY

"Powis Castle, Montgomeryshire, the Seat of
the Earl of Powis," *Country Life* 23 (May 9,
1908), illus. p. 670; Jean Meuvret and
Claude Frégnac, *Les Ebénistes du XVIII^e
siècle français* (Paris, 1963), pp. 306–307,
illus.; Anthony Coleridge, "Clues to the
Provenance of an Outstanding French
Commode," *Connoisseur* 162 (July 1966),
pp. 164–166, illus.; Wilson, "Acquisitions
1977 to mid 1979," no. 11, pp. 46–49, illus.;
Gillian Wilson, "A Pair of Cabinets for
Louis XVI's Bedroom at Saint-Cloud:
Their Present Appearance," *Journal of the
Furniture History Society* 21 (1985), pp. 4–47;
Verlet, *Les Bronzes*, p. 213, illus. p. 46,
fig. 39; Pradère, *Les Ebénistes*, illus. p. 406,
fig. 502; Pierre Verlet, *Le Mobilier royal
français*, vol. 4, *Meubles de la couronne
conservés en Europe et aux Etats-Unis* (Paris,
1990), pp. 116–121, illus.; *Handbook* 1991,
p. 197, illus. p. 196; Ulrich Leben, *Molitor:
Ebéniste from the Ancien Régime to the
Bourbon Restoration* (London, 1992), p. 150,
fig. 153.

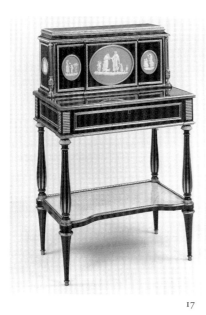

17

17. *Bonheur du Jour*

Paris, circa 1785–1790
Attributed to Adam Weisweiler; Wedgwood
jasperware plaques designed by Elizabeth,
Lady Templetown, and modeled by William
Hackwood
Oak and mahogany veneered with amboyna,
ebony, green stained harewood, and syca-
more; set with five jasperware plaques with
a green ground; gilt-bronze mounts; white
marble top and shelf
Height: 3 ft. 6⅜ in. (107.6 cm); Width:
2 ft. 3¼ in. (69.2 cm); Depth: 1 ft. 4¼ in.
(41.3 cm)
Accession number 72.DA.59

PROVENANCE
(?) Baronne de Gunzburg, Paris (sold, Palais
Galliera, Paris, March 2, 1972, lot 121); pur-
chased at that sale by J. Paul Getty.

EXHIBITIONS
The Los Angeles County Museum of Art,
*Wedgwood from California Collections:
Georgian through Victorian, 1760–1901,*
January 27–March 21, 1976.

BIBLIOGRAPHY
Patricia Lemonnier, *Weisweiler* (Paris, 1983),
no. 211, illus. p. 28; Kjellberg, *Dictionnaire,*
p. 872.

18. **Pair of Cabinets**

Paris, Cabinet .1 circa 1785; Cabinet .2
circa 1810
Pietre dure plaques: Italian and French,
mid-seventeenth to late eighteenth century
Both cabinets attributed to Adam Weisweiler
Oak, pine, and beech veneered with ebony
and mahogany; pewter stringing; set with
pietre dure plaques and micromosaic roun-
dels; gilt-bronze mounts; *portor d'Italie* tops

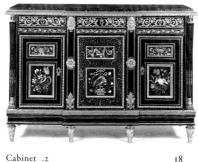

Cabinet .2 18

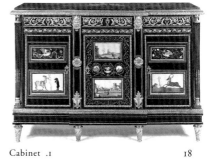

Cabinet .1 18

Cabinet .1 stamped *JME.*
Height: 3 ft. 4 in. (101.6 cm); Width:
4 ft. 11⅛ in. (150.5 cm); Depth: 1 ft. 9½ in.
(54.5 cm)
Accession number 76.DA.9.1–.2

PROVENANCE
76.DA.9.1: M. Marin, Paris (sold, Paris,
March 22, 1790, lot 712, for 3,100 *livres*);
Vincent Donjeux, Paris (sold, Paris, April 29
et seq., 1793, lot 554, for 3,200 *livres*).
76.DA.9.1–.2: (?) William Beckford, Fonthill
Abbey, Wiltshire; (?) Susan Beckford
(Duchess of Hamilton, wife of Alexander
Archibald Douglas, the 10th Duke of
Hamilton and 7th Duke of Brandon,
married 1810, died 1859), Hamilton Palace,
Lanarkshire, Scotland; William, 12th Duke
of Hamilton and 9th Duke of Brandon,
Hamilton Palace, by descent (sold,
Christie's, London, June 19, 1882, lots
185–186); Christopher Beckett-Denison,
London (sold, Christie's, London, June 6,
1885, lot 817, to Maclean for 195 guineas,
and lot 818, to Donaldson for 205 guineas);
[Moss Harris, London]; Maharanee of
Baroda, Paris (sold, Palais Galliera, Paris,
November 29, 1973, lot 114 A–B); [Aveline et
Cie, Paris]; purchased by J. Paul Getty.

BIBLIOGRAPHY

Ronald Freyberger, "Hamilton Palace," *Apollo* 113, no. 238 (December 1981), pp. 401–409; Alvar González-Palacios, *Mosaici e Pietre Dure* (Milan, 1982), illus. p. 48; Kjellberg, *Dictionnaire*, p. 872; Alvar González-Palacios, "Capricci Gusto: Vecchio Barocco e Nuovo Classicismo," *Casa vogue antiques* 13 (May 1991), p. 77, illus. p. 79 (76.DA.9.1 only).

COMMODES

19. **Commode**

Paris, circa 1710–1715
Pine and walnut veneered with *bois satiné;* gilt-bronze mounts
Stamped on the back with a crowned *M*, probably for the Château de Maisons, and an interlaced *AT* over *G.M* for the *garde-meuble* of the comte d'Artois.
Height: 2 ft. 9 1/16 in. (83.9 cm); Width: 4 ft. 7 1/4 in. (140.3 cm); Depth: 1 ft. 11 1/2 in. (59.7 cm)
Accession number 78.DA.87

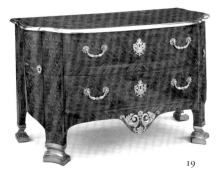

19

PROVENANCE

Marquis de Longueil, Château de Maisons; comte d'Artois, Château de Maisons, after 1777; [(?) Léon Lacroix, Paris, 1938]; purchased by J. Paul Getty, 1938.

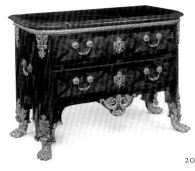

20

20. **Commode**

Paris, circa 1710–1715
Pine, oak, and walnut veneered with rosewood; gilt-bronze mounts; *rouge griotte de Félines* marble top
Height: 2 ft. 9 1/2 in. (85.1 cm); Width: 4 ft. (121.9 cm); Depth: 1 ft. 10 3/8 in. (56.8 cm)
Accession number 73.DA.66

PROVENANCE

M. d'Eustache Bonnemet, Paris (sold, Paris, December 4–14, 1771, lot 164, for 210 *livres*); ducs d'Arenberg, Palais d'Arenberg, Brussels, until 1914; duchesse Mathildis d'Arenberg, Monaco; [Gérard Gallet, Cannes]; [French and Co., New York]; purchased by J. Paul Getty.

21. **Commode**

Paris, circa 1710–1715
Attributed to André-Charles Boulle
Oak and pine veneered with tulipwood and *bois satiné*; gilt-bronze mounts; *brocatelle violette du Jura* marble top
The top of the carcass is stamped *C.M. COCHOIS* and printed in black ink with the number *55406*. The bottom of the marble top is marked with the number *55406/19* in black wax pencil. Many mounts stamped with the crowned *C* for 1745–1749.
Height: 2 ft. 9 3/4 in. (85.7 cm); Width: 4 ft. 3 3/4 in. (131.4 cm); Depth: 1 ft. 11 in. (58.4 cm)
Accession number 70.DA.80

PROVENANCE

(?) Henry Peter, 1st Lord Brougham (1778–1868), Cannes, 1840s or 1850s; (?) William, 2nd Lord Brougham (died 1886), England, after 1868; (?) Hon. Wilfred Brougham, England, after 1886; Maria Sophia Faunce (Hon. Mrs. Wilfred Brougham), England, after 1904; [J. M. Botibol, London, 1938]; purchased by J. Paul Getty, 1938.

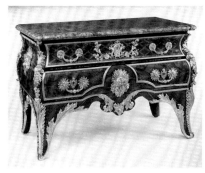

21

BIBLIOGRAPHY
Paul Wescher, "French Furniture of the
Eighteenth Century in the J. Paul Getty
Museum," *Art Quarterly* 18, no. 2 (Summer
1955), p. 117, illus. p. 120, fig. 4; Kjellberg,
Dictionnaire, p. 184.

22. **Commode**

Paris, circa 1725–1730
By Etienne Doirat
Oak, pine, and walnut veneered with king-
wood; gilt-bronze mounts; *brèche d'Alep* top
Stamped *E. DOIRAT* on top of carcass.
Height: 2 ft. 10 in. (86.4 cm); Width:
5 ft. 6½ in. (168.9 cm); Depth: 2 ft. 4¼ in.
(71.7 cm)
Accession number 72.DA.66

PROVENANCE
George Durlacher, London (sold, Christie's,
London, April 6–7, 1938, lot 176, for 273
guineas to Sutch); ("Property of a Gentle-
man," sold, Christie's, London, December 1,
1966, lot 70, for 5,500 guineas to Perman);
[Aveline et Cie, Paris, 1972]; purchased by
J. Paul Getty.

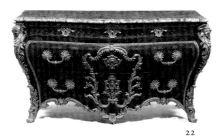

22

BIBLIOGRAPHY
Jean-Dominique Augarde, "Etienne Doirat,
Menuisier en Ebène," *GettyMusJ* 13 (1985),
pp. 33–52, illus. p. 45; *Handbook* 1986, p. 152,
illus.; Pradère, *Les Ebénistes*, illus. p. 122,
fig. 78; Kjellberg, *Dictionnaire*, p. 264;
Handbook 1991, p. 166, illus.

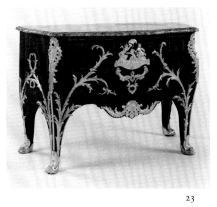

23

23. **Commode**

Paris, circa 1735–1740
By Charles Cressent
Pine and walnut veneered with *bois satiné*
and amaranth; gilt-bronze mounts; *brèche
d'Alep* top
Corner mounts are stamped with the
crowned *C* for 1745–1749.
Height: 2 ft. 11½ in. (90.2 cm); Width:
4 ft. 5¾ in. (136.5 cm); Depth: 2 ft. 1½ in.
(64.8 cm)
Accession number 70.DA.82

PROVENANCE
[Duveen Brothers, New York]; George J.
Gould, Georgian Court, Lakewood, New
Jersey; (possibly sold Anderson Galleries,
New York, May 10–14, 1927, lot 1003);
[Arnold Seligmann, Rey and Co., New
York]; purchased by J. Paul Getty, 1938.

BIBLIOGRAPHY
Cressent sale cat., January 15, 1757, lot 132;
Marie-Juliette Ballot, *Charles Cressent:
Sculpteur, ébéniste, collectionneur, Archives
de l'art français: Nouvelle période 10* (Paris,
1919), no. 132, p. 215; André Boutemy,
"Essais d'attributions de commodes et
d'armoires à Charles Cressent," *Bulletin
de la Société de l'Histoire de l'Art Français*
(1927), pp. 77–79; Paul Wescher, "French
Furniture of the Eighteenth Century in the
J. Paul Getty Museum," *Art Quarterly* 18,
no. 2 (Summer 1955), pp. 114–135; Verlet
et al., *Chefs d'oeuvre*, p. 114, illus.; Getty,
Collecting, p. 144, illus.; Wilson, *Selections*,
no. 19, pp. 38–39, illus.; *Handbook* 1986,
p. 153, illus. p. 152; Kjellberg, *Dictionnaire*,
p. 204; *Handbook* 1991, p. 167, illus. p. 166.

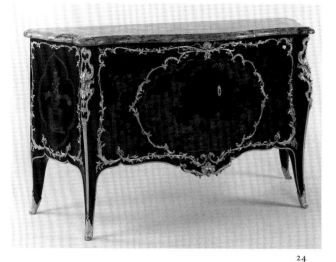

24

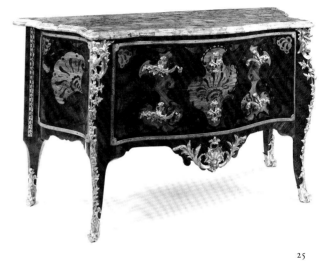

25

24. **Commode**

Paris, circa 1737
By Bernard II van Risenburgh
Oak set with panels of black Japanese
lacquer and painted with *vernis Martin*;
cherry and amaranth on interior of the
doors; gilt-bronze mounts; *sarrancolin*
marble top; eighteenth-century silk fabric
lining and silver metal *galon*
Stamped *BVRB* on top of carcass.
Height: 2 ft. 10¾ in. (88.3 cm); Width:
4 ft. 11¾ in. (151.9 cm); Depth: 1 ft. 10¾ in.
(57.8 cm)
Accession number 65.DA.4

PROVENANCE

(?) Colbert family, France, by repute, from
the eighteenth to the twentieth century;
[René Weiller, Paris]; [Rosenberg and
Stiebel, Inc., New York]; purchased by
J. Paul Getty, 1953.

BIBLIOGRAPHY

Paul Wescher, "French Furniture of the
Eighteenth Century in the J. Paul Getty
Museum," *Art Quarterly* 18, no. 2 (Summer
1955), pp. 121–122, 128, illus. fig. 11; F. J. B.
Watson, *The Wrightsman Collection* (New
York, 1966), vol. 1, p. 152; Hans Huth,
*Lacquer of the West: The History of a Craft
and an Industry, 1550–1950* (Chicago and
London, 1971), p. 91, caption p. 145, illus.
fig. 238; Wilson, *Selections*, no. 14, pp.
28–29, illus.; Daniel Alcouffe, "La
commode du Cabinet de retraite de Marie
Leczinska à Fontainebleau entre au Louvre,"
La Revue du Louvre 4 (1987), pp. 281–284,
illus. p. 282; Pradère, "1737, La Première
Commode en Laque du Japon,"
Connaissances des arts 436 (June 1988), pp.
108–113; Kjellberg, *Dictionnaire*, p. 139;
Daniel Alcouffe, "Bernard Van

Risen Burgh: Commode," *Louvre: Nouvelles
acquisitions du département des objets d'art
1985–1989* (Paris, 1990), p. 144.

25. **Commode**

Paris, circa 1740
Oak veneered with kingwood, walnut,
amaranth, and padouk; gilt-bronze mounts;
brèche d'Alep top
Stamped *DF* on top of carcass.
Height: 2 ft. 10¼ in. (87 cm); Width:
5 ft. 1¼ in. (155.5 cm); Depth: 2 ft. 1 in.
(63.5 cm)
Accession number 76.DA.15

PROVENANCE

Mrs. S. Shrigley-Feigel, Crag Hall, Wray,
Lancashire, England; [Alexander and
Berendt, Ltd., London, 1976]; purchased
by J. Paul Getty.

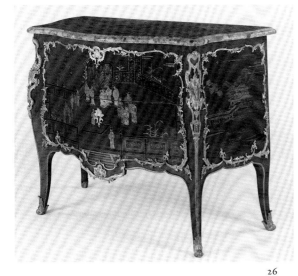

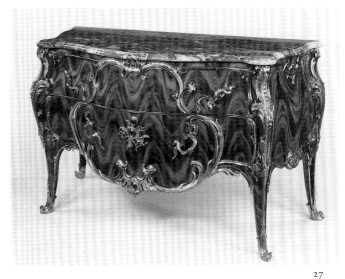

26

27

26. **Commode**

Paris, circa 1740

By Bernard II van Risenburgh

Oak set with panels of red Chinese lacquer
and painted with *vernis Martin*; gilt-bronze
mounts; *brèche d'Alep* top

Stamped *B.V.R.B.* once and *JME* twice on
top of carcass.

Height: 2 ft. 9 in. (83.8 cm); Width:
3 ft. 9 in. (114.3 cm); Depth: 1 ft. 9⅝ in.
(54.9 cm)

Accession number 72.DA.46

PROVENANCE

Private collection, Paris (sold, Palais Galliera,
Paris, March 2, 1972, lot 109); purchased at
that sale by J. Paul Getty.

BIBLIOGRAPHY

Daniel Alcouffe, "La commode du Cabinet
de retraite de Marie Leczinska à Fontaine-
bleau entre au Louvre," *La Revue du Louvre*
4 (1988), pp. 281–284, illus. p. 282; Kjellberg,
Dictionnaire, p. 139; Daniel Alcouffe, "Ber-
nard Van Risen Burgh: Commode," *Louvre:
Nouvelles acquisitions du département des
objets d'art 1985–1989* (Paris, 1990), p. 144.

———

27. **Commode**

Paris, circa 1745–1749

Attributed to Jean-Pierre Latz

Oak veneered with *bois satiné*; gilt-bronze
mounts; *fleur de pêcher* marble top

Stamped *RESTAURE par P. SPOHN* on top
of carcass and one mount stamped with the
crowned *C* for 1745–1749.

Height: 2 ft. 10½ in. (87.7 cm); Width:
4 ft. 11⅝ in. (151.5 cm); Depth: 2 ft. 2⅝ in.
(65 cm)

Accession number 83.DA.356

PROVENANCE

Sir Anthony de Rothschild, England; Hon.
Mrs. Eliot Yorke (née Annie de Rothschild,
daughter of Sir Anthony de Rothschild),
England, by descent (sold, Christie's, Lon-
don, May 5, 1927, lot 138, for 980 guineas
to S. Founès); Mme Duselschon, Château
de Coudira, Prégny, Switzerland; Mme
Rouvière, Lausanne, Switzerland; [Maurice
Segoura, Paris, 1983].

BIBLIOGRAPHY

Wilson, "Acquisitions 1983," pp. 196–199,
illus.; Accquisitions/1983," *GettyMusJ* 12
(1984), no. 9, p. 264, illus.; *Handbook* 1986,
p. 159, illus.; Pradère, *Les Ebénistes*, fig. 136,
p. 160; *Handbook* 1991, p. 177, illus.

———

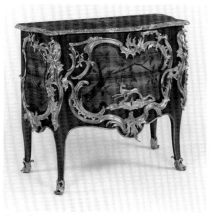

One of a pair 28

28. **Pair of Commodes**

Paris, circa 1750
By Bernard II van Risenburgh
Oak and walnut veneered with tulipwood,
kingwood, and amaranth; gilt-bronze
mounts; one commode with a *brèche violette*
top, one with a *brocatelle jaune* top
Each commode stamped *B.V.R.B.* twice on
top of carcass.
Height: 2 ft. 10⅜ in. (87.3 cm); Width:
3 ft. 4⅛ in. (101.9 cm); Depth: 1 ft. 10 in.
(55.9 cm)
Accession number 71.DA.96.1–.2

PROVENANCE
(?) Given by Louis, Dauphin of France
(1729–1765), to his father-in-law Frederick
Augustus III, King of Poland, Dresden;
listed in inventories of the Residenz,
Dresden, in 1794 and 1798; Prince Ernst
Heinrich von Wettin, Schloss Moritzburg
(near Dresden), Saxony, and installed in the
Tower Room circa 1924 (sold early 1930s);

[C. Ball, Paris, 1934]; Anna Thomson
Dodge, Rose Terrace, Grosse Pointe Farms,
Michigan (sold, Christie's, London, June 24,
1971, lot 102); purchased at that sale by
J. Paul Getty.

BIBLIOGRAPHY
Adolf Feulner, *Kunstgeschichte des Möbels*
(Berlin, 1927), pp. 324–325; Anthony
Coleridge, "Works of Art with a Royal
Provenance from the Collection of the Late
Mrs. Anna Thomson Dodge of Detroit,"
Connoisseur 177, no. 711 (May 1971), p. 36,
illus.; Michael Stürmer, *Handwerk und
höfische Kultur, Europäische Möbelkunst im
18. Jahrhundert* (Munich, 1982), illus. p. 67;
Wilson, *Selections*, no. 20, pp. 40–41, illus.;
Handbook 1986, p. 163, illus. (one); Pradère,
Les Ebénistes, illus. p. 189, fig. 175; Kjellberg,
Dictionnaire, p. 139.

29. **Commode**

Paris, circa 1750
Attributed to Joseph Baumhauer
Oak set with panels of Japanese lacquer
and painted with *vernis Martin*; gilt-bronze
mounts; *campan mélangé vert* marble top
One trade label of the *marchand-mercier*
François-Charles Darnault pasted on top of
carcass and another one pasted underneath.
Height: 2 ft. 10¼ in. (88.3 cm); Width:
4 ft. 9½ in. (146.1 cm); Depth: 2 ft. ⅝ in.
(62.6 cm)
Accession number 55.DA.2

PROVENANCE
Edith and Sir Alfred Chester Beatty (1875–
1968), London; purchased by J. Paul Getty,
1955, through Sir Robert Abdy.

BIBLIOGRAPHY
Verlet et al., *Chefs d'oeuvre*, p. 115, illus.;
Getty, *Collecting*, pp. 144–145, illus.; Wilson,
Selections, no. 23, pp. 46–47, illus.; *Hand-
book* 1986, p. 161, illus.; Jean-Dominique
Augarde, "1749 Joseph Baumhauer, ébéniste
privilegié du roi," *L'Estampille* 204 (June
1987), p. 36; Pradère, *Les Ebénistes*, no. 2,
p. 244, illus. p. 233, fig. 236; Kjellberg,
Dictionnaire, p. 454; *Handbook* 1991, p. 179,
illus.

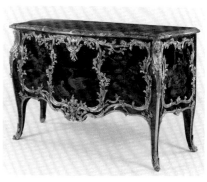

29

30. **Commode**

Paris, circa 1755

By Adrien Faizelot Delorme

Oak veneered with tulipwood and king-
wood; gilt-bronze mounts; *lumachella
pavonazza* marble top

Stamped *DELORME*, *JME*, and *N.PETIT*
on top of carcass.

Height: 2 ft. 11½ in. (90.1 cm); Width:
4 ft. 9 in. (144.8 cm); Depth: 2 ft. 2¼ in.
(66.6 cm)

Accession number 70.DA.79

PROVENANCE

Cécile Sorel, Paris; [Germain Seligmann,
Paris] (sold, April 1933, to Mrs. Langdon K.
Thorne, New York); [J. M. Botibol, Lon-
don, 1938]; purchased by J. Paul Getty, 1938.

BIBLIOGRAPHY

Paul Wescher, "French Furniture of the
Eighteenth Century in the J. Paul Getty
Museum," *Art Quarterly* 18, no. 2 (Summer
1955), p. 118, illus. p. 124, fig. 8; André
Boutemy, "Joseph," *Connaissance des arts*
157 (March 1965), p. 85, illus. p. 84;
Jean-Dominique Augarde, "1749 Joseph
Baumhauer, ébéniste privilegié du roi,"
L'Estampille 204 (June 1987), p. 32; Kjell-
berg, *Dictionnaire*, p. 246.

———

31. **Commode**

Paris, circa 1760

By Jean-François Oeben

Oak veneered with tulipwood, kingwood,
sycamore, amaranth, and burr wood;
gilt-bronze mounts; *campan mélangé vert*
marble top

Stamped *J.F.OEBEN* and *JME* twice on top
of carcass.

Height: 3 ft. ¼ in. (92 cm); Width:
4 ft. 7⅜ in. (140.6 cm); Depth: 1 ft. 6½ in.
(47 cm)

Accession number 72.DA.54

PROVENANCE

Private collection, Paris (possibly Goupil de
Douilla); [Frank Partridge, Ltd., London];
Guedes de Souza, Paris; [Etienne Lévy,
Paris], and [Frank Partridge, Ltd., London,
1972]; purchased by J. Paul Getty.

BIBLIOGRAPHY

Pradère, *Les Ebénistes*, illus. p. 261, fig. 278;
Kjellberg, *Dictionnaire*, pp. 614, 619.

———

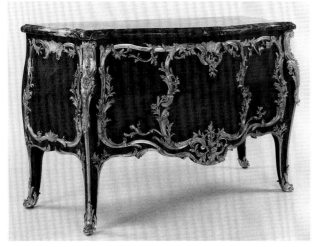

30

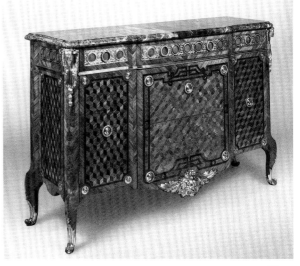

31

32. **Commode**

Paris, 1769

By Gilles Joubert

Oak veneered with kingwood, tulipwood, holly or boxwood, and ebony; gilt-bronze mounts; *sarrancolin* marble top

Painted in black ink on the back with the inventory number *du No 2556.2* of the *Garde-Meuble de la Couronne.*

Height: 3 ft. ¾ in. (93.5 cm); Width: 5 ft. 11¼ in. (181 cm); Depth: 2 ft. 3 in. (68.5 cm)

Accession number 55.DA.5

PROVENANCE

Made for Madame Louise of France (youngest daughter of Louis XV), Château de Versailles, 1769; Emmanuel-Felicité, duc de Duras, Maréchal de France, Château de Fontainebleau, 1785; (?) Baron Lionel Nathan de Rothschild (1808–1879), Gunnersbury Park, Middlesex; by descent to his son, Leopold de Rothschild (1845–1917), Hamilton Place, London; by descent to his son, Lionel Nathan de Rothschild (1882–1942), Exbury House, Hampshire; by descent to his son, Edmund de Rothschild (b. 1916), Inchmery House, Exbury, Hampshire (sold by him in 1947); Edith and Sir Alfred Chester Beatty (1875–1968), London; purchased by J. Paul Getty.

EXHIBITIONS

Paris, Hôtel de la Monnaie, *Louis XV: Un Moment de perfection de l'art français,* 1974, no. 422, pp. 320–321, illus.

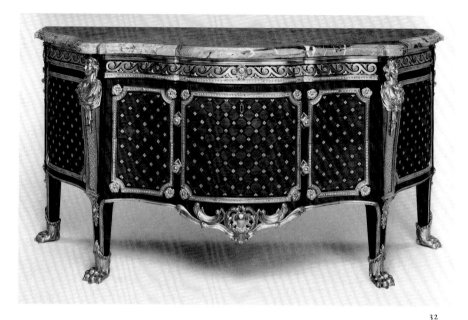

32

BIBLIOGRAPHY

Paul Wescher, "A Commode by Gilles Joubert for Versailles in the J. Paul Getty Museum," *Art Quarterly* 19, no. 3 (Autumn 1956), pp. 324–325, illus.; Pierre Verlet, "Peut-on remeubler Versailles?," *Le Jardin des arts* (February 1958), p. 256, illus. p. 255; F. J. B. Watson, *Louis XVI Furniture* (London, 1960), no. 24, p. 105, illus.; Gerald Messadié, "J. Paul Getty, Malibu, California," *Great Private Collections,* Douglas Cooper, ed. (Zurich, 1963), pp. 180–191, illus. p. 187; Pierre Verlet, *French Royal Furniture* (London, 1963), pp. 77, 111, fig. 7; Verlet et al., *Chefs d'oeuvre,* p. 122, illus.; Getty, *Collecting,* p. 152, illus.; Jean Meuvret and Claude Frégnac, *Les Ebénistes du XVIIIᵉ siècle français* (Paris, 1963), p. 68, fig. 1;

Svend Eriksen, *Early Neo-Classicism in France* (London, 1974), p. 321, pl. 120; Pierre Verlet, *Les Meubles français du XVIIIᵉ siècle* (Paris, 1982), p. 27, illus. (detail) pl. 4; Wilson, *Selections,* no. 30, pp. 60–61, illus.; *Handbook 1986,* p. 173, illus.; Pradère, *Les Ebénistes,* no. 17, p. 216; Kjellberg, *Dictionnaire* (Paris, 1989), pp. 456, 758, illus. p. 759; Pierre Verlet, *French Furniture of the Eighteenth Century,* Penelope Hunter-Stiebel, transl. (Charlottesville, 1991), fig. 4, opposite p. 16; *Handbook 1991,* p. 189, illus.

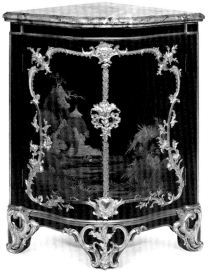

Cupboard .1 33

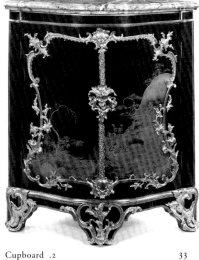

Cupboard .2 33

CORNER CUPBOARDS

33. **Pair of Corner Cupboards**

Paris, circa 1740
By Bernard II van Risenburgh
Oak set with panels of black Japanese
lacquer and painted with *vernis Martin*;
gilt-bronze mounts; *sarrancolin* marble tops
Each cupboard stamped *B.V.R.B.* twice on
top of carcass.
Height: 3 ft. 3⅛ in. (99.4 cm); Width:
2 ft. 10¾ in. (88.3 cm); Depth: 2 ft. ⅛ in.
(61.2 cm)
Accession number 72.DA.44.1–.2

PROVENANCE

[Kraemer et Cie, Paris]; purchased by
J. Paul Getty.

BIBLIOGRAPHY

Kjellberg, *Dictionnaire*, p. 139.

34. **Pair of Corner Cabinets**

Paris, circa 1745
Attributed to Charles Cressent
Oak veneered with tulipwood, kingwood,
and amaranth; gilt-bronze mounts
Height: 6 ft. 3½ in. (191.8 cm); Width:
10 ft. 11 in. (332.7 cm); Depth: 1 ft. 3½ in.
(39.4 cm)
Accession number 79.DA.2.1–.2

PROVENANCE

(?) Baron Mayer Alphonse de Rothschild,
Paris, by 1905; Baron Edouard de Roth-
schild, Paris; Baron Guy de Rothschild,
Paris; by descent to Baron David de Roth-
schild, Paris.

BIBLIOGRAPHY

Marie-Juliette Ballot, *Charles Cressent:
Sculpteur, ébéniste, collectionneur, Archives
de l'art français: Nouvelle période 10* (Paris,
1919), pp. 128, 151–152; Jean Meuvret and
Claude Frégnac, *Les Ebénistes du XVIIIᵉ
siècle français* (Paris, 1963), p. 46; Wilson,
"Acquisitions 1977 to mid 1979," no. 15,
p. 52, illus. (one) p. 51; Pradère, *Les Ebénistes*,
detail illus. on cover.

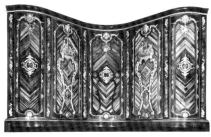

One of a pair 34

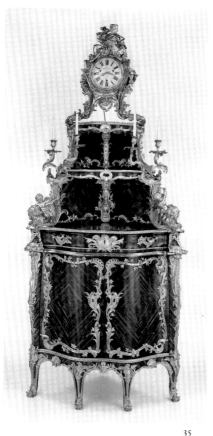

35

35. **Corner Cupboard**

Paris, cupboard: circa 1744–1755; clock: 1744
By Jacques Dubois after a drawing by
Nicolas Pineau; clock movement by Etienne
II Le Noir; enamel dial by Antoine Nicolas
Martinière
Oak veneered with *bois satiné*, tulipwood,
rosewood, and kingwood; enameled metal;
gilt-bronze mounts

Back of carcass stamped *I.DUBOIS* three
times and bears one paper label inscribed
in ink with the Rothschild inventory num-
ber *AR 653*. Painted twice with the same
number *AR 653* on the back. Signed *Etienne
Le Noir Àparis* on dial and movement. Back
of dial signed and dated *a.n. martinière.
1744.-7.bre.*
Height: 9 ft. 6 in. (289.5 cm); Width:
4 ft. 3 in. (129.5 cm); Depth: 2 ft. 4½ in.
(72 cm)
Accession number 79.DA.66

PROVENANCE

Ordered by General Mokronowski through
the *marchand-mercier* Lullier of Warsaw
in 1753 for Count Jan Klemens Branicki
(1689–1772), Warsaw, Poland; (?) Christine
Branicka (sister of Count Branicki), by
descent; (?) Marianna Szymanowska (née
Potocka, granddaughter of Christine
Branicka); Baron Nathaniel de Rothschild,
Vienna, before 1896; Baron Alphonse de
Rothschild, in the Régence (or *Rote*) Salon,
Theresianum Gasse 16–18, Vienna, 1905;
confiscated by the Third Reich in March
1938 and destined for the Hitler Museum
in Linz; restituted to the Baroness Clarice
de Rothschild, Vienna, in 1947 and sent to
New York soon afterward; [Rosenberg and
Stiebel, Inc., New York]; [Wildenstein and
Co., New York, March 16, 1950, stock no.
18018]; [Georges Wildenstein, New York];
[Daniel Wildenstein, New York]; Akram
Ojjeh, 1978 (sold, Sotheby's, Monaco,
June 25–26, 1979, lot 60).

BIBLIOGRAPHY

Emile Molinier, *Histoire générale des arts
appliqués à l'industrie du V^e à la fin du
XVIII^e siècle*, vol. 3, *Le Mobilier au XVII^e et
au XVIII^e siècle* (Paris, 1896), pp. 146–147,
pl. 13; Baron Nathaniel de Rothschild,
Notizen über einige meiner Kunstgegenstände
(1903), no. 80; Robert Schmidt, *Möbel: Ein
Handbuch für Sammler und Liebhaber*
(Berlin, 1920), fig. 130; Adolf Feulner,
Kunstgeschichte des Möbels (Berlin, 1926),
p. 445, illus. p. 321; comte François de
Salverte, *Les Ebénistes du XVIII^e siècle:
Leurs oeuvres et leurs marques* (Paris, 1927),
pp. 104–105, pl. 18; (1953 ed.), p. 197, pl. 19;
and (Paris, 1963 ed.), p. 100, pl. 18; Adolf
Feulner, *Kunstgeschichte des Möbels seit dem
Altertum* (Berlin, 1927), pp. 330–331, Pineau
design illus. p. 321; Charles Packer, *Paris
Furniture by the Master Ebénistes* (Newport,
Monmouthshire, 1956), p. 34, fig. 40; F. J. B.
Watson, *Wallace Collection Catalogues:
Furniture* (London, 1956), p. 69; André
Boutemy, "Des Meubles Louis XV à grands
succès: Les Encoignures," *Connaissance des
arts* 91 (September 1959), p. 36, illus. p. 41;
Jean Meuvret and Claude Frégnac, *Les
Ebénistes du XVIII^e siècle français* (Paris,
1963), pp. 101–102, illus. p. 100; Pierre
Verlet, *French Cabinetmakers of the Eigh-
teenth Century* (Paris, 1963), p. 102; F. J. B.
Watson, *The Wrightsman Collection* (New
York, 1966), vol. 1, p. 231; vol. 2, p. 544;
Alvar González-Palacios, *Gli ebanisti del
Luigi XV* (Milan, 1966), p. 67; Claude
Frégnac, *Les Styles français de Louis XIII à
Napoleon III* (Paris, 1975), p. 100, pl. 2;
Pierre Kjellberg, *Le Mobilier français du*

moyen age à Louis XV (Paris, 1978), p. 192, illus. no. 217, p. 193; Pierre Kjellberg, "Jacques Dubois," *Connaissance des arts* 334 (December 1979), p. 115, illus.; Adolf Feulner, *Kunstgeschichte des Möbels* (Frankfurt am Main, 1980), pp. 180–181, illus. no. 292, caption p. 358; Wilson, "Acquisitions 1979 to mid 1980," no. 1, pp. 1–3, illus.; Wilson, *Selections*, no. 21, pp. 42–43, illus.; William Kingsland, "Collecting French Furniture," *Art and Auction* (December 1983), p. 79, illus.; Pradère, *Les Ebénistes*, figs. 153–154, p. 173; *Handbook* 1986, p. 163, illus. p. 162; Kjellberg, *Dictionnaire*, pp. 267, 273, illus. p. 275; Stéphane Boiron, "Jacques Dubois, maître du style Louis XV," *L'Estampille-L'Objet d'art* 236 (June 1990), pp. 42–59, illus. pp. 52–53; Jonathan Bourne and Vanessa Brett, *Lighting in the Domestic Interior: Renaissance to Art Nouveau* (London, 1991), illus. p. 83, fig. 258; *Handbook* 1991, p. 179, illus. p. 178.

———

36. **Pair of Corner Cupboards**

Paris, circa 1750–1755

Carcass and mounts attributed to Jean-Pierre Latz; marquetry panels attributed to the workshop of Jean-François Oeben

Oak veneered with amaranth, stained sycamore, boxwood, and rosewood; gilt-bronze mounts; *brèche d'Alep* tops

One cupboard once had two paper labels on the back: one inscribed illegibly [*Bollftüd(ct)?*] in German, the other from the Victoria and Albert Museum with the

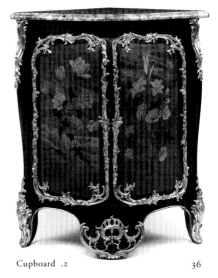

Cupboard .1 36

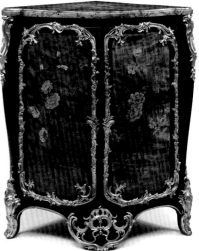

Cupboard .2 36

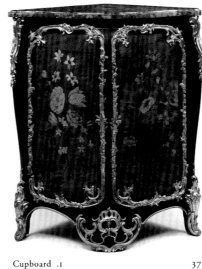

Cupboard .1 37

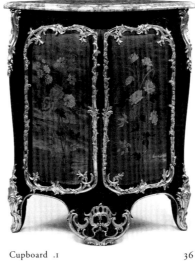

Cupboard .2 37

notation *DEPT. OF WOODWORK ON LOAN FROM L. Currie, Esq. No. 5 / 15.V.1917.*
Height: 3 ft. 2¼ in. (97.2 cm); Width: 2 ft. 9¾ in. (85.7 cm); Depth: 1 ft. 11⅛ in. (58.7 cm)
Accession number 72.DA.39.1–.2

PROVENANCE

Laurence Currie, London, 1917; private collection, Berlin (sold, Hugo Helbing Gallery, Frankfurt am Main, June 23, 1936, lots 260–261); private collection, Germany (sold, Lempertz Gallery, Cologne, March 11, 1938, lot 217); private collection, New York (sold, Parke-Bernet, New York, October 21–22, 1955, lot 358); Philip R. Consolo, Palm Beach, Florida; (?) private collection, California; [Frank Partridge, Ltd., London, 1966]; [French and Co., New York, 1972]; purchased by J. Paul Getty.

EXHIBITIONS

London, The Victoria and Albert Museum, on loan, 1917–1920, from Laurence Currie, Esq.

BIBLIOGRAPHY

Henry Hawley, "Jean-Pierre Latz, Cabinet-maker," *Bulletin of the Cleveland Museum of Art* 57-7 (September–October 1970), no. 49, p. 254, illus. (one), fig. 49; Wilson, *Selections*, no. 24, pp. 48–49, illus.

37. **Pair of Corner Cupboards**

Paris, circa 1750–1755
Carcass and mounts attributed to Jean-Pierre Latz; marquetry panels attributed to the workshop of Jean-François Oeben
Oak veneered with amaranth, stained sycamore, harewood, boxwood, and lignum vitae; gilt-bronze mounts; *brèche d'Alep* tops
Height: 3 ft. ¼ in. (92.1 cm); Width: 2 ft. 8¼ in. (81.9 cm); Depth: 2 ft. (61 cm)
Accession number 72.DA.69.1–.2

PROVENANCE

[Sidney J. Block, London]; [French and Co., New York, 1972]; purchased by J. Paul Getty.

BIBLIOGRAPHY

Henry Hawley, "Jean-Pierre Latz, Cabinet-maker," *Bulletin of the Cleveland Museum of Art* 57-7 (September–October 1970), no. 50, p. 255, illus. (one), fig. 50.

38. **Pair of Corner Cupboards**

Paris, circa 1755
By Jacques Dubois
Oak painted with *vernis Martin*; gilt-bronze mounts; *brèche d'Alep* tops
Each stamped *I.DUBOIS* and *JME* on top of carcass.
Height: 3 ft. 2¼ in. (97.1 cm); Width: 2 ft. 7½ in. (80 cm); Depth: 1 ft. 11⅛ in. (58.6 cm)
Accession number 78.DA.119.1–.2

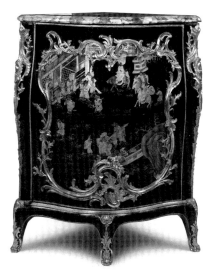

Cupboard .1 38

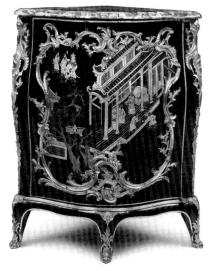

Cupboard .2 38

PROVENANCE

Baron Nathaniel de Rothschild, Vienna;
Baron Alphonse de Rothschild, Vienna;
confiscated by the Third Reich in March
1938; restituted to the Baroness Clarice
de Rothschild, Vienna, in 1947; [Frank
Partridge and Sons, Ltd., London, 1950];
purchased by J. Paul Getty for Sutton Place,
Surrey; distributed by the estate of J. Paul
Getty to the J. Paul Getty Museum.

BIBLIOGRAPHY

Paul Wescher, "French Furniture of the
Eighteenth Century in the J. Paul Getty
Museum," *Art Quarterly* 18, no. 2 (Summer
1955), pp. 121–122; Verlet et al., *Chefs
d'oeuvre*, p. 120, illus.; Getty, *Collecting*,
p. 150, illus.; Hans Huth, *Lacquer of the
West: The History of a Craft and an Industry,
1550–1950* (Chicago and London, 1971), cap-
tion p. 145, fig. 234; Kjellberg, *Dictionnaire*,
p. 273; Stéphane Boiron, "Jacques Dubois,
maître du style Louis XV," *L'Estampille-
L'Objet d'art* 236 (June 1990), pp. 42–59,
illus. p. 56.

39. **Pair of Corner Cupboards**
Paris, circa 1765
By Pierre Garnier
Oak veneered with ebony, kingwood, ama-
ranth, boxwood, and (?) ebonized fruit-
wood; gilt-bronze mounts; gray-veined
white marble tops
Each cupboard stamped *P. GARNIER* on top
of carcass. One incised *1* on top of carcass,
4 on the other.

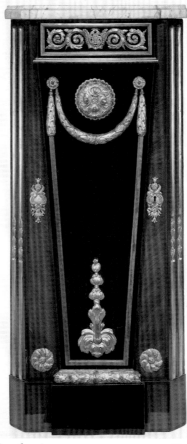

One of a pair 39

Height: 4 ft. 5¼ in. (135.2 cm); Width:
2 ft. (61 cm); Depth: 1 ft. 4½ in. (41.9 cm)
Accession number 81.DA.82.1–.2

PROVENANCE

François-Ferdinand-Joseph Godefroy, Paris
(sold, Hôtel de Bullion, Paris, November 15,
1785, lot 238 bis, to [?] Harcourt); Espirito
Santo Family, Portugal, and Lausanne,
Switzerland (sold circa 1976); [Didier Aaron,
Inc., New York].

BIBLIOGRAPHY

Wilson, "Acquisitions 1981," no. 3, pp. 71–73,
illus.; Wilson, *Selections*, no. 31, pp. 62–63,
illus. figs 14–15; *Handbook* 1986, p. 170,
illus. (one); Pradère, *Les Ebénistes*, no. 238
bis, p. 250.

DESKS

40. **Desk (*bureau "Mazarin"*)**
Paris, after 1692–circa 1700
Oak and walnut veneered with brass,
tortoiseshell, mother-of-pearl, pewter,
copper, ebony, painted and unpainted horn,
and painted paper; silvered-bronze mounts;
steel key
Top engraved with unidentified arms (later
replacement) beneath an electoral bonnet,
surrounded by the Collar and the Order
of the Toison d'Or, supported by crowned
lions.
Height: 2 ft. 3¾ in. (70.5 cm); Width:
2 ft. 11 in. (89 cm); Depth: 1 ft. 8 in. (51 cm)
Accession number 87.DA.77

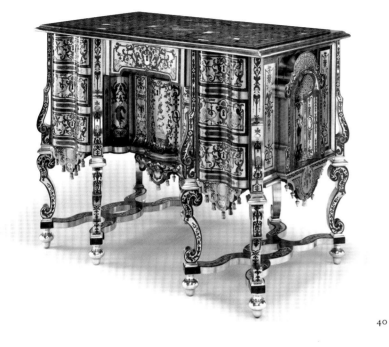

40

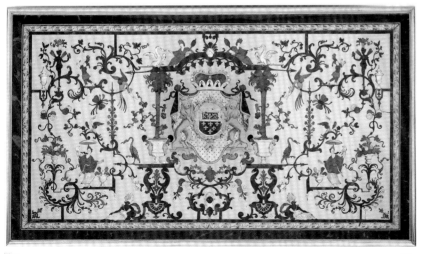

Top 40

PROVENANCE

Max Emanuel, Elector of Bavaria (1662–1726); Captain Thomas Leyland, London, circa 1854; William Cornwallis West, Ruthin Castle, Denbighshire; by descent around 1917 to his daughter, Mary-Theresa Olivia, Princess of Pless; David Style, Esq. (sold, Christie's, Wateringbury Place, Maidstone, Kent, June 1, 1978, lot 545); private collection, London (sold, Sotheby's, Monaco, June 21, 1987, lot 1097).

EXHIBITIONS

London, Gore House, Kensington, *French Decorative Arts*, 1854, lent by Captain Leyland; London, The South Kensington Museum, *Special Exhibition of Works of Art of the Mediaeval, Renaissance, and More Recent Periods*, June 1862, no. 812, lent by Captain Leyland.

BIBLIOGRAPHY

T. A. Strange, *French Interiors: Furniture, Decoration, Woodwork and Allied Arts* (London, circa 1920), p. 1467; *Sotheby's Art at Auction 1986–1987* (London, 1987), p. 262, illus.; "Acquisitions/1987," *GettyMusJ* 16 (1988), no. 66, pp. 176–177, illus.; Jean-Nérée Ronfort and Jean-Dominique Augarde, "Le Maître du Bureau de l'Electeur," *L'Estampille-L'Objet d'art* 243 (January 1991), pp. 42–74, illus. p. 59.

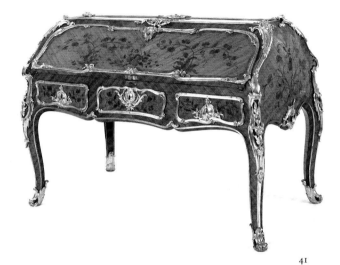

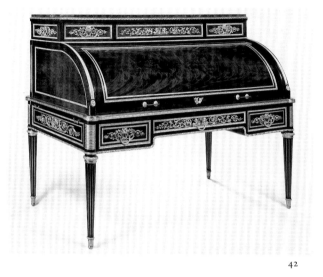

41

42

41. **Double Desk**

Paris, circa 1750
By Bernard II van Risenburgh
Oak veneered with tulipwood, kingwood,
and amaranth; gilt-bronze mounts
Stamped *JME B.V.R.B. JME* underneath
and on interior of carcass. Underside of
carcass bears several red wax seals of the
Duke of Argyll.
Height: 3 ft. 6½ in. (107.8 cm); Width:
5 ft. 2½ in. (158.7 cm); Depth: 2 ft. 9⅜ in.
(84.7 cm)
Accession number 70.DA.87

PROVENANCE

(?) François Balthazar Dangé, *fermier
général*, Hôtel de Villemare, Place Ven-
dôme, Paris, recorded in the inventory
after the death of his wife Anne (née Jarry),

March 27, 1772, and also in the inventory
after his own death, March 17, 1777 (sold,
September 1, 1777, Paris); purchased by his
nephew and heir Louis-Balthazar Dangé
de Bagneux (*fermier général*, 1739–1794),
recorded in the inventory after his death
in 1795; by inheritance to his wife Anne-
Marie Samson and recorded in her inven-
tory after death; by descent to her daughter
Marie-Emilie-Françoise Dangé, married
to Augustin Creuzé, in rue Saint-Honoré
[information: P. Leperlier]; Dukes of Argyll,
Inveraray Castle, Argyll, Scotland, by (?)
the early nineteenth century (sold by Ian,
11th Duke of Argyll, 1951); Sir Robert Abdy,
Bt., London, 1951; [Rosenberg and Stiebel,
Inc., New York, 1952]; purchased by J. Paul
Getty, 1952.

EXHIBITIONS

Paris, Hôtel de la Monnaie, *Louis XV: Un
Moment de perfection de l'art français*, 1974,
no. 430, pp. 327–328, illus.

BIBLIOGRAPHY

Paul Wescher, "French Furniture of the
Eighteenth Century in the J. Paul Getty
Museum," *Art Quarterly* 18, no. 2 (Summer
1955), p. 121, illus. p. 78; Jean Meuvret and
Claude Frégnac, *Les Ebénistes du XVIIIe
siècle français* (Paris, 1963), p. 78, illus.;
Gerald Messadié, "J. Paul Getty, Malibu,
California," *Great Private Collections*,
Douglas Cooper, ed. (Zurich, 1963),
pp. 180–191, illus. p. 188; Verlet et al.,
Chefs d'oeuvre, pp. 116–117, illus.; Claude
Frégnac, *Les Styles français* (Paris, 1975), pl. 4;
Pierre Verlet, *Les Meubles français du XVIIIe
siècle* (Paris, 1982), p. 27, pl. 3 (detail);
Wilson, *Selections*, no. 22, pp. 44–45, illus.;

"The Great Collections," *French Connections: Scotland and the Arts of France* (Edinburgh, 1985), p. 66, fig. 30; *Handbook* 1986, p. 160, illus.; Pierre Cabanne, *L'Art du XVIIIᵉ siècle* (Paris, 1987), p. 97, illus.; Kjellberg, *Dictionnaire*, pp. 135, 139, illus. p. 130; Pierre Verlet, *French Furniture of the Eighteenth Century*, Penelope Hunter-Stiebel, transl. (Charlottesville, 1991), fig. 3 opposite p. 16; *Handbook* 1991, p. 176, illus.

42. **Rolltop Desk**
Paris, circa 1785–1788
By Bernard Molitor. Some mounts cast by the *bronzier* François Rémond after designs by Gambier
Oak veneered with mahogany and lacquer; gilt-bronze mounts; *griotte de Flandre* marble top
Stamped *B. MOLITOR* on lip of one interior drawer.
Height: 4 ft. 6 in. (137 cm); Width: 5 ft. 11¼ in. (181 cm); Depth: 2 ft. 10¼ in. (87 cm)
Accession number 67.DA.9

PROVENANCE
(?) Louis XVI, listed in the inventory of the Château de Saint-Cloud, *an* II (1793–1794); [Vandyck, London] (offered for sale, Christie's, London, May 16, 1800, lot 101, and again February 12, 1801, lot 70, bought in); (?) Octavius E. Coope, London; Mortimer L. Schiff, New York (sold by his heir John L. Schiff, Christie's, London, June 22, 1938, lot 59); purchased at that sale by J. Paul Getty.

BIBLIOGRAPHY
Paul Wescher, "French Furniture of the Eighteenth Century in the J. Paul Getty Museum," *Art Quarterly* 18, no. 2 (Summer 1955), p. 125, illus. p. 133; Gerald Messadié, "J. Paul Getty, Malibu, California," *Great Private Collections*, Douglas Cooper, ed. (Zurich, 1963), pp. 180–191, illus. p. 186; Verlet et al., *Chefs d'oeuvre*, p. 131, illus.; Getty, *Collecting*, illus. p. 161; Ulrich Leben, "Die Werkstatt Bernard Molitors," *Kunst und Antiquitäten* 4 (1987), pp. 52–60, detail illus. p. 52, fig. 1; Ulrich Leben, *Bernard Molitor (1755–1833): Leben und Werk, eines Pariser Kunsttischlers*, Ph.D. diss. (Bonn, 1989), p. 108; Kjellberg, *Dictionnaire*, p. 582; Ulrich Leben, *Molitor: Ebéniste from the Ancien Régime to the Bourbon Restoration* (London, 1992), p. 153, no. 70, pp. 190–191, figs. 8–9, 81–82, 154.

SECRETAIRES

43. *Secrétaire*
Paris, circa 1755
By Jacques Dubois
Oak veneered with panels of red Chinese lacquer and painted with *vernis Martin*; gilt-bronze mounts; *brèche d'Alep* top
Stamped *I.DUBOIS* and *JME* at rear on right upright.
Height: 3 ft. 4½ in. (102.8 cm); Width: 3 ft. 9 in. (114.3 cm); Depth: 1 ft. 3⅛ in. (38.4 cm)
Accession number 65.DA.3

PROVENANCE
[Rosenberg and Stiebel, Inc., New York]; purchased by J. Paul Getty, 1951.

BIBLIOGRAPHY
Paul Wescher, "French Furniture of the Eighteenth Century in the J. Paul Getty Museum," *Art Quarterly* 18, no. 2 (Summer 1955), p. 122, illus. p. 130; Gerald Messadié, "J. Paul Getty, Malibu, California," *Great Private Collections*, Douglas Cooper, ed. (Zurich, 1963), pp. 180–191, illus. p. 189; Verlet et al., *Chefs d'oeuvre*, p. 121, illus.; Getty, *Collecting*, p. 151, illus.; Kjellberg, *Dictionnaire*, p. 273; Stéphane Boiron, "Jacques Dubois, maître du style Louis XV," *L'Estampille-L'Objet d'art* 236 (June 1990), pp. 42–59, illus. p. 56.

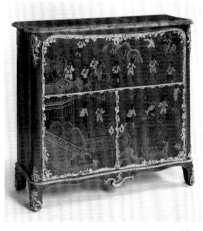

43

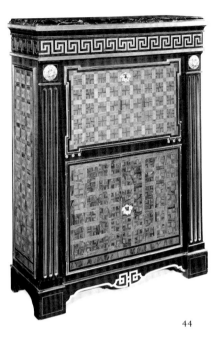

44

44. *Secrétaire*
Paris, circa 1765–1770
By Joseph Baumhauer
Oak veneered with tulipwood, amaranth,
ebony, and boxwood; gilt-bronze mounts;
(?) *portor d'Italie* top
Stamped *JOSEPH* between two fleur-de-lys
three times, twice on the left forecorner and
once on the right forecorner.
Height: 4 ft. 6 in. (137 cm); Width:
3 ft. 5 in. (104 cm); Depth: 1 ft. 3 in. (38 cm)
Accession number 84.DA.969

PROVENANCE
Mrs. Orme Wilson (sold by her executors,
Parke-Bernet, New York, March 25, 1949,
lot 339); Paul Rosenberg, Paris; [Didier
Aaron, Inc., New York, 1984].

EXHIBITIONS
New York, The Cooper-Hewitt Museum,
Writing and Reading, September 1981–
January 1982; Richmond, Virginia, *Experts'
Choice: One Thousand Years of the Art Trade*,
April 22–June 12, 1983, p. 131, illus., lent by
Didier Aaron, Inc.

BIBLIOGRAPHY
Bremer-David, "Acquisitions 1984," no. 4,
pp. 81–83, illus.; "Acquisitions/1984,"
GettyMusJ 13 (1985), no. 62, p. 181, illus.;
Jean-Dominique Augarde, "1749 Joseph
Baumhauer, ébéniste privilegié du roi,"
L'Estampille 204 (June 1987), pp. 15–45,
figs. 1, 36; Pradère, *Les Ebénistes*, no. 53,
p. 245; Kjellberg, *Dictionnaire*, p. 450, illus.
p. 448.

45. *Secrétaire*
Paris, circa 1770
Attributed to Jean-François Leleu
Oak veneered with amaranth, ebony, king-
wood, tulipwood, boxwood, and burr
amboyna; gilt-bronze mounts; steel fittings;
brèche d'Alep top
Inked *1770* inside the carcass. Label printed
Earl of Rosebery pasted on back.
Height: 3 ft. 6⅛ in. (107.3 cm); Width:
3 ft. 11¼ in. (120 cm); Depth: 1 ft. 5¼ in.
(43.6 cm)
Accession number 82.DA.81

PROVENANCE
Baron Mayer Amschel de Rothschild,
Mentmore Towers, Buckinghamshire, late
nineteenth century; Hannah de Rothschild
(Countess of Rosebery, wife of the 5th Earl,
married 1878, died 1890), Mentmore
Towers, Buckinghamshire; Albert Primrose,
6th Earl of Rosebery, Mentmore Towers,
Buckinghamshire; Neil Primrose, 7th Earl of
Rosebery, Mentmore Towers, Buckingham-
shire (sold, Sotheby's, Mentmore Towers,
May 18, 1977, lot 24); private collection,
London, 1977; [Mallett's, London].

BIBLIOGRAPHY
Philippe Jullian, "Mentmore," *Connaissance
des arts* 303 (May 1977), p. 82, illus.; Wilson,
"Acquisitions 1982," no. 12, pp. 56–60,
figs. 79, 81–84; Wilson, *Selections*, no. 37,
pp. 56–57, illus.; Pradère, *Les Ebénistes*,
p. 334, illus. p. 337, fig. 392; Kjellberg,
Dictionnaire, illus. p. 509.

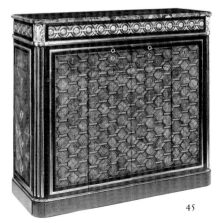

45

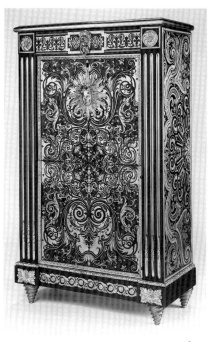

46

46. *Secrétaire*

Paris, circa 1770–1775
By Philippe-Claude Montigny
Oak and pine veneered with tortoiseshell, brass, pewter, and ebony bandings; gilt-bronze mounts
Stamped on the back *MONTIGNY JME.*
Height: 4 ft. 7½ in. (141.5 cm); Width: 2 ft. 9 in. (84.5 cm); Depth: 1 ft. 3¾ in. (40.3 cm)
Accession number 85.DA.378

PROVENANCE

Monsieur de Billy, Paris (sold through the *marchand-mercier* A.-J. Paillet, Hôtel de

Bullion, Paris, November 15–19, 1784, lot 171, for 860 *livres* to Desmarest); Joseph-François de Paule, marquis de Vaudreuil, Paris (sold under the direction of Le Brun in the Grande Salle, rue de Cléry, Paris, November 26, 1787, lot 368, for 1,305 *livres* to Lerouge); [Kraemer et Cie, Paris, early 1960s]; Mme Jorge Ortiz-Linares, Paris (offered for sale, Sotheby's, Monaco, June 14, 1982, lot 423, bought in); [B. Fabre et Fils, Paris].

BIBLIOGRAPHY

Gillian Wilson, "A Secrétaire by Philippe-Claude Montigny," *GettyMusJ* 14 (1986), pp. 121–126, figs. 1, 4, 7; "Acquisitions/1985," *GettyMusJ* 14 (1986), no. 200, p. 246, illus.; Jean-Dominique Augarde, "1749 Joseph Baumhauer, ébéniste privilegié du roi," *L'Estampille* 204 (June 1987), p. 30; Pradère, "Boulle, du Louis XIV sous Louis XVI," *L'Estampille-L'Objet d'art* o (June 1987), pp. 56–67, 118, illus.; Pradère, *Les Ebénistes*, p. 305, illus. p. 307, fig. 347; *Handbook* 1991, p. 190, illus.

———

47. *Secrétaire*

Paris, circa 1775
By Martin Carlin, circular Sèvres porcelain plaque painted by Jean-Jacques Pierre *le jeune*; two of the frieze plaques and two of the spandrel plaques painted by Claude Couturier; central frieze plaque gilded by Etienne-Henri Le Guay.
Oak veneered with kingwood, boxwood, and ebony, incised with colored mastics; set with eight soft-paste porcelain plaques;

gilt-bronze mounts; white marble top
Stamped *M.CARLIN* and *JME* twice on lower back. All the plaques except for two of the spandrels are painted in blue on their reverses with the crossed L's of the Sèvres manufactory. On all but the central frieze plaque the crossed L's enclose the date letter *X* for 1775; the circular plaque bears the painter's mark in blue of *P'* for Pierre *le jeune*, and in black, *216*; two spandrel and the two frieze plaques bear the painter's mark in blue. The central frieze plaque bears the gilder's mark *LG* in gold, partly rubbed. Rothschild inventory numbers each chalked twice on back of carcass: *KKU 859, AR 542, Iv1120*, and *3*.

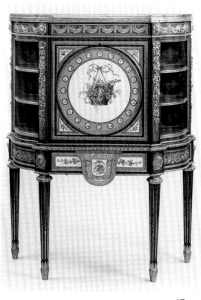

47

Height: 3 ft. 11¼ in. (120 cm); Width:
3 ft. 1 in. (94 cm); Depth: 1 ft. 1¼ in. (34 cm)
Accession number 65.DA.2

PROVENANCE

Baron Nathaniel de Rothschild, Vienna,
by 1903; Baron Alphonse de Rothschild,
Vienna; confiscated by the Third Reich
in March 1938; restituted to the Baroness
Clarice de Rothschild, Vienna, in 1947 and
sent to New York shortly afterward (sold
privately, 1950); [Rosenberg and Stiebel,
Inc., New York, 1950]; purchased by J. Paul
Getty, 1950.

BIBLIOGRAPHY

Baron Nathaniel de Rothschild, *Notizen
über einige meiner Kunstgegenstände* (1903),
no. 319, p. 128; Paul Wescher, "French Fur-
niture of the Eighteenth Century in the
J. Paul Getty Museum," *Art Quarterly* 18,
no. 2 (Summer 1955), p. 131, illus. p. 134;
Charles Packer, *French Furniture by the
Master Ebénistes* (Newport, Monmouth-
shire, 1956), p. 59, fig. 175A; Verlet et al.,
Chefs d'oeuvre, p. 127, illus.; Getty, *Collecting*,
p. 156, illus. p. 157; Michael Stürmer,
*Handwerk und höfische Kultur: Europäische
Möbelkunst im 18. Jahrhundert* (Munich,
1982), p. 47, illus.; Adrian Sassoon, "Sèvres
Plaques," *Techniques of the World's Great
Masters of Pottery and Ceramics*, Hugo
Morley-Fletcher, ed. (Oxford, 1984),
pp. 62–63, illus.; Gisela Zick, "Die russische
Wahrsagerin, Ein Tisch für Marie Karoline
von Neapel," *Kunst und Antiquitäten* 4–5
(1984), pp. 36–52, pl. 4, p. 39; Reinier J.
Baarsen, "Rond een Nederlandse Lodewijk
XVI secretaire op Het Loo," *Antiek* 7

(February 1986), pp. 384–395; Savill, *Sèvres*,
vol. 2, pp. 612, 877, 879; n. 45, p. 613;
nn. 45–46, p. 901; Pradère, *Les Ebénistes*,
no. 29, p. 356; Kjellberg, *Dictionnaire*,
p. 162; Daniel Alcouffe, "Secrétaire à
abbattant," *Louvre: Nouvelles acquisitions
du départment des objets d'art, 1985–1989*
(Paris, 1990), no. 71, p. 154, illus.; Sassoon,
Vincennes and Sèvres Porcelain, no. 35,
pp. 174–176, illus. pp. 175–177.

48. *Secrétaire*

Paris, circa 1775
By René Dubois
Oak veneered with kingwood, tulipwood,
and lemonwood; incised with colored
mastics; set with mother-of-pearl; gilt-
bronze mounts; white marble top
Stamped *I. DUBOIS* and *JME* on back.
Height: 5 ft. 3 in. (160 cm); Width:
2 ft. 3⅝ in. (70.2 cm); Depth: 1 ft. 1¼ in.
(33.7 cm)
Accession number 72.DA.60

PROVENANCE

Sir Richard Wallace, Paris; Lady Wallace,
Paris, by inheritance, 1890; Sir John Murray
Scott, London, by inheritance, 1897 (sold
after his death, Christie's, London, June 24,
1913, lot 54); E. M. Hodgkins; [Jacques
Seligmann, Paris]; Henry Walters, New
York (sold by his widow, Parke-Bernet,
New York, April 26, 1941, lot 712); Baron
and Baroness Cassel van Doorn, Paris (sold,
Galerie Jean Charpentier, Paris, March 9,
1954, lot 90); Guedes de Souza, Paris;

[Frank Partridge and Sons, Ltd., London,
1972]; purchased by J. Paul Getty.

BIBLIOGRAPHY

Jean Nicolay, *L'Art et la Manière des Maîtres
Ebénistes français au XVIII^eme siècle* (Paris,
1956), p. 153, illus.; F. J. B. Watson, *Louis
XVI Furniture* (London, 1960), no. 89, illus.;
Jean Meuvret and Claude Frégnac, *Les
Ebénistes du XVIII^e siècle français* (Paris,
1963), p. 221, illus.; F. Lewis Hinckley,
*A Directory of Antique French Furniture
1735–1800* (New York, 1967), p. 69, illus.

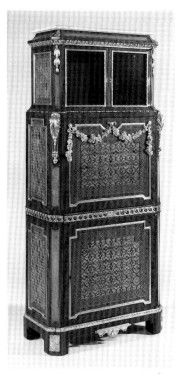

48

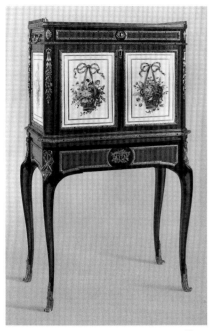

49

49. *Secrétaire*

Paris, circa 1776 with early twentieth-century stand
By Claude-Charles Saunier, replaced stand by F. Durand *fils*; two of the Sèvres porcelain plaques painted by Jean-Baptiste Tandart and two by Edmé-François Bouillat; all four plaques gilded by François Baudouin *père*
Oak veneered with tulipwood and amaranth; set with four soft-paste porcelain plaques; gilt-bronze mounts; white marble top

Stamped *C.C.SAUNIER* on upper back; stamped *F.DURAND Fils* on side rail of the stand. All of the plaques painted on their reverses with the blue crossed *L*'s of the Sèvres manufactory; on the two front plaques the crossed *L*'s enclose the date letter *Y* for 1776, and below is the painter's mark of three dots for Tandart; on the two side plaques the crossed *L*'s are flanked by the date letter *Y* for 1776 and the painter's mark *Y* for Bouillat; each plaque bears the gilder's mark *BD* in gold. Each plaque bears a paper price label (only one intact) printed with crossed *L*'s and inked *132* [*livres*]. Inscribed in pencil *Saunier le Jeune 1776* on carcass.
Height: 4 ft. 1⅞ in. (126.8 cm); Width: 2 ft. 4⅝ in. (72.8 cm); Depth: 1 ft. 4⅛ in. (42.2 cm)
Accession number 67.DA.7

PROVENANCE

(?) Prince Narishkine, New York; Henry Walters, New York (sold by his widow, Parke-Bernet, New York, May 3, 1941, lot 1399); purchased at that sale by J. Paul Getty, through [Duveen].

BIBLIOGRAPHY

Paul Wescher, "French Furniture of the Eighteenth Century in the J. Paul Getty Museum," *Art Quarterly* 18, no. 2 (Summer 1955), p. 131; Charles Packer, *Paris Furniture by the Master Ebénistes* (Newport, Monmouthshire, 1956), fig. 162; Savill, *Sèvres*, vol. 2, n. 45, p. 613; Sassoon, *Vincennes and Sèvres Porcelain*, no. 37, pp. 181–182, illus. pp. 182–183.

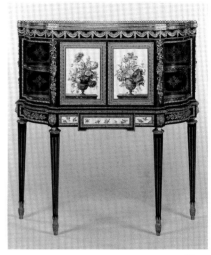

50

50. *Secrétaire*

Paris, circa 1777
By Martin Carlin; the large Sèvres plaques painted by Edmé-François Bouillat and the two smaller Sèvres porcelain plaques in the fall front painted by Raux *fils aîné*
Oak veneered with tulipwood, satinwood, amaranth, and ebony; set with five soft-paste porcelain plaques; enameled metal; gilt-bronze mounts; white marble top
Stamped *M.CARLIN* and *JME* twice under the drawer front. All porcelain plaques painted on their reverses with the blue crossed *L*'s of the Sèvres manufactory. On the two large plaques the crossed *L*'s are flanked by a *Y* on each side: one is the date letter for 1776, the other is the painter's mark; the two small plaques are each painted in black with the painter's mark

of a circle of dots; the long plaque in the frieze bears an unidentified painter's mark in blue and the date letter *Z* for 1777 with a paper price label printed with crossed *L*'s and inked *36* [*livres*]; the small plaque on the right bears the date letter *Z* for 1777 and the marks *X* and *10* in gold.

Height: 3 ft. 6¼ in. (107.9 cm); Width: 3 ft. 4½ in. (103 cm); Depth: 1 ft. 2 in. (35.5 cm)

Accession number 81.DA.80

PROVENANCE

(?) Don Francesco de Borja Alvarez de Toledo, 16th Duke of Medina-Sidonia and 12th Marquess of Villafranca; Don Pedro de Alcantara Alvarez de Toledo, 17th Duke of Medina-Sidonia (sold by his heir the Marquess of Villafranca, Hôtel Drouot, Paris, April 21, 1870, lot 23); purchased at that sale by Richard, 4th Marquess of Hertford, Paris, through [Nieuwenhuys]; Sir Richard Wallace, Paris, by inheritance, 1870; Lady Wallace, Paris, by inheritance, 1890; Sir John Murray Scott, Paris, by inheritance, 1897; Victoria, Lady Sackville, Paris, inherited 1912; [Jacques Seligmann, Paris]; Baron and Baronne Edouard de Rothschild, Paris; Baron Guy de Rothschild, Paris, by descent; Mr. and Mrs. Habib Sabet, Paris, early 1970s.

BIBLIOGRAPHY

F. J. B. Watson, *Wallace Collection Catalogues: Furniture* (London, 1956), p. 159; Wilson, "Acquisitions 1981," no. 1, pp. 63–66, illus.; Dorothée Guilleme-Brulon, "Les Plaques en porcelaine de Sèvres dans le mobilier," *L'Estampille* 163 (November 1983),

pp. 42–43, illus.; Wilson, *Selections*, no. 39, pp. 78–79; *Handbook* 1986, p. 175, illus.; Frederic Edelmann, "Musée Getty, Le Trust de l'art," *Beaux-arts magazine* (September 1987), no. 49, illus. p. 75; Savill, *Sèvres*, vol. 2, p. 877; n. 45, p. 901; vol. 3, p. 1063; n. 3, p. 1064; Pradère, *Les Ebénistes*, no. 28, p. 356; Kjellberg, *Dictionnaire*, p. 160; Sassoon, *Vincennes and Sèvres Porcelain*, no. 38, pp. 184–186, illus. pp. 184, 186; *Handbook* 1991, p. 192, illus.

———

51. **Secrétaire**

Paris, circa 1780

Attributed to Adam Weisweiler; one of the Sèvres porcelain plaques gilded by Henry-François Vincent *le jeune*

Oak veneered with amboyna and ebonized wood; set with five soft-paste porcelain plaques; gilt-bronze mounts; white marble top

One of the oval plaques and the two smaller rectangular plaques are marked in gold on the reverse with the crossed *L*'s of the Sèvres manufactory, adjacent to the gilder's mark *2000*; the central plaque is inscribed *No353*. The central rectangular plaque and one of the oval plaques have paper Sèvres price labels printed with the crossed *L*'s; one is inked *72* [*livres*].

Height: 4 ft. 1 in. (124.5 cm); Width: 2 ft. 8½ in. (81.9 cm); Depth: 1 ft. 2¾ in. (37.5 cm)

Accession number 70.DA.83

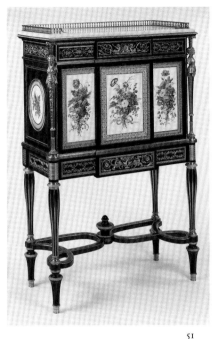

51

PROVENANCE

Jules Lowengard, Paris, before 1908; Baron Nathaniel de Rothschild, Vienna; Baron Alphonse de Rothschild, Vienna; confiscated by the Third Reich in March 1938; restituted to the Baroness Clarice de Rothschild, Vienna, in 1947, and sent to New York soon afterward (sold privately, 1950); [Rosenberg and Stiebel, Inc., New York]; purchased by J. Paul Getty, 1950.

BIBLIOGRAPHY

Seymour de Ricci, *Louis XVI Furniture* (London, 1913), p. 127, illus.; Paul Wescher, "French Furniture of the Eighteenth Century in the J. Paul Getty Museum," *Art*

Quarterly 18, no. 2 (Summer 1955), p. 126, illus. p. 134; Charles Packer, *Paris Furniture by the Master Ebénistes* (Newport, Monmouthshire, 1956), fig. 209; F. J. B. Watson, *Louis XVI Furniture* (London, 1963), no. 86, illus.; Jean Meuvret and Claude Frégnac, *Les Ebénistes du XVIII^e siècle français* (Paris, 1963), p. 286, illus. (erroneously described as being in the Metropolitan Museum of Art, New York); Verlet et al., *Chefs d'oeuvre*, p. 129, illus.; Getty, *Collecting*, pp. 158–159, illus.; Kjellberg, *Dictionnaire*, p. 872; Sassoon, *Vincennes and Sèvres Porcelain*, no. 40, pp. 193–196, illus. pp. 194–197.

52. ***Secrétaire***

(?) Paris, circa 1780
Oak veneered with satinwood, fruitwoods, tulipwood, and ebony; incised with mastics
The back of the *secrétaire* bears six wax seals with the date *1830* and the word *CHARTE*; the back is inscribed with the number *10697*.
Height: 4 ft. 11⅞ in. (152 cm); Width: 3 ft. ¼ in. (92.2 cm); Depth: 1 ft. 9⅞ in. (55.6 cm)
Accession number 85.DA.147

PROVENANCE

Unknown collection, Paris, circa 1830; private collection, Belgium (sold, Galerie Moderne, Brussels, March 15, 1976, lot 1305); [La Cour de Varenne, Paris, late 1970s–1982]; [Dalva Brothers, Inc., New York, 1982].

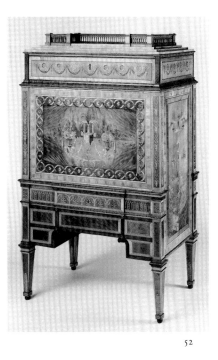

52

BIBLIOGRAPHY

Jean Bedel, *Les Antiquités et la brocante* (Paris, 1981), illus. on the front and back covers; "Acquisitions/1985," *GettyMusJ* 14 (1986), no. 210, p. 250, illus.; Pierre Ramond, *Marquetry* (Newtown, Connecticut, 1989), p. 85, illus.

53. ***Secrétaire***

Paris, circa 1785
Attributed to Jean-Henri Riesener
Oak veneered with panels of black Japanese lacquer and ebony; interior fittings of mahogany; gilt-bronze mounts; black marble top

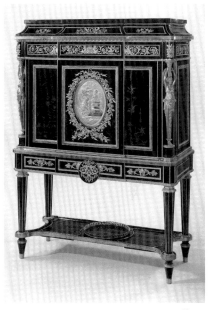

53

Two paper labels inked *Hamilton Palace* on the back.
Height: 5 ft. 1 in. (155 cm); Width: 3 ft. 8¼ in. (112.5 cm); Depth: 1 ft. 6½ in. (47 cm)
Accession number 71.DA.104

PROVENANCE

George Watson Taylor, Erlestoke Mansion, Devizes, Wiltshire (sold, Erlestoke Mansion, July 9 et seq., 1832, lot 26); Alexander Archibald Douglas, the 10th Duke of Hamilton and 7th Duke of Brandon, Hamilton Palace, Lanarkshire, Scotland; listed in the Duke's Dressing Room in an inventory of 1835–1840; William, 12th Duke

of Hamilton and 9th Duke of Brandon, Hamilton Palace, by descent (sold, Christie's, London, July 10, 1882, lot 1296, to Samson Wertheimer); Cornelius Vanderbilt II (1843–1899), The Breakers, Newport, Rhode Island, by (?) the 1890s; Alice Vanderbilt (1846–1934, wife of Cornelius Vanderbilt II), The Breakers, Newport, Rhode Island; Gladys Moore Vanderbilt (Countess Laszlo Széchényi, 1886–1965), by descent (sold by her heirs, Sotheby's, London, November 26, 1971, lot 71); purchased at that sale by J. Paul Getty.

BIBLIOGRAPHY

William Roberts, *Memorials of Christie's* (London, 1897), vol. 2, illus. facing p. 36; Seymour de Ricci, *Louis XVI Furniture* (London, 1913), p. 147, illus.; Frances Buckland, "Die Karriere eines Kunstschreiners: Johann Heinrich Riesener, Ebenist am Hofe Ludwigs XVI," *Kunst und Antiquitäten* 6 (1980), p. 37, illus. p. 28, fig. 7; Ronald Freyberger, "Eighteenth-Century French Furniture from Hamilton Palace," *Apollo* 114, no. 238 (December 1981), pp. 407–408, illus. p. 405, pl. 20; Wilson, *Selections*, no. 41, pp. 82–83, illus.; "The Great Collections," *French Connections: Scotland and the Arts of France* (Edinburgh, 1985), pp. 78, 81, 84, illus. p. 83, fig. 47; Kjellberg, *Dictionnaire*, p. 712, illus. p. 707.

54. *Secrétaire*

Paris, circa 1824
Attributed to Alexandre-Louis Bellangé; possibly after designs by the *marchand* Philippe Claude Maëlrondt
Oak veneered with amaranth, thuya wood, ebony, and pewter; set with twelve hard-paste porcelain plaques; mirrored and painted glass; gilt-bronze mounts; *rouge griotte* marble top
The four porcelain plaques of the fall front are numbered *1, 2, 3, 4* on their reverse; the gilt-bronze collars at the bases of the legs are numbered *1, 2, 3, 4, 5, (?), 7, 8, 9, 10* and *11*; the feet mounts are numbered *6* through *12*; the leg sections are numbered *1* through *12*. Inscribed on carcass, under oval porcelain plaque, *L'ovale ny les porcelaines n'ont point de marques.*
Height: 5 ft. ⅜ in. (153.4 cm); Width: 2 ft. 10⁵⁄₁₆ in. (87.2 cm); Depth: 1 ft. 4¾ in. (42.6 cm)
Accession number 66.DA.1

PROVENANCE

Sold by M. Lapeyrière, *Receveur général des contributions du département de la Seine,* April 19, 1825, lot 97; reputedly purchased at that sale by Marie-Jean-Pierre-Hubert, duc de Cambacérès, Paris; purchased from his heirs by Charles Michel, Paris, 1938; [W. Ball, New York, 1938]; purchased by J. Paul Getty, 1938.

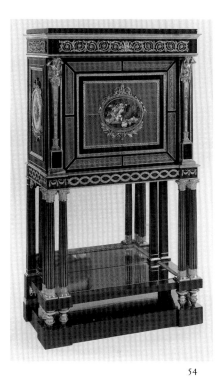

54

BIBLIOGRAPHY

Anne Dion-Tenenbaum, "Alexandre-Louis Bellangé (Attribue à): Secrétaire en cabinet (d'une paire)," *Un âge d'or des arts décoratifs 1814–1848* (Galeries nationales du Grand-Palais, Paris, 1991), p. 151, illus. fig. 55c; Denise Ledoux-Lebard, "Multiples Bellangé," *Connaissance des arts* 477 (December 1991), pp. 80–89, illus. no. 10, p. 88.

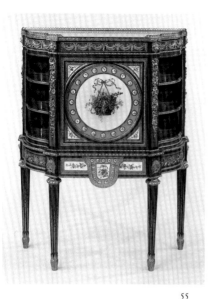

55

55. *Secrétaire*

(?) Paris, mid- to late nineteenth century;
circular Sèvres porcelain plaque circa 1775
Oak veneered with mahogany, satinwood,
and tulipwood; set with one soft-paste and
seven hard-paste porcelain plaques; gilt-
bronze mounts; white marble top
Stamped *LELEU*—a forged stamp for Jean-
François Leleu—and *JME* at the top right
and left corners of the back. Painted with
MA under a crown, a false mark for Marie
Antoinette, on back and bearing under-
neath a metal label stamped *HAMILTON
PLACE*. Circular porcelain plaque painted
on the reverse with the blue crossed *L*'s of
the Sèvres manufactory.

Height: 4 ft. 2 11/16 in. (128.8 cm); Width:
2 ft. 10¼ in. (87 cm); Depth: 1 ft. 2 in.
(35.6 cm)
Accession number 63.DA.1

PROVENANCE
(?) Baron Lionel de Rothschild (1808–1874),
Gunnersbury or New Court, Middlesex;
Leopold de Rothschild (1845–1917), Hamil-
ton Place, London, by 1889; Edmund de
Rothschild (b. 1916), London; Frank Green,
Esq., Ashwick House, Dulverton, Somerset
(sold September 19, 1947); [Frank Partridge
and Sons, Ltd., London]; purchased by
J. Paul Getty, October 1950.

BIBLIOGRAPHY
Getty, *Collecting*, p. 154, illus.; Savill,
Sèvres, vol. 2, p. 879, n. 49, p. 901; Sassoon,
Vincennes and Sèvres Porcelain, no. 36,
pp. 178–180, illus.

TABLES

56. **Reading and Writing Table**
Paris, circa 1670–1675
Walnut and oak veneered with ivory, blue
painted horn, and ebony; gilt-bronze mold-
ings; steel; modern silk velvet
Height: 2 ft. 1 in. (63.5 cm); Width:
1 ft. 7⅛ in. (48.5 cm); Depth: 1 ft. 2 in.
(35.5 cm)
Accession number 83.DA.21

PROVENANCE
Made for Louis XIV; (?) Dupille de Saint-
Severin, Paris (sold, Paris, February 21, 1785,
lot 323); [Bernard Baruch Steinitz, Paris,
1982].

BIBLIOGRAPHY
Gillian Wilson, "Two Newly Discovered
Pieces of Royal French Furniture," *Antologia
di belli arti* 27–28 (1985), pp. 61–66, illus.;
"Acquisitions/1983," *GettyMusJ* 12 (1984),
p. 261, no. 1, illus.; *Handbook* 1986, p. 142,
illus.; Jacques Charles et al., *De Versailles
à Paris: Le Destin des collections royales*
(Paris, 1989), illus. p. 22, fig. 12; Pradère,
Les Ebénistes, p. 47, illus. p. 46, fig. 2; *Hand-
book* 1991, p. 156, illus.

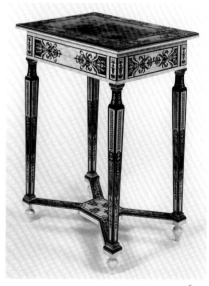

56

57. **Table**

Paris, circa 1680
Attributed to Pierre Golle
Oak and rosewood veneered with ebony,
satinwood, mahogany, tortoiseshell, pewter,
and brass; gilded wood; gilt-bronze mounts
One drawer bears a paper label inked
N.55/48005.
Height: 2 ft. 6½ in. (76.7 cm); Width:
1 ft. 4½ in. (42 cm); Depth: 1 ft. 2¼ in.
(36.1 cm)
Accession number 82.DA.34

PROVENANCE

(?) Louis, Grand Dauphin of France; (?)
H. Burgess (sold, Christie's, London,
May 30, 1899, lot 49, for £22 1s.); Henry
James Laird, Ardmore House, Blackheath
Park, Middlesex (sold, Christie's, London,
March 19, 1936, lot 147); private collection,
Scotland (sold, Phillips, Glasgow, April 16,
1981, lot 305); [Alexander and Berendt, Ltd.,
London, 1981].

BIBLIOGRAPHY

Wilson, "Acquisitions 1982," no. 2, pp. 18–23,
illus.; Wilson, *Selections*, no. 5, pp. 10–11,
illus.; *Handbook* 1986, p. 145, illus.; Jacques
Charles et al., *De Versailles à Paris: Le Destin
des collections royales* (Paris, 1989), illus. p. 22,
fig. 13; *Handbook* 1991, p. 158, illus.

57

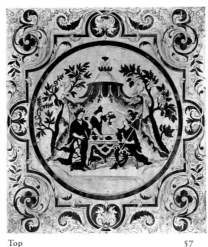

Top 57

58. **Table**

Paris, circa 1680
Attributed to André-Charles Boulle
Oak veneered with tortoiseshell, pewter,
brass, ebony, horn, ivory, boxwood, cherry,
natural and stained sycamore, pear, thuya
wood, satinwood, cedar, beech, and ama-
ranth; gilt-bronze mounts
Height: 2 ft. 4⅜ in. (72 cm); Width:
3 ft. 7½ in. (110.5 cm); Depth: 2 ft. 5 in.
(73.6 cm)
Accession number 71.DA.100

PROVENANCE

(?) Le Despencer Family, Mereworth Castle,
Kent (sold, circa 1831, to Levy, Maidstone,
Kent, £35); London art market, 1831;
Richard, 2nd Duke of Buckingham and
Chandos, Stowe House, Buckinghamshire
(sold, Christie's, Stowe House, August 15
et seq., 1848, lot 256, to [Redfern] for £59);
William Humble, 11th Baron Ward (created
1st Earl of Dudley, 1860, died 1885), 1848;
William Humble, 2nd Earl of Dudley (died
1932), Dudley House, Park Lane, London;
Sir Joseph C. Robinson, Bt., purchased with
the contents of Dudley House; Dr. Joseph
Labia (son-in-law of Sir Joseph C. Robin-
son), London (sold, Sotheby's, London,
May 17, 1963, lot 137); [Ronald Lee, London,
1970]; [Alexander and Berendt, Ltd.,
London, 1971]; purchased by J. Paul Getty.

EXHIBITIONS

The Minneapolis Institute of Arts, June 29–
September 3, 1972, no. 55.

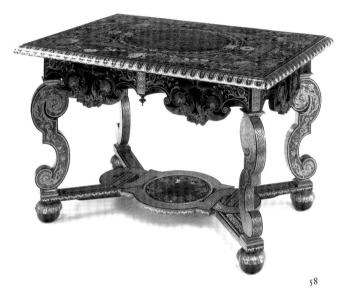

58

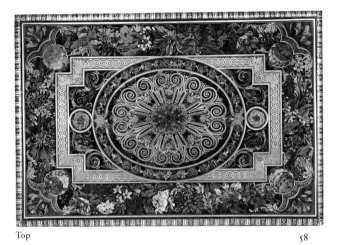

Top 58

BIBLIOGRAPHY

Henry R. Forster, *The Stowe Catalogue: Priced and Annotated* (London, 1848), no. 256, p. 16; Michael Stürmer, *Handwerk und höfische Kultur: Europäische Möbelkunst im 18. Jahrhundert* (Munich, 1982), pp. 35, 215, illus.; Gillian Wilson, "A Late Seventeenth-Century French Cabinet at the J. Paul Getty Museum," *The Art Institute of Chicago Centennial Lecture: Museum Studies 10* (1983), pp. 119–131, illus.; Wilson, *Selections*, no. 4, pp. 8–9, illus.; Alvar González-Palacios, *Il Tempio del gusto: Le Arti decorative in Italia fra Classicismi e barocco* (Milan, 1986), no. 56, p. 26, illus.; *Handbook* 1986, p. 146, illus.; Pradère, *Les Ebénistes*, no. 301, p. 108, illus. p. 99, fig. 56; *Handbook* 1991, p. 160, illus.

59. **Table**

Paris, circa 1680
Attributed to André-Charles Boulle
Oak veneered with ebony, tortoiseshell, horn, pewter, brass, ivory, boxwood, walnut, satinwood or mahogany, amaranth, and stained sycamore; gilt-bronze mounts
Height: 2 ft. 8¼ in. (82 cm); Width: 3 ft. 9⅞ in. (116.5 cm); Depth: 2 ft. 2 in. (66 cm)
Accession number 83.DA.22

PROVENANCE

[Bernheimer, Munich, 1920s]; Hermann, Graf von Arnim, Schloss Muskau, Saxony, taken to Munich, 1945.

BIBLIOGRAPHY

Hermann, Graf von Arnim and Willi Boelcke, *Muskau: Standesherrschaft zwischen Spree und Neiße* (Berlin, 1978), illus. p. 27; "Acquisitions/1983," *GettyMusJ* 12 (1984), no. 2, p. 261, illus.; Pradère, *Les Ebénistes*, no. 302, p. 108.

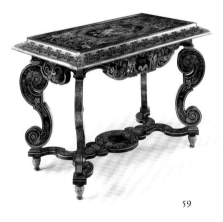

59

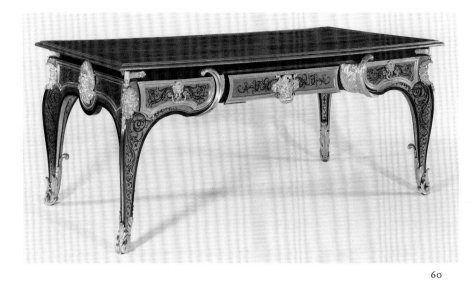

60

60. **Table (*bureau plat*)**

Paris, circa 1710–1715
Attributed to André-Charles Boulle
Oak veneered with tortoiseshell, ebony, and
brass; gilt-bronze mounts; leather top
Height: 2 ft. 7 ¹¹⁄₁₆ in. (80.5 cm); Width:
3 ft. 2¾ in. (98.5 cm); Depth: 6 ft. 4⁹⁄₁₆ in.
(195.4 cm)
Accession number 85.DA.23

PROVENANCE

Alexandre de Flahaut, comte de la Billar-
derie, or Charles Claude de Flahaut, comte
d'Angiviller, Paris; by descent to Auguste-
Charles-Joseph (1785–1870), comte de
Flahaut de la Billarderie, Paris, and French
ambassador to England 1860–1862; by
descent to Emily de Flahaut, Baroness Keith
and Nairne, Paris and London; (?) Lady
Emily Fitzmaurice, London; A. E. H.

Digby, Esq. (sold, Sotheby's, London,
June 22, 1951, lot 70); [Michel Meyer,
Paris, 1985].

BIBLIOGRAPHY

"Le Meuble Boulle," *Connaissance des arts* 2
(April 1952), p. 20; Stéphane Faniel et al.,
Le XVIIIᵉ siècle français (Collection Connais-
sance des arts, Paris, 1958), p. 60, fig. 6;
"Acquisitions/1985," *GettyMusJ* 14 (1986),
no. 193, p. 243, illus.; Pradère, *Les Ebénistes*,
no. 82, p. 102, illus. p. 78, fig. 27.

61. **Table (*bureau plat*)**

Paris, circa 1725
Attributed to the workshops of André-
Charles Boulle
Oak and pine veneered with *satiné rouge*
and amaranth; modern leather top; gilt-
bronze mounts
Black and white chalk drawing, possibly for
a corner mount, on an interior panel.
Height: 2 ft. 6⅛ in. (76.5 cm); Width:
6 ft. 7⅝ in. (202.2 cm); Depth: 2 ft. 11¼ in.
(89.5 cm)
Accession number 67.DA.10

PROVENANCE

H. H. A. Josse, Paris (sold, Galerie Georges
Petit, Paris, May 29, 1894, lot 152); pur-
chased at that sale by Edouard Chappey,
Paris (sold privately after 1900); Ernest
Cronier, Paris (sold, Galerie Georges Petit,
Paris, December 4–5, 1905, lot 135, to
[Jacques Seligmann, Paris]); François Coty,
Paris (sold, Galerie Jean Charpentier, Paris,
November 30–December 1, 1936, lot 84,
to [B. Fabre et Fils, Paris]); confiscated by
the Third Reich, 1940–1945; [Cameron, Lon-
don, 1949]; purchased by J. Paul Getty, 1949.

EXHIBITIONS

Paris, "Le Mobilier à travers les ages aux
grand et Petit Palais," *Exposition universelle
de 1900*, no. 2904; Paris, *Exposition rétro-
spective de l'art français des origines à 1800*,
1900, p. 299, illus. p. 188.

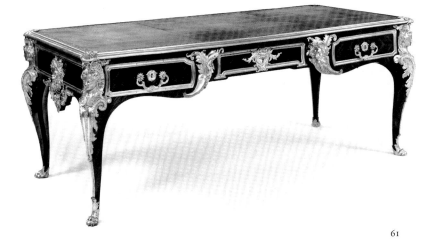

61

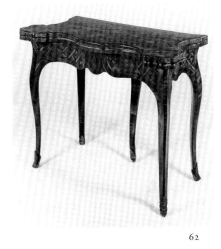

62

BIBLIOGRAPHY

Alfred de Champeaux, *Portefeuille des arts décoratifs 7ème année* (Paris, 1884–1885), pl. 578; Emile Molinier, *Histoire générale des arts appliqués à l'industrie du XVe à la fin du XVIIIe siècle*, vol. 3, *Le Mobilier au XVIIe et au XVIIIe siècle* (Paris, 1896), illus. p. 99; Frantz Marcou and Emile Moliner, *Catalogue officiel illustré de l'exposition rétrospective de l'art français des origines à 1800* (Paris, 1900), illus. pp. 113–114 and fol. 60; Marie-Juliette Ballot, *Charles Cressent: Sculpteur, ébéniste, collectionneur, Archives de l'art français: Nouvelle période 10* (Paris, 1919), pp. 113–114, 136–137, 145; Adolf Feulner, *Kunstgeschichte des Möbels seit dem Altertum* (Berlin, 1927), p. 314; Getty, *Collecting*, pp. 142–143, illus.; Pierre Verlet, *La Maison du XVIIIe siècle en France: Société,* *décoration, mobilier* (Paris, 1966), no. 133, pp. 168–169, illus.; Claude Frégnac, *Les Styles français*, vol. 1 (Paris, 1975), p. 179, illus.; Wilson, *Selections*, no. 10, pp. 20–21, illus.

62. **Writing and Card Table**

Paris, circa 1725

Oak and pine veneered with *satiné rouge* and kingwood; walnut drawers; gilt-bronze mounts; modern silk velvet

Closed Height: 2 ft. 6¼ in. (76.8 cm); Width: 3 ft. 3⅞ in. (101.3 cm); Depth: 1 ft. 8¼ in. (51.4 cm); Opened Height: 2 ft. 5⅛ in. (74 cm); Width: 3 ft. 3⅞ in. (101.3 cm); Depth: 3 ft. 4 in. (101.6 cm)

Accession number 75.DA.2

PROVENANCE

Jane, Countess of Westmorland (wife of the 10th Earl, married 1800, died 1857), Cotterstock Hall, Northamptonshire, from the late eighteenth century; Lieutenant Colonel Hon. Henry Fane (son of Jane, Countess of Westmorland; died 1857), Cotterstock Hall; Henry Dundas, 5th Viscount Melville (cousin of Hon. Henry Fane, died 1904), Cotterstock Hall; Dundas family, Melville Castle, Scotland, until 1967; [Alexander and Berendt, Ltd., London]; [French and Co., New York]; purchased by J. Paul Getty.

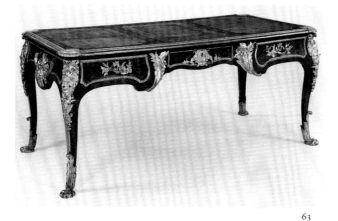

63

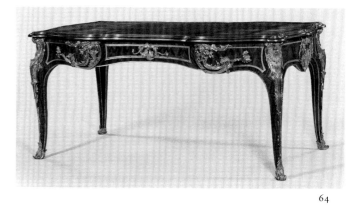

64

63. **Table (*bureau plat*)**
Paris, circa 1735
Attributed to the workshops of André-Charles Boulle
Oak veneered with tulipwood; modern leather top; gilt-bronze mounts
Height: 2 ft. 7⅞ in. (81 cm); Width: 6 ft. 4¼ in. (193.7 cm); Depth: 3 ft. 1½ in. (95.2 cm)
Accession number 55.DA.3

PROVENANCE
F. F. Uthemann, St. Petersburg, late nineteenth century; in Helsinki by 1921; Edith and Sir Alfred Chester Beatty (1875–1968), London; purchased by J. Paul Getty.

EXHIBITIONS
Oslo, Norway, The Nasjonalgalleriet, on loan, 1921–1923.

BIBLIOGRAPHY
Alexandre Benois, "La collection de M. Utheman à St.-Petersbourg," *Starye gody* (April 1908), p. 181, illus.; Getty, *Collecting*, p. 143, illus. p. 142; Alexandre Pradère, "Le Maître aux Pagodes," *L'Estampille-L'Objet d'art* 256 (March 1992), pp. 22–44, illus. p. 35, fig. 17, p. 36, and no. 22, p. 43.

———

64. **Table (*bureau plat*)**
Paris, circa 1745–1749
Attributed to Joseph Baumhauer
Oak veneered with *satiné rouge*; modern leather top; gilt-bronze mounts
All mounts stamped with the crowned *C* for 1745–1749.
Height: 2 ft. 7 1/16 in. (78.9 cm); Width: 5 ft. 11⅜ in. (181.3 cm); Depth: 3 ft. 3⅝ in. (100.7 cm)
Accession number 71.DA.95

PROVENANCE
(?) Empress Elizabeth of Russia, given to her by Louis XV, 1745, or purchased by Count Vorontsov, St. Petersburg, in Paris, 1745; Empress Catherine II of Russia by descent, 1762, or purchased with the Vorontsov Palace; Helen, Duchess of Mecklenburg-Strelitz (Princess of Saxe-Altenburg), Cabinet de la Souveraine, Chinese Palace, Oranienbaum (near St. Petersburg), by 1904; [Duveen Brothers, New York, 1935]; Anna Thomson Dodge, Rose Terrace, Grosse Pointe Farms, Michigan, by 1935 (sold, Christie's, London, June 24, 1971, lot 98); purchased at that sale by J. Paul Getty.

EXHIBITIONS
St. Petersburg, *Exposition rétrospective d'objets d'art à Saint-Petersbourg*, 1904, pp. 229, 231, illus. p. 232.

BIBLIOGRAPHY

Denis Roche, *Le Mobilier français en Russie* (Paris, 1912), vol. 1, pl. 18; Duveen and Co., *A Catalogue of Works of Art of the Eighteenth Century in the Collection of Anna Thomson Dodge* (Detroit, 1933), p. ix, illus.; André Boutemy, "L'Ebéniste Joseph Baumhauer," *Connaissance des arts* 157 (March 1965), illus. p. 88; Jean-Dominique Augarde, "1749 Joseph Baumhauer, ébéniste privilegié du roi," *L'Estampille* 204 (June 1987), pp. 15–45, fig. 3; Pradère, *Les Ebénistes*, no. 27, p. 245.

65. **Table (*bureau plat*)**
Paris, circa 1745–1749
By Bernard II van Risenburgh
Oak veneered with tulipwood and ebony; modern leather top; gilt-bronze mounts
Stamped *B.V.R.B.* underneath. Some of the mounts stamped with the crowned *C* for 1745–1749.

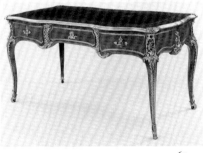

65

Height: 2 ft. 7 in. (78.7 cm); Width: 5 ft. 4½ in. (163.8 cm); Depth: 2 ft. 7⅛ in. (79.6 cm)
Accession number 78.DA.84

PROVENANCE

Henry Hirsch, London (sold, Christie's, London, June 11, 1931, lot 171); [J. M. Botibol, London, 1931]; purchased by J. Paul Getty, 1931.

BIBLIOGRAPHY

André Boutemy, "B.V.R.B. et la morphologie de son style," *Gazette des beaux-arts* 49 (March 1957), pp. 165–167; Barry Shifman, "A Newly-Found Table by Edward Holmes Baldock," *Apollo* 119 (January 1984), pp. 38–42, illus.; Kjellberg, *Dictionnaire*, p. 139.

66. **Mechanical Writing and Toilet Table**
Paris, circa 1750
By Jean-François Oeben
Oak veneered with tulipwood, amaranth, *satiné rouge*, kingwood, and various stained woods; iron mechanism; gilt-bronze mounts
Stamped *J.F.OEBEN* and *JME* underneath.
Height: 2 ft. 4¾ in. (73 cm); Width: 2 ft. 5⅛ in. (73.9 cm); Depth: 1 ft. 2⅞ in. (37.8 cm)
Accession number 70.DA.84

PROVENANCE

[B. Fabre et Fils, Paris]; [Cameron, London]; purchased by J. Paul Getty, 1949.

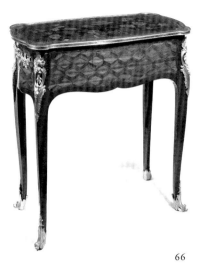

66

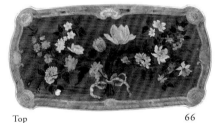

Top 66

BIBLIOGRAPHY

Verlet et al., *Chefs d'oeuvre*, p. 123, illus.; André Boutemy, "Jean-François Oeben Méconnu," *Gazette des beaux-arts* 63 (April 1964), pp. 207–224, illus. p. 215, fig. 23; Getty, *Collecting*, p. 153, illus.; Kjellberg, *Dictionnaire*, p. 619.

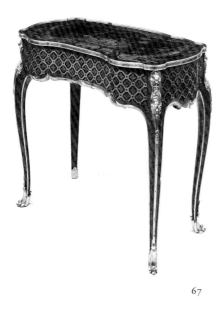

67

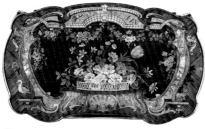

Top 67

67. **Writing and Toilet Table**

Paris, circa 1754

By Jean-François Oeben

Oak veneered with kingwood, tulipwood, amaranth, boxwood, sycamore, pear, satinwood, lemon, padouk, and stained hornbeam; leather; silk fabric lining; gilt-bronze mounts

Stamped *J.F.OEBEN* twice underneath table and inscribed in ink *No. 4*. Label underneath table printed *Mrs John D. Rockefeller, Jr.*; label inside drawer inked *C.6478/J.D.R.JNR/10 West Fifty-fourth Street, New York.*

Height: 2 ft. 4 in. (71.1 cm); Width: 2 ft. 7½ in. (80 cm); Depth: 1 ft. 4⅞ in. (42.8 cm)

Accession number 71.DA.103

PROVENANCE

John George Murray (1871–1917), Marquess of Tullibardine, 8th Duke of Atholl, Scotland; Mary Gavin (Hon. Mrs. Robert Baillie-Hamilton), by inheritance; Lady Harvey, London, by inheritance; [Lewis and Simmons, Paris]; Judge Elbert H. Gary, New York (sold, American Art Association, April 21, 1928, lot 272, when the above provenance was given); [Duveen Brothers, New York]; [Raymond Kraemer, Paris]; Martha Baird (Mrs. John D. Rockefeller, Jr.) (sold, Parke-Bernet, New York, October 23, 1971, lot 712); [The Antique Porcelain Co., New York]; purchased by J. Paul Getty.

BIBLIOGRAPHY

Wilson, *Selections*, no. 27, pp. 54–55, illus.; *Handbook* 1986, p. 166, illus.; Pradère, *Les Ebénistes*, illus. p. 255, fig. 264; Kjellberg, *Dictionnaire*, p. 619; *Handbook* 1991, p. 182, illus.

———

68. **Writing Table**

Paris, circa 1755

By Bernard II van Risenburgh

Oak and pine veneered with tulipwood, kingwood, amaranth, and laburnum; modern leather panel; gilt-bronze mounts

Stamped *B.V.R.B.* and *JME* twice under the front rail. A label pasted underneath printed *Londesborough* under a coronet. Another label printed *J.J.ALLEN, Ltd., Furniture Depositories, LONDON* and stenciled *Countess Londesborough.*

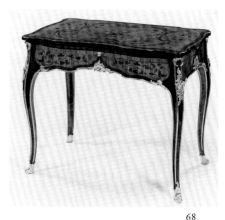

68

Height: 2 ft. 5½ in. (74.9 cm); Width:
3 ft. 1⅞ in. (96.2 cm); Depth: 1 ft. 10¹¹⁄₁₆ in.
(57.6 cm)
Accession number 65.DA.1

PROVENANCE
Lady Grace Adelaide Fane (Countess of
Londesborough, wife of the 2nd Earl,
married 1887, died 1933), London (sold,
Hampton and Sons, London, July 24, 1933,
lot 123); [J. M. Botibol, London, by 1937];
purchased by J. Paul Getty, 1938.

BIBLIOGRAPHY
Verlet et al., *Chefs d'oeuvre*, p. 119, illus.;
Getty, *Collecting*, p. 149, illus.; Kjellberg,
Dictionnaire, p. 139.

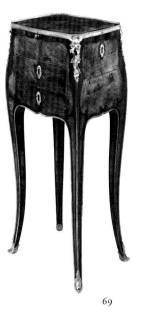

69

69. Table

Paris, circa 1760
By Adrien Faizelot-Delorme
Oak veneered with amaranth and green
stained burr yew; modern silver fittings
in drawer for ink, sand, and sponge; gilt-
bronze mounts
Stamped *DELORME* twice and *JME* once on
drawer panel.
Height: 2 ft. 3⅛ in. (68.9 cm); Width:
11⅝ in. (29.4 cm); Depth: 9⅝ in. (24.4 cm)
Accession number 72.DA.64

PROVENANCE
Paris art market, early 1970s; [Rosenberg
and Stiebel, Inc., New York, 1972]; pur-
chased by J. Paul Getty.

70. Card Table

Paris, circa 1760
By Jean-François Oeben
Oak veneered with tulipwood, kingwood,
and green stained burr wood; modern baize
lining; gilt-bronze mounts
Stamped *J.F.OEBEN* beneath.
Height: 2 ft. 3¾ in. (70.5 cm); Width:
2 ft. 9½ in. (85 cm); Depth: 1 ft. 2½ in.
(36.8 cm)
Accession number 71.DA.105

PROVENANCE
Probably purchased by Sir Charles Mills
or his son Charles Henry, created Lord
Hillingdon in 1886, Essex; Charles, 4th
Lord Hillingdon (born 1922), Essex, by
descent (sold, Christie's, London, May 14,
1970, lot 102); [Frank Partridge, Ltd.,
London, 1970]; [French and Co., New
York]; purchased by J. Paul Getty.

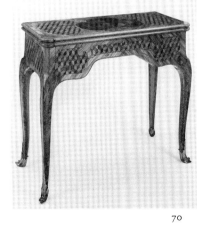

70

71. **Table**

Table: Paris, early twentieth century
Porcelain: Sèvres manufactory, 1761
Carcass perhaps by an imitator of Bernard II
van Risenburgh; porcelain top painted by
Charles-Nicolas Dodin after a design by
François Boucher
Painted oak; set with a soft-paste porcelain
plaque; gilt-bronze mounts
Stamped *B.V.R.B.* and *JME* underneath
drawer. Underside of the porcelain plaque
painted with the blue crossed *L*'s of the
Sèvres manufactory enclosing the date letter
I for 1761, and with the painter's mark *k*.
Height: 2 ft. 2⅜ in. (66.9 cm); Width:
1 ft. 1⅝ in. (34.6 cm); Depth: 11⅛ in.
(28.3 cm)
Accession number 70.DA.85

PROVENANCE

Porcelain *Plateau* only: (?) Miss H.
Cavendish-Bentinck (offered for sale,
Christie's, London, March 3, 1893, lot 123,
bought in); (?) John Cockshut, Esq.
(sold after his death, Christie's, London,
March 11, 1913, lot 92, to Harding).
Table mounted with *Plateau*: Private
English collection; [Rosenberg and Stiebel,
Inc., New York, 1949]; purchased by J. Paul
Getty, 1949.

BIBLIOGRAPHY

Verlet et al., *Chefs d'oeuvre*, p. 118, illus.;
Getty, *Collecting*, p. 148, illus.; Hans Huth,
*Lacquer of the West: The History of a Craft
and an Industry, 1550–1950* (Chicago and
London, 1971), p. 93, caption p. 145, fig. 231;
Adrian Sassoon, "New Research on a Table

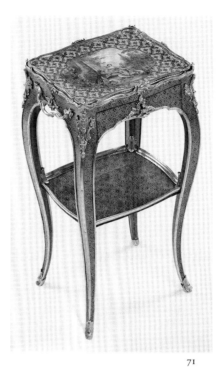

71

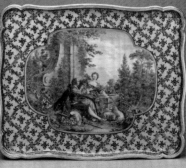

Top 71

Stamped by Bernard van Risenburgh,"
GettyMusJ 9 (1981), pp. 167–174, figs. 1–5,
8–9; Antoinette Fäy-Hallé et al., *François
Boucher* (The Metropolitan Museum of Art,
New York, 1986), no. 97, p. 355; Savill,
Sèvres, vol. 2, n. 2f, p. 812; Kjellberg, *Dictionnaire*, p. 139; Sassoon, *Vincennes and
Sèvres Porcelain*, no. 32, pp. 162–165, illus.
pp. 163, 165.

———

72. **Toilet Table**

Paris, circa 1760–1765
Attributed to Jean-François Leleu
Oak veneered with kingwood, tulipwood,
pear, satinwood, lemon, padouk, amaranth,
sycamore, boxwood, and ebony; gilt-bronze
mounts
The number *499* cast into the reverse of
each mount. Paper label inked *B.F.A.C.
1913 Meyer Sassoon Esq.* inside drawer.
Paper label printed *BURLINGTON FINE
ARTS CLUB EXHIBITION OF THE
FRENCH SCHOOL OF THE XVIIITH
CENT. 1913*, and another label inked *Mr. A.
Barker présenté par M. Chenue, 24 Rue
des petits Champs.....* underneath table.
Height: 2 ft. 3⅝ in. (70.2 cm); Width:
1 ft. 10⅜ in. (56.9 cm); Depth: 1 ft. 3⅞ in.
(40.3 cm)
Accession number 72.DA.49

PROVENANCE

[Alexander Barker, Esq.], probably acquired
in Paris (sold, Christie's, London, June 11,
1874, lot 693); (?) Edmund, 1st Lord
Grimsthorpe (1816–1905); Leopold George
Frederick, 5th Viscount Clifden (sold,

Robinson and Fisher, May 21 et seq., 1895, lot 606, to [Seligmann, Paris], for 750 guineas); Mr. and Mrs. Meyer Sassoon, Pope's Manor, Berkshire; Violet Sassoon (Mrs. Derek C. Fitzgerald), Heathfield Park, Sussex (offered for sale, Sotheby's, London, November 22, 1963, lot 132, bought in; sold, Christie's, London, March 23, 1972, lot 88); purchased at that sale by J. Paul Getty.

EXHIBITIONS

London, The Burlington Fine Arts Club, 1913; London, Morton Lee and Mallet and Sons, *The Royal Cabinetmakers of France*, July 1951, no. 8, illus.

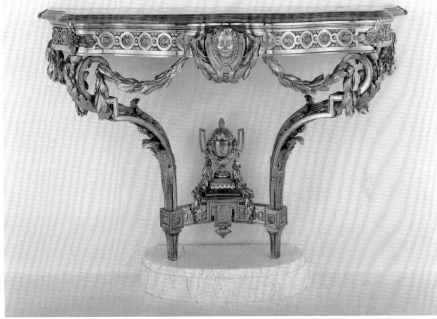

73

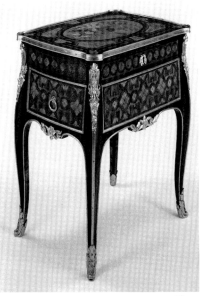

72

73. Console Table

Paris, circa 1765–1770
Design by Victor Louis; table attributed to Pierre Deumier
Silvered and gilt bronze; *bleu turquin* marble top
Each gilt-bronze element is stamped with the letter *B*.
Height: 2 ft. 7⅞ in. (83.5 cm); Width: 4 ft. 3 in. (129.5 cm); Depth: 1 ft. 8½ in. (52 cm)
Accession number 88.DF.118

PROVENANCE

Arturo Lopez-Willshaw, Paris (sold, Sotheby's, Monaco, June 23, 1976, lot 108);

purchased at that sale by The British Rail Pension Fund.

BIBLIOGRAPHY

François-Georges Pariset, "Jeszcze o Pracach Wiktora Louisa Dla Zamku Warszawskiego," *Biuletyn Historii Sztuki*, Nr. 2, Rok 24 (1962), pp. 141, 154; "Acquisitions/1988," *GettyMusJ* 17 (1989), no. 73, p. 142, illus.; David Harris Cohen, "The *Chambre des Portraits* Designed by Victor Louis for the King of Poland," *GettyMusJ* 19 (1991), pp. 75–98, illus. p. 89, fig. 23a; *Handbook* 1991, p. 187, illus.

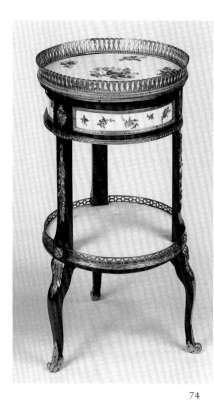

74

74. **Table**

Table: Paris, circa 1770
Porcelain: Sèvres manufactory, 1764
Attributed to Martin Carlin
Oak veneered with tulipwood, ebony, and
holly; set with four soft-paste porcelain
plaques; gilt-bronze mounts; white marble
lower shelf
The circular porcelain plaque painted on
the reverse with the blue crossed *L*'s of the
Sèvres manufactory enclosing the date letter
L for 1764.

Height: 2 ft. 3¾ in. (70.5 cm); Diameter:
1 ft. 3⅜ in. (39.1 cm)
Accession number 70.DA.74

PROVENANCE

Alfred de Rothschild, Halton, Buckingham-
shire, after 1884; Almina Wombwell (daugh-
ter of Alfred de Rothschild, Countess of
Carnarvon, wife of the 5th Earl, married
1895, died 1969), 1918; [Henry Symons
and Co., London, 1919]; [French and Co.,
New York, 1919]; Mortimer L. Schiff, New
York, 1919 (sold by his heir John L. Schiff,
Christie's, London, June 22, 1938, lot 52);
purchased at that sale by J. Paul Getty.

BIBLIOGRAPHY

Pradère, *Les Ebénistes*, no. 70, p. 359; Kjell-
berg, *Dictionnaire*, pp. 158, 162; Sassoon,
Vincennes and Sèvres Porcelain, no. 33,
pp. 166–169, illus. pp. 167–169.

———

75. **Table**

Table: Paris, circa 1773
Porcelain: Sèvres manufactory, 1773
Table by Martin Carlin; circular porcelain
plaque attributed to Jacques-François
Micaud
Oak veneered with tulipwood, holly, and
ebony; set with four soft-paste porcelain
plaques; gilt-bronze mounts
Table stamped *M.CARLIN* and *JME* under-
neath. Circular plaque painted with the
blue crossed *L*'s of the Sèvres manufactory,
the date *1773*, and the painter's mark *X*.
Height: 2 ft. 5 in. (73.5 cm); Diameter:
1 ft. 3¾ in. (40 cm)
Accession number 70.DA.75

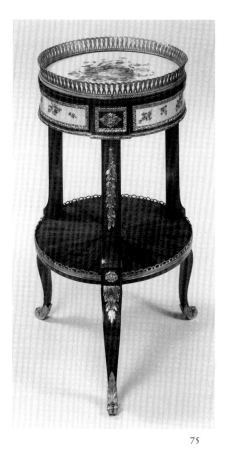

75

PROVENANCE

Alfred de Rothschild, Halton, Buckingham-
shire, after 1884; Almina Wombwell (daugh-
ter of Alfred de Rothschild; Countess of
Carnarvon, wife of the 5th Earl, married
1895, died 1969), 1918; [Henry Symons
and Co., London, 1920]; [French and Co.,
New York, 1920]; Mortimer L. Schiff, New

York, 1920 (sold by his heir John L. Schiff, Christie's, London, June 22, 1938, lot 51); purchased at that sale by J. Paul Getty.

BIBLIOGRAPHY

Verlet et al., *Chefs d'oeuvre*, p. 128, illus.; Getty, *Collecting*, p. 158; Dorothée Guillemé-Brulon, "Un décor pour les meubles," *L'Estampille* 165 (January 1984), pp. 18–30, illus. p. 24; Pradère, *Les Ebénistes*, no. 69, p. 359; Kjellberg, *Dictionnaire*, pp. 158, 162; Sassoon, *Vincennes and Sèvres Porcelain*, no. 34, pp. 170–172, illus. pp. 171–173.

———

76. Music Stand

Paris, circa 1770–1775
Attributed to Martin Carlin
Oak veneered with tulipwood and pearwood; incised with colored mastics; gilt-bronze mounts
Stamped *JME* under oval shelf.
Maximum Height: 4 ft. 10½ in. (148.6 cm);
Minimum Height: 3 ft. 1 in. (94.2 cm);
Width: 1 ft. 7¾ in. (50.2 cm); Depth: 1 ft. 2½ in. (36.8 cm)
Accession number 55.DA.4

PROVENANCE

Sir Robert Abdy, Bt., London; Edith and Sir Alfred Chester Beatty (1875–1968), London; purchased by J. Paul Getty.

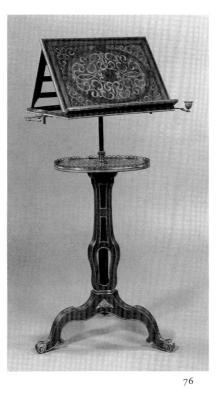

76

BIBLIOGRAPHY

Paul Wescher, "An Inlaid Music Stand by Martin Carlin and Related Pieces," *Bulletin of the J. Paul Getty Museum of Art* (1959), vol. 1, no. 2, pp. 16–32, illus.; F. J. B. Watson, *Louis XVI Furniture* (New York, 1960), no. 125, pp. 130–131, illus.; Verlet et al., *Chefs d'oeuvre*, pp. 125–126, illus.; Getty, *Collecting*, p. 156, illus.

———

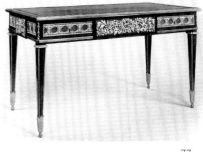

77

77. Table (*bureau plat*)

Paris, 1777
By Jean-Henri Riesener
Oak veneered with satinwood and amaranth; modern leather top; gilt-bronze mounts
Underside of table painted in black with the partly obliterated French royal inventory mark *No. 2905*. Stamped under same panel, in the form of a circle that is half cut away, *[GARDE-MEUB]LE DE LA REINE* enclosing the monogram *MA*. Also painted underneath table is a crown that originally appeared over the letters *CT*, which are now cut away.
Height: 2 ft. 5½ in. (74.9 cm); Width: 4 ft. 5½ in. (135.9 cm); Depth: 2 ft. 3⅞ in. (70.8 cm)
Accession number 71.DA.102

PROVENANCE

Ordered by Marie-Antoinette for the *cabinet* of Louis XVI in the Petit Trianon, Versailles, and delivered on August 6, 1777 (sold, Versailles, August 25, 1793 to August 11, 1794, lot 828, for 600 *livres* to Dumont); [Frank Partridge and Sons, Ltd., London, 1967–1971]; purchased by J. Paul Getty.

BIBLIOGRAPHY

Geoffrey de Bellaigue, *The James A. de Rothschild Collection at Waddesdon Manor: Furniture, Clocks and Gilt Bronzes* (Fribourg, 1974), vol. 1, no. 69; vol. 2, no. 103; Christian Baulez and Denise Ledoux-Lebard, *Il mobile Francèse dal Luigi XVI all'art decó* (Milan, 1981), p. 12, fig. 12; Jacques Charles et al., *De Versailles à Paris: Le Destin des collections royales,* (Paris, 1989), illus. p. 191; Kjellberg, *Dictionnaire,* p. 712; Pierre Verlet, *Le Mobilier royal français,* vol. 4, *Meubles de la couronne conservés en Europe et aux Etats-Unis* (Paris, 1990), pp. 80–82, illus. pp. 11, 81.

78. **Toilet Table**

Paris, circa 1777–1780
Oak and pine veneered with tulipwood and stained holly; marquetry panels of amaranth, satinwood, pearwood, tulipwood, applewood, ebony, and other stained fruitwoods; gilt-bronze mounts
Height: 2 ft. 4⅛ in. (71.3 cm); Width: 2 ft. 7¾ in. (80.6 cm); Depth: 2 ft. 8⅝ in. (83 cm)
Accession number 72.DA.67

PROVENANCE

Sir Albert Edward Primrose, 6th Earl of Rosebery (sold, Christie's, London, December 2, 1971, lot 112); [French and Co., New York, 1971]; purchased by J. Paul Getty.

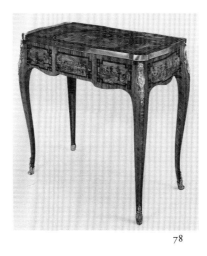

78

BIBLIOGRAPHY

Geoffrey de Bellaigue, *The James A. de Rothschild Collection at Waddesdon Manor: Furniture, Clocks and Gilt Bronzes* (Fribourg, 1974), vol. 2, pp. 498–499.

79. **Writing Table (*bureau plat*)**

Table: Paris, circa 1778
Porcelain: Sèvres manufactory, circa 1778
The table by Martin Carlin; at least seven Sèvres porcelain plaques gilded by Jean-Baptiste-Emmanuel Vandé *père*
Oak veneered with tulipwood; set with fourteen soft-paste porcelain plaques; modern leather top; gilt-bronze mounts
Stamped *M.CARLIN* (partly effaced) and *JME* under front-right rail. Printed paper trade label of Dominique Daguerre underneath left-rear rail; three Russian inventory numbers painted on carcass; central drawer contains a paper label inked with the twentieth-century Duveen inventory number *29615.* Porcelain plaques marked variously (not all are marked) with the crossed *L*'s of the Sèvres manufactory in red, the date letters *AA* for 1778, Vandé's mark *VD*, and paper labels printed with the crossed *L*'s and inked with the prices of *30* and *96* [*livres*].
Height: 2 ft. 6½ in. (77.5 cm); Width: 4 ft. 3⅝ in. (131.2 cm); Depth: 2 ft. ⅜ in. (62 cm)
Accession number 83.DA.385

PROVENANCE

Grand Duchess Maria-Feodorovna of Russia (later czarina of Paul I), purchased in 1782 from the *marchand-mercier* Dominique Daguerre in Paris, installed in her *chambre à coucher* at Pavlovsk (near St. Petersburg), Russia; Russian Imperial Collections, Palace of Pavlovsk; [Duveen and Co., New York], purchased in 1931 from the Soviet government; Anna Thomson Dodge, Rose Terrace, Grosse Pointe Farms, Michigan, 1931 (sold, Christie's, London, June 24, 1971, lot 135); Habib Sabet, Geneva, 1971 (sold, Christie's, London, December 1, 1983, lot 54).

BIBLIOGRAPHY

Alexandre Benois, *Les Trésors d'art en Russie* (St. Petersburg, 1907), vol. 7, p. 186, pl. 20; Denis Roche, *Le Mobilier français en Russie* (Paris, 1913), vol. 2, pl. 55; Duveen and Co., *A Catalogue of Works of Art of the Eighteenth Century in the Collection of Anna Thomson Dodge* (Detroit, 1933), introduction p. vii

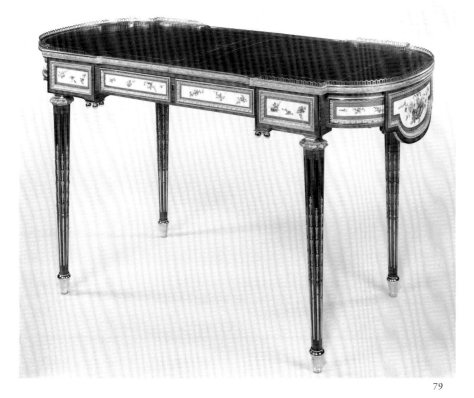

79

and non-paginated entry, illus.; Duveen and
Co., *A Catalogue of Works of Art in the
Collection of Anna Thomson Dodge* (Detroit,
1939), vol. 1, introduction pp. xv–xvi and
non-paginated entry, illus.; Carl Dauterman
et al., *Decorative Art from the S. H. Kress
Collection at the Metropolitan Museum of Art*
(London, 1964), pp. 112, 114, 130; Anthony
Coleridge, "Works of Art with a Royal
Provenance from the Collection of the Late
Mrs. Anna Thomson Dodge," *Connoisseur*

177, no. 711 (May 1971), pp. 34–36, illus.;
Sassoon, "Acquisitions 1983," no. 10, pp. 201,
204–207, illus.; *Handbook* 1986, p. 174,
illus.; Savill, *Sèvres*, vol. 2, p. 887; nn. 83, 87,
p. 901; Pradère, *Les Ebénistes*, no. 39, p. 358;
Kjellberg, *Dictionnaire*, pp. 160, 162, illus.
p. 157; Sassoon, *Vincennes and Sèvres Porce-
lain*, no. 39, pp. 188–192, illus. pp. 189–192.

CARVED TABLES

80. Table

French, circa 1660–1670
Gessoed and gilded walnut; modern paint
Height: 2 ft. 8½ in. (77.5 cm); Width:
3 ft. 3½ in. (100.3 cm); Depth: 2 ft. 3 in.
(68.5 cm)
Accession number 87.DA.7

PROVENANCE

[Bernard Baruch Steinitz, Paris, 1986].

BIBLIOGRAPHY

"Acquisitions/1987," *GettyMusJ* 16 (1988),
no. 65, p. 176, illus.

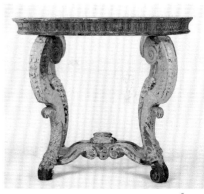

80

81. **Table or Stand**

Paris, circa 1700–1715
Gessoed and gilded oak
Height: 2 ft. 4½ in. (72.5 cm); Width:
2 ft. 6½ in. (77 cm); Depth: 1 ft. 8½ in.
(52 cm)
Accession number 90.DA.23

PROVENANCE

English private collection; London art mar-
ket; [B. Fabre et Fils, Paris, 1989].

BIBLIOGRAPHY

"Acquisitions/1990," *GettyMusJ* 19 (1991),
no. 55, p. 161, illus.

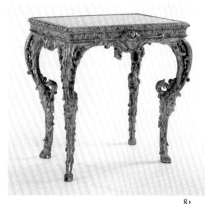

81

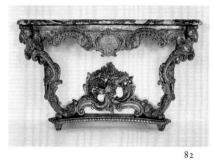

82

82. **Console Table**

Paris, circa 1725
Gessoed and gilded oak; *lumachella pavo-
nazza* marble top
Pasted under back rail, the remains of a
printed label, *102, George Street, Portman
Square, W1.*
Height: 2 ft. 10⅜ in. (87.3 cm); Width:
4 ft. 11⅞ in. (152.1 cm); Depth: 1 ft. 11¼ in.
(59.1 cm)
Accession number 72.DA.68

PROVENANCE

Christie Robert, London, circa 1885–1916;
Baroness van Zuylen van Nyevelt van de
Haar, Paris, by 1964 (sold, Palais Galliera,
Paris, June 8, 1971, lot 77); [Rosenberg and
Stiebel, Inc., New York, 1972]; purchased by
J. Paul Getty.

BIBLIOGRAPHY

Eveline Schlumberger, "En Hommage à
Gérard Mille: l'appartement qui illustre le
mieux le style baroque qui couronna sa car-
rière de décorateur," *Connaissance des arts*
146 (April 1964), illus. p. 71.

83. **Console Table**

Paris, circa 1725–1730
Gessoed and gilded oak and pine;
marble top
Height: 2 ft. 10⅞ in. (87.5 cm); Width:
2 ft. 3 in. (68.5 cm); Depth: 1 ft. 3¾ in.
(40 cm)
Accession number 85.DA.125

PROVENANCE

[Gerard Kerin, London] (sold, Christie's,
London, July 1, 1982, lot 42); [Didier
Aaron, Paris]; [Rosenberg and Stiebel, Inc.,
New York].

BIBLIOGRAPHY

"Acquisitions/1985," *GettyMusJ* 14 (1986),
no. 194, p. 244, illus.

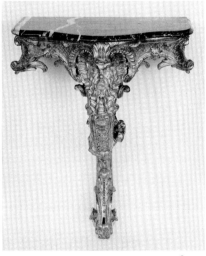

83

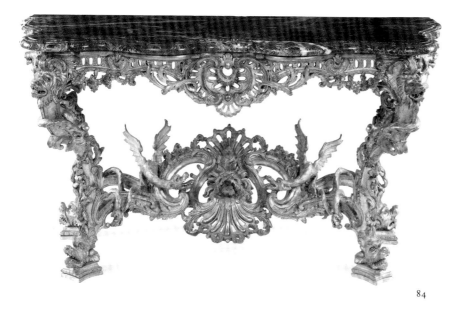

84

Height: 2 ft. 10½ in. (87.6 cm); Width:
6 ft. 5⅝ in. (197.1 cm); Depth: 3 ft. 9⅝ in.
(115.8 cm)
Accession number 72.DA.58

PROVENANCE
(?) Baroness Lionel de Rothschild (née
Charlotte von Rothschild), Gunnersbury
Park, Middlesex; Alfred de Rothschild
(1842–1918), Halton, Buckinghamshire, by
1884; by descent to Edmund de Rothschild
(b. 1916), Exbury, Hampshire; [Frank
Partridge and Sons, Ltd., London, 1972];
[French and Company, New York, on con-
signment from Frank Partridge and Sons,
Ltd., London]; purchased by J. Paul Getty.

84. **Side Table**
Paris, circa 1730
Gessoed and gilded oak; *brèche violette* top
Height: 2 ft. 11⅛ in. (89.3 cm); Width:
5 ft. 7 in. (170.2 cm); Depth: 2 ft. 8 in.
(81.3 cm)
Accession number 79.DA.68

PROVENANCE
Vicomtesse de B..., Paris (sold, Hôtel
Drouot, Paris, April, 26, 1923, lot 21);
[François-Gérard Seligmann, Paris].

BIBLIOGRAPHY
Wilson, "Acquisitions 1979 to mid 1980,"
no. 3, pp. 5–6, illus.; *Handbook* 1986, p. 154,
illus.; *Handbook* 1991, p. 168, illus.

85. **Center Table**
Top: See entry no. 320 under
Italian Furniture
Support: Paris, circa 1745
Gessoed and gilded wood

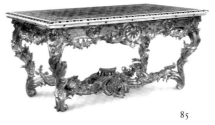

85

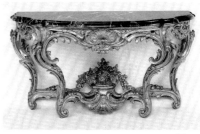

86

86. **Console Table**
Paris, circa 1750–1755
Design closely related to the work of
Contant d'Ivry (1698–1777)
Gessoed and gilded oak; modern marble top
Height (without top): 3 ft.¼ in. (92.1 cm);
Width: 5 ft. 8¾ in. (174.6 cm); Depth:
2 ft. 3¾ in. (70.5 cm)
Accession number 91.DA.21

PROVENANCE

The Barons of Hastings, Melton Constable, Norfolk; by descent to the 21st Baron, Sir Albert Edward Delaval (sold with the house in 1940 to the Duke of Westminster); Roger Gawn, Melton Constable, Norfolk (sold, Christie's, London, December 4, 1986, lot 96); [Jonathan Harris, London].

BIBLIOGRAPHY

Pallot, *L'Art du siège*, illus. p. 155; "Acquisitions/1991," *GettyMusJ* 20 (1992), no. 77, p. 174, illus.

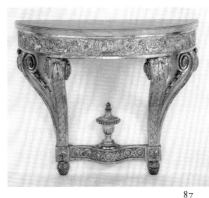

87

87. **Console Table**

Paris, circa 1775
Gessoed, painted, and gilded oak; *bleu turquin* marble top
Height: 2 ft. 9¾ in. (85.7 cm); Width: 3 ft. 5¼ in. (104.7 cm); Depth: 1 ft. 6¼ in. (46.3 cm)
Accession number 89.DA.29

PROVENANCE

[Kraemer et Cie, Paris].

BIBLIOGRAPHY

"Acquisitions/1989," *GettyMusJ* 18 (1990), no. 56, p. 195, illus.

88

88. **Console Table**

Paris, circa 1780
After designs by Richard de Lalonde.
Painted walnut
Height: 2 ft. 9 in. (84 cm); Width: 2 ft. 9 in. (84 cm); Depth: 1 ft. ¾ in. (32.5 cm)
Accession number 91.DA.16

PROVENANCE

[B. Fabre et Fils, Paris, 1990].

BIBLIOGRAPHY

"Acquisitions/1991," *GettyMusJ* 20 (1992), no. 73, p. 173, illus.

SEAT FURNITURE

89. **Pair of Settees**

Settee .1: French, circa 1700
Settee .2: English, circa 1830
Gessoed and gilded wood; modern upholstery
Height: 3 ft. 10⅛ in. (117.1 cm); Width: 6 ft. 11¾ in. (212.7 cm); Depth: 2 ft. 1 in. (63.6 cm)
Accession number 78.DA.100.1–.2

PROVENANCE

Sir Ivor Churchill Guest, Viscount Wimbourne (born 1873), Ashby St. Ledgers, Northampton, England; [Frank Partridge, Ltd., London]; purchased by J. Paul Getty for Sutton Place, Surrey, 1968; distributed by the estate of J. Paul Getty to the J. Paul Getty Museum.

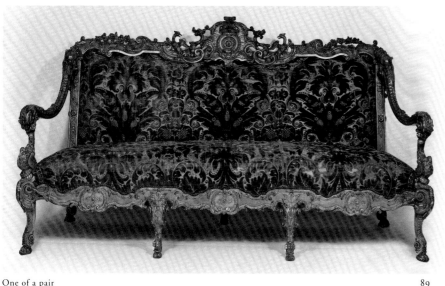

One of a pair 89

EXHIBITIONS
London, 25 Park Lane, *Three French Reigns*, February–April 1933, no. 529, illus.; Woodside, California, Filoli, on loan, 1979–1991.

90. **Stool (*tabouret*)**

Paris, circa 1710–1720
Gessoed and gilded walnut; modern leather upholstery
Stamped *GHC* under each side rail. The stool bears two paper labels, one glued to the inside of each side rail, printed with *From the David Zork Company / Exclusive Furniture and Decoration / 201–207 North Michigan Boulevard / Chicago, Illinois.*

Both paper labels are partially covered by a second, round label printed with *A La Vieille Russie.*
Height: 1 ft. 6½ in. (47 cm); Width: 2 ft. 1 in. (63.5 cm); Depth: 1 ft. 6⅞ in. (48 cm)
Accession number 84.DA.970

PROVENANCE
Pierre Crozat (1661–1740), *trésorier de France à Paris* in 1704; by descent to his niece Antoinette-Louise-Marie Crozat de Thiers, comtesse de Béthune-Pologne (1731–1809); by descent to the families of La Tour du Pin and de Chabrillan; by descent to le comtesse Armand de Caumont La Force, née Anne-Marie de Chabrillan (1894–1983) and her son, le comte Robert-Henry de Caumont La Force, at the Château de

Thugny (Ardennes); [(?) David Zork Co., Chicago, Illinois]; [A La Vieille Russie, New York, 1984].

EXHIBITIONS
Reims, France, Palais archiepiscopal, 1876, (?) no. 267, lent by M. le comte de Chabrillan [information: P. Leperlier].

BIBLIOGRAPHY
"Acquisitions/1984," *GettyMusJ* 13 (1985), no. 48, p. 176, illus.; Jean Feray, "Le Mobilier Crozat," *Connaissance des arts* 429 (November 1987), pp. 67–68, n. 2; "The Crozat Suite," *Christie's Review of the Season 1988* (Oxford, 1989), pp. 214–215; Daniel Alcouffe, "Les récentes acquisitions des musées nationaux, Musée du Louvre, 'Deux fauteuils du mobilier Crozat,' " *La Revue du Louvre et des Musées de France* 4 (1989), p. 264; Daniel Alcouffe, "Paire de Fauteuils," *Louvre: Nouvelles acquisitions du département des objets d'art, 1985–1989* (Paris, 1990), no. 67, pp. 140–142.

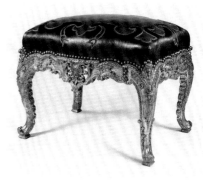

90

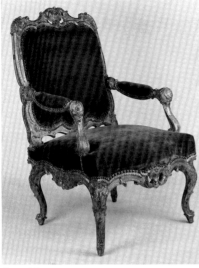

One of four 91

91. **Four Armchairs (*fauteuils à la reine*)**

Paris, circa 1735
Gessoed and gilded walnut, modern silk velvet upholstery
Height: 3 ft. 5¼ in. (104.8 cm); Width:
2 ft. 1¼ in. (64.1 cm); Depth: 1 ft. 10¾ in.
(57.8 cm)
Accession number 75.DA.8.1–.4

PROVENANCE

Hubert de Givenchy, Paris; [Jacques Kugel, Paris]; purchased by J. Paul Getty.

BIBLIOGRAPHY

Pallot, *L'Art du siège*, p. 108, illus.

92. **Desk Chair (*fauteuil de cabinet*)**

Paris, circa 1735
Attributed to Etienne Meunier
Walnut; leather upholstery; velvet pocket linings; brass studs
Height: 2 ft. 11⅜ in. (90.8 cm); Width:
2 ft. 4 in. (71.1 cm); Depth: 2 ft. 1¼ in.
(64.1 cm)
Accession number 71.DA.91

PROVENANCE

[Duveen Brothers, New York]; Anna Thomson Dodge, Rose Terrace, Grosse Pointe Farms, Michigan (sold, Christie's, London, June 24, 1971, lot 48); purchased at that sale by J. Paul Getty.

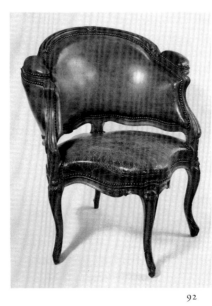

92

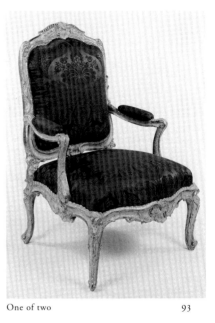

One of two 93

93. **Two Armchairs (*fauteuils*) and Two Side Chairs (*chaises*)**

Paris, circa 1735–1740
Gessoed and gilded beech; modern silk upholstery
Armchairs: Height: 3 ft. 7½ in. (110.5 cm);
Width: 2 ft. 6⅛ in. (76.6 cm); Depth:
2 ft. 8⅞ in. (83.7 cm); Side Chairs: Height:
3 ft. 1 in. (94.1 cm); Width: 2 ft. ⅜ in.
(62 cm); Depth: 2 ft. 3⅜ in. (69.4 cm)
Accession number 82.DA.95.1–.4

PROVENANCE

Private collection, England, from the eighteenth century until 1979; [William Redford, London, 1979]; [Alexander and Berendt, Ltd., London, 1979].

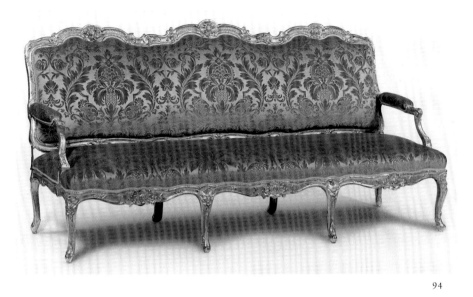

94

BIBLIOGRAPHY

Sassoon, "Acquisitions 1982," no. 4,
pp. 28–33, illus.; *Handbook* 1986, p. 156,
illus. (one armchair); Pallot, *L'Art du siège*,
p. 102, illus.; *Handbook* 1991, p. 171, illus.
(one armchair).

94. **Pair of Armchairs (*fauteuils à la reine*)
and One Settee**

Paris, circa 1750–1755
By Jean Avisse
Gessoed and gilded oak; modern upholstery
Each chair stamped *IAVISSE* beneath rear
rail. Settee stamped *IAVISSE* twice beneath
rear rail.

Chairs: Height: 3 ft. 5¼ in. (104.7 cm);
Width: 2 ft. 6 in. (76.2 cm); Depth:
1 ft. 11⁷⁄₁₆ in. (59.6 cm); Settee: Height:
3 ft. 6 in. (106.7 cm); Width: 7 ft. ½ in.
(214.5 cm); Depth: 3 ft. (91.4 cm)
Accession numbers: Chairs: 83.DA.230.1–.2;
Settee: 84.DA.70

PROVENANCE

Chairs: Private collection, New York (sold,
Sotheby's, New York, October 1981, lot 314);
[Matthew Schutz, Ltd., New York, 1982].
Settee: Mrs. Rose Freda, New York;
[Edward De Pasquale, New York, 1983]
(sold, Sotheby's, New York, May 4, 1984,
lot 41).

BIBLIOGRAPHY

Bremer-David, "Acquisitions 1983,"
GettyMusJ 12 (1984), no. 8 (armchairs),
pp. 198–199, illus.; "Acquisitions/1983,"
GettyMusJ 12 (1984), no. 10 (armchairs),
p. 265, illus.; "Acquisitions/1984," *GettyMusJ*
13 (1985), no. 56 (settee), p. 179, illus.; Pallot,
L'Art du siège, p. 278, illus. and p. 300;
Kjellberg, *Dictionnaire*, pp. 33, 37.

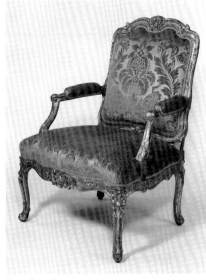

One of a pair 94

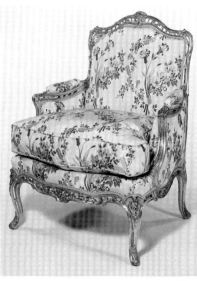

95

95. Armchair (*bergère à la reine*)

Paris, circa 1755
By Nicolas Heurtaut
Gessoed and gilded wood; modern silk
upholstery
Stamped *N. HEURTAUT* under rear rail.
Height: 3 ft. 3¾ in. (101 cm); Width:
2 ft. 7¾ in. (80.6 cm); Depth: 2 ft. 5¾ in.
(75.5 cm)
Accession number 84.DA.69

PROVENANCE

Private collection, New York; [Matthew
Schutz, Ltd., New York, circa 1960] (sold,
Sotheby, Parke, Bernet, New York, May 4,
1984, lot 59).

BIBLIOGRAPHY

"Acquisitions/1984," *GettyMusJ* 13 (1985),
no. 59, p. 180, illus.; Kjellberg, *Dictionnaire*,
p. 403.

––––

96. Pair of Armchairs (*fauteuils à la reine*)

Frames: Paris, 1762
Upholstery: Aubusson, nineteenth century
Frames by Nicolas-Quinibert Foliot
Gessoed and gilded wood; wool tapestry
Each armchair stamped *N Q FOLIOT* inside
rear rail and stenciled in the same place with
a crowned *F* and the number *832* for the
Château de Fontainebleau.

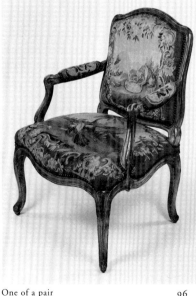

One of a pair 96

Height: 3 ft. ¾ in. (93.3 cm); Width:
2 ft. 2⅝ in. (67.6 cm); Depth: 1 ft. 9⅞ in.
(55.5 cm)
Accession number 70.DA.70.1–.2

PROVENANCE

Château de Versailles, 1762; Château de
Fontainebleau; listed as in the lodgings of
Charles-Claude de Taillepied, *seigneur de
la Garenne*, on November 1, 1786, and
again in 1787; Annette Lefortier, Paris
(sold, American Art Association, New York,
November 20, 1937, lot 151); purchased at
that sale by J. Paul Getty.

BIBLIOGRAPHY

Pallot, *L'Art du siège*, pp. 284, illus., and
308–309; Kjellberg, *Dictionnaire*, p. 317.

––––

97. Armchair (*bergère*)

Paris, circa 1765–1770
By Georges Jacob
Painted oak; pink and green silk upholstery
The frame of the chair is stamped *G IACOB*
and with an anchor flanked by *C* and *P*
beneath a crown, the mark of the Château
de Chanteloup. The dust cover of the seat
and the underside of the cushion are also
stenciled with the mark of the Château de
Chanteloup.
Height: 3 ft. 3 in. (99 cm); Width: 3 ft. 1 in.
(94 cm); Depth: 2 ft. 6 in. (76 cm)
Accession number 88.DA.123

PROVENANCE

Etienne-François de Stainville, duc de Choiseul, Château de Chanteloup; Louis de Bourbon, duc de Penthièvre, Château de Chanteloup, 1785; "Poitevin Joubert et femme Fleury," after 1794, purchased at the sale of the contents of the château; [Bernard Baruch Steinitz, Paris, 1988].

BIBLIOGRAPHY

Alfred Gabeau, "Le Mobilier d'un château à la fin du XVIII^e siècle: Chanteloup," *Réunion des sociétés des beaux-arts des départements* (Paris, April 1898), pp. 529, 541; Jehanne d'Orliac, *La Vie merveilleuse d'un beau domaine français-Chanteloup du XIII^e siècle au XX^e siècle* (Paris, 1929), p. 231; "Acquisitions/1988," *GettyMusJ* 17 (1989), no. 74, pp. 142–143, illus.

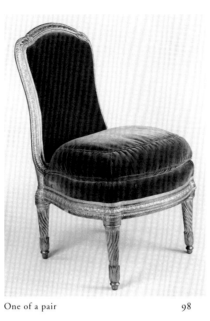

One of a pair 98

98. **Pair of Side Chairs (*chaises à la reine*)**
Paris, circa 1765–1770
By Jean Boucault
Gessoed and gilded beech; modern silk velvet upholstery
Each stamped *J.BOUCAULT* and branded with a crowned double *V*, the mark of the Château de Versailles, under the seat rail. Each also stenciled with various royal inventory numbers.
Height: 2 ft. 11¾ in. (91 cm); Width: 1 ft. 10½ in. (57 cm); Depth: 2 ft. 2¼ in. (66.5 cm)
Accession number 71.DA.92.1–.2

PROVENANCE

Part of a suite of seat furniture acquired by the order of baron de Breteuïl and delivered to the *garde meuble* in 1783; Château de Versailles (sold, November 25, 1793 [5 *frimaire, an* II], lot 5672, to Gastinet for 1,610 *livres*); Jacques, comte de Béraudière (sold, Paris, May 18–30, 1885, part of lot 902); [Duveen Brothers, New York]; Anna Thomson Dodge, Rose Terrace, Grosse Pointe Farms, Michigan (sold, Christie's, London, June 24, 1971, lot 65); purchased at that sale by J. Paul Getty.

BIBLIOGRAPHY

Anthony Coleridge, "Works of Art with a Royal Provenance from the Collection of the Late Mrs. Anna Thomson Dodge of Detroit," *Connoisseur* 177, no. 711 (May 1971), p. 34; Pallot, *L'Art du siège*, p. 192, illus., and p. 301; Kjellberg, *Dictionnaire*, pp. 84–85.

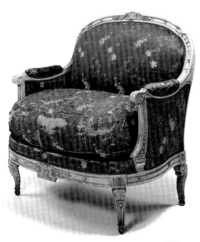

97

99. **Four Armchairs (*fauteuils à la reine*) and One Settee**

Paris, circa 1770–1775
By Jacques-Jean-Baptiste Tilliard
Gessoed and gilded beech; modern silk velvet upholstery
Each piece stamped *TILLIARD* under rear seat rail.
Chairs: Height: 3 ft. 4 in. (101.6 cm); Width: 2 ft. 5¼ in. (75 cm); Depth: 2 ft. 5½ in. (74.9 cm); Settee: Height: 3 ft. 11⅜ in. (120.3 cm); Width: 7 ft. 6½ in. (229.7 cm); Depth: 3 ft. 1¼ in. (94.6 cm)
Accession number 78.DA.99.1–.5

PROVENANCE

Mortimer L. Schiff, New York (sold by his heir John L. Schiff, Christie's, London,

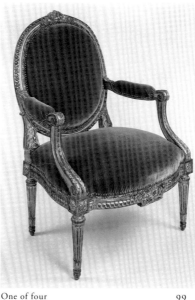

One of four 99

June 22, 1938, lot 55); purchased at that sale by J. Paul Getty for Sutton Place, Surrey; distributed by the estate of J. Paul Getty to the J. Paul Getty Museum.

BIBLIOGRAPHY

Wilson, *Selections*, no. 46, pp. 92–93, illus.; *Handbook* 1986, p. 174, illus. (one); Pallot, *L'Art du siège*, p. 218, illus., and p. 318; Kjellberg, *Dictionnaire*, p. 840; *Handbook* 1991, p. 190, illus. (one).

100. **Four Side Chairs (*chaises à la reine*)**

Paris, 1780–1781
By François-Toussaint Foliot after designs by Jacques Gondoin
Gessoed and gilded beech, modern silk upholstery
One chair stenciled *GARDE MEUBLE DE LA REINE* under seat rail. Another bears a label inscribed *Ex museo L.Double.*
Height: 2 ft. 11 in. (89 cm); Width: 1 ft. 9¾ in. (55 cm); Depth: 1 ft. 10¼ in. (56.5 cm)
Accession number 71.DA.93.1–.4

PROVENANCE

Marie-Antoinette, Salon du Rocher, "Hameau de la Reine," Petit Trianon, Versailles, ordered from the *menuisier* François-Toussaint Foliot on November 29, 1780; (?) removed from the Château de Versailles, 1791; Léopold Double, Paris (sold, Paris, May 30–June 1, 1881, lot 427); Henri, comte de Greffulhe, Paris; [Duveen Brothers, New York]; Anna Thomson

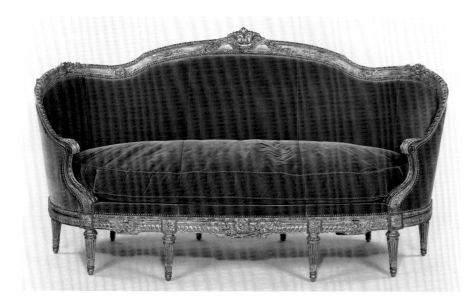

99

Dodge, Rose Terrace, Grosse Pointe Farms, Michigan (sold, Christie's, London, June 24, 1971, lot 66); purchased at that sale by J. Paul Getty.

BIBLIOGRAPHY

Anthony Coleridge, "Works of Art with a Royal Provenance from the Collection of the Late Mrs. Anna Thomson Dodge of Detroit," *Connoisseur* 177, no. 711 (May 1971), p. 34, illus.; Kjellberg, *Dictionnaire*, p. 426; Jean-Pierre Babelon, "Un magnifique enrichissement des collections nationales-Musée national du Château de Versailles," *La Revue du Louvre et des Musées de France* 5 (1990), p. 350.

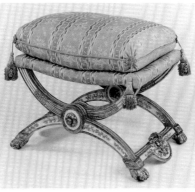

One of a pair 101

101. Pair of Folding Stools (*pliants*)

Paris, circa 1786
By Jean-Baptiste-Claude Sené; carved by Nicolas Vallois
Gessoed, painted, and gilded beech; modern upholstery
Each stool branded with three fleur-de-lys beneath a crown and with *TH*, the mark of the Palais des Tuileries.
Height (without cushion): 1 ft. 4¼ in. (42 cm); Width: 2 ft. 4½ in. (72.5 cm); Depth: 1 ft. 9 in. (53 cm)
Accession number 71.DA.94.1–.2

PROVENANCE

Marie-Antoinette, from a set of sixty-four ordered in two groups by Jean Hauré in 1786, at the cost of 720 *livres* for each stool, for the gaming rooms in the Château de Fontainebleau and the Château de Compiègne; Palais du Luxembourg or Palais des

Tuileries, Paris, 1797–circa 1806; [Michel, Paris, 1933]; Anna Thomson Dodge, Rose Terrace, Grosse Pointe Farms, Michigan (sold, Christie's, London, June 24, 1971, lot 69); purchased at that sale by J. Paul Getty.

BIBLIOGRAPHY

Pierre Verlet, "Les meubles sculptés du XVIIIᵉ siècle: Quelques identifications," *Bulletin de la Société de l'histoire de l'art français* (1937), pp. 259–263; Pierre Verlet, *French Royal Furniture* (London, 1963), pp. 35–36; Anthony Coleridge, "Works of Art with a Royal Provenance from the Collection of the Late Mrs. Anna Thomson Dodge of Detroit," *Connoisseur* 177, no. 711 (May 1971), p. 34; Pierre Verlet, *Les Meubles français du XVIIIᵉ siècle* (Paris, 1982), p. 227; Kjellberg, *Dictionnaire*, p. 818.

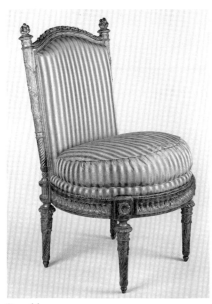

One of four 100

102. **Swivel Chair (** *fauteuil* [?] *de toilette***)**
Paris, circa 1787
By Georges Jacob; carved by Triquet and
Rode; originally painted by Chaillot and
upholstered with fabric by Desfarges
of Lyon
Beech; caning; modern silk velvet
upholstery
Painted with *8758* (Dalva Brothers' inven-
tory number) under the rail.
Height: 2 ft. 9¼ in. (84.5 cm); Width:
1 ft. 10⅛ in. (56.2 cm); Depth: 2 ft. 1⅝ in.
(65 cm)
Accession number 72.DA.51

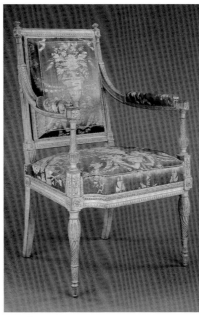

One of a pair 103

PROVENANCE
Marie-Antoinette, ordered by Bonnefoy-
Duplan for the *chambre à coucher du treillage*
in the Petit Trianon, Versailles, 1787 (sold
with the contents of the Petit Trianon,
Versailles, August 25 et seq., 1793, lot 2477,
to the dealer Rocheux, Paris, through the
agent *citoyen* Hébert); Edith M. K. Wet-
more and Maude A. K. Wetmore, Château-
sur-Mer, Newport, Rhode Island (offered
for sale, Parke-Bernet, Château-sur-Mer,
September 16–18, 1969, lot 1037, bought in;
sold, Parke-Bernet, New York, February 20,
1971, lot 122); [Dalva Brothers, Inc., New
York, 1971]; purchased by J. Paul Getty.

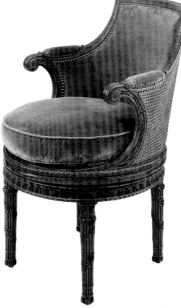

102

BIBLIOGRAPHY
Michel Beurdeley, *La France à l'encan* (Fri-
bourg, 1981), p. 109; Kjellberg, *Dictionnaire*,
p. 426.

103. **Pair of Armchairs (** *fauteuils à la reine***)**
Paris, circa 1790–1792
By Georges Jacob
Painted beech; modern silk upholstery
Each stamped *G·IACOB* under the front
seat rail.
Height: 3 ft. 1 in. (94 cm); Width:
1 ft. 11½ in. (59 cm); Depth: 1 ft. 11¾ in.
(60.5 cm)
Accession number 91.DA.15.1–.2

PROVENANCE
[Kraemer et Cie, Paris, 1990].

BIBLIOGRAPHY
"Acquisitions/1991," *GettyMusJ* 20 (1992),
no. 72, p. 172, illus. (one).

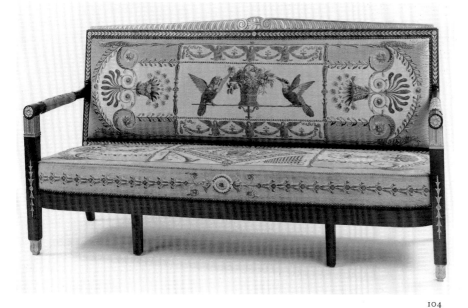

104

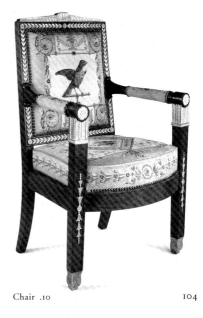

Chair .10 104

104. **One Settee and Ten Armchairs (two *bergères* and eight *fauteuils*)**

Paris, circa 1810

Frames attributed to Jacob Desmalter et Cie; tapestry upholstery woven at the Beauvais manufactory

Mahogany; gilt-bronze mounts; silk and wool tapestry upholstery

Settee: Height: 3 ft. 4½ in. (102.9 cm); Width: 6 ft. 2⅞ in. (190.2 cm); Depth: 2 ft. ⅛ in. (61.3 cm); Chairs: Height: 3 ft. 3⅝ in. (100.6 cm); Width: 2 ft. 1 in. (63.5 cm); Depth: 1 ft. 7 in. (48.2 cm)

Accession number 67.DA.6.1–.11

PROVENANCE

Private collection, Paris, by 1908; [Jacques Seligmann, Paris]; Grand Duke Nicolai Michailoff, Palais Michailoff, St. Petersburg, purchased December 4, 1912; Museums and Palaces Collections, Palais Michailoff, St. Petersburg (sold, Lepke, Berlin, November 7, 1928, lot 73, with a fire screen); Ives, comte de Cambacérès, Paris; Edouard Mortier, 5th duc de Trévise, Paris (sold, Galerie Charpentier, Paris, May 19, 1938, lot 47); purchased at that sale by J. Paul Getty.

EXHIBITIONS

New York, The Cooper-Hewitt Museum, *L'Art de Vivre: Decorative Arts and Designs in France 1789–1989*, February–September 1989, illus. p. 19, fig. 10 (*fauteuil* 67.DA.6.10 only).

BIBLIOGRAPHY

Décorations intérieurs et meubles des epoques Louis XV, Louis XVI et Empire, Revue d'art décoratif (1908–1909), illus. no. 17, pl. 7.

BEDS

105. **Bed (*lit à la turque*)**
Paris, circa 1750–1760
Attributed to Jacques-Jean-Baptiste Tilliard
Gilded beech; modern silk upholstery
Height: 5 ft. 8½ in. (174 cm); Width:
8 ft. 8¼ in. (264.8 cm); Depth: 6 ft. 2 in.
(188 cm)
Accession number 86.DA.535

PROVENANCE
Private collection, England, since the end
of the eighteenth century; [Alexander and
Berendt, Ltd., London, 1986].

BIBLIOGRAPHY
"Acquisitions/1986," *GettyMusJ* 15 (1987),
no. 106, p. 213, illus.; Pallot, *L'Art du siège*
(Paris, 1987), p. 75, illus.

SUPPORTS

106. **Pair of *Gueridons***
Paris, circa 1680
Attributed to André-Charles Boulle
Oak veneered with ebony, tortoiseshell,
blue painted horn, brass, pewter; gilt-bronze
mounts
Height: 4 ft. 8⅝ in. (143.8 cm); Width
(at base): 1 ft. 4½ in. (41.9 cm); Depth (at
base): 1 ft. 5⅛ in. (43.5 cm)
Accession number 87.DA.5.1–.2

PROVENANCE
(?) Pierre-Louis Randon de Boisset, Paris
(sold, Paris, February 27 to March 25, 1777,
lot 796, for 1,000 *livres*, to Sr. Platrier);
(?) Pierre-Nicolas, baron Hoorn van
Vlooswyck, Paris (sold, Paris, November 22,
1809, lot 593, to the dealer Hennequart);
Princesse de Faucigny-Lucinge, Paris, circa
1937; [Maurice Segoura, Paris, 1986].

BIBLIOGRAPHY
Geneviève Mazel, "1777, La Vente Randon
de Boisset et le marché de l'art au 18ᵉ
siècle," *L'Estampille* 202 (April 1987), p. 41,
illus.; Michel Beurdeley, "Paris 1777: La
Vente Randon de Boisset ou le mécanisme
secret des ventes publiques au XVIIIᵉ siècle,"
Trois siècles de ventes publiques (Fribourg,
1988), p. 53, illus.; "Acquisitions/1987,"
GettyMusJ 16 (1988), no. 67, p. 177, illus.;
Pradère, *Les Ebénistes*, nos. 255–256, p. 106.

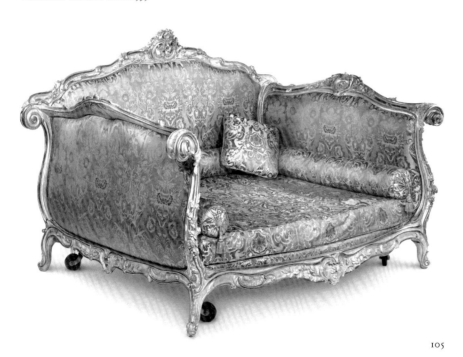

105

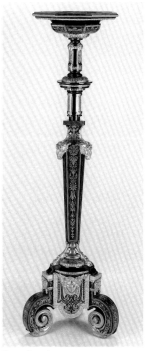

One of a pair 106

107. **Pair of Pedestals**

Paris, circa 1700
Attributed to André-Charles Boulle
Pine and oak veneered with ebony, brass,
and tortoiseshell; gilt-bronze mounts
Height: 3 ft. 11¹¹⁄₁₆ in. (121.2 cm); Width:
1 ft. 9⅞ in. (55.5 cm); Depth: 1 ft. 9⅞ in.
(55.5 cm)
Accession number 88.DA.75.1–.2

PROVENANCE

Antoine-Alexandre Dubois, Paris (sold,
Paillet, Paris, December 18, 1788, lot 168, to
"Berotaire" for 5599 *livres*); ([?] sold, Paillet

et Delaroche, Paris, July 11, 1803, lot 41);
Baron James de Rothschild, Paris, before
1860; Baron Gustave Salomon de Roth-
schild, Paris; Baron Robert de Rothschild,
Paris; Baron Alain de Rothschild, Paris;
Baron Eric de Rothschild, Paris (sold, Hôtel
Drouot, Paris, December 4, 1987, lot 112);
[Same Art, Ltd., Zurich].

EXHIEBITIONS

Paris, *L'Exposition de l'art français sous Louis
XIV et sous Louis XV au profit de l'oeuvre de
l'hospitalité du nuit* (1888), no. 94.

BIBLIOGRAPHY

"Acquisitions/1988," *GettyMusJ* 17 (1989),
no. 68, pp. 140–141, illus.; Pradère, *Les
Ebénistes*, nos. 189–190, p. 105.

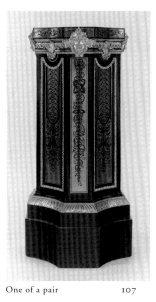

One of a pair 107

108. **Wall Bracket**

Paris, circa 1715–1720
Gessoed and gilded oak
Height: 1 ft. 6 in. (45.7 cm); Width:
1 ft. 9½ in. (54.6 cm); Depth: 8½ in.
(21.6 cm)
Accession number 84.DH.86

PROVENANCE

Private collection, New York; [Matthew
Schutz, Ltd., New York, 1984].

BIBLIOGRAPHY

"Acquisitions/1984," *GettyMusJ* 13 (1985),
no. 49, p. 177, illus.

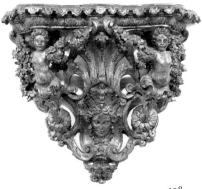

108

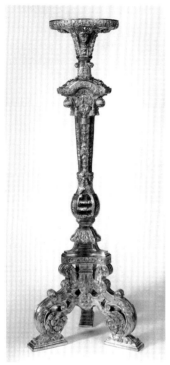

One of a pair 109

109. **Pair of *Torchères***

Paris, circa 1725
Gessoed and gilded wood
Height: 5 ft. 8¼ in. (173.3 cm); Diameter
(at top): 1 ft. 3¾ in. (40 cm); Diameter (at
base): 1 ft. 10½ in. (57.1 cm)
Accession number 71.DA.98.1–.2

PROVENANCE
[Duveen Brothers, New York]; Anna
Thomson Dodge, Rose Terrace, Grosse
Pointe Farms, Michigan (sold, Christie's,
London, June 24, 1971, lot 75); purchased
at that sale by J. Paul Getty.

110. **Pair of Supports (*gaines*)**

French, circa 1770
After designs by Jean-Charles Delafosse
Pine with traces of gesso and paint
Height: 4 ft. 2 in. (127 cm); Width: 1 ft. 4 in.
(40.7 cm); Depth: 1 ft. (30.5 cm)
Accession number 89.DA.2.1–.2

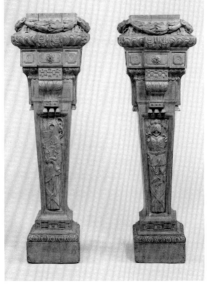

110

PROVENANCE
[Galaries Heilbrönner]; [French and Co.,
New York, 1912–1925 (stock no. 5174)];
Mrs. James B. Haggin, New York, 1925;
[Midtown Antiques, New York, 1950];
[Frederick P. Victoria and Son, Inc., New
York, circa 1950–1988]; [Michel Otin, Paris];
[Patrick Perrin, Paris].

BIBLIOGRAPHY
"Acquisitions/1989," *GettyMusJ* 18 (1990),
no. 55, p. 194, illus.

FIRE SCREENS

111. **Fire Screen (*écran coulisse*)**

Paris, circa 1785–1790
Attributed to Georges Jacob
Walnut
One upright of the screen is carved with the
monogram *JH* and the other with *C(T?)*.
Height: 4 ft. 2 in. (127 cm); Width:
2 ft. 7½ in. (80 cm); Depth: 1 ft. 5 in. (43 cm)
Accession number 88.DA.124

PROVENANCE
[Bernard Baruch Steinitz, Paris, 1988].

BIBLIOGRAPHY
"Acquisitions/1988," *GettyMusJ* 17 (1989),
no. 80, pp. 144–145, illus.

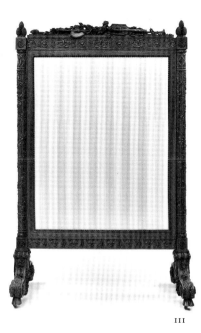

111

DECORATIVE RELIEFS

112. **Still Life**

Paris, 1789
By Aubert-Henri-Joseph Parent
Limewood
Incised *AUBERT PARENT FECIT AN. 1789* under the base.
Height: 2 ft. 3⅜ in. (69.4 cm); Width: 1 ft. 6⅞ in. (47.9 cm); Depth: 2⅜ in. (6.2 cm)
Accession number 84.SD.76

PROVENANCE

David Peel, London; Paul Mellon (sold, Christie's, New York, November 22, 1983, lot 275); [Dalva Brothers, Inc., New York, 1983].

BIBLIOGRAPHY

Colin Streeter, "Two Carved Reliefs by Aubert Parent," *GettyMusJ* 13 (1985), pp. 53–66, figs. 1a–d; "Acquisitions/1984," *GettyMusJ* 13 (1985), no. 65, p. 183, illus.

113. **Still Life**

Paris, 1791
By Aubert-Henri-Joseph Parent
Limewood
Incised *AUBERT PARENT. 1791* under the base. An inventory number, *172n*, is stenciled in black on the back.

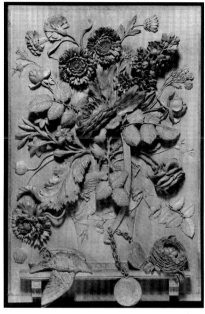

113

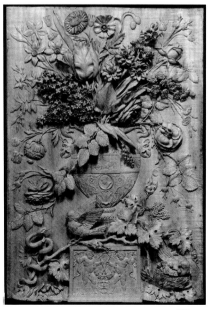

112

Height: 1 ft. 11⅛ in. (58.7 cm); Width: 1 ft. 3⅝ in. (39.7 cm); Depth: 2¼ in. (5.7 cm)
Accession number 84.SD.194

PROVENANCE

[Jacques Kugel, Paris, 1984].

BIBLIOGRAPHY

Colin Streeter, "Two Carved Reliefs by Aubert Parent," *GettyMusJ* 13 (1985), pp. 53–66, figs. 3a–b; "Acquisitions/1984," *GettyMusJ* 13 (1985), no. 66, p. 183, illus.

114

Architectural Woodwork and Fixtures

FRAMES

114. **Frame for a Mirror**
Paris, circa 1690–1700
Gessoed and gilded oak; modern mirror
glass
Height: 6 ft. 8 in. (183.5 cm); Width:
4 ft. 2 in. (127 cm); Depth: 4 in. (10.2 cm)
Accession number 87.DH.78

PROVENANCE
Private collection, Switzerland, 1980s;
[Rainer Zietz, Ltd., London]; [Rosenberg
and Stiebel, Inc., New York].

BIBLIOGRAPHY
"Acquisitions/1987," *GettyMusJ* 16 (1988),
no. 68, p. 177, illus.

115. **Frame**
Paris, circa 1775–1780
(?) By Paul Georges
Gessoed and gilded oak
Overall Height: 6 ft. 10 in. (208.3 cm);
Width: 5 ft. ¼ in. (152.4 cm); Interior Height:
4 ft. 8⅞ in. (144 cm); Width: 3 ft. 7⅛ in.
(109.8 cm)
Stamped *P. GEORGES* on back and inked *61*
across the top.
Accession number 88.DA.49

PROVENANCE
George Baillie-Hamilton, 12th Earl of
Haddington, Tyninghame House, East
Lothian, Scotland (sold after his death,
Sotheby's, Tyninghame House, Septem-
ber 28–29, 1987, lot 551); [Christopher
Gibbs, London].

BIBLIOGRAPHY
"Acquisitions/1988," *GettyMusJ* 17 (1989),
no. 75, p. 143, illus.

115

116

116. **Frame for a Mirror**
Paris, circa 1775–1780
Painted and gilded oak; modern mirror
glass
Height: 6 ft. 1¾ in. (187.2 cm); Width:
4 ft. 3½ in. (131 cm); Depth: 3¾ in. (9.5 cm)
Accession number 92.DH.20

PROVENANCE
[Kraemer et Cie, Paris].

BIBLIOGRAPHY
"Acquisitions/1992," *GettyMusJ* 21 (1993),
in press, illus.

PANELING AND
MANTELPIECES

117. **Ten Panels**
Paris, circa 1661
Design attributed to Charles Le Brun
Painted and gilded oak
Panels .1–.2: Height: 6 ft. 11⅞ in. (213 cm);
Width: 2 ft. 10⅝ in. (88 cm); Panels .3–.4:
Height: 6 ft. 11⅞ in. (213 cm); Width:
2 ft. 7⅛ in. (79 cm); Panels .5–.6: Height:
3 ft. 11¼ in. (120 cm); Width: 2 ft. 9¾ in.
(80.4 cm); Panels .7–.8: Height: 3 ft. 10⁷⁄₁₆
in. (118 cm); Width: 2 ft. 9¾ in. (80.4 cm);
Panel .9: Height: 1 ft. 8⅛ in. (51 cm);
Width: 5 ft. 11¹⁄₁₆ in. (180.5 cm); Panel .10:
Height: 1 ft. 7½ in. (49.5 cm); Width:
6 ft. 8¹³⁄₁₆ in. (202.25 cm)
Accession number 91.DH.18.1–.10

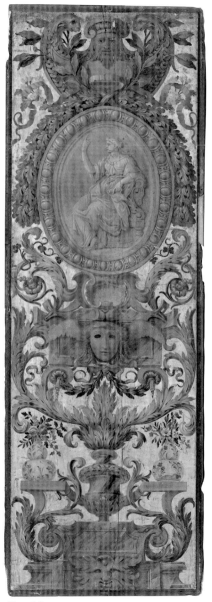

One of four 117

One of four 117

PROVENANCE
(?) Nicolas Fouquet, Château de Vaux-le-
Vicomte; Felix Harbord, England, 1960s;
Felix Fenston, England (sold by his widow,
Sotheby's, London, May 25, 1990, lot 50, to
[Christopher Gibbs, London]).

BIBLIOGRAPHY
"Acquisitions/1991," *GettyMusJ* 20 (1992),
no. 76, p. 174, illus. (two).

118

118. **Mantelpiece**

(?) Paris, circa 1690–1700
Sarrancolin des Pyrénées marble (also known as *marbre d'Antin*) and *brèche violette*
Height: 5 ft. 10½ in. (179.1 cm); Width: 7 ft. 10¼ in. (240 cm); Depth: 1 ft. 1½ in. (34.3 cm)
Accession number 89.DH.30

PROVENANCE
[B. Fabre et Fils, Paris].

BIBLIOGRAPHY
"Acquisitions/1989," *GettyMusJ* 18 (1990), no. 52, p. 193, illus.

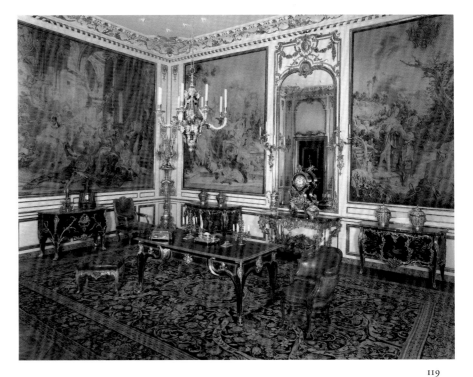

119

119. **Paneling**

Paris, 1725–1726
By Jacques Gaultier, *menuisier*, after the designs of Armand-Claude Mollet
Painted and gilded oak and walnut; *brèche d'Alep* mantelpiece; modern mirror glass
Height: 13 ft. (396.2 cm); Width: 26 ft. 9 in. (815 cm); Depth: 22 ft. (670.6 cm)
Accession number 71.DH.118

PROVENANCE
Guillaume Cressart, Hôtel Cressart, installed in 1725 and 1726 in the *chambre à coucher* of 18 place Vendôme, Paris; Louis-Auguste Duché, 1733; Jean-Baptiste Duché (brother of Louis-Auguste Duché), by 1743; Elisabeth-Louis Duché (wife of Jacques Bertrand, marquis de Scépeaux et de Beaupreau), after 1743; Elisabeth-Louise-Adélaïde de Scépeaux de Beaupreau (wife of the comte de La Tour d'Auvergne), 1769; Jean-Louis Milon d'Inval, Paris, 1774; by inheritance to his wife, Antoinette Bureau Seraudey (Mme d'Inval), in *an* III (1794–

1795) (sold by her heirs in 1836); Sophie Dawes (baronne de Feuchères), 1836; the *chambre à coucher* became the *salon* at this time (sold by her heirs after her death in 1841); the marquise de Las Marismas del Guadalquivir (Mme Alexandre Aguado), 1842; Union Artistique, 1865; [André Carlhian, Paris; *boiseries* removed in 1936]; [Duveen Brothers, New York, 1939; stored in Paris until removed to New York in 1959]; Norton Simon, New York, 1965; purchased by J. Paul Getty.

BIBLIOGRAPHY
René Colas, "Les Hôtels de la place Vendôme," *Paris qui reste: vieux hôtels, vieilles demeures, rive droite* (Paris, 1914), pp. 105–106, pl. 94; Bruno Pons, "Les boiseries de l'Hôtel Cressart au Getty Museum," *GettyMusJ* 11 (1983), pp. 67–88, illus.

Detail of one 120

120. **Eleven Panels**

Paris, circa 1730–1735
Oak
Panels .1–.2: Height: 9 ft. 2¼ in. (280 cm); Width: 4 ft. ½ in. (123 cm); Panels .3–.4: Height: 9 ft. 2¼ in. (280 cm); Width: 4 ft. 6½ in. (139 cm); Panels .5–.7: Height: 9 ft. 2 in. (279.4 cm); Width: 1 ft. 3¾ in. (40.4 cm); Panel .8: Height: 9 ft. 2 in. (279.4 cm); Width: 1 ft. 6¼ in. (46.3 cm); Panel .9: Height: 9 ft. 2 in. (279.4 cm); Width: 1 ft. 10 in. (55.9 cm); Panels .10–.11: Height: 6 ft. 1 in. (185.4 cm); Width: 10 in. (25.4 cm)
Accession number 84.DH.52.1–.11

PROVENANCE
Château de Marly-Le-Roi, Yvelines, by repute; Mallett family, Louveciennes, early nineteenth century; Mme Claude Melin, Louveciennes, 1984, by descent.

121. **Mantelpiece**

Paris, circa 1730–1735
Brecciated marble of a variety of *sarrancolin des Pyrénées*; modern brick
Height: 3 ft. 7½ in. (110.5 cm); Width: 5 ft. 9 in. (175.3 cm); Depth: 11½ in. (29.2 cm)
Accession number 85.DH.92

PROVENANCE
Private residence, Paris; [François Léage, Paris].

BIBLIOGRAPHY
"Acquisitions/1985," *GettyMusJ* 14 (1986), no. 195, p. 244, illus.

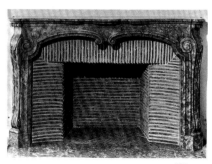

121

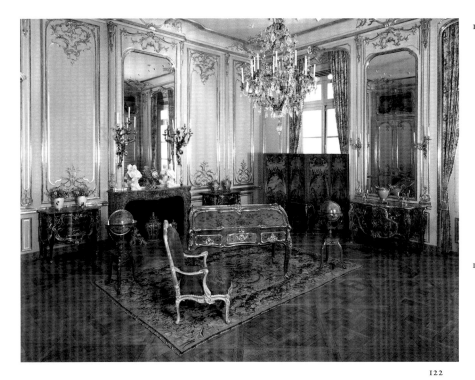

122

122. **Paneled Room**

Paris, circa 1755
Painted and gilded oak; four oil-on-canvas overdoor paintings; *brèche d'Alep* mantelpiece; modern mirror glass; gilt-bronze hardware
Height: 14 ft. 4 in. (436.9 cm); Width: 23 ft. 6½ in. (718 cm); Depth: 25 ft. 6 in. (777 cm)
Accession number 73.DH.107

PROVENANCE

An unidentified hôtel on the quai Malaquais, Paris, until 1900; Mme Doucet, Paris, 1900–1907; duc de Gramont, avenue Georges Mandel, Paris, 1907 (offered for sale in situ, Ader Picard, Paris, October 9, 1969, bought in); [R. and M. Carlhian, Paris]; purchased by J. Paul Getty.

BIBLIOGRAPHY

La comtesse Jean Louis de Maigret, "Un demi-siècle à l'Hôtel Gramont," *Connaissance des arts* 141 (November 1963), p. 92, illus.

123. **Paneled Room**

Paris, circa 1770–1775
Painted and gilded oak; plaster overdoors; mirror glass; *brèche d'Alep* mantelpiece; gilt-bronze hardware
Height (without cornice): 15 ft. ¹⁵⁄₁₆ in. (458 cm); Width: 30 ft. 4³⁄₁₆ in. (925 cm); Depth: 20 ft. 7⅞ in. (627 cm)
Accession number 84.DH.34

PROVENANCE

[Jacques Seligmann, Paris, 1920s]; [François-Gérard Seligmann, Paris].

124. **Paneled Room**

Paris, circa 1788–1789
Panels attributed to Rousseau de la Rottière after designs by Claude-Nicolas Ledoux
Painted and gilded oak; plaster overdoors; mirror glass; white marble mantelpiece
Four Double Doors: Height: 9 ft. 5¼ in. (287.7 cm); Width (of one door): 2 ft. 3¾ in. (70.5 cm); Four Large Panels: Height: 9 ft. 5⅛ in. (297.3 cm); Width: 2 ft. 8¾ in. (83.2 cm); Five Panels: Height: 9 ft. 3½ in. (285.1 cm); Width: 1 ft. 6½ in. (46.9 cm); Four Panels: Height: 9 ft. 3½ in. (285.1 cm); Width: 1 ft. ½ in. (31.8 cm); Four Overdoors: Height: 2 ft.¾ in. (90.8 cm); Width: 5 ft. ¼ in. (167 cm)
Accession number (moldings only) 91.DH.60.1–.26

PROVENANCE

"Grand salon," Maison Hosten, rue Saint-Georges, Paris, until circa 1892; Mme C. Lelong, Paris, after 1892; Fournier, Paris,

pp. 128–129, illus. p. 181, fig. 106; Michel Gallet, *Claude-Nicolas Ledoux 1736–1806* (Paris, 1980), pp. 209–213, figs. 372–383; *La Nouvelle Athènes: Le Quartier Saint-Georges de Louis XV à Napoleon III* (Musée Carnavalet, Paris, 1984), no. 22, p. 20.

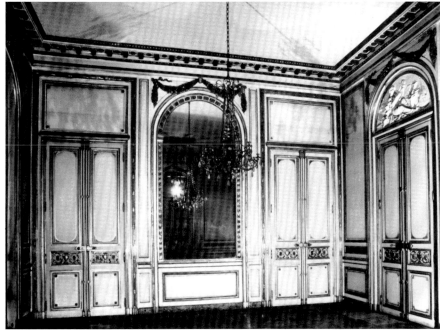

Room as formerly installed in Paris 123

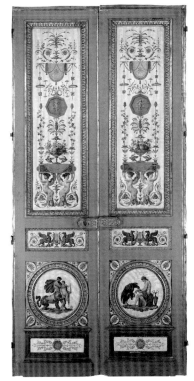

Two door panels 124

before (?) 1897; duc de Rivoli, no. 8 rue Jean Goujon, Paris, (?) 1897 to May 1913; [in storage with Maison Carlhian from May 1913 to January 1920, when consigned to both Maison Carlhian and Jacques Seligmann]; [Maison Carlhian and Jacques Seligmann, Paris, 1921].

Panels only: Otto Wolff, Cologne, 1925 or 1928; private collection, Cologne, before 1969; [Joachim Kaiser and Georg Fahrbach, Cologne, 1969–1986]; [Axel Vervoordt, Belgium, 1986]; acquired by the J. Paul Getty Trust.

Moldings only: [R. and M. Carlhian, Paris].

BIBLIOGRAPHY

Krafft and Ransonette, *Choix des plus belles maisons de Paris* (Paris, 1805), pl. 5; Alfred de Champeaux, *L'art décoratif dans le vieux Paris* (Paris, 1898), p. 319; Paul Marmottan, *Le Style empire: Architecture et décors d'intérieurs* (Paris, 1927), vol. 4, pp. 1–2, pls. 1–7; Marcel Raval, *Claude-Nicolas Ledoux 1736–1806* (Paris, 1945), p. 51, pls. 50–59; Louis Hautecoeur, *Histoire de l'architecture classique en France*, vol. 5, *Révolution et l'empire* (Paris, 1953), pp. 347, 371; Jacques Hillairet, *Dictionnaire historique des rues de Paris* (Paris, 1963), vol. 2, p. 408; "Ledoux et Paris," *Cahiers de la rotonde* 3 (Paris, 1979),

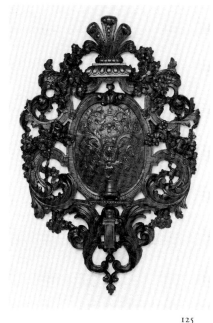

125

125. **Wall Light**

Lorraine (Nancy), circa 1700
Bois de Sainte-Lucie (*cerasus mahaleb*)
Height: 2⁹⁄₁₆ in. (6.5 cm); Width:
1 ft. 10⅝ in. (59.5 cm); Depth: 8¼ in.
(21 cm)
Accession number 85.DH.284

PROVENANCE

[Neidhardt Antiquitäten GmbH, Munich,
1985].

BIBLIOGRAPHY

"Acquisitions/1985," *GettyMusJ* 14 (1986),
no. 190, p. 242, illus.

NEWEL POST

126. **Newel Post**

Paris, circa 1735
Painted and gilded iron
Height: 2 ft. 11⅛ in. (90.5 cm); Width:
11½ in. (29.2 cm); Depth: 1 ft. 3¾ in.
(40 cm)
Accession number 79.DH.164

PROVENANCE

A. Gignoux, Paris; purchased by J. Paul
Getty, circa 1950.

126

Clocks and Barometers

127. **Long-case Clock (*régulateur*)**

Paris, circa 1680–1690
Case attributed to André-Charles Boulle;
the movement by Antoine I Gaudron
Oak veneered with tortoiseshell, ebony,
brass, and pewter; gilt-bronze mounts; glass
Inscribed *Gaudron Æaris* on clock face and
movement and *Solem Audet Dicere Falsum*
(It dares the sun to tell a lie) on face.
Height: 8 ft. 1⁵⁄₁₆ in. (246.5 cm); Width:
1 ft. 6⅞ in. (48 cm); Depth: 7½ in. (19 cm)
Accession number 88.DB.16

PROVENANCE

[Jeanne Durier, Paris, circa 1945]; private
collection, Burgundy, from 1948–1988;
[Alain Moatti, Paris].

BIBLIOGRAPHY

"Acquisitions/1988," *GettyMusJ* 17 (1989),
no. 66, p. 140, illus.; *Handbook* 1991,
p. 160, illus.

128. **Model for a Mantel Clock**

Paris, circa 1700
Terracotta; enameled metal plaques
Height: 2 ft. 7 in. (78.7 cm); Width:
1 ft. 8½ in. (52.1 cm); Depth: 9½ in.
(24.2 cm)
Accession number 72.DB.52

PROVENANCE

[Dalva Brothers, Inc., New York]; pur-
chased by J. Paul Getty.

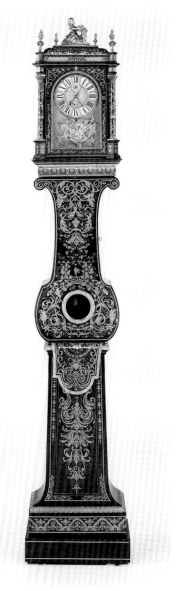

127

EXHIBITIONS

New York, The Metropolitan Museum of Art, *Magnificent Time-Keepers*, January 1971–March 1972, no. 67.

BIBLIOGRAPHY

Wilson, *Clocks*, no. 1, pp. 8–11, illus.; Wilson, *Selections*, no. 7, pp. 14–15, illus.; *Handbook* 1986, p. 149, illus.; Verlet, *Les Bronzes*, p. 164, illus. p. 164, fig. 200; C. E. Zonneyville-Heyning, "Gilden," *Visuele Kunsten: Kunstgeschiedenis van de nieuwe tijd* 3 (1989), p. 44, illus.; *Handbook* 1991, p. 161, illus.

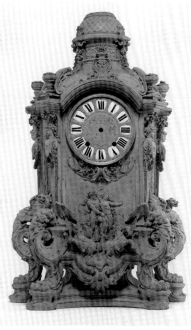

128

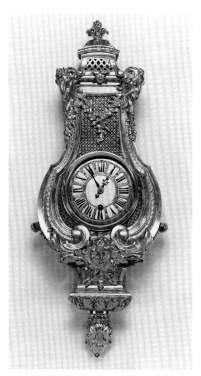

129

129. **Wall Clock (*pendule d'alcove*)**
Paris, circa 1710
Case attributed to André-Charles Boulle
Gilt bronze; blue painted horn; enameled metal; glass
Label on back inked *Vernon House, Staircase.*
Height: 2 ft. 4 in. (71.1 cm); Width: 11¼ in. (28.6 cm); Depth: 4½ in. (11.4 cm)
Accession number 73.DB.74

Charles William, 2nd Lord Hillingdon,
Vernon House, London; Charles, 4th Lord
Hillingdon, by descent (sold, Christie's,
London, June 29, 1972, lot 56); [French
and Co., New York, 1972]; purchased by
J. Paul Getty.

BIBLIOGRAPHY
Wilson, *Clocks*, no. 3, pp. 18–21, illus.

———

130. **Long-case Musical Clock**

Paris, circa 1712
Movement by Jean-François Dominicé;
musical movement by Michel Stollenwerck;
movement repaired and dial and hands
replaced by Pierre-Bazile Lepaute; case and
stand attributed to André-Charles Boulle;
grill under dial and some mounts after
drawings by Gilles-Marie Oppenordt
Oak veneered with brass and red painted
tortoiseshell; enameled metal; bronze
mounts; glass
Movement engraved *J.F. Dominicé A Paris*
and *Fait par Stollenwerck dans l'abbaye St.
German à Paris*; dial engraved *LEPAUTE*.
Height: 8 ft. 7 in. (261.6 cm); Width:
3 ft. ½ in. (92.7 cm); Depth: 1 ft. 3 in.
(38.1 cm)
Accession number 72.DB.40

PROVENANCE
(?) Vincent Donjeux, Paris (sold, Paris,
April 29, 1793, lot 562); Peter Burrell, 1st
Lord Gwydir (1754–1820); by descent to
Peter Burrell, 2nd Lord Gwydir (1782–1865)

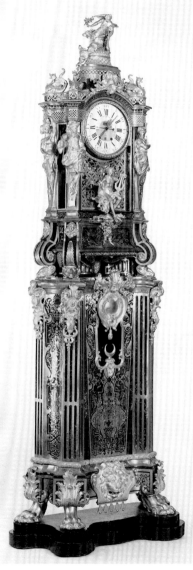

130

(sold, Christie's, London, March 11–12,
1829, lot 103, to [Samuel Fogg, London]);
Henry George Brownlow, 4th Marquess of
Exeter (sold, Christie's, London, June 7–8,
1888, lot 261, to [Charles Davis, London]);
Cornelius Vanderbilt II (1843–1899), The
Breakers, Newport, Rhode Island, by (?) the
1890s; Alice Vanderbilt (1846–1934, wife of
Cornelius Vanderbilt II), The Breakers,
Newport, Rhode Island; Gladys Moore
Vanderbilt (Countess Laszlo Széchényi,
1886–1965), by descent (sold by her heirs in
1971 to [Rosenberg and Stiebel, Inc., New
York]); [French and Co., New York, 1971];
purchased by J. Paul Getty, 1971.

BIBLIOGRAPHY
Wilson, *Clocks*, no. 5, pp. 26–33, illus.;
Jean-Nérée Ronfort, "André-Charles Boulle:
Die Bronzearbeiten und seine Werkstatt im
Louvre," *Vergoldete Bronzen: Die Bronzear-
beiten des Spätbarock und Klassizismus*,
Hans Ottomeyer and Peter Pröschel, eds.
(Munich, 1986), vol. 2, p. 491.

———

131. **Pedestal Clock**

Paris, circa 1715–1720
Case attributed to André-Charles Boulle;
movement by Julien II Le Roy
Oak veneered with tortoiseshell, ebony, and
brass; enameled metal plaques; gilt-bronze
mounts; glass
Movement engraved *Karel Solle 1846* and
4869 as well as *Julien Leroy* on backplate;
enamel plaque painted *JULIEN LE ROY*.

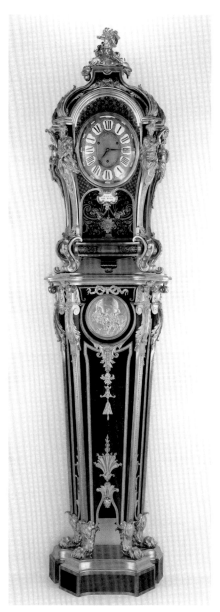

131

Height: 9 ft. 4 in. (284.5 cm); Width: 2 ft. 3⅜ in. (69.5 cm); Depth: 1 ft. 1 in. (33 cm)
Accession number 74.DB.1

PROVENANCE
English collection, nineteenth century; the Duke of Medinaceli, Spain; [Smolen, Paris, circa 1962]; [Manuel Gonzales Lopez-Garcia, Galeria Velasquez, Madrid, circa 1965]; [French and Co., New York, 1972]; purchased by J. Paul Getty.

EXHIBITIONS
Madrid, Sociedad Española de Amigos del Arte, *El reloj en arte*, May–June 1965, no. 10, illus.

BIBLIOGRAPHY
Luis Montañes, "Un péndulo desconocido de Julien Le Roy," *Dersa* (July 1967), no. 34, pp. 8–16, illus. p. 1; Geoffrey de Bellaigue, *The James A. de Rothschild Collection at Waddesdon Manor: Furniture, Clocks and Gilt Bronzes*, vol. 1 (Fribourg, 1974), p. 54; Wilson, *Clocks*, no. 2, pp. 12–17, illus.; *The Country Life International Dictionary of Clocks*, Alan Smith, ed. (New York, 1979), p. 87, fig. 7; Luis Montañes, *Relojes en ABC* (1983), pp. 96–99; Wilson, *Selections*, no. 9, pp. 18–19, illus.; *Handbook* 1986, p. 150, illus.; Verlet, *Les Bronzes*, p. 114, caption to fig. 141.

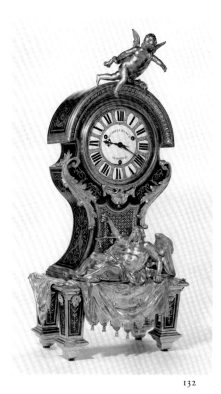

132

132. **Mantel Clock**
Paris, circa 1715–1725
Case attributed to André-Charles Boulle; movement by Paul Gudin, called Gudin *le jeune*; figure of Chronos after a model by François Girardon
Oak veneered with tortoiseshell, blue painted horn, brass, and ebony; enameled metal; gilt-bronze mounts; glass
Movement engraved *Gudin lejeune Àaris*; dial painted *GUDIN LE JEUNE ÀARIS*.

Height: 3 ft. 3¾ in. (100.9 cm); Width:
1 ft. 6⅛ in. (46 cm); Depth: 11¼ in.
(28.6 cm)
Accession number 72.DB.55

PROVENANCE
Count János Pálffy (sold, Bad Pistyan,
Czechoslovakia, June 30, 1924, lot 285);
[Etienne Lévy, Paris, 1971]; [French and Co.,
New York]; purchased by J. Paul Getty.

EXHIBITIONS
Paris, Hôtel George V, *Haute Joaillerie de
France*, June 1971; New York, The Frick
Collection, *French Clocks in North American
Collections*, November 1982–January 1983,
no. 38, p. 45, illus. p. 46.

BIBLIOGRAPHY
Wilson, *Clocks*, no. 4, pp. 22–25, illus.; *The
Country Life International Dictionary of
Clocks*, Alan Smith, ed. (New York, 1979),
p. 90, fig. 6; Ottomeyer and Pröschel,
Vergoldete Bronzen, p. 40, fig. 1.2.5.

———

133. **Wall Clock (*pendule de répétition*)**
Paris, circa 1735–1740
Case attributed to Charles Cressent; move-
ment by Jean-Jacques Fieffé *père*
Gilt bronze; enameled metal; wood carcass;
glass
Dial painted *FIEFFE DELOBSERVATOIR*;
movement engraved *Fieffé Àparis*.
Height: 4 ft. 4½ in. (133.3 cm); Width:
2 ft. 2½ in. (67.3 cm); Depth: 5⅝ in.
(14.4 cm)
Accession number 72.DB.89

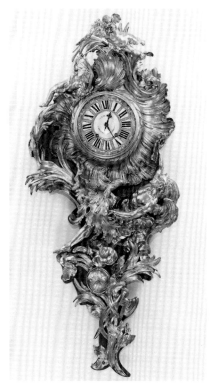

133

PROVENANCE
Baron Mayer Alphonse de Rothschild,
Château de Ferrières, Tarn; Baron Edouard
de Rothschild, Château de Ferrières, by
descent; Baron Guy de Rothschild, Château
de Ferrières (sold, Sotheby's, London,
November 24, 1972, lot 7); purchased at
that sale by J. Paul Getty.

BIBLIOGRAPHY
Eveline Schlumberger, "Caffiéri, le bronzier
de Louis XV," *Connaisance des arts* (May
1965), illus. p. 83; Wilson, *Clocks*, no. 6,
pp. 34–37, illus.; Gérard Mabille, *Le Style
Louis XV* (Paris, 1978), p. 175, illus.; Otto-
meyer and Pröschel, *Vergoldete Bronzen*,
p. 112, fig. 2.3.4.

———

134. **Barometer on Bracket**
Paris, circa 1740
Clock case attributed to Charles Cressent;
bracket attributed to Jean-Joseph de
Saint-Germain; movement by Digue
Gilt bronze; enameled metal; wood carcass;
glass
Dial painted *DIGUE A PARIS*.
Height: 4 ft. 2 in. (127 cm); Width:
1 ft. 5½ in. (44.3 cm); Depth: 7¼ in.
(18.4 cm)
Accession number 71.DB.116

PROVENANCE
[Duveen Brothers, New York]; Anna
Thomson Dodge, Rose Terrace, Grosse
Pointe Farms, Michigan (sold, Christie's,
London, June 24, 1971, lot 40 [together
with no. 139 in this book]); purchased at
that sale by J. Paul Getty.

BIBLIOGRAPHY
Duveen and Co., *A Catalogue of Works of
Art of the Eighteenth Century in the Collection
of Anna Thomson Dodge* (Detroit, 1933),
non-paginated entry, illus.; Theodore Dell,

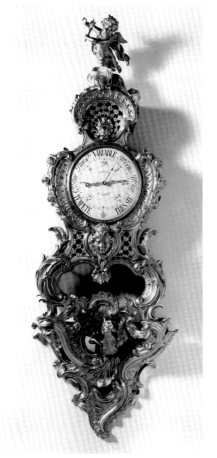

134

"The Gilt-Bronze Cartel Clocks of Charles
Cressent," *Burlington Magazine* 109 (April
1967), pp. 210–217; Wilson, *Clocks*, nos. 8–9
(with no. 139 in this book), pp. 45–51, illus.;
Ottomeyer and Pröschel, *Vergoldete
Bronzen*, p. 79, illus. fig. 1.12.7.

135

135. **Wall Clock (*pendule d'alcove*)**
Paris and Chantilly manufactory, circa 1740
Movement by Charles Voisin
Soft-paste porcelain; gilt bronze; enameled
metal; glass
Movement engraved C^{les} *Voisin Æaris.*
and dial painted *CHARLES VOISIN ÆARIS*
Height: 2 ft. 5½ in. (74.9 cm); Width:
1 ft. 2 in. (35.6 cm); Depth 4⅜ in. (11.1 cm)
Accession number 81.DB.81

PROVENANCE
[Jacques Kugel, Paris, 1980].

BIBLIOGRAPHY
Wilson, "Acquisitions 1981," no. 2,
pp. 66–71, illus.; Wilson, *Selections*, no. 13,
pp. 26–27, illus.; *Handbook* 1986, p. 154,
illus. p. 155; *Handbook* 1991, p. 168, illus.
p. 169.

136. **Mantel Clock**
Paris, circa 1742
Movement by Julien II Le Roy; enamel dial
by Antoine-Nicolas Martinière
Gilt bronze; enameled metal; glass

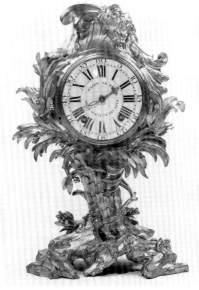

136

Dial painted *.JULIEN.LE ROY. .DE LA. SOCIÉTÉ DES ARTS*; movement engraved on back *Julien Le Roy À Paris*; dial enameled on reverse *a.n. martiniere 1742*.
Height: 1 ft. 6⅛ in. (46 cm); Width: 1 ft. ¾ in. (32.4 cm); Depth: 8⅛ in. (20.6 cm)
Accession number 79.DB.4

PROVENANCE
[Jacques Kugel, Paris, 1978].

EXHIBITIONS
New York, The Frick Collection, *French Clocks in North American Collections*, November 1982–January 1983, no. 52, p. 58, illus. p. 13.

BIBLIOGRAPHY
Wilson, "Acquisitions 1977 to mid 1979," no. 14, pp. 50–52, illus.

137. **Wall Clock**
Paris, circa 1747
Case by Jacques Caffieri; movement by Julien II Le Roy; enamel dial by Antoine-Nicolas Martinière
Gilt bronze; enameled metal; glass
Case engraved *fait par Caffieri* and stamped with the crowned *C* for 1745–1749. Dial inscribed *·JULIEN·LE·ROY·* and on reverse *a.n. Martiniere Privilégié Du Roi 1747*. Movement engraved *Julien Le Roy À Paris*.
Height: 2 ft. 6½ in. (77.5 cm); Width: 1 ft. 4 in. (40.6 cm); Depth: 4½ in. (11.4 cm)
Accession number 72.DB.45

PROVENANCE
Sold anonymously, Christie's, London, July 15, 1971, lot 21; [French and Co., New York]; purchased by J. Paul Getty.

BIBLIOGRAPHY
Wilson, *Clocks*, no. 10, pp. 52–55, illus.; *The Country Life International Dictionary of Clocks*, Alan Smith, ed. (New York, 1979), p. 237, fig. 2; Ottomeyer and Pröschel, *Vergoldete Bronzen*, p. 114, fig. 2.5.2.

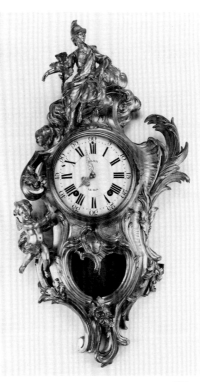

137

138. **Planisphere Clock**
Paris, circa 1745–1749
Case attributed to Jean-Pierre Latz; movement (now missing) by Alexandre Fortier
Oak veneered with kingwood; bronze mounts; glass; gilt paper
Dial engraved *Inventé par A. FORTIER*; mounts of lower sections stamped with the crowned *C* for 1745–1749.
Height: 9 ft. 3 in. (282 cm); Width: 3 ft. ½ in. (92.7 cm); Depth: 1 ft. 3½ in. (39.5 cm)
Accession number 74.DB.2

PROVENANCE
Baron Gustave de Rothschild, Paris; Charles Davis (sold, Christie's, London, June 29, 1906, lot 132, for £577 to Stettiner); Maurice Ephrussi, Paris (offered for sale, Galerie Georges Petit, May 22, 1911, lot 63, [?] bought in); (sold, "Property of a Lady of Title," Sotheby's, London, November 24, 1972, lot 34); [Rosenberg and Stiebel, Inc., New York, 1974]; purchased by J. Paul Getty.

EXHIBITIONS
New York, The Metropolitan Museum of Art, *The Grand Gallery*, CINOA, October 1974–January 1975, no. 44.

BIBLIOGRAPHY
Wilson, *Clocks*, no. 7, pp. 38–43, illus.; Wilson, *Selections*, no. 18, p. 36–37, illus.; Verlet, *Les Bronzes*, p. 115, illus.

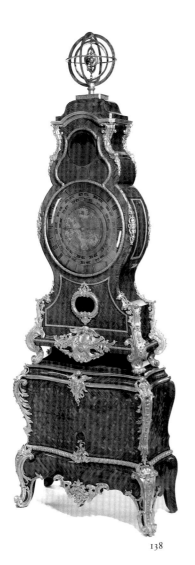

138

139. Clock on Bracket

Paris, circa 1758
Movement by Jean Romilly; clock case
attributed to Charles Cressent; bracket by
Jean-Joseph de Saint-Germain
Gilt bronze; enameled metal; wood carcass;
glass
Bracket stamped *ST. GERMAIN*; movement
engraved and dial painted *Romilly Æaris*;
one spring inscribed for William II Blakey
and dated *1758*; all gilt-bronze elements
stamped *E* on reverse.
Height: 4 ft. 2 in. (127 cm); Width:
1 ft. 5¾ in. (45.1 cm); Depth: 7¼ in.
(18.4 cm)
Accession number 71.DB.115

PROVENANCE

George Jay Gould, Georgian Court, Lake-
wood, New Jersey; [Duveen Brothers,
New York]; Anna Thomson Dodge, Rose
Terrace, Grosse Pointe Farms, Michigan
(sold, Christie's, London, June 24, 1971,
lot 40 [together with no. 134 in this book]);
purchased at that sale by J. Paul Getty.

BIBLIOGRAPHY

Duveen and Co., *A Catalogue of Works of
Art of the Eighteenth Century in the Collection
of Anna Thomson Dodge* (Detroit, 1933),
non-paginated entry, illus.; Theodore Dell,
"The Gilt-Bronze Cartel Clocks of Charles
Cressent," *Burlington Magazine* 109 (April
1967), pp. 210–217; Wilson, *Clocks*, nos. 8–9
(with no. 134 in this book), pp. 45–51, illus.;
Ottomeyer and Pröschel, *Vergoldete
Bronzen*, p. 79, fig. 1.12.7.

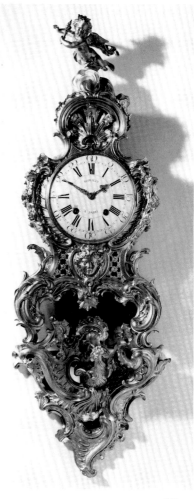

139

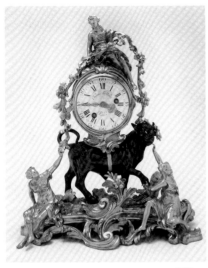

140

140. **Mantel Clock**

Paris, circa 1763

Case attributed to Robert Osmond; movement by Etienne II Le Noir and/or Pierre-Etienne Le Noir

Patinated and gilt bronze; enameled metal; glass

Dial painted *Etienne Le Noir Àparis* and movement engraved *Etienne le Noir Àparis No. 396*; springs are inscribed *Masson 1763*.

Height: 1 ft. 9⅛ in. (54.3 cm); Width: 1 ft. 5¾ in. (45.1 cm); Depth: 9⅛ in. (23.2 cm)

Accession number 73.DB.85

PROVENANCE

Sold, "Property of a Nobleman," Christie's, London, July 5, 1973, lot 31; purchased at that sale by J. Paul Getty.

BIBLIOGRAPHY

Wilson, *Clocks*, no. 11, pp. 56–59, illus.

141. **Wall Clock on Bracket**

Paris, circa 1764

Movement by Lapina; case by Antoine Foullet

Oak veneered with panels of green, red, and cream painted horn; brass; enameled metal; gilt-bronze mounts

Stamped *ANT FOUVLLET JME* on back of case and bracket. Movement engraved *Lapina A Paris*; one spring is inscribed *Richard X de 1764 Mouvement foule M Ebeniter* and a second spring is engraved *Richard X de 1764 Sonnerie A foulé Eben.*

Height: 3 ft. 10¾ in. (118.7 cm); Width: 1 ft. 7½ in. (49.5 cm); Depth: 11¼ in. (28.6 cm)

Accession number 75.DB.7

PROVENANCE

Private collection, Cornwall; [Alexander and Berendt, Ltd., London, 1974].

BIBLIOGRAPHY

Wilson, *Clocks*, no. 12, pp. 60–63, illus.; Ottomeyer and Pröschel, *Vergoldete Bronzen*, p. 158, fig. 3.2.6; Verlet, *Les Bronzes*, p. 122, illus. p. 113, fig. 137; Pradère, *Les Ebénistes*, p. 275.

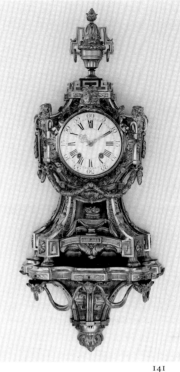

141

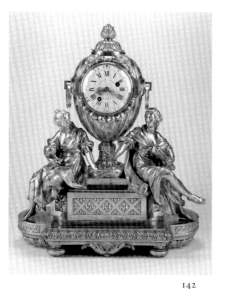

142

142. **Mantel Clock**
Paris, circa 1769
Movement by workshop of Charles Le Roy;
case attributed to Etienne Martincourt
Gilt bronze, enameled metal
Painted *CHARLES LE ROY A PARIS* on dial;
movement engraved *Ch^{les} Le Roy A^aris*
and stamped *2417* on backplate; two move-
ment springs are signed and dated *Richard
Fevrier 1772.*
Height: 2 ft. 4 in. (66 cm); Width:
1 ft. 11½ in. (59.7 cm); Depth: 1 ft. 1⅛ in.
(33.3 cm)
Accession number 73.DB.78

PROVENANCE
Louis XV, *Chambre du Roi*, Marly; furnished
by the *valet de chambre-horloger du Roi*,
Alexandre Lefaucheur, in May 1769 for the
Menus Plaisirs; later in the *Salle du Conseil*
of the Palais des Tuileries, 1790; stored
in the Hôtel de Coigny, Paris, between
August 10, 1792, and 24 *prairial, an* II
(June 2, 1794); Palais Petit Luxembourg,
Paris, from 29 *frimaire, an* IV (December 20,
1795); (?) the marquis de Saint-Cloud (sold,
Hôtel Drouot, February 25–26, 1861, lot 1);
[Kraemer et Cie, Paris]; [French and Co.,
New York, 1973].

EXHIBITIONS
The Detroit Institute of Arts, 1973; New
York, The Frick Collection, *French Clocks
in North American Collections*, November
1982–January 1983, no. 63, illus. p. 67.

BIBLIOGRAPHY
Wilson, *Clocks*, no. 13, pp. 64–76, illus.;
Wilson, *Selections*, no. 32, pp. 64–65, illus.;
Ottomeyer and Pröschel, *Vergoldete
Bronzen*, p. 181, fig. 3.7.10; *Handbook* 1986,
p. 169, illus.; *Handbook* 1991, p. 186, illus.

143. **Barometer**
Paris, circa 1770–1775
Oak veneered with ebony; gilt-bronze
mounts; enameled metal; ivory; glass
barometrical tube
Height: 4 ft. ½ in. (123.2 cm); Width: 9½ in.
(24.1 cm); Depth: 1⅞ in. (4.8 cm)
Accession number 86.DB.632

PROVENANCE
Marquis da Foz, probably removed from
Lisbon to London (sold, Christie's, London,
June 10, 1892, lot 65); Mrs. Orme Wilson
(sold, Parke-Bernet, New York, March 25–26,
1949, lot 386); Mme Lucienne Fribourg
(sold, Parke-Bernet, New York, April 19,
1969, lot 189); [Alexander and Berendt, Ltd.,
London]; Frau Quandt, Bad Homburg,
Germany; [B. Fabre et Fils, Paris], owned
jointly with [Jeremy, Ltd., London, 1986].

BIBLIOGRAPHY
"Acquisitions/1986," no. 108, p. 214, illus.

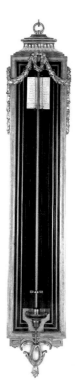

143

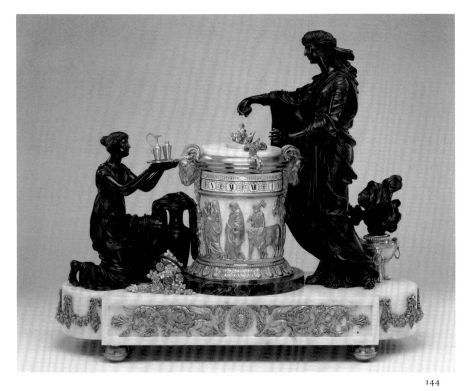

144

145. **Mantel Clock (*pendule squelette*)**
Paris, circa 1790–1800
Movement by Nicolas-Alexandre Folin;
enamel plaques by Georges-Adrien Merlet
Gilt bronze; enameled metal; white marble
base; glass and gilded metal case
Painted *Folin L'ainé A PARIS* on dial;
painted *G. Merlet* on one enameled ring.
Height: 1 ft. 7½ in. (49.5 cm); Width:
10⅞ in. (27.6 cm); Depth: 5½ in. (14 cm)
Accession number 72.DB.57

PROVENANCE
Louis Guiraud (sold, Palais Galliera, Paris,
December 10, 1971, lot 35); [French and Co.,
New York, 1971].

BIBLIOGRAPHY
Wilson, *Clocks*, no. 14, pp. 68–71, illus.

144. **Mantel Clock**
Paris, circa 1785
Attributed to Pierre-Philippe Thomire; dial
enameled by Dubuisson
Gilt and patinated bronze; enameled metal;
vert Maurin des Alpes marble; white marble
Enameled clock ring inscribed on the inte-
rior *Dubuisson*; movement scratched with
Sweden 1811.
Height: 1 ft. 9 in. (53.3 cm); Width:
2 ft. 1⅛ in. (63.8 cm); Depth: 9¼ in.
(23.5 cm)
Accession number 82.DB.2

PROVENANCE
Private collection, Sweden, by 1811; (sold,
Sotheby's, London, December 11, 1981,
lot 99).

BIBLIOGRAPHY
Wilson, "Acquisitions 1981," pp. 79–84,
illus.; Alvar González-Palacios, *The Adjec-
tives of History* (P. and D. Colnaghi and
Co., London, 1983), pp. 44–45; Wilson,
Selections, no. 42, pp. 84–85, illus.; Otto-
meyer and Pröschel, *Vergoldete Bronzen*,
p. 299, fig. 4.18.8.

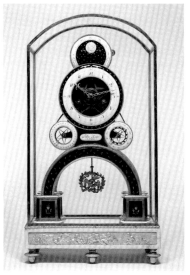

145

Scientific Instruments

146. **Pair of Globes**

Paris, terrestrial globe, circa 1728
Celestial globe, circa 1730
Globes made by the Abbé Jean-Antoine
Nollet; terrestrial map engraved by Louis
Borde and celestial map engraved by
Nicolas Bailleul, called Bailleul *le jeune*;
camomille and *capucin* lacquered decoration
attributed to the Martin family
Printed paper; *papier mâché*; wood painted
with *vernis Martin*; bronze; glass
The terrestrial globe is inscribed *Dedie
et presenté a S.A.S. MADAME LA
DUCHESSE DU MAINE par [son] tres hum-
ble et trés obéissant [serviteur] Nollet.Lic. en
Theologie. [1728], Borde exc.*, and *GLOBE
TERRESTRE DRESSÉ sur les observations les
plus nouvelles et le plus exactes approuvées par
Mrs. de l'Academie Roïale des sciences Æaris
avec privilege du Roi. 1728 Monté par l'auteur.*
The celestial globe is inscribed *DEDIÉ et
présenté à S.A.S. Monseigneur le Comte de
[Cle]rmont [par son très] humble [et] tres
[obéissent] serv[iteur] [Nollet de la So]c[iété
des Arts 173]0.* and *Globe celeste [c]alculé pour
l'année [17]30 sur les observa[tions] les plus
nouvelles [et le]s plus exactes. [APa]ris avec
privileg[e] du Roy. Bailleul le je[une sculpsit.
Monté par l'auteur.]* Each stand painted
underneath in yellow *N. 32* and in blue, per-
haps stenciled, (?) *3323*.
Height: 3 ft. 7¼ in. (110 cm); Width:
1 ft. 5½ in. (45 cm); Depth: 1 ft. ½ in.
(32 cm)
Accession number 86.DH.705.1–.2

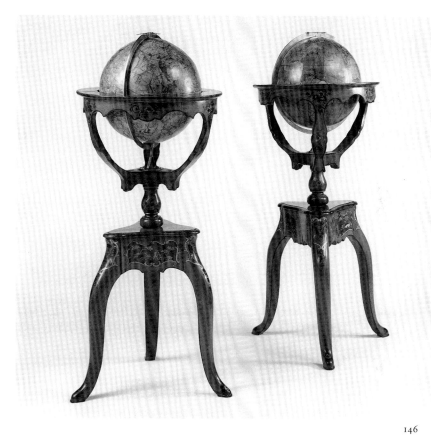

146

PROVENANCE
Guillaume de Gontaut-Biron, 12th marquis
de Biron, Paris; le duc de Talleyrand and
by descent to le duc de Dino Andia y
Talleyrand-Périgord, Château de Saint-Brice-
sous-Forêt, Pavillon Colombe, Val d'Oise;
[Maurice Segoura, Paris].

BIBLIOGRAPHY
Wlaldimir d'Ormesson, *Merveilles des
Châteaux de l'Île de France: Collection
réalités* (Paris, 1965), p. 131, illus.; "Acquisi-
tions/1986," *GettyMusJ* 15 (1987), no. 101,
p. 211, illus.; Jean-Nérée Ronfort, "Science
and Luxury: Two Acquisitions by the J. Paul
Getty Museum," *GettyMusJ* 17 (1989),
pp. 47–82, figs. 13–17; *Handbook* 1991, p. 176,
illus.

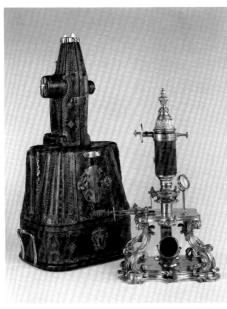

147

147. **Compound Microscope and Case**

Paris, after 1749
Micrometric stage invented by Michel-
Ferdinand, duc de Chaulnes
Gilt bronze; enamel; shagreen; glass; case
of wood; gilded leather; brass; velvet; silver
galon and lace; various natural specimens in
slides; and a number of extra lenses
Microscope: Height: 1 ft. 6⅞ in. (48 cm);
Width: 11 in. (28 cm); Depth: 8¹⁄₁₆ in.
(20.5 cm); Case: Height: 2 ft. 2 in. (66 cm);
Width: 1 ft. 1¾ in. (34.9 cm); Depth:
10⅝ in. (27 cm)
Accession number 86.DH.694

PROVENANCE
Private collection, Paris (sold, Sotheby's,
Monaco, February 23, 1986, lot 901);
Mrs. Kila Kugel, New York, 1986.

BIBLIOGRAPHY
"Acquisitions/1986," *GettyMusJ* 15 (1987),
no. 102, p. 212, illus.; Jean Perfettini, *Le
Galuchat*, 1988, pp. 62–63, illus.; Jean-Nérée
Ronfort, "Science and Luxury: Two Acqui-
sitions by the J. Paul Getty Museum,"
GettyMusJ 17 (1989), pp. 47–82, figs.
18–19, 21, 23, 25, 28–29, 35; *Handbook* 1991,
p. 175, illus.

Metalwork

GILT BRONZE: CANDELABRA
AND CANDLESTICKS

148. **Pair of *Girandoles***

Paris, circa 1680–1690
Gilt bronze; beads and drops of rock crystal,
coral, jasper, amethyst, carnelian, agate, and
garnet
Height: 1 ft. 3 in. (38 cm); Width: 10 in.
(25.5 cm); Diameter (at base): 5 in. (13 cm)
Accession number 85.DF.382.1–.2

PROVENANCE
[Bernard Baruch Steinitz, Paris].

BIBLIOGRAPHY
"Acquisitions/1985," *GettyMusJ* 14 (1986),
no. 188, p. 241, illus.

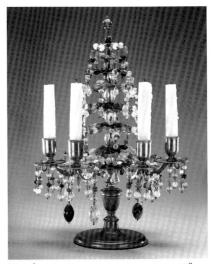

One of a pair 148

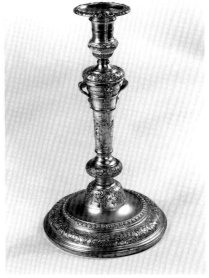

One of a pair 149

149. **Pair of Candlesticks**

Paris, circa 1680–1690
Gilt bronze
Height: 10 in. (25.4 cm); Diameter: 5¾ in.
(14.6 cm)
Accession number 72.DF.56.1–.2

PROVENANCE

Baron Nathaniel de Rothschild, Vienna;
Baron Alphonse de Rothschild, Vienna;
confiscated by the Third Reich in March
1938; restituted to the Baroness Clarice de
Rothschild, Vienna, in 1947; [Rosenberg
and Stiebel, Inc., New York, 1971]; pur-
chased by J. Paul Getty.

BIBLIOGRAPHY

Ottomeyer and Pröschel, *Vergoldete Bronzen,*
p. 58, illus.

150. **Pair of *Girandoles***

Paris, circa 1730
Rock crystal; gilt bronze
Height: 2 ft. 10 in. (86.3 cm); Width:
2 ft. ½ in. (62.3 cm); Depth: 1 ft. 2¾ in.
(37.5 cm)
Accession number 75.DF.53.1–.2

PROVENANCE

[Kraemer et Cie, Paris]; purchased by
J. Paul Getty.

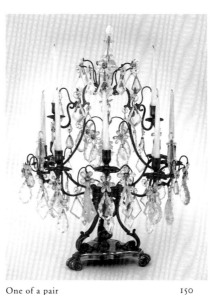

One of a pair 150

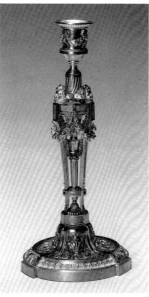

One of a pair 151

151. **Pair of Candlesticks**

Paris, circa 1780
By Etienne Martincourt
Gilt bronze
Each candlestick stamped *MARTINCOURT*
under base. One inscribed *Louis Antoine
Blois* and *LA* inside base.
Height: 11¾ in. (29.9 cm); Diameter: 5⅜ in.
(13.7 cm)
Accession number 72.DF.48.1–.2

PROVENANCE

Mr. and Mrs. Meyer Sassoon, Pope's
Manor, Berkshire, by 1914; Violet Sassoon
(Mrs. Derek C. Fitzgerald) (sold, Christie's,
London, March 23, 1972, lot 59); purchased
at that sale by J. Paul Getty.

EXHIBITIONS

London, The Burlington Fine Arts Club,
1914, no. 117.

BIBLIOGRAPHY

F. J. B. Watson, *Wallace Collection Cata-
logues: Furniture* (London, 1956), p. 95;
Ottomeyer and Pröschel, *Vergoldete Bronzen,*
p. 230, illus.

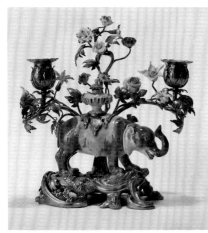

One of a pair 152

152. **Pair of Candelabra**

Elephants: German (Meissen manufactory),
circa 1741–1745
Flowers: (?) Vincennes manufactory, circa
1745–1750
Mounts: Paris, circa 1750
Elephants modeled by Peter Reinicke
in 1741
Hard-paste porcelain elephants; soft-paste
porcelain flowers; gilt-bronze mounts
Height: 9⅛ in. (23.2 cm); Width: 9¾ in.
(24.7 cm); Depth: 4⅛ in. (10.5 cm)
Accession number 75.DI.68.1–.2

PROVENANCE

Baron Maximilian von Goldschmidt-
Rothschild, Frankfurt am Main; [Rosenberg
and Stiebel, Inc., New York, 1975]; pur-
chased by J. Paul Getty.

153. **Pair of Candelabra**

Paris, circa 1775
Attributed to Pierre Gouthière
Gilt bronze
Height: 1 ft. 3 in. (38.3 cm); Width: 8½ in.
(21.6 cm); Depth: 7⅞ in. (19.9 cm)
Accession number 72.DF.43.1–.2

PROVENANCE

(?) Baron Henri de Rothschild, Paris;
[François-Gérard Seligmann, Paris, circa
1948]; Carreras Savedra, Director of the
Museum of Fine Arts, Buenos Aires;
[Jacques Helft, Buenos Aires]; [French and
Co., New York]; purchased by J. Paul Getty.

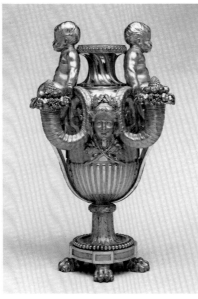

One of a pair 153

BIBLIOGRAPHY

Ottomeyer and Pröschel, *Vergoldete Bronzen*,
p. 230, illus.

154. **Pair of Candelabra**

Paris, circa 1785
Attributed to Pierre-Philippe Thomire and
Louis-Simon Boizot
Patinated and gilt bronze; white and *griotte*
marble
Height: 2 ft. 10¾ in. (83.2 cm); Diameter:
11½ in. (29.2 cm)
Accession number 86.DF.521.1–.2

PROVENANCE

(?) Anatole Demidov, Prince of San Donato,
San Donato Palace, Pratolino, near Florence
(sold, San Donato Palace, March 15, 1880,
lot 804, *en suite* with a mantel clock);
[Bernard Baruch Steinitz, Paris].

BIBLIOGRAPHY

"Acquisitions/1986," *GettyMusJ* 15 (1987),
no. 109, p. 214, illus.; *Handbook* 1991, p. 196,
illus.

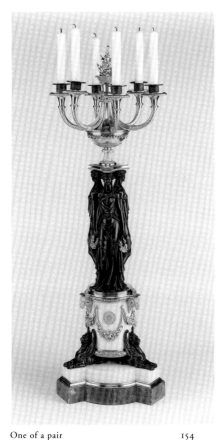

One of a pair 154

155. **Pair of Candelabra**
Paris, circa 1784–1786
Attributed to L. F. Feuchère
Blued metal; gilt bronze
Height: 3 ft. 8¾ in. (113.7 cm); Width:
1 ft. 5¾ in. (45.1 cm); Depth: 10½ in.
(26.7 cm)
Accession number 71.DF.99.1–.2

PROVENANCE
Baron Mayer Amschel de Rothschild, Ment-
more Towers, Buckinghamshire; Hannah
de Rothschild (Countess of Rosebery, wife
of the 5th Earl, married 1878, died 1890),
Mentmore Towers; Albert Primrose,
6th Earl of Rosebery, Mentmore Towers,
by inheritance (sold, Sotheby's, London,
April 17, 1964, lot 25); [Claude Sère, Paris,
1964]; private collection, Paris, late 1960s;
[Frank Partridge and Sons, Ltd., London,
1971]; purchased by J. Paul Getty.

EXHIBITIONS
London, 25 Park Lane, *Three French Reigns*,
February–April 1933, no. 485, illus.

BIBLIOGRAPHY
"French Furniture at the Exhibition of
'Three French Reigns', 25 Park Lane,"
Country Life 73-1884 (February 25, 1933),
p. 206, figs. 5, 7; Ottomeyer and Pröschel,
Vergoldete Bronzen, p. 261, illus.; Jonathan
Bourne and Vanessa Brett, *Lighting in the
Domestic Interior: Renaissance to Art Nouveau*
(London, 1991), illus. p. 101, fig. 321.

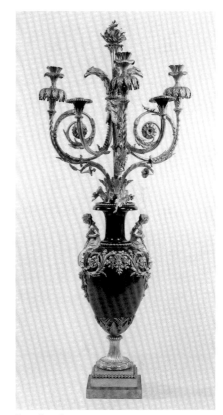

One of a pair 155

GILT BRONZE: CHANDELIERS

156. **Chandelier**

Paris, circa 1700
Lead glass and rock crystal; gilt bronze
Height: 3 ft. 6⅛ in. (107 cm); Diameter:
2 ft. 5⅛ in. (74 cm)
Accession number 88.DH.17

PROVENANCE
[Kraemer et Cie, Paris].

BIBLIOGRAPHY
"Acquisitions/1988," *GettyMusJ* 17 (1989),
no. 67, p. 140, illus.

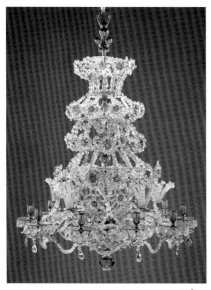

156

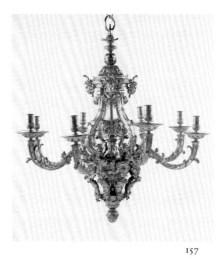

157

157. **Chandelier**

Paris, circa 1700
Gilt bronze
Height: 3 ft. 9¼ in. (115 cm); Diameter:
3 ft. 6¼ in. (110 cm)
Accession number 87.DF.28

PROVENANCE
Edouard Chappey, Paris, circa 1900;
[Michel Meyer, Paris, 1986].

EXHIBITIONS
Paris, *Exposition Universelle de 1900*, 1900,
no. 2891, p. 190.

BIBLIOGRAPHY
"Acquisitions/1987," *GettyMusJ* 16 (1988),
no. 69, p. 177, illus.

158. **Chandelier**

Paris, circa 1710
Attributed to André-Charles Boulle
Gilt bronze
Each element is stamped with the crowned
C for 1745–1749.
Height: 2 ft. 6½ in. (77.5 cm); Diameter:
2 ft. 8 in. (81.3 cm)
Accession number 76.DF.13

PROVENANCE
Antenor Patiño, Paris; [Kraemer et Cie,
Paris, 1976]; purchased by J. Paul Getty.

BIBLIOGRAPHY
Ottomeyer and Pröschel, *Vergoldete Bronzen*,
p. 51, illus.; Jean-Nérée Ronfort, "André-
Charles Boulle: die Bronzearbeiten und
seine Werkstatt im Louvre," *Vergoldete
Bronzen: Die Bronzearbeiten des Spätbarock
und Klassizismus*, Hans Ottomeyer and
Peter Pröschel, eds. (Munich, 1986), vol. 2,
p. 505; Verlet, *Les Bronzes*, pp. 91, 269, fig. 98.

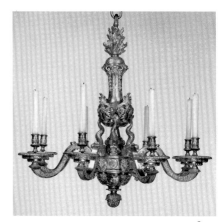

158

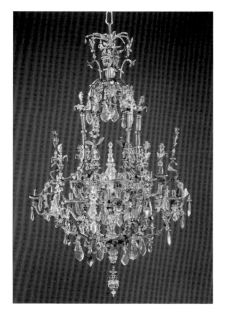

159

159. **Chandelier**

(?) Paris, circa 1710–1715
Colored and plain glass; silvered foils
lacquered with pink and green translucent
varnish; silvered pakton; gilt and silvered
bronze; rock crystal
Height: 2 ft. 5½ in. (75 cm); Diameter:
2 ft. 8 in. (81.3 cm)
Accession number 74.DH.29

PROVENANCE

Private Collection, Turin; [Jacques Kugel,
Paris]; [Michel Meyer, Paris]; [Kraemer et
Cie, Paris]; purchased by J. Paul Getty.

160. **Chandelier**

Paris, circa 1818–1819
By André Galle
Glass; enameled metal; gilt bronze
Height: 4 ft. 3 in. (129.5 cm); Diameter:
3 ft. 2 in. (96.5 cm)
Accession number 73.DH.76

PROVENANCE

Sold, Hôtel Drouot, Paris, early 1960s;
(sold, Hôtel Drouot, Paris, February 7,
1972, lot 83); [Kraemer et Cie, Paris, 1972];
[French and Co., New York]; purchased by
J. Paul Getty.

BIBLIOGRAPHY

Michael Shapiro, "Monsieur Galle, Bronzier
et Doreur," *GettyMusJ* 6–7 (1978–1979),
pp. 61–66, illus. figs 3–5, 8; Ottomeyer and
Pröschel, *Vergoldete Bronzen*, p. 359, illus.;
Handbook 1986, p. 179, illus.

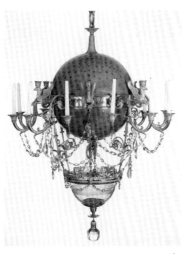

160

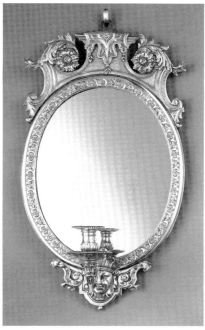

One of a pair 161

GILT BRONZE: WALL LIGHTS AND BRACKETS

161. **Pair of *Girandoles***

(?) Paris, circa 1710
Silvered bronze; mirror glass; oak support
Girandole .1 is painted *22* in black on the
wooden backing and its *bobèche* is stamped
with the crowned *C* for 1745–1749. *Giran-
dole* .2 is painted *20* in black on the wooden
backing and its *bobèche* is indistinctly
stamped with the crowned *C*.

Height: 1 ft. 7½ in. (50 cm); Width: 11½ in. (29.5 cm); Depth: 6¾ in. (17.2 cm)
Accession number 85.DG.49.1–.2

PROVENANCE
Swedish art market, circa 1980; [Michel Meyer, Paris, 1984].

EXHIBITIONS
New York, The Cooper-Hewitt Museum and Pittsburgh, The Carnegie Museum, *Courts and Colonies: The William and Mary Style in Holland, England, and America*, November 1988–May 1989, no. 126, p. 169, illus.

BIBLIOGRAPHY
John A. Cuadrado, "Antiques: Lighting and Style," *Architectural Digest* (April 1983), p. 106, illus.; "Acquisitions/1985," *GettyMusJ* 14 (1986), no. 209, p. 249, illus.

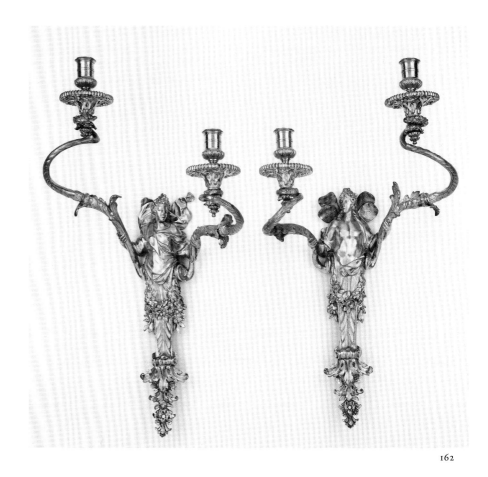

162

162. **Pair of Wall Lights**
Paris, circa 1700–1715
Gilt bronze
Height: 1 ft. 9½ in. (54.6 cm); Width: 1 ft. (30.5 cm); Depth: 9 in. (22.9 cm)
Accession number 85.DF.383.1–.2

PROVENANCE
[François Léage, Paris].

BIBLIOGRAPHY
"Acquisitions/1985," *GettyMusJ* 14 (1986), no. 191, p. 242, illus.

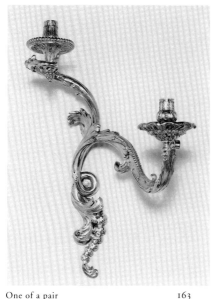

One of a pair 163

163. **Pair of Wall Lights**

Paris, circa 1715–1720
Attributed to André-Charles Boulle
Gilt bronze
Height: 1 ft. 8 1/16 in. (51 cm); Width: 1 ft. 2 in.
(35.5 cm); Depth: 9 13/16 in. (25 cm)
Accession number 83.DF.195.1–.2

PROVENANCE

Pierre de Faucigny-Lucinge, Vaux-le-Penil
(near Melun); [François-Gérard Seligmann,
Paris]; Samuel Kahn, Verbere (Oise) and
Nice; [Bernard Baruch Steinitz, Paris, 1982].

BIBLIOGRAPHY

Jean-Nérée Ronfort, "Le Fondeur Jean-
Pierre Mariette et la Fin de l'Atelier
d'André-Charles Boulle," *L'Estampille* 173
(September 1984), pp. 72–73, illus.;

Bremer-David, "Acquisitions 1983," no. 4,
p. 187, illus.; "Acquisitions/1983," *GettyMusJ*
12 (1984), no. 6, p. 263, illus.; Ottomeyer
and Pröschel, *Vergoldete Bronzen*, p. 62,
illus. pp. 62, 83; Jean-Nérée Ronfort,
"André-Charles Boulle: Die Bronzearbeiten
und seine Werkstatt im Louvre," *Vergoldete
Bronzen: Die Bronzearbeiten des Spätbarock
und Klassizismus*, Hans Ottomeyer and
Peter Pröschel, eds. (Munich, 1986), vol. 2,
p. 495; n. 229, p. 519; Anna Saratowicz,
"Apliki do Sali Rycerskiej," *Kronika
Zamkowa* 3-17 (1988), pp. 18–30, illus. p. 20.

———

164. **Pair of Wall Lights**

(?) Paris, circa 1730
Gilt bronze
Height: 1 ft. 11 in. (58.5 cm); Width: 11 1/8 in.
(28.3 cm); Depth: 8 in. (20.3 cm)
Accession number 78.DF.89.1–.2

PROVENANCE

[Cameron, London, 1950]; purchased by
J. Paul Getty, 1950.

BIBLIOGRAPHY

Ottomeyer and Pröschel, *Vergoldete Bronzen*,
p. 109, illus.

———

165. **Wall Bracket**

Paris, circa 1730–1735
Gilt bronze, brass, with oak core
Height: 1 ft. 3/4 in. (32.5 cm); Width:
1 ft. 3 3/8 in. (39 cm); Depth: 6 3/4 in.
(17.2 cm)
Accession number 87.DF.136

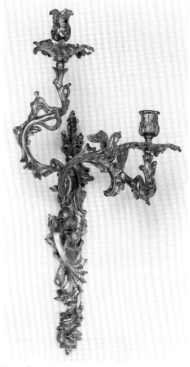

One of a pair 164

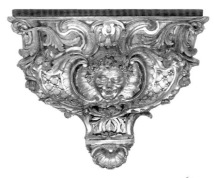

165

PROVENANCE

Paul Wallraf, London (sold, Sotheby's, London, December 8, 1983, lot 579); [La Cour de Varenne, Paris, 1987].

BIBLIOGRAPHY

"Acquisitions/1987," *GettyMusJ* 16 (1988), no. 70, pp. 177–178, illus.

166. **Four Wall Lights**

Paris, circa 1740
Soft-paste porcelain flowers; gilt bronze
Height: 1 ft. 6 in. (45.7 cm); Width: 1 ft. 1½ in. (34.3 cm); Depth: 7¾ in. (19.7 cm)
Accession number 75.DF.4.1–.4

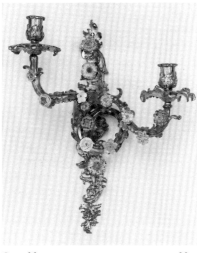

One of four 166

PROVENANCE

Henry Seymour, London (with another pair); [French and Co., New York (six)]; two lights sold to [Arnold Seligmann, Rey and Co., 1941], later in the Georges Lurcy collection, New York; Rita Lydig, (?) New York, 1927; Sidney J. Lamon, New York (sold, Christie's, London, November 29, 1973, lot 69); [Frank Partridge and Sons, Ltd., London, 1973]; purchased by J. Paul Getty.

167. **Pair of Wall Lights**

Paris, circa 1745–1749
Gilt bronze
Each light bears one crowned *C* for 1745–1749.
Height: 2 ft. 4½ in. (72.4 cm); Width: 1 ft. 6¾ in. (47.6 cm); Depth: 10½ in. (26.7 cm)
Accession number 89.DF.26.1–.2

PROVENANCE

European private collection; [Alexander and Berendt, Ltd., London].

BIBLIOGRAPHY

"Acquisitions/1989," *GettyMusJ* 18 (1990), no. 53, p. 193, illus.; *Handbook* 1991, p. 177, illus.

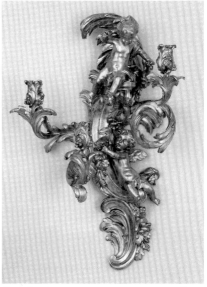

One of a pair 167

168. **Four Wall Lights**

Paris, circa 1750
Attributed to Jacques Caffieri
Gilt bronze
Two lights stamped with a crown flanked by *CR* for *Casa Reale* and the inventory numbers *C.562.1* and *C.562.2* on front near base. Two other lights stamped similarly *C.1068.1* and *C.1068.2*.
Height: 3 ft. 1 in. (94 cm); Width: 1 ft. 10¾ in. (57.8 cm); Depth: 1 ft. 1⅜ in. (34 cm)
Accession number 84.DF.41.1–.4

PROVENANCE

Mme Louise-Elisabeth of France (Duchess of Parma), Palazzo di Colorno (near Parma), circa 1753; ducal collection of Parma; private collection, France (sold, Ader, Picard et

Tajan, Paris, December 12, 1978, lot 48); [Partridge (Fine Arts) Ltd., London, 1978]; private collection, London; [Partridge (Fine Arts) Ltd., London, 1983].

BIBLIOGRAPHY
Bremer-David, "Acquisitions 1984," no. 3, pp. 76–79, illus.; "Acquisitions/1984," *GettyMusJ* 13 (1985), no. 57, p. 180, illus.; Ottomeyer and Pröschel, *Vergoldete Bronzen*, pp. 100, 140, illus.; Alvar González-Palacios, *Il Tempio del Gusto: Le arti decorative in Italia fra Classicismi e barocco* (Milan, 1986), vol. 1, p. 206; vol. 2, pp. 230–231, fig. 453; *Handbook* 1986, p. 161, illus. (one).

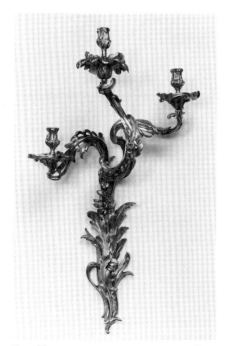

One of four 168

169. Four Wall Lights

(See entry no. 303.)
Paris, 1756
By François-Thomas Germain
Gilt bronze

Two wall lights engraved *FAIT PAR F.T.GERMAIN.SCULP.ORF.DU ROI AUX GALLERIES DU LOUVRE.1756* at lower right and left. Two stamped with Palais du Luxembourg inventory number *1051 LUX 1* and two with *1051 LUX 2.* All punched with Château de Compiègne inventory marks *CP* under a crown and *N⁰ 28,* at lower rear. Various numbers stamped on *bobèches* and drip pans.

Wall Light .1.a: Height: 3 ft. 3¼ in. (99.6 cm); Width: 2 ft. ⅞ in. (63.2 cm); Depth: 1 ft. 4⅛ in. (41.0 cm); Wall Light .1.b: Height: 3 ft. 1¼ in. (94.6 cm); Width: 1 ft. 10⅝ in. (57.5 cm); Depth: 1 ft. 1⅝ in. (34.6 cm); Wall Light .2.a: Height: 3 ft. 4½ in. (102.9 cm); Width: 2 ft. 1 in. (63.5 cm); Depth: 1 ft. 1½ in. (34.3 cm); Wall Light .2.b: Height: 2 ft. 11⅛ in. (89.2 cm); Width: 1 ft. 10⅜ in. (56.8 cm); Depth: 1 ft. 3⅞ in. (40.3 cm)
Accession number 81.DF.96.1.a–.b and .2.a–.b

PROVENANCE

Made for Louis-Philippe, duc d'Orléans; four pairs installed in the *Chambre de Parade* and the *Salon des Jeux* of the Palais Royal, Paris, circa 1756; sold privately in 1786 by Louis-Philippe-Joseph, duc d'Orléans, and purchased by the *bronzier* Feuchère (probably Pierre-François Feuchère) for Louis XVI; four pairs purchased by the Mobilier Royal, Paris, August 30, 1786, and described as having damaged gilding; two

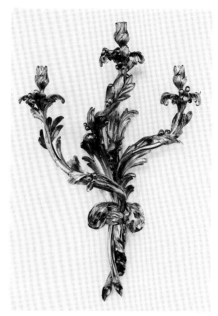

One of four 169

pairs regilded by Feuchère in the first six months of 1787 for 500 *livres* a pair and installed in the *Salon des Nobles de la Reine,* Château de Compiègne, until 1791; Government of France, Palais du Luxembourg, Paris, after 1792; Baron Mayer Amschel de Rothschild, the Great Dining Room, Mentmore Towers, Buckinghamshire, late nineteenth century; Hannah de Rothschild (Countess of Rosebery, wife of the 5th Earl, married 1878, died 1890), Mentmore Towers; Albert Primrose, 6th Earl of Rosebery, Mentmore Towers (sold, Sotheby's, London, April 17, 1964, lot 18); [François-Gérard Seligmann, Paris]; private collection,

Argentina and Switzerland (offered for sale, Sotheby's, Monaco, June 14–15, 1981, lot 148a–b, bought in).

BIBLIOGRAPHY
Denis Diderot and Jean d'Alembert, *Encyclopédie ou dictionnaire raisonné des sciences, planches* (Paris, 1762), vol. 1, s.v. "*architecture,*" pls. 32–33; Axelle de Broglie de Gaigneron, "Le 3ème Témoin de l'art de F-Th. Germain, bronzier," *Connaissance des arts* 199 (September 1968), pp. 76–77, illus.; Max Terrier, "L'Appliqué: Sa Provenance," *Connaissance des arts* 201 (November 1968), pp. 32–33; Svend Eriksen, *Early Neo-Classicism in France* (London, 1974), p. 349, pl. 202; Pierre Verlet, "Bronzes d'ameublement français du XVIIIᵉ siècle: Notes et documents," *Bulletin de la Société de l'histoire de l'art français* (1980), pp. 200–201, illus. p. 203; Michel Beurdeley, *La France à l'encan 1789–1799* (Fribourg, 1981), p. 167, pls. 177–178; Wilson, "Acquisitions 1981," no. 4, pp. 73–78 (with a note on conservation by Barbara Roberts); Wilson, *Selections,* no. 25, pp. 50–51, illus.; Ottomeyer and Pröschel, *Vergoldete Bronzen,* p. 145, illus.; *Handbook* 1986, p. 164, illus. (one); Jean-Louis Baritou and Dominique Foussand, *Chevolet-Contant-Chaussard: Un Cabinet d'architectes au siècle des lumières* (Lyon, 1987), pp. 135–140, illus. p. 182; Verlet, *Les Bronzes,* pp. 296–299, illus. p. 30, fig. 18; p. 171, fig. 209; p. 256, fig. 275; p. 297, figs. 327–329; p. 298, figs. 330–331; Pallot, *L'Art du siège,* p. 160, illus.; Anna Saratowicz, "Apliki do Sali Rycerskiej,"

Kronika Zamkowa 3-17 (1988), pp. 18–30; Jacques Charles et al., *De Versailles à Paris: Le Destin des collections royales* (Paris, 1989), illus. p. 143, fig. 2; Jonathan Bourne and Vanessa Brett, *Lighting in the Domestic Interior: Renaissance to Art Nouveau* (London, 1991), illus. p. 75, fig. 237; *Handbook* 1991, p. 180, illus. (one).

170. **Six Wall Lights**

Paris, circa 1765–1770
By Philippe Caffieri
Gilt bronze
Lights 78.DF.263.1 and 82.DF.35.1 stenciled *No 151* on back. Light 82.DF.35.1 engraved *fait par Caffiery* on one drip pan and stamped with the numbers *2* and *3* on back. 82.DF.35.2 stamped with the number *4* on back.
Height: 2 ft. 1½ in. (64.8 cm); Width: 1 ft. 4½ in. (41.9 cm); Depth: 1 ft. ¼ in. (31.1 cm)
Accession numbers 78.DF.263.1–.4 and 82.DF.35.1–.2

PROVENANCE
78.DF.263.1–.4: (?) Sold, Hôtel Drouot, Paris, May 26–27, 1921, lot 99, to de Friedel; private collection, Paris (sold, Etude Couturier Nicolaÿ, Paris, April 6, 1978, lot 52); [Alexander and Berendt, Ltd., London, 1978]. 82.DA.35.1–.2: Henri Smulders, Amsterdam (sold, two from a set of four, Frederik Muller and Co. [Mensing et Fils], Amsterdam, June 26–27, 1934, lot 98); private collection, Los Angeles, probably purchased in Paris; Mr. Lee Greenway, Los Angeles (sold,

Sotheby's, Los Angeles, October 21, 1980, lot 787A); [Alexander and Berendt, Ltd., London, 1980].

BIBLIOGRAPHY
Wilson, "Acquisitions 1977 to mid 1979," no. 7, pp. 42–43, illus. (one); Sassoon, "Acquisitions 1982," no. 10, pp. 52–53, illus.; Wilson, *Selections,* no. 35, pp. 70–71, illus. (one); Ottomeyer and Pröschel, *Vergoldete Bronzen,* pp. 190–191, illus.; *Handbook* 1986, p. 173, illus. (one); Verlet, *Les Bronzes,* p. 293, illus. p. 199, fig. 228, and p. 253, fig. 267; *Handbook* 1991, p. 189, illus. (one).

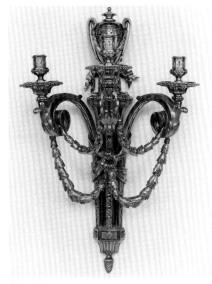

One of six 170

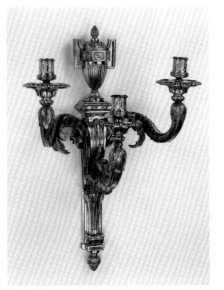

One of four 171

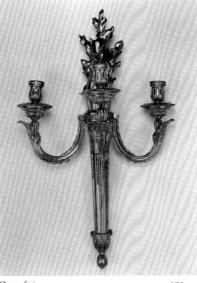

One of six 172

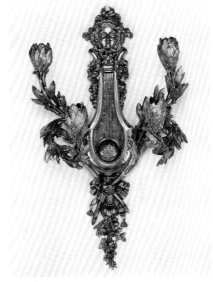

One of a pair 173

171. **Four Wall Lights**

Paris, circa 1765–1770
Attributed to Philippe Caffieri
Gilt bronze
Height: 1 ft. 10¼ in. (56.5 cm); Width:
1 ft. 3¾ in. (40 cm); Depth: 10¼ in. (26 cm)
Accession number 92.DF.18.1–.4

PROVENANCE

Sold, Palais Galliera, Paris, March 29, 1966,
lot 45, to [B. Fabre et Fils, Paris, circa 1977];
private collection, Paris, circa 1977; [Maurice
Segoura, Paris].

BIBLIOGRAPHY

"Acquisitions/1992," *GettyMusJ* 21 (1993),
in press, illus.

172. **Six Wall Lights**

Paris, circa 1775
After a design attributed to Richard de
Lalonde
Gilt bronze
Height: 2 ft. 3 in. (68.6 cm); Width:
1 ft. 1¼ in. (33.7 cm); Depth: 10½ in.
(26.7 cm)
Accession numbers 74.DF.3.1–.2 and
77.DF.29.1–.4

PROVENANCE

74.DF.3.1–.2: [Alexander and Berendt, Ltd.,
London, 1974]; purchased by J. Paul Getty.
77.DF.29.1–.4: Sold, Christie's, London,
December 2, 1976, lot 3; [Alexander and
Berendt, Ltd., London, 1976].

BIBLIOGRAPHY

Ottomeyer and Pröschel, *Vergoldete Bronzen*,
p. 173, illus. p. 172, fig. 3.5.4 (here attributed
to Jean-Louis Prieur); Jonathan Bourne and
Vanessa Brett, *Lighting in the Domestic
Interior: Renaissance to Art Nouveau* (London,
1991), n. 84, p. 110.

173. **Pair of Wall Lights**

Paris, circa 1781
Attributed to Pierre Gouthière, after a
design by François-Joseph Bélanger
Gilt bronze
Height: 1 ft. 8½ in. (52.1 cm); Width:
10¹⁵⁄₁₆ in. (27.8 cm); Depth: 7 in. (17.8 cm)
Accession number 74.DF.5.1–.2

PROVENANCE
[Kraemer et Cie, Paris, 1974]; purchased by
J. Paul Getty.

BIBLIOGRAPHY
Ottomeyer and Pröschel, *Vergoldete Bronzen*,
p. 243, illus.

174. **Pair of Wall Lights**
Paris, circa 1787
Attributed to Pierre-Philippe Thomire
Gilt bronze
Height: 3 ft. 6½ in. (107.9 cm); Width:
1 ft. 10⁷⁄₁₆ in. (57 cm); Depth: 11⅞ in.
(30.1 cm)
Accession number 83.DF.23.1–.2

PROVENANCE
Ducs de Mortemart, Château de Saint-
Vrain, Seine-et-Oise, from the eighteenth
century, by descent until 1982; [Maurice
Segoura, Paris, 1982].

BIBLIOGRAPHY
Sassoon, "Acquisitions 1983," no. 11,
pp. 207–208, 211, illus.; "Acquisitions/1983,"
GettyMusJ 12 (1984), no. 13, p. 266, illus.;
Ottomeyer and Pröschel, *Vergoldete Bronzen*,
p. 290, illus. p. 291.

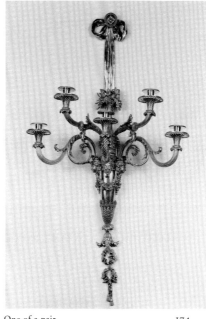

One of a pair 174

175. **Pair of Wall Lights**
Paris, circa 1787–1788
Attributed to Pierre-François or
Jean-Pierre Feuchère
Gilt bronze
Height: 2 ft. ¼ in. (61.6 cm); Width:
1 ft. ⁹⁄₁₆ in. (32 cm); Depth: 7¼ in. (18.5 cm)
Accession number 78.DF.90.1–.2

PROVENANCE
J. Bardac, Paris; Paul Dutasta, Paris (sold,
Galerie Georges Petit, Paris, June 4, 1926,
lot 105); (?) Rothschild collection, Paris;
[Rosenberg and Stiebel, Inc., New York];
purchased by J. Paul Getty, 1953.

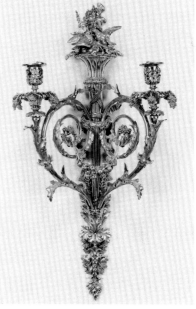

One of a pair 175

BIBLIOGRAPHY
Ottomeyer and Pröschel, *Vergoldete Bronzen*,
p. 292, illus.; Verlet, *Les Bronzes*, pp. 336,
378–379, illus. p. 383, fig. 393.

GILT BRONZE: FIREDOGS

176. **Pair of Firedogs**
Paris, circa 1735
Gilt bronze
Left: Height: 1 ft. 2⅛ in. (35.9 cm); Width:
1 ft. 3 in. (38.1 cm); Depth: 9⅝ in. (24.4 cm);
Right: Height: 1 ft. ¼ in. (32.3 cm); Width:
1 ft. 3¼ in. (38.7 cm); Depth: 8⅞ in.
(22.6 cm)
Accession number 71.DF.114.1–.2

PROVENANCE

[Duveen Brothers, New York]; Anna
Thomson Dodge, Rose Terrace, Grosse
Pointe Farms, Michigan (sold, Christie's,
London, June 24, 1971, lot 18); purchased
at that sale by J. Paul Getty.

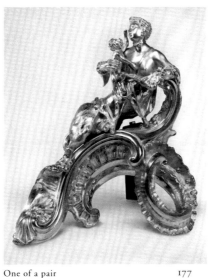

One of a pair 177

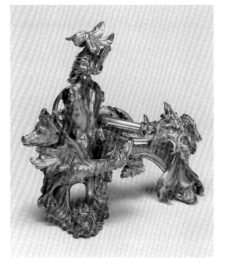

Firedog .1 176

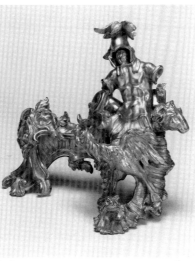

Firedog .2 176

177. **Pair of Firedogs**
Paris, circa 1735
By Charles Cressent
Gilt bronze
Height: 1 ft. 3¼ in. (38.7 cm); Width:
1 ft. 2⅜ in. (36.4 cm); Depth: 8⅛ in.
(20.6 cm)
Accession number 73.DF.63.1–.2

PROVENANCE

Private collection, Paris; [Didier Aaron,
Paris, by 1971]; [French and Co., New York,
1972]; purchased by J. Paul Getty.

EXHIBITIONS

Amsterdams Historisch Museum, *Fourth
International Exhibition Presented by
CINOA*, March–May 1970, no. 237.

BIBLIOGRAPHY

Marie-Juliette Ballot, *Charles Cressent:
Sculpteur, ébéniste, collectionneur, Archives
de l'art français: Nouvelle période 10* (Paris,
1919), p. 218; Wilson, *Selections*, no. 17,
p. 34, illus.; Ottomeyer and Pröschel,
Vergoldete Bronzen, p. 112.

178. **Pair of Firedogs**

Paris, circa 1775
Attributed to Pierre Gouthière
Gilt bronze; dark blue enamel panels
Stamped in various places with either the
letters *A*, *E*, or *EA*.
Height: 1 ft. 3¾ in. (40 cm); Width:
1 ft. 3 in. (38 cm); Depth: 5½ in. (14 cm)
Accession number 62.DF.1.1–.2

PROVENANCE

(?) Louise-Jeanne de Durfort, duchesse de
Mazarin, Paris (sold, Paris, December 10–15,
1781, lot 285); comtesse de Clermont-
Tonnerre, Paris (sold, Hôtel Drouot, Paris,
October 10–13, 1900, lot 290); private col-
lection, Paris (sold, Hôtel Drouot, Paris,
February 4, 1909, lot 96); Mortimer L.
Schiff, New York (sold by his heir John L.
Schiff, Christie's, London, June 22, 1938, lot
45); purchased at that sale by J. Paul Getty.

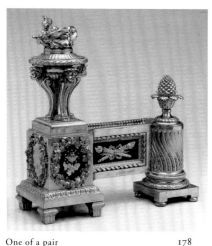

One of a pair 178

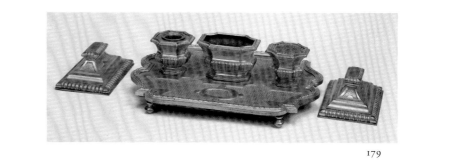

179

BIBLIOGRAPHY

Verlet et al., *Chefs d'oeuvre*, p. 130, illus.;
Getty, *Collecting*, p. 150; Ottomeyer and
Pröschel, *Vergoldete Bronzen*, p. 272, illus.

———

GILT BRONZE: INKSTANDS

179. **Inkstand and Paperweights**

Paris, circa 1715
Gilt bronze
Inkstand: Height: 4¼ in. (10.8 cm); Width:
1 ft. 2¹¹⁄₁₆ in. (37.2 cm); Depth: 11⅛ in.
(28.2 cm); Paperweights: Height: 2⅝ in.
(6.7 cm); Width: 6⅜ in. (16.2 cm); Depth:
4½ in. (11.4 cm)
Accession number 75.DF.6.1–.3

PROVENANCE

[Michel Meyer, Paris]; [Kraemer et Cie,
Paris, 1975]; purchased by J. Paul Getty.

———

180. **Inkstand**

Porcelain: Chinese, early eighteenth century
Lacquer: French, circa 1750
Mounts: Paris, circa 1750
Hard-paste porcelain, *vernis Martin*; gilt-
bronze mounts
Height: 8 in. (20.3 cm); Width: 1 ft. 2 in.
(35.6 cm); Depth: 10½ in. (26.7 cm)
Accession number 76.DI.12

PROVENANCE

[B. Fabre et Fils, Paris, 1976]; purchased by
J. Paul Getty.

BIBLIOGRAPHY

Wilson et al., *Mounted Oriental Porcelain*,
no. 14, pp. 68–69, illus.

———

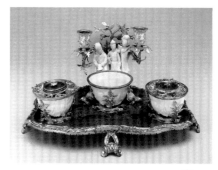

180

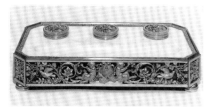

181

181. **Inkstand**

Paris, circa 1810
White marble; gilt bronze; velvet
Height: 3½ in. (8.9 cm); Width: 1 ft. 6½ in.
(47 cm); Depth: 9½ in. (24.1 cm)
Accession number 73.DJ.67

PROVENANCE

Adolphe Lion, Paris, 1929; Mrs. Benjamin
Stern, New York (sold, American Art
Association, New York, April 4–7, 1934,
lot 848); [Frederick Victoria, Inc., New
York]; [Mallett and Son, Ltd., London,
1973]; purchased by J. Paul Getty.

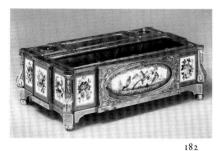

182

182. **Inkstand**

(?) Paris, late nineteenth century
Oak veneered with rosewood; set with hard-
paste porcelain plaques; gilt-bronze mounts
One plaque bears an unidentified mark in
script. Base pasted with paper label printed
Palace of Pavlovsk in Russian, inked with the
inventory number *1004*, and overstamped
with a French customs stamp. Another
paper label inked with the Duveen inven-
tory number *29652* and another stenciled
with a French customs stamp. Base painted
1044 in white and *Uh.6522* in blue.
Height: 3⅞ in. (9.8 cm); Width: 11¼ in.
(28.6 cm); Depth: 7¼ in. (18.4 cm)
Accession number 71.DH.97

PROVENANCE

Russian Imperial Collections, Palace of
Pavlovsk (near St. Petersburg), until the
early twentieth century; [Duveen Brothers,
New York]; Anna Thomson Dodge, Rose
Terrace, Grosse Pointe Farms, Michigan
(sold, Christie's, London, June 24, 1971, lot
33); purchased at that sale by J. Paul Getty.

EXHIBITIONS

The Detroit Institute of Arts, *French Taste
in the Eighteenth Century*, April–June 1956,
no. 174, illus. p. 50.

BIBLIOGRAPHY

Savill, *Sèvres*, vol. 2, n. 15, p. 860.

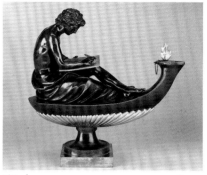

L'Etude 183

GILT BRONZE:
FIGURAL BRONZES

183. **Pair of Figures, *L'Etude* and *La Philosophie***

Paris, circa 1780–1785
Attributed to Pierre-Philippe Thomire after
models by Louis-Simon Boizot
Patinated and gilt bronze
Male Figure: Height: 1 ft. 1 in. (33 cm);
Width: 1 ft. 2 in. (35.7 cm); Depth: 4⅝ in.
(11.7 cm); Female Figure: Height: 1 ft. 1 in.
(33 cm); Width: 1 ft. 1⅞ in. (35.2 cm);

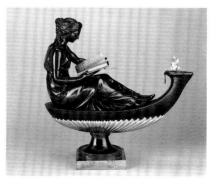

La Philosophie 183

Depth: 4⅝ in. (11.7 cm)
Accession number 88.SB.113.1–.2

PROVENANCE
Private collection, Château de la Chesaie,
Eaubonne (sold, Sotheby's, Monaco,
February 5, 1978, lot 20); purchased at that
sale by The British Rail Pension Fund.

BIBLIOGRAPHY
"Acquisitions/1988," *GettyMusJ* 17 (1989),
no. 78, p. 144, illus.

PAINTED BRONZE: FIGURAL BRONZES

184. **Pair of Decorative Bronzes**
Paris; silver, 1738–1750; bronzes, 1745–1749
The lacquer painting of the figures is
attributed to Etienne-Simon Martin and
Guillaume Martin
Painted bronze; silver
The base of each bronze is stamped with
the crowned *C* for 1745–1749. Each silver
element is marked with a crowned *Y* (the
warden's mark used between October 4,
1738, and October 12, 1739); a fox's head
(the Paris discharge mark for small works
in silver and gold used between October 4,
1738, and October 12, 1744); and a helmet
with open visor (the Paris discharge mark
for works in gold and small works in old
silver used between October 13, 1744, and
October 9, 1750). The silver also bears an
obliterated mark which might be a charge
or maker's mark.

Height: 9 in. (22.8 cm); Diameter: 6 in.
(15.2 cm)
Accession number 88.DH.127.1–.2

PROVENANCE
Marquise de Pompadour, Paris, before 1752;
[Kraemer et Cie, Paris]; private collection,
Paris, purchased circa 1910; [Jean-Luc
Chalmin, Paris, 1988].

BIBLIOGRAPHY
*Livre-Journal de Lazare Duvaux, Marchand-
Bijoutier ordinaire du Roy, 1748–1758*, Louis
Courajod, ed. (Paris, 1873), vol. 2, p. 135,
no. 1213; "Acquisitions/1988," *GettyMusJ* 17
(1989), no. 72, p. 142, illus.; *Handbook* 1991,
p. 172, illus. (one).

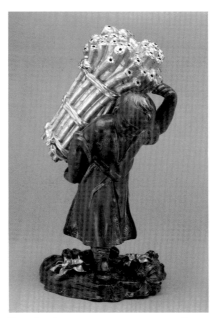

One of a pair 184

SILVER

185. **Fountain**
Paris, 1661–1663, with English alterations of
1695, 1758, and circa 1762
Jean IV Le Roy, probably altered in London
in 1695 by Ralph Leeke, in 1758 by Phillips
Garden, and again later in the eighteenth
century
Silver
Marked on body with the maker's stamp
of *J.L.R.* flanking a scepter and the device
of a laurel wreath and two grains below a
fleur-de-lys; a crowned *R* (the warden's
mark used between December 30, 1661,
and January 26, 1663). Scratched with the
weights *348 14* (partially obliterated) and
363 13 under base. Engraved with the arms
of Curzon and Colyear on central cartouche.
Height: 2 ft. 1⅝ in. (65.2 cm); Width:
1 ft. 2⅛ in. (35.9 cm); Depth: 1 ft. 2¼ in.
(36.2 cm)
Accession number 82.DG.17

PROVENANCE
In England by 1694, when probably adapted
from a lidded one-handled vase with a spout
mounted higher, and when a matching
fountain and two basins were made by Ralph
Leeke; Sir Nathaniel Curzon, 1st Baron
Scarsdale (born 1726, married Caroline
Colyear 1750, died 1804), Kedleston Hall,
Derbyshire, by 1750; Earls of Scarsdale,
Kedleston Hall, by descent (offered for sale,
Christie's, London, July 16, 1930, lot 42,
bought in; offered for sale, Christie's,

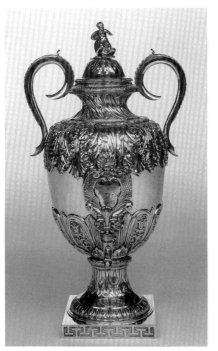

185

London, November 7, 1945, bought in);
[Jacques Helft, Paris, 1940s]; Arturo Lopez-
Willshaw, Paris, late 1940s; Patricia Lopez-
Willshaw (widow of Arturo Lopez-Willshaw),
Paris (offered for sale, Sotheby's, Monaco,
June 23, 1976, lot 48, bought in).

EXHIBITIONS
Paris, Musée des Arts Décoratifs, *Louis XIV:
Faste et décors*, May–October 1960, no. 378,
pl. 58.

BIBLIOGRAPHY
Jacques Helft, *French Master Goldsmiths and
Silversmiths* (New York, 1966), pp. 60–61,
illus.; Wilson, *Selections*, no. 2, pp. 4–5,
illus.; Gillian Wilson, "The Kedleston Foun-
tain: Its Development from a Seventeenth-
Century Vase," *GettyMusJ* 11 (1983), pp. 1–12,
figs. 1–4, 6–7, 9, 11, 16–17.

186. **Pair of Tureens, Liners, and Stands**
Paris, 1726–1729
By Thomas Germain, with arms added in
1764 by his son François-Thomas Germain
Silver
Marked variously on tureens, liners, and
stands with a crowned *K* (the warden's mark
used between August 13, 1726, and August
13, 1727); a crowned *M* (the warden's mark
used between August 12, 1728, and August
26, 1729); a crowned *A* overlaid with crossed
L's (the charge mark used between May 6,
1722, and September 3, 1727, under the *fer-
mier* Charles Cordier); a crowned *A* on its
side (the charge mark used between
September 3, 1727, and December 22, 1732,
under the *fermier* Jacques Cottin); (?) a
chancellor's mace (the discharge mark used
between September 3, 1727, and December
22, 1732); an artichoke mark (for old works
in silver to which new parts have been
added, used between November 22, 1762,
and December 23, 1768); and with three
obliterated marks, probably of Thomas
Germain. One tureen, stand, and liner
engraved *N⁰·1*, the others *N⁰·2*; tureens
engraved with the weights ·$48^{m}1^{oz}2^{d}$

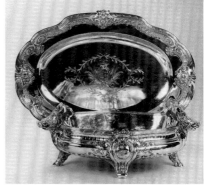

One of a pair 186

and ·$48^{m}3^{oz}2^{d}$; stands engraved with the
weights ·$48^{m}2^{d}$ and ·$48^{m}5^{d}$ Both stands,
one with the added date *1764*, engraved
*FAIT.PAR.F.T.GERMAIN.ORF.SCULP.DU.R
OY.AUX GALLERIES.DU LOUVRE.APARIS.*
The coat of arms of the Mello e Castro
family engraved on stands and applied on
tureens.
Tureens: Height: 6⅞ in. (17.4 cm); Width:
1 ft. 6½ in. (47 cm); Depth: 10 in. (25.4 cm);
Stands: Height: 1⁷⁄₁₆ in. (3.7 cm); Width:
1 ft. 10⁷⁄₁₆ in. (57 cm); Depth: 1 ft. 4 in.
(40.6 cm)
Accession number 82.DG.12.1–.2

PROVENANCE
(?) Jacques-Samuel Bernard (1686–1753),
comte de Coubert, in the *salle à manger* of
his hôtel, 46 rue du Bac, Paris [information:
B. Pons]; altered by François-Thomas
Germain in 1764 for D. Martinho de Mello
e Castro, Count of Galveias, the Portuguese
ambassador in London (1755) and in Paris

from 1760–1761 (temporarily residing in the hôtel Jacques-Samuel Bernard in the rue du Bac), and later Secretary of State to King José I and subsequently to Queen Maria I, listed in the September 14, 1796, inventory of his possessions (taken after his death) with their lids decorated with artichokes, cauliflowers, birds, shells, and shrimp (these lids were probably lost at the beginning of the nineteenth century); Mello e Castro de Vilhena family, Portugal and Paris, by descent; (sold, Christie's, Geneva, November 11, 1975, lot 230); Jean Rossignol, Geneva, 1975.

EXHIBITIONS
Lisbon, Museu Nacional de Arte Antiga, *Exposição de arte francesa*, May–June 1934, nos. 230–231; Paris, Musée des Arts Décoratifs, *Les Trésors de l'orfèvrerie du Portugal*, November 1954–January 1955, no. 453.

BIBLIOGRAPHY
Daniel Alcouffe, *Louis XV: Un Moment de perfection de l'art français,*" Hôtel de la Monnaie, Paris, 1974, no. 484, p. 358; Thomas Milnes-Gaskell, "Thomas Germain," *Christie's Review of the Season 1975* (London and New York, 1976), pp. 219–221, illus.; Wilson, "Acquisitions 1982," no. 3, pp. 24–28, illus.; Wilson, *Selections*, no. 11, pp. 22–23, illus.; Armin B. Allen, *An Exhibition of Ornamental Drawings* (New York, 1982), no. 53, illus.; *Handbook* 1986, p. 157, illus. (one); Bruno Pons, "Hôtel Jacques-Samuel Bernard," *Le Faubourg Saint-Germain: la rue du Bac, Etudes offertes à Colette Lamy-Lassalle* (Paris, 1990), pp. 126–153; Leonor d'Orey, *The Silver Service of the Portuguese Crown* (Lisbon, 1991), pp. 24–25, illus. p. 25.

———

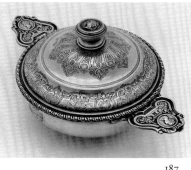

187

187. **Lidded** *Ecuelle*
Paris, 1727
By Claude-Gabriel Dardet
Silver-gilt
Marked on bowl with the maker's stamp of *C.G.D.*, a dart, and two grains below a crowned fleur-de-lys; a crowned *L* (the warden's mark used between August 13, 1727, and August 12, 1728); a crowned *A* (the charge mark used between September 3, 1727, and December 22, 1732, under the *fermier* Jacques Cottin); a fleur-de-lys within a pomegranate (the discharge mark used on large silver objects between September 3, 1727, and December 22, 1732); an unidentified flower, possibly a lily of the valley (a discharge mark used to indicate a minimum standard of silver between 1727 and 1732); and a boar's head (the "restricted warranty" of .800 minimum silver standard used in Paris exclusively from May 10, 1838). Bowl engraved with the coat of arms of the Moulinet family, probably in the nineteenth century.
Height: 4¼ in. (10.8 cm); Width: 11¾ in. (29.9 cm); Depth: 7⅜ in. (18.7 cm)
Accession number 71.DG.77.a–.b

PROVENANCE
Moulinet family, Île-de-France; M. Marquis, Paris (sold, Hôtel Drouot, Paris, February 10–18, 1890, lot 110 [?]); David David-Weill, Paris (sold, Palais Galliera, Paris, November 24, 1971, lot 17); purchased at that sale by J. Paul Getty.

BIBLIOGRAPHY
Emile Dacier, *L'Art au XVIII^eme siècle en France* (Paris, 1951), no. 192, p. 110, illus.

———

188. **Lidded Bowl and Stand**
Lacquer: Japanese, early eighteenth century
Mounts: Paris, circa 1727–1738
Wood lacquered with red and brown pigments; gold powder; silver-gilt mounts
Lid, bowl, and stand mounts variously marked with the unidentified maker's stamp *P.L.R.* with a crescent, two grains, and a fleur-de-lys; a crowned bell (the Paris countermark used between September 3, 1727, and December 22, 1732, under the *fermier* Jacques Cottin); a crowned *S* (the warden's mark used between September 18, 1734, and September 23, 1735); and an unidentified mark.

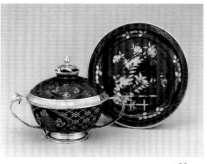

188

Overall Height: 5⁹⁄₁₆ in. (14.1 cm); Bowl: Height: 5³⁄₁₆ in. (13.2 cm); Width: 7³⁄₈ in. (18.7 cm); Depth: 5³⁄₈ in. (13.6 cm); Stand: Height: ⅞ in. (2.3 cm); Diameter: 7³⁄₁₆ in. (18.2 cm)
Accession number 84.DH.74.1.2a–.2b

PROVENANCE

Hans Backer, London; Martin Norton, London.

BIBLIOGRAPHY

Nieda, "Acquisitions 1984," no. 2, pp. 72–76, illus.; "Acquisitions/1984," *GettyMusJ* 13 (1985), no. 52, p. 177, illus.

189. **Pair of Sugar Castors**

Paris, 1743

By Simon Gallien

Silver

Each castor is marked with the maker's stamp of *S.G.*, a sun and two grains below a crowned fleur-de-lys; a crowned *C* (the warden's mark used between May 30, 1743, and July 6, 1744); a crowned *A* (the charge mark used between October 4, 1738, and October 13, 1744, under the *fermier* Louis Robin); a fox's head (the discharge mark used on small silver objects between October 4, 1738, and October 13, 1744); a salmon's head (the discharge mark used on small silver objects between October 13, 1744, and October 10, 1750, under the *fermier* Antoine Leschaudel); a fly (the countermark used between October 13, 1744, and October 10, 1750, under the *fermier* Antoine Leschaudel); a laurel leaf (the countermark used between October 13, 1756, and November 22, 1762, under the *fermier* Eloy Brichard); an open right hand (the countermark used between November 22, 1762, and December 23, 1768, under the *fermier* Jean-Jacques Prévost); an *N* inscribed in an oval (the Dutch date letter for 1822 for works in precious metal); and an ax (a Dutch standard mark used since 1852 for old silver objects returned to circulation). The base of castor .1 is inscribed *409*; the base of castor .2 is inscribed *409A*.
Castor .1: Height: 10¼ in. (26 cm); Diameter: 4½ in. (11.5 cm); Castor .2: Height: 10½ in. (26.6 cm); Diameter: 4⅝ in. (11.7 cm)
Accession number 84.DG.744.1–.2

PROVENANCE

F. J. E. Horstmann (sold, Frederik Müller, Amsterdam, November 19–21, 1929, lot 178); Jean-Louis Bonnefoy, Paris; Sir Robert Abdy, Bt., Newton Ferrers, Cornwall; by descent to Sir Valentine Abdy; [S. J. Phillips, London].

BIBLIOGRAPHY

"Acquisitions/1984," *GettyMusJ* 13 (1985), no. 53, p. 178, illus.

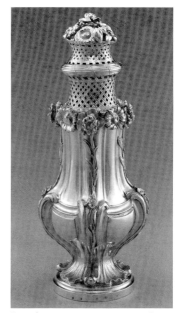

One of a pair 189

190. **Pair of Lidded Tureens, Liners, and Stands**

Paris, 1744–1750
By Thomas Germain
Silver

Marked variously on the tureens, liners, lids, and stands with a crowned *D* (the warden's mark used between July 6, 1744, and November 27, 1745); a crowned *I* (the warden's mark used between July 18, 1749, and July 15, 1750); a crowned *K* (the warden's mark used between July 15, 1750, and January 22, 1751); an indistinct mark, possibly a crowned *A* (the charge mark used between October 4, 1738, and October 13, 1744, under the *fermier* Louis Robin); a crowned *A* (the charge mark used between October 13, 1744, and October 10, 1750, under the *fermier* Antoine Leschaudel); a hen's head (the discharge mark used on small silver objects between October 10, 1750, and October 13, 1756, under the *fermier* Julien Berthe); a boar's head (the discharge mark used on large silver objects between October 10, 1750, and October 13, 1756); and a laurel leaf (the countermark used between October 13, 1756, and November 22, 1762, under the *fermier* Eloy Brichard); and several obliterated marks. One tureen, liner, lid, and stand engraved with *DU Nº 3*; the other with *DU Nº 4*. Stands scratched with various dealers' marks of twentieth-century date. Originally engraved with an archbishop's coat of arms surrounded by the collar and cross of the Order of Christ, now partly erased and replaced with the arms of Robert John Smith, 2nd Lord Carrington.

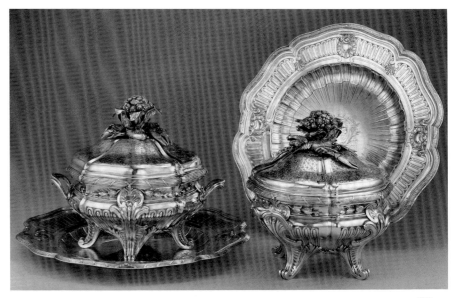

190

Tureens: Height: 11 3/16 in. (30 cm); Width: 1 ft. 1 3/4 in. (34.9 cm); Depth: 11 1/8 in. (28.2 cm); Stands: Height: 1 5/8 in. (4.2 cm); Width: 1 ft. 6 3/16 in. (46.2 cm); Depth: 1 ft. 6 9/16 in. (47.2 cm)
Accession number 82.DG.13.1–.2

PROVENANCE
(?) Archbishop Dom Gaspar de Bragança (1716–1789, archbishop of Braga 1757), Braga, Portugal; Robert John Smith, 2nd Lord Carrington (succeeded to the title in 1838), England; [S. J. Phillips, London, 1920s or 1930s]; Mr. and Mrs. Meyer Sassoon, Pope's Manor, Berkshire, by the 1930s; [S. J. Phillips, London]; [Jacques Helft, Paris]; José and Vera Espirito Santo, Paris, by 1954 (sold, Christie's, Geneva, April 27, 1976, lot 446); private collection, Geneva, 1976.

EXHIBITIONS
Paris, Musée des Arts Décoratifs, *Les Trésors de l'orfèvrerie du Portugal*, November 1954–January 1955, no. 455, illus.

BIBLIOGRAPHY
Thomas Milnes-Gaskell, "Thomas Germain," *Christie's Review of the Season 1975* (London and New York, 1976), pp. 219–221, illus.; Wilson, "Acquisitions 1982," no. 7, pp. 39–45, illus.; *Storia degli Argenti*, Kirsten Aschengreen-Piacenti, ed. (Novara, 1987), p. 129, illus.; *Handbook 1991*, p. 173, illus. (one).

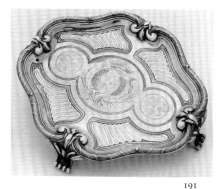

191

191. **Tray**
Paris, 1750
By François-Thomas Germain
Silver
Marked underneath with the maker's stamp of *F.T.G.*, a lamb's fleece, two grains, and a crowned fleur-de-lys; a crowned *K* (the warden's mark used between July 15, 1750, and January 22, 1751); a crowned *A* with palm and laurel branches (the charge mark used between October 10, 1750, and October 13, 1756, under the *fermier* Julien Berthe); a boar's head (the "restricted warranty" of .800 minimum silver standard used in Paris exclusively from May 10, 1838); and a swan in an oval (the standard mark for silver of unknown origin that is sold at auction as used by contracting countries between July 1, 1893, and 1970). Engraved in the center with the arms of the marquis de Menars.
Height: 1⅜ in. (3.8 cm); Width: 8⅝ in. (21.9 cm); Depth: 7⅞ in. (20 cm)
Accession number 71.DG.78

PROVENANCE
Marquis de Menars; (?) Junius Spencer Morgan, New York; [Puiforcat, Paris, by 1926, and through 1938]; David David-Weill, Paris (sold, Palais Galliera, Paris, November 24, 1971, lot 24); purchased at that sale by J. Paul Getty.

EXHIBITIONS
Paris, Musée des Arts Décoratifs, *Exposition d'orfèvrerie française civile du XVIᵉ siècle au début du XIXᵉ*, April–May 1926, no. 91; London, 25 Park Lane, *Three French Reigns*, February–April 1933, no. 388; New York, The Metropolitan Museum of Art, *French Domestic Silver*, May–September 1938, no. 149, pl. 85.

BIBLIOGRAPHY
S. Brault and Y. Bottineau, *L'Orfèvrerie française du XVIIIᵉ siècle* (Paris, 1959), p. 186, pl. 17; Faith Dennis, *Three Centuries of French Domestic Silver: Its Makers and Its Marks* (New York, 1960), vol. 1, p. 116, fig. 149; Henry Nocq, *Le Poinçon de Paris* (Paris, 1968), vol. 2, p. 243, illus. opposite p. 244.

192. **Sauceboat on Stand**
Paris, 1762
By Jean-Baptiste-François Cheret
Silver; silver-gilt
Sauceboat and stand marked with maker's stamp of *J.B.C.*; a key and two grains below a crowned fleur-de-lys; a crowned *Y* (the warden's mark used between July 21, 1762, and July 13, 1763); a crowned *A* with laurel

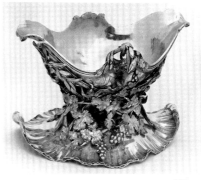

192

leaves (the charge mark used between November 22, 1762, and December 23, 1768, under the *fermier* Jean-Jacques Prévost); crossed laurel branches (the charge mark used on small silver objects between November 22, 1762, and December 23, 1768, under the *fermier* Jean-Jacques Prévost); a pointer's head (the discharge mark used on small silver objects between November 22, 1762, and December 23, 1768); a hunting horn (the countermark used between December 23, 1768, and September 1, 1775, under the *fermier* Julien Alaterre); a man's slipper (the countermark used between September 1, 1775, and April 7, 1781, under the *fermier* Jean-Baptiste Fouache); a boar's head (the "restricted warranty" of .800 minimum silver standard used in Paris exclusively from May 10, 1838); and a swan in an oval (the standard mark for silver of unknown origin that is sold at auction as used by contracting countries between July 1, 1893, and 1970). A coat of arms has probably been burnished off the cartouche on the sauceboat.

Height: 4¾ in. (12.1 cm;); Width: 5⅛ in. (14.3 cm); Depth: 7¾ in. (19.8 cm)
Accession number 71.DG.76.1–.2

PROVENANCE
Dukes of Buckingham and Chandos, London (sold 1903); J. H. Fitzhenry, London (sold, Christie's, London, November 20, 1913, lot 214); [Gaston Bensimon, Paris]; David David-Weill, Paris (sold, Palais Galliera, Paris, November 24, 1971, lot 14); purchased at that sale by J. Paul Getty.

EXHIBITIONS
Paris, Musée des Arts Décoratifs, *Exposition d'orfèvrerie française civile du XV^e siècle au début du XIX^e*, April–May 1926, no. 108, on loan from David David-Weill.

BIBLIOGRAPHY
Storia degli Argenti, Kirsten Aschengreen-Piacenti, ed. (Novara, 1987), p. 128, illus.

193. **Pair of Candelabra**
Paris, 1779–1782
By Robert-Joseph Auguste
Silver
Marked variously with maker's stamp of *R.J.A.* with a palm branch and two grains, below a crowned fleur-de-lys; a crowned *P* (the warden's mark used between July 18, 1778, and July 21, 1781); a crowned *S* (the warden's mark used between August 1, 1781, and July 13, 1782); the letters *P.A.R.I.S.* (the charge mark used between September 1, 1775, and April 7, 1781, under the *fermier* Jean-Baptiste Fouache); crossed *L*'s (the charge mark used between April 7, 1781,

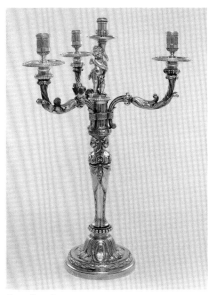

One of a pair 193

and June 4, 1783, under the *fermier* Henry Clavel); a jug (the discharge mark used on works destined for export between April 7, 1781, and June 4, 1783); an ant in a rectangle (the mark of .800 minimum standard for works imported into France from contracting countries as used since July 1, 1893); and the letter *G* (of unknown meaning). Each base engraved with the monogram *GR III* under a crown.
Height: 1 ft. 10⅛ in. (56.1 cm); Width: 1 ft. 3⅛ in. (38.5 cm) Depth: 1 ft. 2⅜ in. (36.5 cm)
Accession number 84.DG.42.1–.2

PROVENANCE
From a service made for George III of England; (?) Ernst Augustus, Duke of Cumberland and Brunswick-Lüneburg, King of Hanover, 1837; (?) Ernst Augustus, Duke of Cumberland and Brunswick-Lüneburg, 1851 (sold after his death, circa 1924); Cartier, Ltd., London, by 1926; Louis Cartier, Paris, by the 1960s; Claude Cartier, Paris, 1970s (sold, Sotheby's, Monaco, November 25–27, 1979, lot 824, with another pair of matching candelabra); Veronique Cartier, Paris, 1979.

EXHIBITIONS
Paris, Musée des Arts Décoratifs, *Exposition d'orfèvrerie française civile du XV^e siècle au début du XIX^e*, April–May 1926, no. 144, on loan from Cartier, Ltd., London; Paris, Galerie Mellerio, *L'Orfèvrerie et le bijou d'autrefois*, 1935, no. 70.

BIBLIOGRAPHY
Faith Dennis, *Three Centuries of French Domestic Silver: Its Makers and Its Marks* (New York, 1960), vol. 1, no. 20, p. 45, illus. vol. 2, p. 31; Claude Frégnac et al., *Les Grands orfèvres de Louis XIII à Charles X* (Collection Connaissance des arts, Paris, 1965), pp. 240–241, fig. 2; Jacques Helft, *French Master Goldsmiths and Silversmiths* (New York, 1966), p. 240, fig. 2; Serge Grandjean et al., *Cinq années d'enrichissement du patrimoine national 1975–1980*, Grand Palais, Paris, November 1980–March 1981, no. 109, pp. 128–129; "Acquisitions/ 1984," *GettyMusJ* 13 (1985), no. 63, p. 182, illus. (one); Jonathan Bourne and Vanessa Brett, *Lighting in the Domestic Interior: Renaissance to Art Nouveau* (London, 1991), illus. p. 108, fig. 344.

194

Back view 194

GOLD: JEWELRY

194. **Hercules Pendant**

Paris, circa 1540
Gold; white, blue, and black enamel; and
a baroque pearl
Height: 2⅜ in. (6 cm); Width: 2⅛ in.
(5.4 cm)
Accession number 85.SE.237

PROVENANCE

Baron Alphonse de Rothschild, Vienna;
Baron Nathaniel de Rothschild, Vienna;
C. Ruxton Love, New York (sold, Christie's,
Geneva, November 13, 1984, lot 45); [David,
Inc., Vaduz].

EXHIBITIONS

New York, A La Vieille Russie, *The Art of
the Goldsmith and the Jeweller*, November 6–23, 1968, no. 8, p. 15.

BIBLIOGRAPHY

Yvonne Hackenbroch, "Bijoux de l'Ecole
de Fontainebleau," *Actes du Colloque International sur l'Art de Fontainebleau* (Paris,
1975), p. 71, figs. 1–2; Yvonne Hackenbroch,
Renaissance Jewellery (London, 1979),
dust jacket illus. and pl. 7, nos. 140A-B,
pp. 63–64; *Christie's Review of the Season
1984* (Oxford, 1985), p. 338; Souren
Melikian, *Art and Auction* 7 (January 1985),
p. 144; "La Cote du Mois," *L'Estampille* 177
(January 1985), p. 67; "Acquisitions/1985,"
GettyMusJ 14 (1986), no. 216, pp. 252–253,
illus.; *Handbook* 1991, p. 204, illus.

ENAMELS

195. **Prudence *Commesso* Hat Badge
(*enseigne*)**

1550–1560
Gold; white, blue, red, and black enamel;
chalcedony; and a table-cut diamond
Height: 2¼ in. (5.7 cm)
Accession number 85.SE.238

PROVENANCE

Baronne James de Rothschild, Paris, 1866;
Thomas F. Flannery, Jr., Winnetka, Illinois
(sold, Sotheby's, London, December 1, 1983,
lot 288); [David, Inc., Vaduz].

EXHIBITIONS

Loyola University of Chicago, *The Art of
Jewelry, 1450–1600*, 1975, no. 9; The Fine Arts
Museums of San Francisco, *The Triumph
of Humanism: Three Phases of Renaissance
Decorative Arts 1450–1600*, October 1977–
January 1978, no. 99.

195

BIBLIOGRAPHY

Edouard Lièvre, *Les Collections célèbres
d'oeuvres d'art* (Paris, 1866), pl. 49; Donald F.
Rowe, "The Art of Jewellery, 1540–1650,"
Connoisseur 188 (April 1975), p. 293, pl. 4;
Yvonne Hackenbroch, *Renaissance Jewellery*
(London, 1979), pp. 90–92, pl. 8, fig. 236;
Art at Auction: the Year at Sotheby's 1983–1984
(London, 1984), p. 202; "Acquisitions/1985,"
GettyMusJ 14 (1986), no. 217, p. 253, illus.

196. **Twelve Plaques with Scenes from the
Passion of Christ**

Limoges, 1530s
By Jean II Pénicaud
Polychrome enamel on copper with gold
highlights
Each stamped on back under clear counter-
enamel with a *P* surmounted by a crown
(Pénicaud workshop stamp). Also inscribed
SANCT. PETR. on Saint Peter's robe in *The
Entry into Jerusalem* plaque and *IOSEP .
DABAR* on robe of Joseph in *The Entomb-
ment* plaque.
Height (each plaque): approx. 3 7/10 in.
(9.4 cm); Width: approx. 2 4/5 in. (7.3 cm)
Accession number 88.SE.4.1–.12

PROVENANCE

Alessandro Castellani, Rome (sold, Hôtel
Drouot, Paris, May 12–16, 1884, lot 472);
Mante collection, Paris, 1884; by descent to
Robert Mante, Paris, until 1986; [Same Art,
Ltd., Zurich].

196

EXHIBITIONS

Lille, *Exposition rétrospective de l'art français
au Trocadéro*, 1889, no. 1037.

BIBLIOGRAPHY

Hippolyte Mireur, *Dictionnaire des ventes
d'art faites en France et à l'étranger. . .* (Paris,
1901–1912; rpr. Hildesheim, 1971), p. 522;
"Acquisitions/1988," *GettyMusJ* 17 (1989),
no. 89, pp. 148–150, illus.; Peggy Fogelman,
"The Passion of Christ: Twelve Enamel
Plaques in the J. Paul Getty Museum,"
GettyMusJ 18 (1990), pp. 127–140.

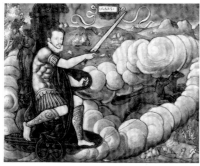

Mars 197

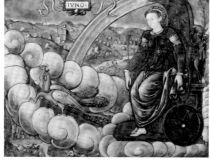

Juno 197

197. ***Allegory of Charles IX as Mars***
Allegory of Catherine de' Medici as Juno
Limoges, 1573
Léonard Limosin
Polychrome enamel on copper and silver
with painted gold highlights; modern
frames
Signed *LL* on sword of Mars, dated *1573* in
center of cloud at left of Mars. Signed *LL* at
bottom of cloud in bottom center of Juno.
Inscribed on backs at a later date *C DE
MEDICIS* and *CHARLES IX*.
Height: 6⅞ in. (17.5 cm); Width: 9 in.
(23 cm), each plaque, without frames
Accession numbers: 86.SE.536.1 (Mars);
86.SE.536.2 (Juno)

PROVENANCE

Debruge-Dumenil, 1847; Albert Primrose,
6th Earl of Rosebery, Mentmore Towers,
Buckinghamshire (sold, Sotheby's, London,
May 20, 1977 [*hors* catalogue]); Lord Astor,
Hever Castle (sold, Sotheby's, London, May
6, 1983, lot 296); [Cyril Humphris,
London].

BIBLIOGRAPHY

Joseph Laborde, *Déscription des objets d'art
qui composent la collection Debruge
Dumenil* (Paris, 1847), nos. 704–705;
Joseph Laborde, *Notice des émaux, bijoux,
et objets divers exposés dans les galeries du
Musée du Louvre* (Paris, 1853), pp. 186–187;
Louis Dimier, *Histoire de la peinture de
portrait en France au XVI^e siècle*, vol. 3
(Paris and Brussels, 1926), no. 33, p. 250;
Philippe Verdier, *The Frick Collection*, vol.
8 (New York, 1977), no. 13, pp. 124, 126;
"Acquisitions/1986," *GettyMusJ* 15 (1987),
no. 199, pp. 218–219, illus.

Ceramics

198. **Oval Basin**
Saintes, circa 1550
Attributed to Bernard Palissy
Lead-glazed earthenware
Height: 2 ⅝ in. (6.6 cm); Length: 1 ft. 7 in.
(48.2 cm); Width: 1 ft. 2½ in. (36.8 cm)
Accession number 88.DE.63

PROVENANCE

Carl Becker, Cologne; private collection,
England; British art market.

BIBLIOGRAPHY

*Katalog der Kunst-Sammlung, Consul Carl
Becker*, J. M. Heberle (H. Lempertz Söhne),
Versteigerung zu Köln (Cologne, 1898),
no. 12, p. 2; Alan Gibbon, *Céramiques de
Bernard Palissy* (Paris, 1986), book jacket;
"Acquisitions/1988," *GettyMusJ* 17 (1989),
no. 84, p. 146, illus.

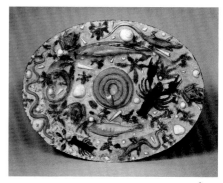

198

199. **(?) Model for a Ceramic Vessel**

Paris, circa 1725–1730

Terracotta

Incised under the base *EX MUSEO P.C. DE. MONCREIFFE. DOCT. ET. SOC. SORBONICI. ECLE AE DUEN (?)SI DECANUS.* Modeled with the arms, monogram, and coronet (now partly missing) of Louis-Henri, prince de Condé, duc de Bourbon.

Height: 1 ft. ¾ in. (32.4 cm); Width: 11¾ in. (29.8 cm); Depth: 11¾ in. (29.8 cm)

Accession number 83.DE.36

PROVENANCE

Louis-Henri, 7th prince de Condé, duc de Bourbon, Château de Chantilly (1692–1740); (?) François-Augustin Paradis de Moncrif (1687–1770); Pierre-Charles de Moncrif, archbishop of the cathedral church d'Autun, recorded as item 6 in Moncrif's *cabinet de curiosités* in the inventory taken after his death on September 25, 1771 [information: B. Pons]; David David-Weill, Paris; [Didier Aaron, Paris, 1981].

BIBLIOGRAPHY

Wilson, "Acquisitions 1983," no. 5, pp. 187, 189–192, 194, illus.; "Acquisitions/1983," *GettyMusJ* 12 (1984), no. 7, p. 263, illus.

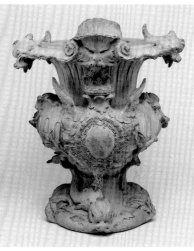

199

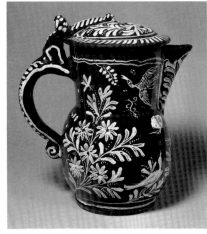

200

NIVERNOIS

200. **Lidded Jug**

Nivernois, 1680–1690

Tin-glazed and painted earthenware

Height: 7½ in. (19.1 cm); Width: 7⅛ in. (18.1 cm); Depth: 4 in. (10.2 cm)

Accession number 88.DE.126

PROVENANCE

De Jouvenal collection, France; [Georges Lefebvre, Paris, 1988].

BIBLIOGRAPHY

"Acquisitions/1988," *GettyMusJ* 17 (1989), no. 65, p. 140, illus.

SAINT-CLOUD

201. **Lidded Ewer and Basin**

Porcelain: Saint-Cloud manufactory, early eighteenth century

Mounts: Paris, 1717–1722

Soft-paste porcelain, underglaze blue decoration; silver mounts

The base of the ewer bears a paper label *5.L. 4338.8* and *Charles E. Dunlap.* Each silver mount has a fleur-de-lys without a crown (the Paris discharge mark for small silver works used between October 23, 1717, and May 5, 1722) and an indistinct mark.

Ewer: Height: 6⅝ in. (17 cm); Width: 5 in. (12.8 cm); Depth: 4 in. (10.2 cm); Basin: Height: 3³⁄₁₆ in. (8.1 cm); Diameter: 8¼ in. (20.8 cm)

Accession number 88.DI.112.1–.2

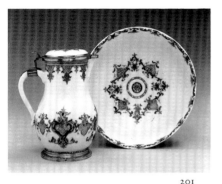

201

PROVENANCE

Mrs. H. Dupuy, New York (sold, Parke-Bernet, New York, April 3, 1948, lot 358); estate of Mrs. Charles E. Dunlap, New York (sold, Sotheby, Parke, Bernet, New York, December 3, 1975, lot 231); purchased at that sale by The British Rail Pension Fund.

EXHIBITIONS

New York, The Metropolitan Museum of Art, *Masterpieces of European Porcelain*, 1949, no. 144; Malibu, The J. Paul Getty Museum, on loan, 1982–1988.

BIBLIOGRAPHY

"Acquisitions/1988," *GettyMusJ* 17 (1989), no. 70, p. 141, illus.

MOUSTIERS

202. **Lidded Jar**

Moustiers, (?) Clérissy manufactory, circa 1723–1725
Tin-glazed earthenware
Painted with the arms of Jean d'Arlatan, marquis de la Roche and baron de Lauris, on the jar and lid. The base is painted in blue (?) *FA*.
Height: 10¼ in. (26 cm); Diameter: 8¾ in. (22.5 cm)
Accession number 84.DE.917.a–.b

PROVENANCE

Jean d'Arlatan, marquis de la Roche, circa 1723; [Nicolier, Paris].

BIBLIOGRAPHY

"Acquisitions/1984," *GettyMusJ* 13 (1985), no. 51, p. 177, illus.

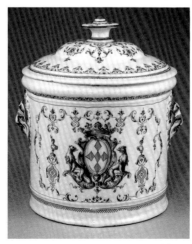

202

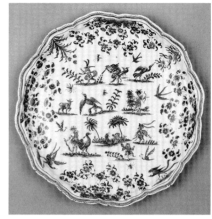

203

203. **Plate**

Moustiers, Olerys manufactory, circa 1740–1760
Earthenware; polychrome enamel decoration
Height: 1⁷⁄₁₆ in. (3.7 cm); Diameter: 1 ft. 5⅝ in. (44.8 cm)
Accession number 87.DE.25

PROVENANCE

[Georges Lefebvre, Paris, 1986].

BIBLIOGRAPHY

"Acquisitions/1987," *GettyMusJ* 16 (1988), no. 75, p. 178, illus.

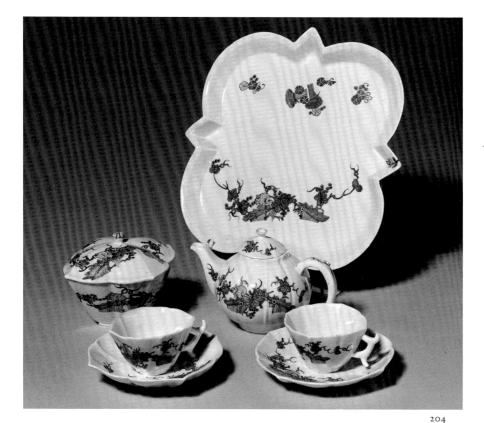

204

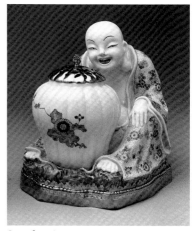

One of a pair 205

CHANTILLY

204. **Tea Service**
Chantilly manufactory, circa 1730–1735
Soft-paste porcelain; polychrome enamel
decoration
Tray: Height: ¹³⁄₁₆ in. (2.1 cm); Width:
8¹³⁄₁₆ in. (22.4 cm); Depth: 8¹⁵⁄₁₆ in. (22.7 cm);
Cups: Height: 1⁹⁄₁₆ in. (4 cm); Width: 3¼ in.
(8.2 cm); Depth: 2⅝ in. (6.7 cm); Saucers:

Height: ¹⁵⁄₁₆ in. (2.3 cm); Width: 4⁹⁄₁₆ in.
(11.6 cm); Depth: 4¹⁷⁄₃₂ in. (11.5 cm); Sugar
Bowl: Height: 3⅛ in. (7.7 cm); Width:
4⅜ in. (11.1 cm); Depth: 4¹⁄₁₆ in. (10.3 cm);
Teapot: Height: 3½ in. (8.9 cm); Width:
5⅛ in. (13.1 cm); Depth: 3⁵⁄₁₆ in. (8.4 cm)
Accession number 82.DE.167.1–.5

PROVENANCE
[Klaber and Klaber, London, 1980];
[Winifred Williams, Ltd., London, 1982].

EXHIBITIONS
New York, The Cooper-Hewitt Museum,
Design in the Service of Tea, August–
October 1984.

BIBLIOGRAPHY
Sassoon, "Acquisitions 1982," no. 5,
pp. 33–36, illus.

205. **Pair of *Magot* Figures**
Chantilly manufactory, circa 1740
Soft-paste porcelain; polychrome enamel
decoration; gilt-bronze mounts
Height: 7 in. (18 cm); Width: 7 in. (18 cm);
Depth: 7 in. (18 cm)
Accession number 85.DI.380.1–.2

PROVENANCE
Miss A. Phillips, London (sold, Sotheby's, London, February 28, 1961, lot 56); [Winifred Williams, Ltd., London]; [Partridge (Fine Arts) Ltd., London].

BIBLIOGRAPHY
"Acquisitions/1985," *GettyMusJ* 14 (1986), no. 197, p. 245, illus.

206. **Chamber Pot (*bourdaloue*)**
Chantilly manufactory, circa 1740
Soft-paste porcelain; polychrome enamel decoration
Painted on the base with the iron-red hunting horn mark of the Chantilly manufactory.

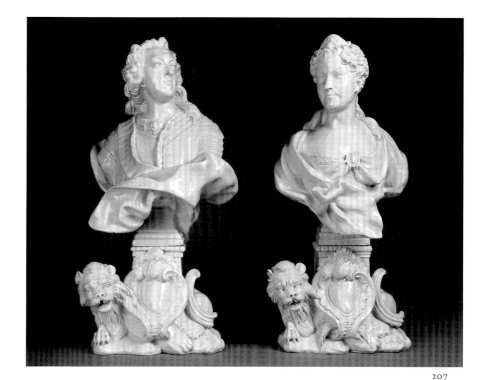

207

Height: 3¹³⁄₁₆ in. (9.8 cm); Width: 7¹¹⁄₁₆ in. (19.6 cm); Depth: 4⅝ in. (11.8 cm)
Accession number 82.DE.9

PROVENANCE
Pierre de Regainy, Paris, 1957; Wilfred J. Sainsbury, England; [Kate Foster, Rye, England]; [Rosenberg and Stiebel, Inc., New York, 1977].

BIBLIOGRAPHY
Sassoon, "Acquisitions 1982," no. 6, pp. 36–38, illus.

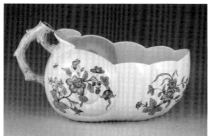

206

LUNEVILLE

207. **Pair of Busts: Louis XV and Marie Leczinska**
Lunéville manufactory, circa 1755
Lead-glazed earthenware (*faïence fine*)
Bust of Louis XV: Height: 1 ft. 8⅞ in. (53 cm); Width: 9⁷⁄₁₆ in. (24 cm); Depth: 9⅞ in. (25 cm); Bust of Marie Leczinska: Height: 1 ft. 8⅞ in. (53 cm); Width: 6⅛ in. (15.5 cm); Depth: 9⅞ in. (25 cm)
Accession number 86.DE.668.1–.2

PROVENANCE
[Michel Vandermeersch, Paris].

BIBLIOGRAPHY
"Acquisitions/1986," *GettyMusJ* 15 (1987),
no. 103, pp. 212–213, illus.

MENNECY

208. **Bust of Louis XV**
Mennecy manufactory, circa 1750–1755
Soft-paste porcelain
Height: 1 ft. 5 in. (43.2 cm); Width: 9 9/16 in.
(24.5 cm); Depth: 5 11/16 in. (14.5 cm)
Accession number 84.DE.46

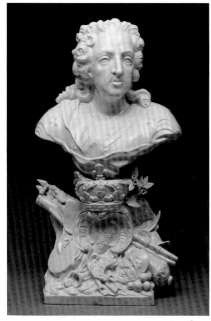

208

PROVENANCE
Private collection, Paris (sold, Hôtel Drouot,
Paris, March 14, 1910, lot 44); [Vander-
meersch, Paris, late 1940s]; Mr. and Mrs.
William Brown Meloney, Riverdale, New
York, late 1940s; [The Antique Porcelain
Co., Zurich, from late 1950s].

BIBLIOGRAPHY
Babette Craven, "French Soft Paste Porce-
lain in the Collection of Mr. and Mrs.
William Brown Meloney," *Connoisseur* 143
(May 1959), pp. 135–142, fig. 10; "Acquisi-
tions/1984," *GettyMusJ* 13 (1985), no. 55,
p. 179, illus.; *Handbook* 1986, p. 160, illus.;
Handbook 1991, p. 176, illus.

209. **Figure of a Street Vendor**
Mennecy manufactory, circa 1755–1760
Soft-paste porcelain
Impressed on the right side of the base with
the Mennecy manufactory mark *DV*.

DV

Height: 9 3/8 in. (23.9 cm); Width: 4 1/2 in.
(11.5 cm); Depth: 4 1/4 in. (10.7 cm)
Accession number 86.DE.473

PROVENANCE
Mr. and Mrs. William Brown Meloney,
Riverdale, New York; [The Antique Porce-
lain Co., New York, 1986].

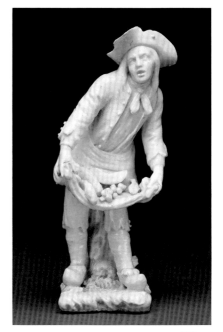

209

BIBLIOGRAPHY
Babette Craven, "French Soft Paste Porce-
lain in the Collection of Mr. and Mrs.
William Brown Meloney," *Connoisseur* 143
(May 1959), p. 142; "Acquisitions/1986,"
GettyMusJ 15 (1987), no. 104, p. 213, illus.

SCEAUX

210. **Vase (*pot-pourri*)**

Sceaux manufactory, circa 1755
Attributed to Jacques Chapelle
Glazed earthenware; polychrome enamel
decoration
Height: 1 ft. 1 in. (33 cm); Width: 9½ in.
(24.1 cm); Depth: 6 in. (15.2 cm)
Accession number 85.DE.347

PROVENANCE

Florence J. Gould, Villa El Patio, Cannes
(sold, Sotheby's, Monaco, June 27, 1984,
lot 1588); [The Antique Porcelain Co.,
London].

BIBLIOGRAPHY

"Acquisitions/1985," *GettyMusJ* 14 (1986),
no. 198, p. 245, illus.

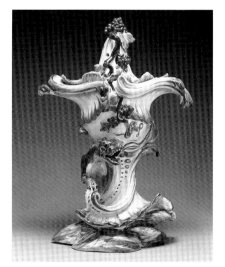

210

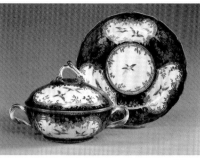

211

VINCENNES

211. **Lidded Bowl and Stand (*écuelle ronde et plateau rond*)**

Vincennes manufactory, circa 1752–1753
Soft-paste porcelain, *bleu lapis* ground color;
polychrome enamel decoration; gilding
Bowl and stand both painted underneath
with the blue crossed *L*'s of the Vincennes
manufactory; both incised *I*.

Bowl: Height: 5½ in. (14 cm); Width: 8¾ in.
(22.2 cm); Depth: 6⅝ in. (16.7 cm); Stand:
Height: 1⅛ in. (4.1 cm); Diameter: 8¹⁵⁄₁₆ in.
(22.8 cm)
Accession number 89.DE.44.a–.b

PROVENANCE

Private collection, England; [Alexander and
Berendt, Ltd., London, 1988].

BIBLIOGRAPHY

"Acquisitions/1989," *GettyMusJ* 18 (1990),
no. 51, p. 192, illus.

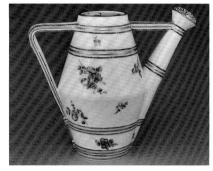

212

212. **Watering Can (*arrosoir, deuxième grandeur*)**

Vincennes manufactory, 1754
Painted by Bardet
Soft-paste porcelain, polychrome enamel
decoration; gilding
Painted underneath with the blue crossed
L's of the Vincennes manufactory (with a
dot at their apex) enclosing the date letter *B*
for 1754, and with the painter's mark of two
short parallel lines. Incised *4*.

Height: 7¾ in. (19.7 cm); Width: 9⁹⁄₁₆ in.
(24.5 cm); Depth: 5⅛ in. (13 cm)
Accession number 84.DE.89

PROVENANCE

Florence, Countess of Northbrook (wife of
the 2nd Earl, married 1899, died 1946) (sold,
Christie's, London, November 25, 1940, part
of lot 78); Hugh Burton-Jones, England,
1940; Kathleen Burton-Jones (Mrs. Gifford

Scott) (sold, Sotheby's, London, June 12, 1984, lot 172); [Winifred Williams, Ltd., London, 1984].

BIBLIOGRAPHY
Adrian Sassoon, "Vincennes and Sèvres Porcelain Acquired by the J. Paul Getty Museum in 1984," *GettyMusJ* 13 (1985), pp. 89–91, illus.; "Acquisitions/1984," *GettyMusJ* 13 (1985), no. 58, p. 180, illus.; *Sotheby's Concise Encyclopedia of Porcelain*, David Battie, ed. (London, 1990), p. 107, illus.; Sassoon, *Vincennes and Sèvres Porcelain*, no. 1, pp. 4–7, illus. pp. 5, 7.

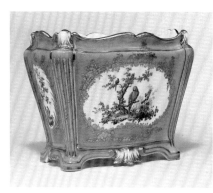

213.

213. **Vase (*cuvette à tombeau, première grandeur*)**
Vincennes manufactory, 1754–1755
Painted by the crescent mark painter
Soft-paste porcelain, *bleu céleste* ground color; polychrome enamel decoration; gilding

Painted underneath with the blue crossed *L*'s of the Vincennes manufactory enclosing the date letter *A* for 1753, and with the painter's mark of a crescent.

Height: 9 ¼ in. (23.4 cm); Width: 11 ⅞ in. (30 cm); Depth: 8 ½ in. (21.6 cm)
Accession number 73.DE.64

PROVENANCE
(?) Sold by the Vincennes manufactory between January 1 and August 20, 1756, to the *marchand-mercier* Lazare Duvaux, Paris, for 840 *livres*; (?) sold by Lazare Duvaux on March 1, 1756, to Count Joachim Godske Moltke of Copenhagen, Denmark, as part of a garniture of five vases (sold by his descendants in Paris in the nineteenth century); [(?) Gilbert Lévy, Paris, early twentieth century]; private collection, Paris; [Rosenberg and Stiebel, Inc., New York, early 1970s]; purchased by J. Paul Getty..

BIBLIOGRAPHY
Le Livre-Journal de Lazare Duvaux, marchand-bijoutier ordinaire du roy, 1748–1758, Louis Courajod, ed. (Paris, 1873), vol. 2, no. 2420, p. 274; Savill, *Sèvres*, vol. 1, p. 33; n. 2a, p. 40; Tamara Préaud and Antoine d'Albis, *La Porcelaine de Vincennes* (Paris, 1991), p. 67, illus., and no. 195, p. 180, illus.; Sassoon, *Vincennes and Sèvres Porcelain*, no. 2, pp. 8–10, illus. pp. 9, 11.

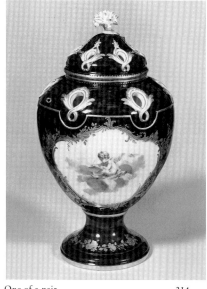

One of a pair 214

214. **Pair of *Pot-pourri* Vases (*pots-pourris Pompadour, troisième grandeur*)**
Vincennes manufactory, 1755
Model design by Jean-Claude Duplessis; painted by Jean-Louis Morin after engraved designs by François Boucher
Soft-paste porcelain, *bleu lapis* ground color, carmine red decoration; gilding
Each vase painted under the base with blue crossed *L*'s of the Vincennes manufactory enclosing the date letter *C* for 1755, also with Morin's mark *M* in blue and two blue dots. Each vase incised *2* under the base.

Height: 10 in. (25.5 cm); Diameter: 6 in. (15.2 cm)
Accession number 84.DE.3.1–.2

PROVENANCE
(?) Sold by the Sèvres manufactory between August 20, 1756, and September 1756 to the *marchand-mercier* Lazare Duvaux, Paris, for 180 *livres* each; (?) sold by Lazare Duvaux in September 1756 to Frederick, 3rd Viscount St. John, 2nd Viscount Bolingbroke, Lydiard Park, Wiltshire; anonymous collection (sold, Sotheby's, London, March 5, 1957, lot 96); [The Antique Porcelain Co., London, 1957]; private collection; [The Antique Porcelain Co., London, 1983].

BIBLIOGRAPHY
Adrian Sassoon, "Vincennes and Sèvres Porcelain Acquired by the J. Paul Getty Museum in 1984," *GettyMusJ* 13 (1985), pp. 91–94, illus.; "Acquisitions/1983," *GettyMusJ* 13 (1985), no. 60, p. 181, illus.; Savill, *Sèvres*, vol. 1, p. 129; n. 3k, p. 132; nn. 26, 32, p. 134; vol. 2, p. 851; n. 59, p. 857; Sassoon, *Vincennes and Sèvres Porcelain*, no. 3, pp. 12–18, illus. pp. 13–15, 18.

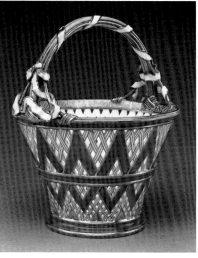

215

SEVRES

215. **Basket (*panier, deuxième grandeur*)**
Sèvres manufactory, 1756
Soft-paste porcelain, green ground color; gilding
Painted under the base with the blue crossed *L*'s of the Sèvres manufactory enclosing the date letter *D* for 1756, and with three dots. Incised with *répareur*'s mark *PZ* under the base.

Height: 8⅝ in. (22 cm); Width: 7⅞ in. (20.1 cm); Depth: 7⅛ in. (18 cm)
Accession number 82.DE.92

PROVENANCE
Private collection, France (sold, Christie's, London, June 28, 1982, lot 19); [Armin B. Allen, New York, 1982].

BIBLIOGRAPHY
Sassoon, "Acquisitions 1982," no. 8, pp. 45–47, illus.; Wilson, *Selections*, no. 26, pp. 52–53, illus.; Adrian Sassoon, "Sèvres: Luxury for the Court," *Techniques of the World's Great Masters of Pottery and Ceramics*, Hugo Morley-Fletcher, ed. (Oxford, 1984), pp. 52–57, illus.; *Handbook* 1986, p. 165, illus.; Antoine d'Albis, "Le Marchand Mercier Lazare Duvaux et la Porcelaine de Vincennes," *Les Décors des boutiques parisiennes*, La Delegation à l'Action Artistique de la Ville de Paris, eds. (Paris, 1987), pp. 76–88; Savill, *Sèvres*, vol. 2, p. 752; n. 3d, p. 756; Sassoon, *Vincennes and Sèvres Porcelain*, no. 4, pp. 20–22, illus. pp. 21–22; *Handbook* 1991, p. 181, illus.

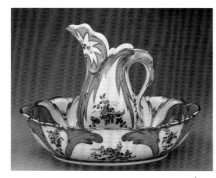

216

216. Ewer and Basin (*broc et jatte feuille d'eau, première grandeur*)

Sèvres manufactory, 1757
Possibly modeled after a design by Jean-Claude Duplessis
Soft-paste porcelain, pink ground color; polychrome enamel decoration; gilding
Basin painted underneath with the blue crossed *L*'s of the Sèvres manufactory enclosing the date letter *E* for 1757, and with an unidentified painter's mark. Ewer incised *.T.m*; basin incised *C.N.*

Ewer: Height: 7 9/16 in. (19.2 cm); Width: 5 5/8 in. (14.1 cm); Depth: 3 3/16 in. (8.1 cm); Basin: Height: 2 3/4 in. (7.1 cm); Width: 11 1/2 in. (29.1 cm); Depth: 8 7/16 in. (22.1 cm)
Accession number: 84.DE.88.a-.b

PROVENANCE
(?) William John Cavendish-Bentinck-Scott, 5th Duke of Portland (died 1879); Dukes of Portland, by descent, Welbeck Abbey, Nottinghamshire (sold, Henry Spencer and Sons, Retford, Nottinghamshire, July 23, 1970, lot 288); [Winifred Williams, Ltd., London, 1970]; Eric Robinson, Mereworth Castle, Kent (sold, Sotheby's, London, June 12, 1984, lot 213); [Winifred Williams, Ltd., London, 1984].

BIBLIOGRAPHY
Best, Son, and Carpenter, *Catalogue of the Ornamental Furniture, Works of Art, and Porcelain at Welbeck Abbey* (London, 1897), no. 296, p. 52; Adrian Sassoon, "Vincennes and Sèvres Porcelain Acquired by the J. Paul Getty Museum in 1984," *GettyMusJ* 13 (1985), pp. 95–98, illus.; "Acquisitions/1984," *GettyMusJ* 13 (1985), no. 61, p. 181, illus.; *Sotheby's Concise Encyclopedia of Porcelain*, David Battie, ed. (London, 1990), p. 109, illus.; Sassoon, *Vincennes and Sèvres Porcelain*, no. 5, pp. 24–28, illus. pp. 25–27.

217. Pair of Figure Groups: *The Flute Lesson* (Le Flûteur) and *The Grape Eaters* (Les Mangeurs de Raisins)

Sèvres manufactory, circa 1757–1766
After designs by François Boucher
Soft-paste biscuit porcelain, traces of red pigment
The Flute Lesson incised *F* on back.

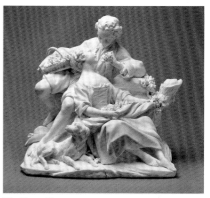

The Flute Lesson: Height: 8 3/4 in. (22.3 cm); Width: 10 in. (25.4 cm); Depth: 6 in. (15.2 cm); *The Grape Eaters*: Height: 9 in. (22.9 cm); Width: 9 3/4 in. (24.8 cm); Depth: 7 in. (17.8 cm)

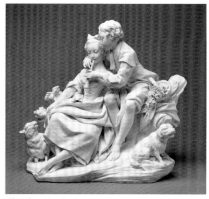

The Flute Lesson 217

The Grape Eaters 217

Accession number 70.DE.98.1–.2

PROVENANCE
Goury de Rosland, Paris (sold, Galerie Georges Petit, Paris, May 29–30, 1905, lot 108); Mortimer L. Schiff, New York (sold by his heir John L. Schiff, Christie's, London, June 22, 1938, lot 27); purchased at that sale by J. Paul Getty.

BIBLIOGRAPHY

Antoine d'Albis, "Le Marchand Mercier Lazare Duvaux et la Porcelaine de Vincennes," *Les Décors des boutiques parisiennes* (Paris, 1987), La Delegation à l'Action artistique de la Ville de Paris, eds., pp. 76–88, *The Flute Lesson* illus. p. 83; Sassoon, *Vincennes and Sèvres Porcelain*, no. 6, pp. 29–34, illus. pp. 31–33.

218. Tray (*plateau carré, deuxième grandeur*)

Sèvres manufactory, 1758
Soft-paste porcelain; pink ground color; polychrome enamel decoration; gilding
Painted underneath with the blue crossed *L*'s of the Sèvres manufactory enclosing the date letter *F* for 1758, and with an unidentified painter's mark of a blue *E*. Incised *60* underneath.

Height: ¹⁵⁄₁₆ in. (2.3 cm); Width: 5 in. (12.7 cm); Depth: 5¹⁄₁₆ in. (12.8 cm)
Accession number 72.DE.75

PROVENANCE

Anne and Deane Johnson, Los Angeles (sold, Sotheby's, New York, December 9, 1972, lot 27); purchased at that sale by J. Paul Getty.

BIBLIOGRAPHY

Savill, *Sèvres*, vol. 2, n. 3m, p. 589; Sassoon, *Vincennes and Sèvres Porcelain*, no. 7, pp. 36–38, illus. p. 37.

218

219. Pair of Cups and Saucers (*gobelets Calabre et soucoupes*)

Sèvres manufactory, 1759
Painted by Charles Buteux *père*
Soft-paste porcelain, pink and green ground colors; polychrome enamel decoration; gilding
Saucers painted underneath with the blue crossed *L*'s of the Sèvres manufactory enclosing the date letter *g* for 1759, and with the painter's mark of a blue anchor. One cup incised under the base with an *h*; the other cup incised with an indecipherable mark in script.

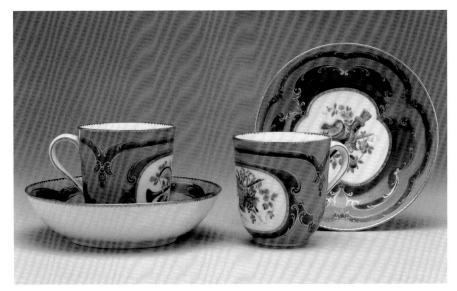

219

Cups: Height: 3¼ in. (8.3 cm); Width: 4 in. (10.2 cm); Depth: 3⅛ in. (7.9 cm); Saucers: Height: 1⅝ in. (4.1 cm); Diameter: 6³⁄₁₆ in. (15.7 cm)
Accession number 72.DE.74.1–.2

PROVENANCE
Otto and Magdalena Blohm, Hamburg (sold, Sotheby's, London, July 5, 1960, lots 126–127); Anne and Deane Johnson, Los Angeles (sold, Sotheby's, New York, December 9, 1972, lot 21); purchased at that sale by J. Paul Getty.

BIBLIOGRAPHY
E. S. Auscher, *A History and Description of French Porcelain* (London and New York, 1905), pl. 4; Robert Schmidt, *Early European Porcelain as Collected by Otto Blohm* (Munich and London, 1953), p. 101, illus.; Savill, *Sèvres*, vol. 2, pp. 629, 652; n. 2, p. 637; n. 134, p. 666; Sassoon, *Vincennes and Sèvres Porcelain*, no. 8, pp. 39–40, illus. pp. 40–41.

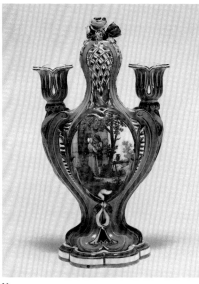

Vase .1 220

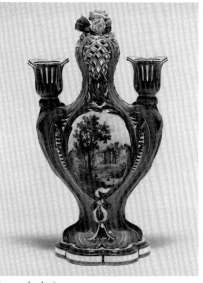

Vase .1 back view 220

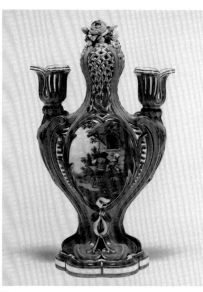

Vase .2 220

Vase .2 back view 220

220. **Pair of Vases (*pot-pourri à bobèches*)**
Sèvres manufactory, 1759
Painted by Charles-Nicolas Dodin after
engraved designs by David Teniers *le jeune*
Soft-paste porcelain, pink and green
ground colors; polychrome enamel decoration; gilding
One painted underneath with the blue
crossed *L*'s of the Sèvres manufactory
enclosing the date letter *G* for 1759, and
with Dodin's mark *k*. Various paper collectors' labels pasted under the bases. One
vase unmarked.

Height: 9 ¹³⁄₁₆ in. (24.9 cm); Width: 5 ¹¹⁄₁₆ in.
(14.4 cm); Depth: 3 ¹¹⁄₁₆ in. (9.4 cm)
Accession number 75.DE.65.1–.2

PROVENANCE
[Duveen Brothers, New York]; J. Pierpont
Morgan, London and New York; J. Pierpont Morgan, Jr., New York (sold, Parke-Bernet, New York, March 25, 1944, lot 647);
Paula de Koenigsberg, Buenos Aires, 1945;
Claus de Koenigsberg, Buenos Aires;
[Rosenberg and Stiebel, Inc., New York,
1975]; purchased by J. Paul Getty.

EXHIBITIONS
New York, The Metropolitan Museum of
Art, on loan 1914–1915 from J. Pierpont
Morgan; Buenos Aires, Museo Nacional de
Bellas Artes, *Exposición de obras maestras:
Colección Paula de Koenigsberg*, October
1945, no. 206, illus.; Buenos Aires, Museo
Nacional de Arte Decorativo, *El Arte de
vivir en francia del siglo XVIII*, September–
November 1968, no. 427, pl. 221.

BIBLIOGRAPHY
P. G. Konody, "Die Kunsthistorische
Sammlung Pierpont Morgans," *Kunst und
Kunsthandwerk* (Vienna, 1903), no. 6, p. 158;
comte Xavier de Chavagnac, *Catalogue
des porcelaines françaises de M. J. Pierpont
Morgan* (Paris, 1910), no. 107, pl. 32; Gillian
Wilson, "Sèvres Porcelain at the J. Paul
Getty Museum," *GettyMusJ* 4 (1977),
pp. 5–24, illus.; Adrian Sassoon, "Sèvres
Vases," *Techniques of the World's Great
Masters of Pottery and Ceramics*, Hugo
Morley-Fletcher, ed. (Oxford, 1984),
pp. 64–67, illus. p. 31; Pierre Ennès,
"Essai de réconstitution d'une garniture
de Madame de Pompadour," *Journal of
the Walters Art Gallery* 42–43 (1984–1985),
pp. 70–82; *J. Pierpont Morgan, Collector:
European Decorative Arts from the Wadsworth Atheneum*, Linda Horvitz Roth, ed.
(Hartford, 1987), p. 203; Barry Shifman,
"Eighteenth-Century Sèvres Porcelain in
America," *Madame de Pompadour et la
floraison des arts* (Montréal, 1988), pp. 118–123;
Sassoon, *Vincennes and Sèvres Porcelain*,
no. 9, pp. 42–48, illus. pp. 42–45.

221. **Lidded *Pot-pourri* Vase (*vase or
pot-pourri vaisseau à mât, deuxième
grandeur*)**
Sèvres manufactory, circa 1760
Painting attributed to Charles-Nicolas
Dodin

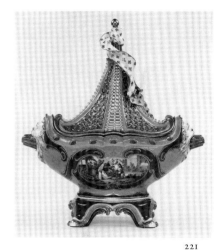

221

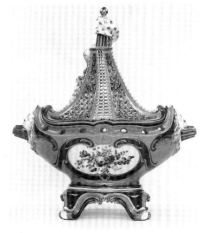

Back view 221

Soft-paste porcelain, pink and green ground colors; polychrome enamel decoration; gilding
Painted underneath with the blue crossed *L*'s (partially abraded) of the Sèvres manufactory.
Height: 1 ft. 2¾ in. (37.5 cm); Width: 1 ft. 1¹¹⁄₁₆ in. (34.8 cm); Depth: 6¹³⁄₁₆ in. (17.4 cm)
Accession number 75.DE.11.a–.b

PROVENANCE

(?) George William, 6th Earl of Coventry, Croome Court, Worcestershire; George William, 7th Earl of Coventry, Croome Court, Worcestershire (sold, Christie's, London, June 12, 1874, part of lot 150, for £10,500); William Humble, 1st Earl of Dudley, Dudley House, London, 1874; (sold privately, 1885–1886); William J. Goode, London (offered for sale, Christie's, London, July 17, 1895, part of lot 147, bought in for £8,400; sold, Christie's, London, May 20, 1898, part of lot 94b, for £6,450 to Pilkington); [Asher Wertheimer, London, 1898]; [Duveen Brothers, New York]; J. Pierpont Morgan, New York, 1908–1910 (purchased for £15,500); J. Pierpont Morgan, Jr., New York, 1913 (sold, Parke-Bernet, New York, January 8, 1944, lot 486); Paula de Koenigsberg, Buenos Aires, 1945; Claus de Koenigsberg, Buenos Aires; [Rosenberg and Stiebel, Inc., New York, 1975]; purchased by J. Paul Getty.

EXHIBITIONS

New York, The Metropolitan Museum of Art, on loan 1914–1915 from J. Pierpont Morgan; Buenos Aires, Museo Nacional de Bellas Artes, *Exposición de obras maestras: Colección Paula de Koenigsberg*, October 1945, no. 205, illus.; Buenos Aires, Museo Nacional de Arte Decorativo, *El arte de vivir en francia del siglo XVIII*, September–November 1968.

BIBLIOGRAPHY

George Redford, *Art Sales 1628–1887* (London, 1888), vol. 1, pp. 400, 438; comte Xavier de Chavagnac, *Catalogue des porcelaines françaises de M. J. Pierpont Morgan* (Paris, 1910), no. 109, pl. 33; Frederick Litchfield, "Imitations and Reproductions: Part I—Sèvres Porcelain," *Connoisseur* (September 1917), p. 6; C. C. Dauterman, J. Parker, and E. Standen, *Decorative Art from the S. H. Kress Collection in the Metropolitan Museum of Art* (London, 1964), p. 195; Gillian Wilson, "Sèvres Porcelain at the J. Paul Getty Museum," *GettyMusJ* 4 (Malibu, 1977), pp. 5–24, illus. pp. 6–7; Wilson, *Selections*, no. 29, pp. 58–59, illus.; Pierre Ennès, *Nouvelles acquisitions du département des objets d'art, 1980–1984* (Musée du Louvre, Paris, 1985), p. 135; *Handbook* 1986, p. 167, illus.; Sir John Plumb, "The Intrigues of Sèvres," *House and Garden* 158, no. 1 (U.S.A., January 1986), pp. 44–45; *J. Pierpont Morgan, Collector: European Decorative Arts from the Wadsworth Atheneum*, Linda Horvitz Roth, ed. (Hartford, 1987), p. 34, illus. fig. 8, p. 162, and p. 203; Barry Shifman, "Eighteenth-Century Sèvres Porce-

lain in America," *Madame de Pompadour et la floraison des arts* (Montréal, 1988), pp. 118–123; Savill, *Sèvres*, vol. 1, p. 192; nn. 43–44, p. 55; n. 25, p. 117; n. 3h, p. 196; n. 23, p. 197; Sassoon, *Vincennes and Sèvres Porcelain*, no. 10, pp. 49–56, illus. pp. 51, 53–55; *Handbook* 1991, p. 183, illus.

———

222. **Pair of Vases (*pots-pourris fontaine* or *pots-pourris à dauphins*)**
Sèvres manufactory, circa 1760
Painting attributed to Charles-Nicolas Dodin
Soft-paste porcelain, pink, green, and *bleu lapis* ground colors; polychrome enamel decoration; gilding
Painted underneath the central section of one vase with the blue crossed *L*'s of the Sèvres manufactory.

Height: 11¾ in. (29.8 cm); Width: 6½ in. (16.5 cm); Depth: 5¾ in. (14.6 cm)
Accession number 78.DE.358.1–.2

PROVENANCE

Marquise de Pompadour, Hôtel Pompadour, Paris, 1760–1764; Mme Legère, Paris (sold, Paris, December 15–17, 1784, part of lot 152); (?) Grace Caroline, Duchess of Cleveland (married the 6th Duke 1815, died 1883); William Goding, before 1862 (sold, Christie's, London, March 19, 1874, lot 100, to [E. Rutter, Paris] [for the Earl of

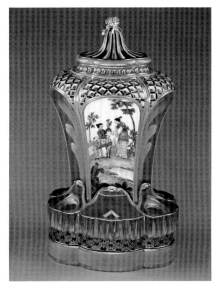

Vase .1 222

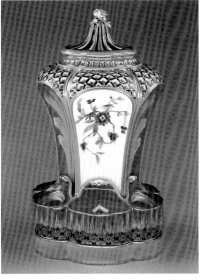

Vase .1 back view 222

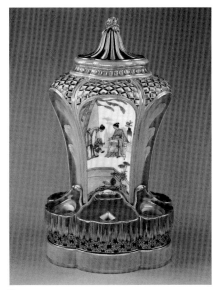

Vase .2 222

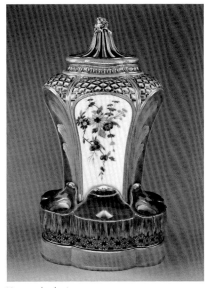

Vase .2 back view 222

Dudley], for £6,825); William Humble, 1st
Earl of Dudley (offered for sale, Christie's,
London, May 21, 1886, lot 194, bought in
for £2,625, returned to Dudley House,
London); Sir Joseph C. Robinson, Bt.,
acquired circa 1920 with the contents of
Dudley House, London; Dr. Joseph Labia
(son-in-law of Sir J. C. Robinson, Bt.),
London (sold, Sotheby's, London, February
26, 1963, lot 23); [The Antique Porcelain
Co., London and New York, 1963]; Nelson
Rockefeller, New York, 1976–1977; The
Sloan-Kettering Institute for Cancer
Research, New York, 1976–1977.

EXHIBITIONS
London, The South Kensington Museum,
Special Loan Exhibition of Works of Art,
June 1862, nos. 1281–1282, lent by William
Goding; Memphis, Dixon Gallery and
Gardens, and New York, Rosenberg and
Stiebel, Inc., *Louis XV and Madame de
Pompadour: A Love Affair with Style*, 1990,
no. 57, p. 97 and p. 84; illus. p. 85, fig. 60;
Handbook 1991, p. 184, illus. (one).

BIBLIOGRAPHY
George Redford, *Art Sales 1628–1887*
(London, 1888), vol. 1, pp. 193, 440; Jean
Cordey, *Inventaire des biens de Madame de
Pompadour rédigé après son décès* (Paris, 1939),
p. 39, no. 380; Ronald Freyberger, "Chinese
Genre Painting at Sèvres," *American Ceramic
Circle Bulletin* (1970–1971), pp. 29–44, illus.;
Marcelle Brunet and Tamara Préaud, *Sèvres:
Des origines à nos jours* (Fribourg, 1978),
p. 68, illus. (one) pl. 22; Wilson, "Acqui-
sitions 1977 to mid 1979," p. 44, illus.;
Rosalind Savill, "Two Pairs of Sèvres Vases

at Boughton House," *Apollo* 110, no. 210 (August 1979), pp. 128–133, illus.; Madeleine Jarry, *Chinoiserie* (New York, 1981), p. 120, illus. (detail of one); Wilson, *Selections*, no. 28, pp. 56–57, illus.; Adrian Sassoon, "Sèvres Vases," *Techniques of the World's Great Masters of Pottery and Ceramics*, Hugo Morley-Fletcher, ed. (Oxford, 1984), pp. 64–67, illus.; Pierre Ennès, "Essai de réconstitution d'une garniture de Madame de Pompadour," *Journal of the Walters Art Gallery* 42–43 (1984–1985), pp. 70–82; Pierre Ennès, *Nouvelles Acquisitions du département des objets d'art, 1980–1984* (Musée du Louvre, Paris, 1985), p. 135; *Handbook* 1986, p. 168, illus. (one); Barry Shifman, "Eighteenth-Century Sèvres Porcelain in America," *Madame de Pompadour et la floraison des arts* (Montréal, 1988), pp. 118–123, illus. p. 123; Savill, *Sèvres*, vol. 1, p. 192; n. 29, p. 68; nn. 24, 33, p. 197; Sassoon, *Vincennes and Sèvres Porcelain*, no. 11, pp. 57–63, illus. pp. 58–62.

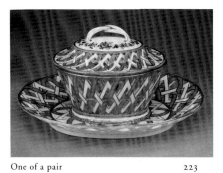

One of a pair 223

223. **Pair of Lidded Chestnut Bowls (*marronnières à ozier*)**

Sèvres manufactory, circa 1760
Soft-paste porcelain, *bleu céleste* ground color; polychrome enamel decoration; gilding
Bowl .1 incised underneath with the mark *j* and with *FR* for the *répareur*.

Bowl .1: Height: 5¼ in. (13.4 cm); Width: 10⁹⁄₁₆ in. (27 cm); Depth: 8⁵⁄₁₆ in. (21.1 cm); Bowl .2: Height: 5¼ in. (13.4 cm); Width: 10½ in. (26.7 cm); Depth: 8³⁄₁₆ in. (20.8 cm)
Accession number 82.DE.171.1–.2

PROVENANCE
Swiss art market, 1980; [Armin B. Allen, New York, 1980].

BIBLIOGRAPHY
Savill, *Sèvres*, vol. 2, p. 759; n. 4f, p. 761; Sassoon, *Vincennes and Sèvres Porcelain*, no. 12, pp. 64–68, illus. pp. 65, 67.

224. **Plaques on a *Jardinière***

Paris, circa 1760
Painting attributed to Charles-Nicolas Dodin
Soft-paste porcelain, green ground color; polychrome enamel decoration; gilding; gilt-bronze frame
Height: 6⁹⁄₁₆ in. (16.6 cm); Width: 11½ in. (29.2 cm); Depth: 5⅝ in. (14.3 cm)
Accession number 73.DI.62

PROVENANCE
Miss Botham (sold after her death, Christie's, London, May 5, 1817 et seq., lot 96, for £61 10s to the Earl of Yarmouth [later 3rd Marquess of Hertford]); private collection, Paris; [Gaston Bensimon, Paris]; purchased by J. Paul Getty.

BIBLIOGRAPHY
Savill, *Sèvres*, vol. 1, n. 18, p. 191; vol. 2, p. 838; n. 11, p. 841; Sassoon, *Vincennes and Sèvres Porcelain*, no. 13, pp. 69–70, illus. pp. 69, 71.

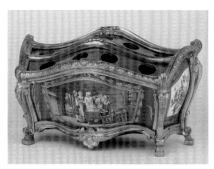

224

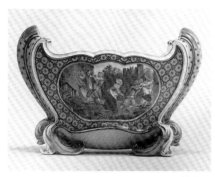

225

225. Vase (*cuvette Mahon, troisième grandeur*)

Sèvres manufactory, 1761
Painted by Jean-Louis Morin
Soft-paste porcelain, pink ground color
overlaid with blue enamel; polychrome
enamel decoration; gilding
Painted under one foot with the blue
crossed *L*'s of the Sèvres manufactory
enclosing the date letter *I* for 1761, and
with Morin's mark *M*.

Height: 5⅞ in. (15 cm); Width: 9⅟₁₆ in.
(23 cm); Depth: 4¹¹⁄₁₆ in. (11.9 cm)
Accession number 72.DE.65

PROVENANCE

Sold, March 30, 1763, by the Sèvres manu-
factory to Lemaître, as part of a *garniture*
with another *cuvette Mahon*, for 264 *livres*
each, and with a *cuvette à masques*; de
Bargigli collection (offered for sale, Christie's,

Geneva, April 22, 1970, lot 18, bought in;
sold, Christie's, London, October 4, 1971,
lot 42); [Olivier Lévy, Paris, 1971]; [French
and Co., New York, 1971]; purchased by
J. Paul Getty.

BIBLIOGRAPHY

Gillian Wilson, "Sèvres Porcelain at the
J. Paul Getty Museum," *GettyMusJ* 4 (1977),
pp. 19–24, illus.; Savill, *Sèvres*, vol. 1, pp. 38,
93; nn. 40, 43, p. 42; n. 44, p. 55; nn. 15, 22,
p. 97; Sassoon, *Vincennes and Sèvres Porce-
lain*, no. 14, pp. 72–76, illus. p. 73.

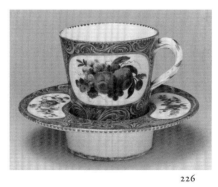

226

226. Cup and Saucer (*gobelet et soucoupe enfoncé, première grandeur*)

Sèvres manufactory, 1761
Soft-paste porcelain, pink ground color
overlaid with blue enamel; polychrome
enamel decoration; gilding
Saucer painted underneath with the blue
crossed *L*'s of the Sèvres manufactory
enclosing the date letter *I* for 1761, and
with a dot. Saucer incised *oo* underneath.
Cup incised *DU* underneath in two places.

Cup: Height: 3⁹⁄₁₆ in. (9.1 cm); Width:
4³⁄₁₆ in. (10.7 cm); Depth: 3⅜ in. (8.6 cm);
Saucer: Height: 1½ in. (3.8 cm); Diameter: 6
⅛ in. (15.6 cm)
Accession number 79.DE.62.a–.b

PROVENANCE

[Olivier Lévy, Paris]; [French and Co., New
York, early 1970s]; Mrs. John W. Christner,
Dallas (sold, Christie's, New York, June 9,
1979, lot 241).

BIBLIOGRAPHY

Wilson, "Acquisitions 1979 to mid 1980,"
p. 19, illus.; Savill, *Sèvres*, vol. 2, p. 675;
nn. 21, 26, p. 685; Sassoon, *Vincennes and
Sèvres Porcelain*, no. 15, pp. 78–80, illus.
pp. 79–80.

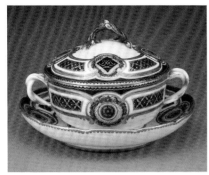

227

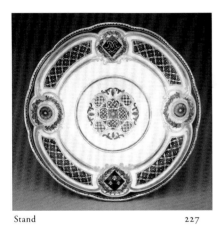

Stand 227

227. **Lidded Bowl on Stand (*écuelle ronde
et plateau rond*)**
Sèvres manufactory, 1764
Painted by Pierre-Antoine Méreaud *l'aîné*
Soft-paste porcelain; polychrome enamel
decoration; gilding

Bowl and stand both painted underneath
with the blue crossed *L*'s of the Sèvres manu-
factory enclosing the date letter *L* for 1764,
and with Méreaud's mark *S*. Bowl incised
DU and *O* and the stand, *I*.

Bowl: Height: 4⅞ in. (12.4 cm); Width:
7¾ in. (19.7 cm); Depth: 6 in. (15.2 cm);
Stand: Height: 1⁹⁄₁₆ in. (3.9 cm); Diameter:
8⁵⁄₁₆ in. (21.1 cm)
Accession number 78.DE.65.a–.c

PROVENANCE
Madame Louise of France (youngest daugh-
ter of Louis XV), 1764; Mrs. Lyne Stephens,
Norfolk, London, and Paris (sold, Christie's,
London, May 9 et seq., 1895, lot 733, to
William Boore for £130); Mortimer L.
Schiff, New York (sold by his heir John L.
Schiff, Christie's, London, June 22, 1938, lot
25); purchased at that sale by J. Paul Getty.

BIBLIOGRAPHY
Barry Shifman, "A Newly Discovered Piece
of Royal Sèvres Porcelain," *GettyMusJ* 6–7
(1978–1979), pp. 53–56, illus.; Wilson, *Selec-
tions*, no. 33, p. 66–67, illus.; *Handbook* 1986,
p. 169, illus.; Barry Shifman, "Eighteenth-
Century Sèvres Porcelain in America,"
*Madame de Pompadour et la floraison des
arts* (Montréal, 1988), pp. 118–123; Savill,
Sèvres, vol. 2, pp. 648, 800; n. 33d, p. 663;
n. 99c, p. 665; n. 36, p. 804; Sassoon, *Vin-
cennes and Sèvres Porcelain*, no. 16, pp. 81–82,
illus. pp. 82–83; *Handbook* 1991, p. 185, illus.

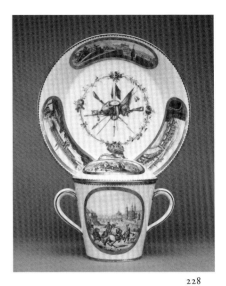

228

228. **Covered Cup and Saucer (*gobelet à lait
et soucoupe, deuxième grandeur*)**

Sèvres manufactory, circa 1760–1765
Soft-paste porcelain; *camaïeu rose* enamel
decoration; gilding
The base of the cup is incised with a reverse
S above a dot.

Cup: Height: 3⁹⁄₁₆ in. (9.1 cm); Width:
5½ in. (14 cm); Depth: 3¹³⁄₁₆ in. (9.7 cm);
Saucer: Height: 1¹¹⁄₁₆ in. (4.3 cm); Diameter:
7⅝ in. (19.3 cm)
Accession number 87.DE.134.a–.c

PROVENANCE
(?) Isabella Anne Ingram-Shepherd, 2nd
Marchioness of Hertford, Hertford House,

London, 1834; (sold, Christie's, London, March 25, 1985, lot 9); [Winifred Williams, Ltd., London].

BIBLIOGRAPHY
"Acquisitions/1987," *GettyMusJ* 16 (1988), no. 73, p. 178, illus.; Sassoon, *Vincennes and Sèvres Porcelain*, no. 17, pp. 84–86, illus. pp. 85–87.

229. **Pair of Lidded Vases (*vases à têtes de bouc*)**

Sèvres manufactory, circa 1768
Possibly molded by Michel-Dorothée Coudray; possibly finished by the *répareur* Nantier
Soft-paste porcelain, *bleu nouveau* ground color; gilding
Each incised *c.d.* underneath for the *mouleur*. Vase .1 incised *N 1*; Vase .2 incised *N 2* underneath for the *répareur*.

Height: 1 ft. 1 7/16 in. (34.2 cm); Width: 8 5/8 in. (21.9 cm); Depth: 6 5/8 in. (16.8 cm)
Accession number 82.DE.36.1–.2

PROVENANCE
(?) Sold by the Sèvres manufactory to Henry Pelham-Clinton, through Sir John Lambert, October 5, 1768, for 600 *livres* each; Earls of Lincoln, by descent (sold, Christie's, London, June 9, 1937, part of lot 115); [J. Rochelle Thomas, London]; private collection, New York (sold, Parke-Bernet, New York, January 12, 1957, lot

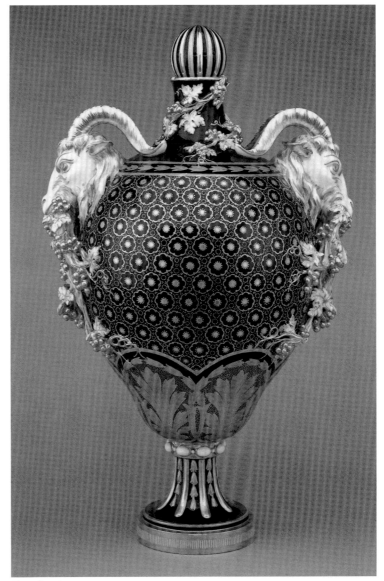

One of a pair 229

247); Christian Humann, New York (sold, Sotheby's, New York, April 22, 1982, lot 41); [Armin B. Allen, New York, 1982].

BIBLIOGRAPHY
Sassoon, "Acquisitions 1982," no. 11, pp. 54–56, illus.; Sassoon, *Vincennes and Sèvres Porcelain*, no. 18, pp. 88–92, illus. pp. 89, 91, 93.

――――――

230. **Pair of Vases ([?] *vases œuf*)**
Sèvres manufactory, 1768–1769
Figure painting attributed to Jean-Baptiste-Etienne Genest
Soft-paste porcelain, *bleu Fallot* ground; grisaille enamel decoration; gilding; gilt-bronze mounts
Vase .1 incised with the number *4* on its body, foot, and twice on its lid; Vase .2 incised with the number *1* on the body, with (?) *3* on its foot, and *2* on its lid.

Height: 1 ft. 5¾ in. (45.1 cm); Width: 9½ in. (24.1 cm); Depth: 7½ in. (19.1 cm)
Accession number 86.DE.520.1–.2

PROVENANCE
Purchased by Sir Harry Fetherstonhaugh, Uppark, Sussex, from the *marchand-mercier* Rocheux, Paris, September 22, 1819; Alfred de Rothschild, in the South Drawing Room, Halton, Buckinghamshire, 1884; Leopold de Rothschild, Ascott, Buckinghamshire, before 1918; by descent to Lionel de Rothschild, Exbury, Hampshire; by descent to

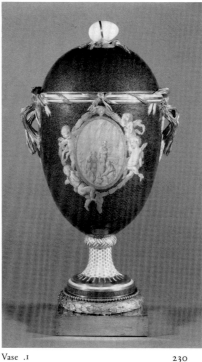

Vase .1 230

Edmund de Rothschild, Exbury House, Hampshire, 1942 (sold with a mounted *vase Hébert*, Christie's, London, July 4, 1946, lot 90); [Frank Partridge, Ltd., London]; Seymour Egerton, 7th Earl of Wilton, London, 1947 (this pair of vases only, without the *vase Hébert*); Sir Charles Clore, London and Monte Carlo (sold after his death, Christie's, Monaco, December 6, 1945, lot 6).

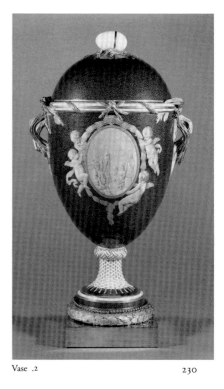

Vase .2 230

BIBLIOGRAPHY
James Sassoon, "The Art Market/Sèvres and Vincennes," *Apollo* 125, no. 304 (June 1987), pp. 440–441, illus.; "Acquisitions/1986," *GettyMusJ* 15 (1987), no. 107, p. 214, illus.; Savill, *Sèvres*, vol. 1, pp. 184, 377; n. 2j, p. 190; n. 16, p. 191; n. 9, p. 383; Sassoon, *Vincennes and Sèvres Porcelain*, no. 19, pp. 94–101, illus. pp. 95–96, 99–101; *Handbook* 1991, p. 188, illus.

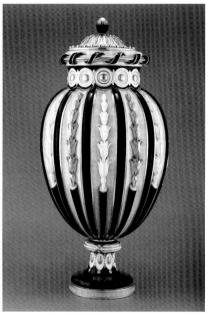

231

231. Vase (*vase à chaîne* or *vase à côte de melon*)

Sèvres manufactory, circa 1765–1770
After a design attributed to Jean-Claude
Duplessis *père*; modeled by Michel-Dorothé
Coudray and possibly Roger *père*
Soft-paste porcelain, *bleu nouveau* ground
color; gilding
Painted underneath with the blue crossed
L's of the Sèvres manufactory: foot ring
incised *CD* and foot incised *R*.

Height: 1 ft. 5¾ in. (45 cm); Diameter:
8⅝ in. (22.2 cm)

Accession number 90.DE.113

PROVENANCE
The Earls of Sefton, Croxteth Hall (near
Liverpool) (sold in the early 1970s); private
collection, England; [Alexander and Berendt,
Ltd., London, 1989].

BIBLIOGRAPHY
"Acquisitions/1990," *GettyMusJ* 19 (1991),
no. 56, p. 161, illus.

232. Tea Service (*déjeuner ruban*)

Sèvres manufactory, circa 1765–1770
Gilded by Etienne-Henri Le Guay
Soft-paste porcelain; polychrome enamel
decoration; gilding

Tray (*plateau ovale polylobé*) painted under-
neath with the blue crossed *L*'s of the Sèvres
manufactory and with Le Guay's mark *LG*
in gold; also bears the original price label
(no price indicated) and incised with an
oval crossed by a line. Teapot (*théière
Calabre*) incised with an arrow and an inde-
cipherable mark ([?]901); lidded sugar bowl
(*pot à sucre Calabre*) incised with a square.
One cup (*gobelet Bouillard*) painted under-
neath with the blue crossed *L*'s of the Sèvres
manufactory and with the gilder's mark for
Le Guay, *LG*, in gold. Second cup incised
with an *F* and the same indecipherable mark
as on the teapot. Both saucers (*soucoupes*)
painted underneath with the blue crossed
L's of the Sèvres manufactory and with the

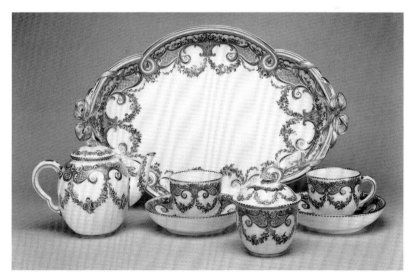

232

gilder's mark for Le Guay, *LG*, in gold; one saucer incised with a cross and two dots and the other with an *X* within a square.
Tray: Height: 1⅞ in. (4.8 cm); Width: 1 ft. 3¼ in. (38.8 cm); Depth: 10¼ in. (26 cm); Teapot: Height: 4⅞ in. (12.4 cm); Width: 6½ in. (16.5 cm); Depth: 3¾ in. (7.6 cm); Lidded Sugar Bowl: Height: 2⁷⁄₁₆ in. (6.2 cm); Diameter: 3 in. (7.6 cm); Cup: Height: 2⁵⁄₁₆ in. (8.8 cm); Width: 3⅝ in. (9.2 cm); Depth: 2¾ in. (7 cm); Saucer: Height: 1¼ in. (3.2 cm); Diameter: 5¼ in. (3.3 cm)
Accession number 89.DE.25.1–.5

PROVENANCE

[Michel Vandermeersch, Paris]; [Bernard Dragesco and Didier Cramoisan, Paris, 1988].

BIBLIOGRAPHY

"Acquisitions/1989," *GettyMusJ* 18 (1990), no. 50, p. 192, illus.

233. **Lidded Vase (*vase à panneaux, première grandeur*)**
Sèvres manufactory, circa 1765–1770
Reserve scene after a painting by Nicolas Berchem
Soft-paste porcelain, *bleu nouveau* ground color; polychrome enamel decoration; gilding; gilt-bronze mount
The interior of the lip is incised *2*.

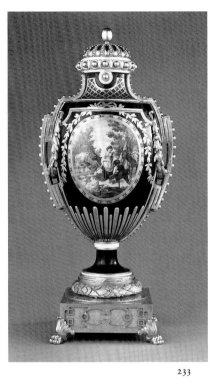

233

Height: 1 ft. 6¾ in. (47.5 cm); Width: 10¼ in. (26 cm); Depth: 8⁵⁄₁₆ in. (20.5 cm)
Accession number 85.DE.219.a–.b

PROVENANCE

(?) Comte de Jarnac, Thomastown Castle, Ireland (sold, Christie's, London, June 23, 1876, lot 89); William Humble, 1st Earl of Dudley; possibly sold by his widow; Alfred de Rothschild, Halton, Buckinghamshire, by 1884; by descent to Lionel de Rothschild,

Exbury, Southampton, Hampshire, 1918; by descent to Edmund de Rothschild, Exbury, Hampshire, 1942 (sold, Christie's, London, July 4, 1946, lot 87, to [Frank Partridge, Ltd., London]); Col. Norman Colville, England; private collection, California (sold, Christie's, New York, January 30, 1985, lot 137); [The Antique Porcelain Co., New York].

BIBLIOGRAPHY

C. Davis, *A Description of the Works of Art: Collection of Alfred de Rothschild* (London, 1884), vol. 2, fig. 87; C. Gay Nieda, "A Sèvres *Vase à Panneaux*," *GettyMusJ* 14 (1986), pp. 127–134, figs. 1–3, 8–9; "Acquisitions/1985," *GettyMusJ* 14 (1986), no. 199, p. 246, illus.; Savill, *Sèvres*, vol. 1, pp. 278, 325, and 380; n. 31, p. 244; n. 19, p. 281; n. 3c, p. 332; n. 21, p. 383; vol. 3, p. 1125; Sassoon, *Vincennes and Sèvres Porcelain*, no. 21, pp. 106–110, illus. pp. 107–108, 110–111.

234. **Cup and Saucer (*gobelet Bouillard et soucoupe*)**
Sèvres manufactory, 1770
Painted by Jacques Fontaine
Soft-paste porcelain, *bleu céleste* ground color; grisaille enamel decoration; gilding
Cup painted with the blue crossed *L*'s of the Sèvres manufactory enclosing the date letter *r* for 1770, and with Fontaine's mark of five dots. Cup incised *C*; saucer incised *6*.

Cup: Height: 2½ in. (6.3 cm); Width:
3⅝ in. (9.2 cm); Depth: 2¹³⁄₁₆ in. (7.1 cm);
Saucer: Height: 1¼ in. (3.2 cm); Diameter:
5⁵⁄₁₆ in. (13.5 cm)
Accession number 79.DE.65.a–.b

PROVENANCE
Private collection (sold, Christie's, London,
June 21, 1976, lot 151); Mrs. John W.
Christner, Dallas (sold, Christie's, New
York, June 9, 1979, lot 227).

BIBLIOGRAPHY
Wilson, "Acquisitions 1979 to mid 1980,"
item B, p. 19, illus.; Sassoon, *Vincennes and
Sèvres Porcelain*, no. 20, pp. 102–105, illus.
pp. 103–104.

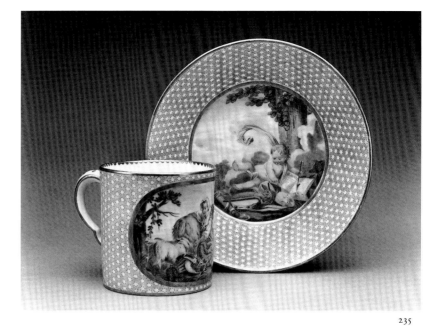

235

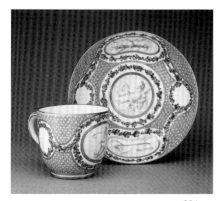

234

235. **Cup and Saucer (*gobelet litron et
soucoupe, deuxième grandeur*)**
Sèvres manufactory, 1773
Painted by Etienne-Jean Chabry; gilded by
Michel-Barnabé Chauveaux *aîné*
Soft-paste porcelain, *bleu céleste* ground
color; polychrome enamel decoration;
gilding
Cup and saucer painted underneath with
the blue crossed *L*'s of the Sèvres manufac-
tory enclosing the date letter *U* for 1773, and
with Chabry's mark *ch* in blue; also painted
with Chauveaux's mark *#* in gold. Saucer
incised *da* underneath.

Cup: Height: 2⅝ in. (6.7 cm); Width:
3½ in. (8.9 cm); Depth: 2⁹⁄₁₆ in. (6.6 cm);
Saucer: Height: 1⁹⁄₁₆ in. (3.9 cm); Diameter:
5⁷⁄₁₆ in. (13.9 cm)
Accession number 79.DE.64.a–.b

PROVENANCE
Sold, Sotheby's, London, July 26, 1977, lot
345; Mrs. John W. Christner, Dallas (sold,
Christie's, New York, June 9, 1979, lot 226).

BIBLIOGRAPHY
Wilson, "Acquisitions 1979 to mid 1980,"
item C, p. 19, illus.; Sassoon, *Vincennes and
Sèvres Porcelain*, no. 22, pp. 112–114, illus.
pp. 113–114.

236. **Pair of Vases (*vases bouc du Barry B*)**

Sèvres manufactory, 1778
Painted by Fallot; gilded by Jean Chauveaux *le jeune*
Hard-paste porcelain; polychrome enamel decoration; gilding
Each vase painted underneath with the gold crossed *L*'s of the Sèvres manufactory flanked by the date letters *AA* in gold for 1778, all under a crown for hard paste; each vase also painted underneath with Chauveaux's mark *IN* in gold and with an abraded (?) *F* for Fallot.

Height: 11⅝ in. (29.5 cm); Width: 7 in. (17.9 cm); Depth: 4¾ in. (12 cm)
Accession number 70.DE.99.1–.2

PROVENANCE
Sir Richard Wallace, Paris, probably acquired after 1870; Lady Wallace, Paris, by inheritance, 1890; Sir John Murray Scott, Paris, by inheritance, 1897; Victoria, Lady Sackville, Paris, by inheritance, 1912; [Jacques Seligmann, removed to New York, 1916–1917]; Mortimer L. Schiff, New York (sold by his heir John L. Schiff, Christie's, London, June 22, 1938, lot 26); purchased at that sale by J. Paul Getty.

BIBLIOGRAPHY
Rosalind Savill, "A Pair of Sèvres Vases: From the Collection of Sir Richard Wallace to the J. Paul Getty Museum," *GettyMusJ* 14 (1986), pp. 135–142, figs. 1a–c; Savill, *Sèvres*, vol. 1, p. 442; n. 45, p. 446; vol. 3, n. 2, p. 1022; Sassoon, *Vincennes and Sèvres Porcelain*, no. 23, pp. 115–118, illus. pp. 116–117.

———

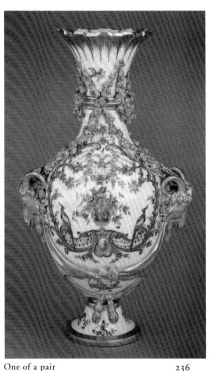

One of a pair 236

237. **Garniture of Three Vases (*vases des âges: vase des âges à têtes de vieillards, première grandeur; vases des âges à têtes de jeunes femmes, deuxième grandeur*)**

Sèvres manufactory, 1781
After designs by Jacques François Deparis, at least one vase modeled by Etienne-Henry Bono, painted by Antoine Caton after engravings by Jean-Baptiste Tilliard; enamel jeweling by Philippe Parpette and gilding by Etienne-Henri Le Guay *père*
Soft-paste porcelain, *bleu nouveau* ground color; polychrome enamel decoration; opaque and translucent enamel "jewels"; gilding and gold foils

Vase .1 (with the scene "Minerva protects Telemachus and preserves him from Cupid's darts") is incised *I O B age 1e g* (for *première grandeur*) on the base and *.IO.B* on the neck. Vase .2 (with the scene "Venus, in order to satisfy her resentment against Telemachus, brings Love to Calypso") is painted underneath with the gold crossed *L*'s of the Sèvres manufactory and with *LG*, the gilder's mark; it is incised *39 A* on the base and *A 16* on the neck. Vase .3 (with the scene "Telemachus, in the deserts of Oasis, is consoled by Temosiris, Priest of Apollo")

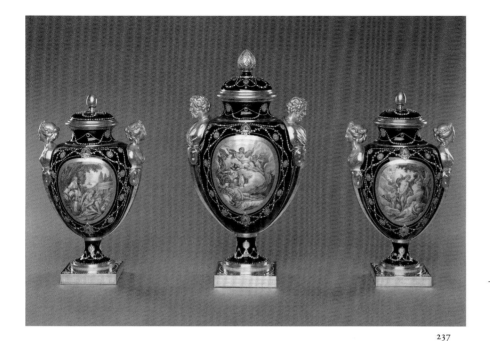

237

1984," *GettyMusJ* 13 (1985), no. 4, pp.
98–104, figs. 22–23, 25–33; "Acquisitions /
1984," *GettyMusJ* 13 (1985), no. 64, p. 182,
illus.; Geoffrey de Bellaigue, *Sèvres
Porcelain in the Collection of Her Majesty the
Queen: The Louis XVI Service* (Cambridge
and New York, 1985), p. 12, fig. 8, and p. 24,
no. 2; Svend Eriksen and Geoffrey de
Bellaigue, *Sèvres Porcelain: Vincennes and
Sèvres 1740–1800* (London and Boston,
1987), p. 139, no. 147, p. 339, illus. p. 338;
Savill, *Sèvres*, vol. 1, p. 458; n. 25, p. 462;
and vol. 3, p. 1056; n. 16, p. 1017; n. 10, p.
1057; Sassoon, *Vincennes and Sèvres
Porcelain*, no. 25, pp. 126–135, illus. pp.
127–134; *Handbook* 1991, p. 193, illus.

is painted underneath with the gold crossed
L's of the Sèvres manufactory and with *LG*;
it is incised *age 2e g* (for *deuxième grandeur*)
on the base and *Bono* over *B* on the neck.
Vase .1: Height: 1 ft. 6½ in. (49.6 cm);
Width: 10⅞ in. (27.7 cm); Depth: 7⅝ in.
(19.3 cm); Vase .2: Height: 1 ft. 4 in.
(40.8 cm); Width: 9¾ in. (24.8 cm); Depth:
7¼ in. (18.4 cm); Vase .3: Height: 1 ft. 3¹⁵⁄₁₆
in. (40.5 cm); Width: 10 in. (25.4 cm);
Depth: 7³⁄₁₆ in. (18 cm)
Accession number 84.DE.718.1–.3

PROVENANCE
Louis XVI, in the bibliothèque at the
Château de Versailles, November 2, 1781;
Lionel de Rothschild, Exbury, Hampshire;
by descent to Edmund de Rothschild,
Exbury, Hampshire, 1942 (sold, Christie's,
London, July 4, 1946, lot 89, for £1,575 to
"*FP*" [Frank Partridge?]); [The Antique
Porcelain Co., London, by 1951].

BIBLIOGRAPHY
Pierre Verlet, "Orders for Sèvres from the
French Court," *Burlington Magazine* 96
(July 1954), pp. 202–206; Adrian Sassoon,
"Vincennes and Sèvres Porcelain Acquired
by the J. Paul Getty Museum in

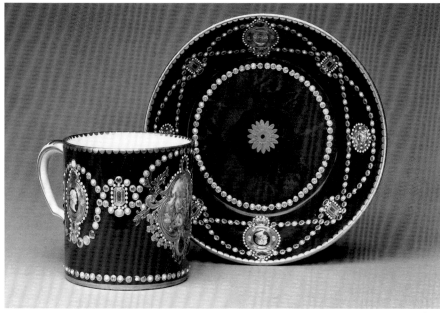

238

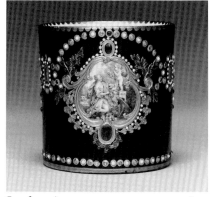

Cup, front view 238

238. Cup and Saucer (*gobelet litron et soucoupe*)

Sèvres manufactory, 1781
Ground color painted by Antoine Capelle; the painted reserve and cameos attributed to Pierre-André Le Guay; flat gilding by Etienne-Henri Le Guay; enamel jeweling by Philippe Parpette
Soft-paste porcelain, brown ground color ([?] *merde d'oie*); polychrome enamel decoration; enamels in imitation of jewels; gilding and gold foils
Cup and saucer both painted underneath with the blue crossed *L*'s of the Sèvres manufactory enclosing the date letters *DD* for 1781, and with Capelle's blue triangular

mark. Saucer also painted with the gilder Le Guay's mark *LG* in blue. Saucer is incised *44;* cup is incised *36a* and *6.* Saucer bears a paper label under the base inked *Colln. of the Marchioness of Conyngham 1908. R.M. Wood Esq.*

Cup: Height: 2¾ in. (6.9 cm); Depth: 3¹¹⁄₁₆ in. (9.4 cm); Saucer: Height: 1⅜ in. (3.6 cm); Diameter: 5⁵⁄₁₆ in. (13.5 cm)
Accession number 81.DE.28.a–.b

PROVENANCE

Jane, Marchioness of Conyngham (wife of the 3rd Marquess, married 1854, died

1907), London and Ascot, Berkshire (sold, Christie's, London, May 4, 1908, lot 289, to [Harding] for 1629 guineas 15s); R. M. Wood, London (sold, Christie's, London, May 27, 1919, lot 96, to [Mallett's, London], for 152 guineas 12s); Henry Walters, New York (sold by his widow, Parke-Bernet, New York, November 30, 1943, lot 1009); private collection, New York (sold, Christie's, New York, December 3, 1977, lot 166); [Armin B. Allen, New York, 1977].

BIBLIOGRAPHY

Adrian Sassoon, "Two Acquisitions of Sèvres Porcelain," *GettyMusJ* 10 (1982), pp. 87–90, illus.; Wilson, *Selections*, no. 40, pp. 80–81, illus.; Adrian Sassoon, "Sèvres: Luxury for the Court," *Techniques of the World's Great Masters of Pottery and Ceramics,* Hugo Morley-Fletcher, ed. (Oxford, 1984), pp. 52–57, illus.; Sassoon, *Vincennes and Sèvres Porcelain,* no. 24, pp. 119–124, illus. pp. 120–121, 123, and 125.

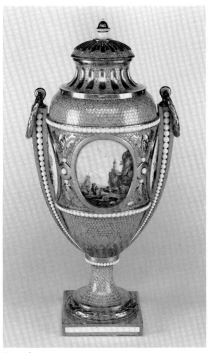

One of a pair 239

239. Pair of Vases (*vases Bolvry à perles* or *vases à cartels Bolvry*)

Sèvres manufactory, 1781–1782
Painted by Vincent Taillandier, Mme
Geneviève Taillandier, and Philippe Castel
Hard-paste porcelain, pink *fond pointillé*;
polychrome enamel decoration; gilding
Both vases are painted underneath with
the crowned, blue crossed *L*'s of the Sèvres
manufactory enclosing the date letter *EE* for
1781–1782, and with the painter's mark for
Vincent Taillandier, a fleur-de-lys. Vase .1 is
incised *gu* under the base.

Height: 1 ft. 4⅞ in. (42.5 cm); Width: 9 in.
(22.9 cm); Depth: 6⅝ in. (16.8 cm)
Accession number 88.DE.137.1–.2

PROVENANCE

[Jacques Seligmann, Paris]; (anonymous
sale, Nouveau Drouot, Paris, June 16, 1987,
lot 104); [Jean Lupu, Paris, 1988].

BIBLIOGRAPHY

"Acquisitions/1988," *GettyMusJ* 17 (1989),
no. 76, pp. 143-144, illus.

240. Plate (*assiette d'echantillons*)

Sèvres manufactory, 1782
Ground color painted by Antoine Capelle,
flowers painted by Jacques-François-Louis
de Laroche; gilded by Henri-Martin Prévost
jeune
Soft-paste porcelain, (?) *fond Capelle* ground
color; colored enamel decoration; gilding
Painted underneath with the blue crossed
L's of the Sèvres manufactory enclosing the
date letter *EE* for 1782, the painters' marks
for Capelle, a blue triangle, and Laroche, *Lr*
in script, the gilder's mark, an *HP* in gold,
and incised *31a*.

Height: 1 in. (2.5 cm); Diameter: 9⅝ in.
(23.6 cm)
Accession number 88.DE.2

PROVENANCE

William J. Goode (sold, Christie's, London,
July 17–18, 1895, lot 17, as "formerly the
property of the Director of the Sèvres Porce-
lain Factory," for 39 guineas to Gibson); pri-
vate collection, England; [Bernard Dragesco
and Didier Cramoisan, Paris, 1987].

BIBLIOGRAPHY

Edouard Garnier, *La Porcelaine tendre de
Sèvres* (Paris, 1889), pl. xxvi; "Acquisitions/
1988," *GettyMusJ* 17 (1989), no. 77, p. 144,
illus.; Sassoon, *Vincennes and Sèvres Porce-
lain*, no. 26, pp. 136–137, illus. pp. 136–137.

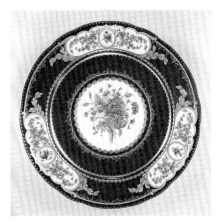

240

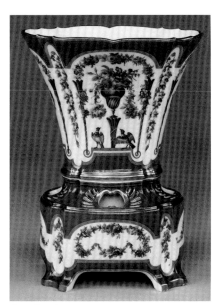

One of a pair 241

241. **Pair of Vases (*vases hollandois nouveaux*, [?] *deuxième grandeur*)**
Sèvres manufactory, 1785
Painted by Jacques-François-Louis de Laroche; gilded by Antoine-Toussaint Cornaille
Soft-paste porcelain, *bleu céleste* ground color; polychrome enamel decoration; gilding
Each base painted underneath with the blue crossed *L*'s of the Sèvres manufactory and Laroche's mark *Lr* in script. Base of each central section incised *25*; one base section incised *O*.

Height: 10 ft. (25.3 cm); Width: 7⅞ in. (22.5 cm); Depth: 6¼ in. (15.9 cm)
Accession number 83.DE.341.1–.2

PROVENANCE
(?) The Rt. Hon. Lord Ashburton, Buckenham, Norfolk (sold, Christie's, London, February 24, 1869, lot 64, for 819 guineas to Rhodes); Baroness Alexis de Goldschmidt-Rothschild, Switzerland; [Lovice Reviczky A. G., Zurich, 1983].

BIBLIOGRAPHY
Sassoon, "Acquisitions 1983," no. 12, pp. 209–211, 214, illus.; "Acquisitions/1983," *GettyMusJ* 12 (1984), no. 14, p. 266, illus.; Savill, *Sèvres*, vol. 1, p. 111; n. 2h, p. 116; vol. 3, n. 5, p. 1040; Sassoon, *Vincennes and Sèvres Porcelain*, no. 27, pp. 138–141, illus. pp. 139, 141.

———

242. **Pair of Lidded Bowls (*vases cassolettes à monter*)**
Paris and Sèvres manufactory, circa 1785
Mounts attributed to Pierre-Philippe Thomire
Hard-paste porcelain, *bleu nouveau* ground color; *rouge griotte* marble; gilt-bronze mounts
Height: 1 ft. 2¾ in. (37.5 cm); Width: 1 ft. 1½ in. (34.3 cm); Depth: 10¼ in. (26.1 cm)
Accession number 73.DI.77.1–.2

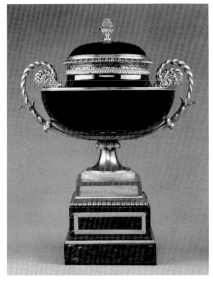

One of a pair 242

PROVENANCE
Mrs. H. Dupuy, New York (sold, Parke-Bernet, New York, April 3, 1948, lot 404); private collection, South America; [P. Cei and E. Lugli, Florence]; [French and Co., New York, 1973]; purchased by J. Paul Getty.

BIBLIOGRAPHY
Ottomeyer and Pröschel, *Vergoldete Bronzen*, p. 268, illus.; Savill, *Sèvres*, vol. 1, n. 17, p. 209; n. 51, p. 480; Sassoon, *Vincennes and Sèvres Porcelain*, no. 28, pp. 142–144, illus. p. 143.

———

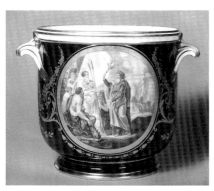

243

243. **Wine Bottle Cooler (*seau à bouteille ordinaire*)**

Sèvres manufactory, 1790
Model designed by Jean-Claude Duplessis;
painted decoration attributed to Charles-Eloi
Asselin after engraved designs by Charles
Monnet and Jean-Baptiste-Marie Pierre;
gilding attributed to Etienne-Henri Le Guay
Soft-paste porcelain, *bleu nouveau* ground
color; polychrome enamel decoration;
gilding
Bowl incised *38* underneath; foot ring
incised *5*. Monogram *WJG* for the owner
William J. Goode scratched on the under-
side in two places.

Height: 7 7/16 in. (18.9 cm); Width: 10 3/16 in.
(25.8 cm)
Accession number 82.DE.5

PROVENANCE

Made for Louis XVI, ordered in 1783 for
the Château de Versailles and delivered in
December 1790; (?) Musée National, Paris,
sold 1797–1798; Robert Napier, Glasgow,
the Shandon collection, by 1862 (sold,
Christie's, London, April 11, 1877, lot 347,
for £262 10s to Goode); William J. Goode,
London (sold, Christie's, London, July 17,
1895, lot 136, for 230 guineas to Waller);
T. W. Waller, Esq. (sold, Christie's, London,
June 8, 1910, lot 171, for £630 to A. Wert-
heimer); [Asher Wertheimer, London] (sold,
Christie's, London, June 16, 1920, lot 30, for
£84 to Clements); private collection (sold
as nineteenth century, Sotheby's, Begravia,
April 24, 1980, lot 162); private collection,
England (sold, Sotheby's, London, Octo-
ber 21, 1980, lot 207); [Winifred Williams,
Ltd., London, 1980].

EXHIBITIONS

London, The South Kensington Museum,
Special Loan Exhibition of Works of Art,
June 1862, no. 1323, p. 122; Leeds, England,
Exhibition Offices, *National Exhibition of
Works of Art at Leeds, 1868*, no. 2102 or 2103
under Ornamental Arts, p. 262, loaned by
Robert Napier.

BIBLIOGRAPHY

J. C. Robinson, *Catalogue of the Works of
Art Forming the Collection of Robert Napier*
(London, 1865), no. 3501 or 3502, p. 260;
Adrian Sassoon, "Two Acquisitions of
Sèvres Porcelain," *GettyMusJ* 10 (1982),
pp. 91–94, illus.; Wilson, *Selections*, no. 48,
pp. 96–97, illus.; Geoffrey de Bellaigue,
*Sèvres Porcelain in the Collection of Her
Majesty the Queen: The Louis XVI Service*
(Cambridge and New York, 1986), no. 149,
pp. 28, 45, 52, 55–56, 64, 222, 259, 266;
Handbook 1986, p. 178, illus.; Sassoon,
Vincennes and Sèvres Porcelain, no. 29,
pp. 146–150, illus. pp. 147, 149, 151; *Hand-
book* 1991, p. 197, illus.

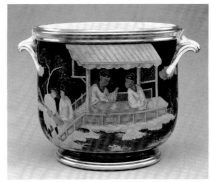

Cooler .1 244

244. **Pair of Wine Bottle Coolers (*seaux à demi-bouteilles ordinaires*)**

Sèvres manufactory, 1791
Model designed by Jean-Claude Duplessis;
gilded by Jean-Jacques Dieu
Hard-paste porcelain, black ground color;
platinum and gold decoration
Each cooler painted underneath with the
gold crossed *L*'s of the Sèvres manufactory
enclosing the date letters *OO* in gold for
1792–1793, all under a crown for hard paste;
each cooler also painted with Dieu's tri-
angular mark (abraded on one). *Répareur*'s
mark *AB* incised on one; *BS* incised on
the other.

Height: 6⁷⁄₁₆ in. (16.3 cm); Width: 9³⁄₁₆ in. (23.4 cm); Depth: 7⁵⁄₁₆ in. (18.6 cm)
Accession number 72.DE.53.1–.2

PROVENANCE

[Dalva Brothers, Inc., New York, 1972]; purchased by J. Paul Getty.

BIBLIOGRAPHY

Wilson, *Selections*, no. 49, pp. 98–99, illus.; The Cooper-Hewitt Museum, *Wine: Celebration and Ceremony* (New York, 1985), p. 97, illus. (one); Sassoon, *Vincennes and Sèvres Porcelain*, no. 30, pp. 152–156, illus. pp. 153, 155, 157.

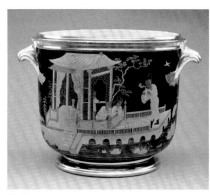

Cooler .2 244

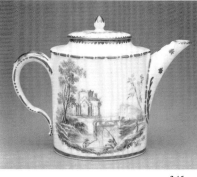

245

245. **Teapot (*théière litron*)**

Sèvres maufactory, late eighteenth century, painted decoration later
Soft-paste porcelain, carmine red enamel; gilding
Painted underneath with the blue crossed *L*'s of the Sèvres manufactory. Incised *26* and *48*.

Height: 3⁷⁄₁₆ in. (8.8 cm); Width: 4¹¹⁄₁₆ in. (11.9 cm); Depth: 2¹¹⁄₁₆ in. (6.8 cm)
Accession number 79.DE.63.a–.b

PROVENANCE

Mrs. John W. Christner, Dallas (sold, Christie's, New York, June 9, 1979, lot 204).

BIBLIOGRAPHY

Wilson, "Acquisitions 1979 to mid 1980," item D, p. 19, illus.; Sassoon, *Vincennnes and Sèvres Porcelain*, no. 31, pp. 158–160, illus. pp. 159, 161.

Mounted Oriental Porcelain

246. **Ewer**

Porcelain: Chinese, Kangxi (1662–1722), circa 1660
Mounts: Paris, circa 1700–1710
Hard-paste porcelain; polychrome enamel decoration; gilt-bronze mounts
Height: 1 ft. 6⅛ in. (46.1 cm); Width: 1 ft. 1⅞ in. (35.2 cm); Depth: 5⅜ in. (13.8 cm)
Accession number 82.DI.3

PROVENANCE

Edward R. Bacon, New York, by 1919; [Gaston Bensimon, Paris] (sold, Hôtel Drouot, Paris, November 18–19, 1981, lot 103).

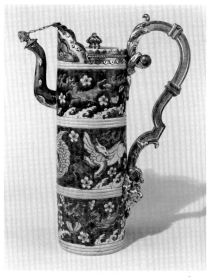

246

BIBLIOGRAPHY

John Getz, *Catalogue of Chinese Art Objects, Including Porcelains, Potteries, Jades, Bronzes, and Cloisonné Enamels, Collected by Edward R. Bacon* (New York, 1919), no. 65, p. 31, pl. 12; Wilson, "Acquisitions 1981," no. 6, pp. 85–86, illus.; Wilson et al., *Mounted Oriental Porcelain*, no. 1, pp. 21–23, illus.; *Handbook* 1986, p. 146, illus.; *Handbook* 1991, p. 163, illus.

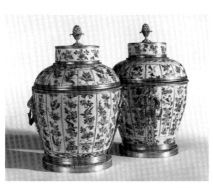

247

247. Pair of Lidded Vases

Porcelain: Chinese, Kangxi (1662–1722)
Mounts: Paris, circa 1710–1715
Hard-paste porcelain; polychrome enamel decoration; gilt-bronze mounts
Height: 1 ft. 3¾ in. (40 cm); Diameter: 11 in. (27.9 cm)
Accession number 72.DI.50.1–.2

PROVENANCE

M. and Mme Louis Guiraud, Paris (sold, Palais Galliera, Paris, December 10, 1971, lot 11); [Alexander and Berendt, Ltd., London, 1971]; purchased by J. Paul Getty.

EXHIBITIONS

New York, The China Institute in America, *Chinese Porcelains in European Mounts*, October 1980–January 1981, no. 14, illus.

BIBLIOGRAPHY

D. F. Lunsingh Scheurleer, *Chinesisches und japanisches Porzellan in europäischen Fassungen* (Braunschweig, 1980), p. 60, illus. pp. 252–253, figs. 158a–b; Wilson et al., *Mounted Oriental Porcelain*, no. 2, pp. 24–27, illus.

248. Pair of Lidded Vases

Porcelain: Chinese, Kangxi (1662–1680)
Mounts: Paris, circa 1715–1720
Hard-paste porcelain; polychrome enamel decoration; gilt-bronze mounts
Mounts stamped with the crowned *C* for 1745–1749.
Height: 1 ft. 1½ in. (34.2 cm); Width: 1 ft. ¾ in. (32.5 cm); Depth: 1 ft. 1 in. (33 cm)
Accession number 75.DI.5.1–.2

PROVENANCE

Bouvier collection, France; [Jacques Seligmann, Paris, before 1938]; Mrs. Langdon K. Thorne, New York; [Matthew Schutz, Ltd., New York, 1975]; purchased by J. Paul Getty.

EXHIBITIONS

New York, The China Institute in America, *Chinese Porcelains in European Mounts*, October 1980–January 1981, no. 3, illus.

BIBLIOGRAPHY

D. F. Lunsingh Scheurleer, *Chinesisches und japanisches Porzellan in europäischen Fassungen* (Braunschweig, 1980), p. 59, illus. p. 250, fig. 151; Wilson et al., *Mounted Oriental Porcelain*, no. 4, pp. 32–35, illus.

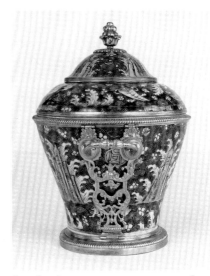

One of a pair 248

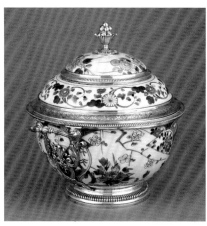

249

249. **Lidded Bowl**

Porcelain: Japanese (Imari), circa 1700
Mounts: Paris, circa 1717–1722
Hard-paste porcelain; polychrome enamel
decoration; gilding; silver mounts
Height: 11 in. (27.9 cm); Width: 1 ft. 1⅜ in.
(34 cm); Depth: 10⅞ in. (27.5 cm)
Accession number 79.DI.123.a–.b

PROVENANCE

Mrs. Walter Hayes Burns, North Mymms
Park, Hertfordshire, by 1933; Major General
Sir George Burns (grandson of Mrs. Walter
Hayes Burns), North Mymms Park (sold,
Christie's, North Mymms Park, Septem-
ber 24–26, 1979, lot 45).

EXHIBITIONS

London, 25 Park Lane, *Three French Reigns*,
February–April 1933, no. 226; New York,
The Frick Collection, *Mounted Oriental
Porcelain*, December 1986–March 1987,
no. 13, illus.

BIBLIOGRAPHY

Wilson, "Acquisitions 1979 to mid 1980,"
no. 5, pp. 8–9, illus.; Wilson et al., *Mounted
Oriental Porcelain*, no. 3, pp. 28–31, illus.;
Handbook 1986, p. 148, illus.; *Handbook*
1991, p. 164, illus.

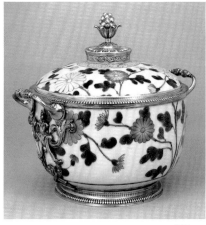

250

250. **Lidded Bowl**

Porcelain: Japanese (Imari), circa 1680
Mounts: Paris, circa 1717–1727
Hard-paste porcelain, underglaze blue deco-
ration; polychrome enamel; gilding; silver
mounts
Silver elements marked variously with a
fleur-de-lys without a crown (the Paris dis-
charge mark for small silver works used
between October 23, 1717, and May 5, 1722);
a butterfly (the countermark used between
May 6, 1722, and September 2, 1727, under
the *fermier* Charles Cordier); a dog's head

(the Paris discharge mark for small works
used between December 22, 1732, and
October 3, 1738); and a salmon's head
(the Paris discharge mark for small silver
works used between October 13, 1744, and
October 9, 1750).
Height: 8¾ in. (22.3 cm); Width: 10⅝ in.
(27.1 cm); Depth: 8⅜ in. (21.2 cm)
Accession number 74.DI.27

PROVENANCE

Consuelo Vanderbilt (Mme Jacques Balsan);
[Matthew Schutz, Ltd., New York, 1974];
purchased by J. Paul Getty.

BIBLIOGRAPHY

D. F. Lunsingh Scheurleer, *Chinesisches
und japanisches Porzellan in europäischen
Fassungen* (Braunschweig, 1980), p. 114,
illus. p. 403, fig. 439; Wilson et al.,
Mounted Oriental Porcelain, no. 5, pp.
36–38, illus.

251. Lidded Bowl

Porcelain: Chinese, Kangxi (1662–1722)
Mounts: Paris, circa 1722–1727
Hard-paste porcelain; enamel decoration;
gilding; silver mounts
Each silver mount bears a dove (the Paris
discharge mark for small silver works used
between May 6, 1722, and September 2,
1727, under the *fermier* Charles Cordier).
Height: 8 in. (20.3 cm); Diameter: 9⅞ in.
(25.1 cm)
Accession number 87.DI.4

PROVENANCE
[Jacques Kugel, Paris, 1986].

BIBLIOGRAPHY
"Acquisitions/1987," *GettyMusJ* 16 (1988),
no. 71, p. 178, illus.

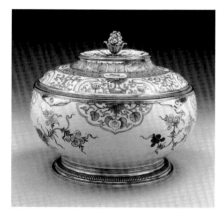

251

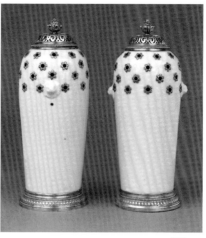

252

252. Pair of Lidded Vases

Porcelain: Chinese (Dehua), Kangxi
(1662–1722), circa 1700
Mounts: Paris, circa 1722–1727
Hard-paste porcelain; silver mounts
Each lid and base mount bears a dove (the
Paris discharge mark for small silver works
used between May 6, 1722, and September 2,
1727, under the *fermier* Charles Cordier); a
boar's head facing right (the Paris discharge
mark for small and old works used between
December 23, 1768, and September 1, 1775,
under the *fermier* Julien Alaterre); and the
profile head of Minerva (the mark for .800
standard silver works sold in France after
May 10, 1838).
Vase .1: Height: 7⁹⁄₁₆ in. (19.2 cm); Width:
3¼ in. (8.3 cm); Depth: 2⅞ in. (7.3 cm);
Vase .2: Height: 7⅝ in. (19.4 cm); Width:
3¼ in. (8.3 cm); Depth: 2⅞ in. (7.3 cm)
Accession number 91.DI.103.1–.2

PROVENANCE
Gift of Mme Simone Steinitz, Paris, 1991.

BIBLIOGRAPHY
"Acquisitions/1991," *GettyMusJ* 20 (1992),
no. 75, p. 174, illus. (one).

253. Figure of Guanyin

Porcelain: Chinese, Kangxi (1662–1722)
Mounts: Paris, circa 1735–1740
Hard-paste porcelain; gilt-bronze mount
Height: 1 ft. 1¼ in. (33.6 cm); Width: 5¾ in.
(14.6 cm); Depth: 4 in. (10.2 cm)
Accession number 78.DI.64

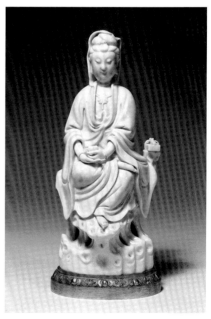

253

PROVENANCE
Mortimer L. Schiff, New York (sold by
his heir John L. Schiff, Christie's, London,
June 22, 1938, lot 15); purchased at that sale
by J. Paul Getty.

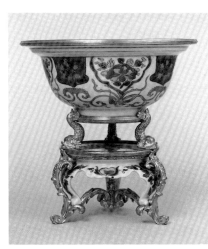

254

254. **Bowl on Stand**

Bowl: Chinese, Kangxi (1662–1722)
Stand: Japanese (Imari), late seventeenth
century
Mounts: French, circa 1740
Hard-paste porcelain; polychrome enamel
decoration; gilding; gilt-bronze mounts
Bowl painted with unidentified coat of arms.
Height: 7⅛ in. (18.7 cm); Diameter: 7¹³⁄₁₆ in.
(19.9 cm)
Accession number 74.DI.28

PROVENANCE
Anne Beddard (sold, Sotheby's, London,
June 15, 1973, lot 36); [Frank Partridge, Ltd.
London, 1973]; purchased by J. Paul Getty.

EXHIBITIONS
New York, The China Institute in America,
Chinese Porcelains in European Mounts,
October 1980–January 1981, no. 9, illus.

BIBLIOGRAPHY
D. F. Lunsingh Scheurleer, *Chinesisches
und japanisches Porzellan in europäischen
Fassungen* (Braunschweig, 1980), illus.
p. 406, fig. 451; Wilson et al., *Mounted
Oriental Porcelain*, no. 6, pp. 39–41, illus.

255. **Pair of Decorative Groups**

Figures, rockwork, and foo-dogs: Chinese,
Kangxi (1662–1722)
Spheres: Chinese, Qianlong (1736–1795)
Flowers: Chantilly manufactory, circa 1740
Mounts: Paris, circa 1740–1745
Hard- and soft-paste porcelain; polychrome
enamel decoration; gilt-bronze mounts
Height: 1 ft. (30.4 cm); Width: 9 in.
(22.8 cm); Depth: 5 in. (12.7 cm)
Accession number 78.DI.4.1–.2

PROVENANCE
H. J. King (sold, Christie's, London, Febru-
ary 17, 1921, lot 13, to [Duveen]); Edgar
Worsch, New York, 1928; Robert Ellsworth,
New York, 1975; (sold, Robert C. Eldred Co.,
Inc., New York, August 29–30, 1975, lot 151);
Alan Hartman, New York; [Matthew Schutz,
Ltd., New York, 1977].

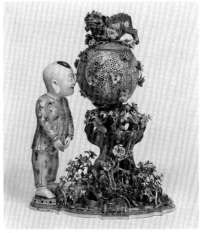

Group .1 255

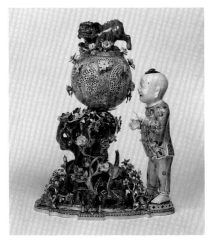

Group .2 255

BIBLIOGRAPHY
Wilson, "Acquisitions 1977 to mid 1979,"
no. 5, pp. 40–41, illus.; Wilson et al.,
Mounted Oriental Porcelain, no. 7, pp. 42–44,
illus.; *Handbook* 1991, p. 172, illus. (one).

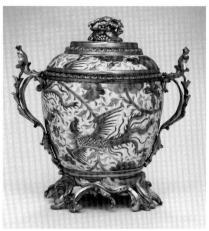

One of a pair 256

256. Pair of Lidded Vases

Porcelain: Chinese, Kangxi (1662–1722)
Mounts: Paris, circa 1745–1749
Hard-paste porcelain; polychrome enamel
decoration; gilding; gilt-bronze mounts
Mounts on vases stamped with the crowned
C for 1745–1749.
Height: 1 ft. ½ in. (31.8 cm); Width: 1 ft.¼ in.
(31.2 cm); Depth: 8½ in. (21.6 cm)
Accession number 72.DI.41.1–.2

PROVENANCE

Baroness van Zuylen van Nyevelt van de
Haar, Paris (sold, Palais Galliera, Paris,
June 8, 1971, lot 42); [Michel Meyer, Paris];
[Rosenberg and Stiebel, Inc., New York,
1971]; purchased by J. Paul Getty.

EXHIBITIONS

New York, The China Institute in America,
Chinese Porcelains in European Mounts,
October 1980–January 1981, no. 16, illus.

BIBLIOGRAPHY

D. F. Lunsingh Scheurleer, *Chinesisches
und japanisches Porzellan in europäischen
Fassungen* (Braunschweig, 1980), p. 63, illus.
p. 260, fig. 175; Wilson et al., *Mounted
Oriental Porcelain*, no. 8, pp. 45–47, illus.

257. Pair of Ewers

Porcelain: Chinese, Kangxi (1662–1722)
Mounts: Paris, circa 1745–1749
Hard-paste porcelain, celadon ground color;
underglaze blue and copper red decoration;
gilt-bronze mounts

Mounts stamped with the crowned *C* for
1745–1749. Mounts of ewer .1 also stamped
No and *No 16*; painted under the base in red
B-27-a. Mounts of ewer .2 stamped *No 16*;
painted under the base in red *B-27-b*.
Height: 1 ft. 11⅝ in. (60 cm); Width:
1 ft. 1 in. (33 cm); Depth: 8½ in. (21.5 cm)
Accession number 78.DI.9.1–.2

PROVENANCE

Ives, comte de Cambacérès, Paris; Germaine
Ancel, Paris; [François-Gérard Seligmann,
Paris]; [Jacques Helft, Paris]; [Hans Stiebel,
Paris]; Henry Ford II, Grosse Pointe Farms,
Michigan (sold, Sotheby, Parke, Bernet,
New York, February 25, 1978, lot 56).

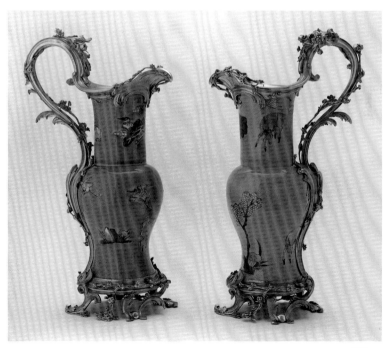

257

EXHIBITIONS

New York, The China Institute in America, *Chinese Porcelains in European Mounts*, October 1980–January 1981, no. 28, illus.; New York, The Frick Collection, *Mounted Oriental Porcelain*, December 1986–March 1987, no. 19, illus.

BIBLIOGRAPHY

Wilson, "Acquisitions 1977 to mid 1979," no. 6, pp. 41–42, illus.; Wilson et al., *Mounted Oriental Porcelain*, no. 9, pp. 48–52, illus.; F. J. B. Watson, "Chinese Porcelains in European Mounts," *Orientations* 12 (September 1981), vol. 9, pp. 26–33, illus. p. 29.

258. **Lidded Bowl**

Porcelain: Chinese, Kangxi (1662–1722), circa 1700–1720
Mounts: Paris, circa 1745–1749
Hard-paste porcelain, celadon ground color; gilt-bronze mounts
Mounts stamped with the crowned *C* for 1745–1749. Inside of bowl incised with a six-character Chinese reign mark of the Ming emperor Xuande. Base painted with the two characters *zen you* (precious jade).
Height: 1 ft. 3¾ in. (40 cm); Width: 1 ft. 3½ in. (39.3 cm); Depth: 11 in. (27.8 cm)
Accession number 74.DI.19

PROVENANCE

Sold, Galerie Jean Charpentier, Paris, December 14, 1933, lot 107; Mme Henry Farman, Paris (sold, Palais Galliera, Paris, March 15, 1973, lot 25); [Partridge (Fine

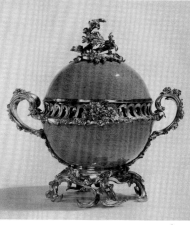

258

Arts), Ltd., London, 1973]; purchased by J. Paul Getty.

EXHIBITIONS

New York, The China Institute in America, *Chinese Porcelains in European Mounts*, October 1980–January 1981, no. 19, illus.

BIBLIOGRAPHY

Wilson et al., *Mounted Oriental Porcelain*, no. 10, pp. 53–57, illus.

259. **Pair of Vases**

Porcelain: Chinese, Kangxi (1662–1722)
Mounts: Paris, circa 1745–1749
Hard-paste porcelain; polychrome enamel decoration; gilt-bronze mounts
Mounts for each vase stamped with the crowned *C* for 1745–1749.
Height: 1 ft. ½ in. (31.7 cm); Width: 1 ft. 2 in. (35.5 cm); Depth: 10½ in. (26.7 cm)
Accession number 79.DI.121.1–.2

PROVENANCE

Masurel family, France (sold late 1970s); [Bernard Baruch Steinitz, Paris]; [Alexander and Berendt, Ltd., London, 1979].

EXHIBITIONS

New York, The China Institute in America, *Chinese Porcelains in European Mounts*, October 1980–January 1981, no. 20, illus.; New York, The Frick Collection, *Mounted Oriental Porcelain*, December 1986–March 1987, no. 18, illus.

BIBLIOGRAPHY

Wilson, "Acquisitions 1979 to mid 1980," no. 6, pp. 9–10, illus.; Wilson et al., *Mounted Oriental Porcelain*, no. 11, pp. 58–61, illus.; F. J. B. Watson, "Chinese Porcelains in European Mounts," *Orientations* 12 (September 1981), no. 9, pp. 26–33, illus. p. 31.

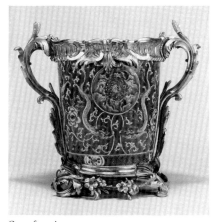

One of a pair

259

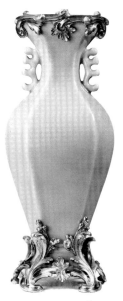

260

260. **Vase**

Porcelain: Chinese, Yongzheng, circa 1730
Mounts: Paris, circa 1745–1750
Hard-paste porcelain, celadon ground color;
gilt-bronze mounts
Height: 1 ft. 2½ in. (36.8 cm); Width: 6 in.
(15.2 cm); Depth: 4½ in. (11.5 cm)
Accession number 75.DI.69

PROVENANCE

Trustees of Swinton Settled Estates (sold,
Christie's, London, December 4, 1975, lot
46); purchased at that sale by J. Paul Getty.

EXHIBITIONS

New York, The China Institute in America,
Chinese Porcelains in European Mounts,
October 1980–January 1981, no. 18, illus.

BIBLIOGRAPHY

D. F. Lunsingh Scheurleer, *Chinesisches
und japanisches Porzellan in europäischen
Fassungen* (Braunschweig, 1980), p. 94, illus.
p. 330, fig. 318; Wilson et al., *Mounted
Oriental Porcelain*, no. 12, pp. 62–64, illus.

261. **Pair of *Pot-pourri* Vases**

Porcelain: Japanese (Arita or early Hirado
kilns), late seventeenth century
Mounts: Paris, circa 1750
Hard-paste porcelain, celadon ground color;
polychrome enamel decoration; gilt-bronze
mounts
Height: 6 in. (15.2 cm); Width: 7⅜ in.
(18.7 cm); Depth: 6½ in. (16.5 cm)
Accession number 77.DI.90.1–.2

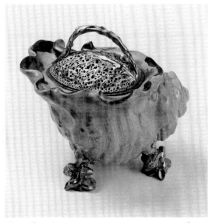

One of a pair 261

PROVENANCE

(?) M. Jullienne, Paris (sold by C. F. Julliot,
Paris, 1767, no. 1403); (?) Pierre-Louis
Randon de Boisset, Paris (sold, Paris,
February 3, 1777, lot 603, to the duchesse
de Mazarin for 600 *livres*); (?) C. F. Julliot,
Paris (sold, Paris, November 20, 1777, lot
331); (?) Radix de Sainte-Foix, Paris (sold,
Paris, April 22, 1782, lot 55, for 130 *livres*
to Lebrun; (?) Jean-Baptiste-Pierre Lebrun,
Paris (sold, Paris, April 11, 1791, lot 698, for
120 *livres* to M. Paillet, who was probably
the *commissaire-priseur*); [Didier Aaron and
Claude Lévy, Paris, 1970s]; [Etienne Lévy,
Paris, 1977].

EXHIBITIONS

New York, The Frick Collection, *Mounted
Oriental Porcelain*, December 1986–March
1987, no. 27, pp. 82-83, illus.

BIBLIOGRAPHY

Wilson, "Acquisitions 1977 to mid 1979,"
no. 2, p. 37, illus.; Wilson et al., *Mounted
Oriental Porcelain*, no. 13, pp. 65–67, illus.;
Geneviève Mazel, "1777, La Vente Randon
de Boisset et le marché de l'art au 18ᵉ siècle,"
L'Estampille 202 (April 1987), p. 47, illus.;
Michel Beurdeley, "Paris 1777: La Vente
Randon de Boisset ou le mécanisme secret
des ventes publiques au XVIIIᵉ siècle," *Trois
siècles des ventes publiques* (Fribourg, 1988),
p. 53, illus.

262. **Vase**

Porcelain: Chinese, Qianlong (1736–1795)
Mounts: Paris, circa 1750–1755
Hard-paste porcelain, celadon ground color;
gilt-bronze mounts
One mount marked on inside with a
double *T*.
Height: 1 ft. 2½ in. (36.9 cm); Width:
1 ft. 4¼ in. (41.2 cm); Depth: 11 in.
(27.9 cm)
Accession number 72.DI.42

PROVENANCE

[Rosenberg and Stiebel, Inc., New York,
1972]; purchased by J. Paul Getty.

EXHIBITIONS

New York, The China Institute in America,
Chinese Porcelains in European Mounts,
October 1980–January 1981, no. 8, illus.

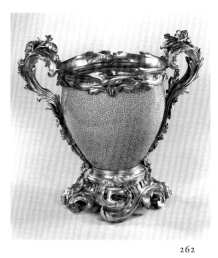

262

263

BIBLIOGRAPHY

D. F. Lunsingh Scheurleer, *Chinesisches
und japanisches Porzellan in europäischen
Fassungen* (Braunschweig, 1980), p. 95, illus.
p. 334, fig. 326; Wilson et al., *Mounted
Oriental Porcelain*, no. 15, pp. 70–73, illus.

263. **Lidded Pot**

Porcelain: Chinese (Dehua), Kangxi
(1662–1722)
Mounts: Paris, circa 1765–1770
Hard-paste porcelain; gilt-bronze mounts
Porcelain lid impressed with a seal mark.
Height: 9⅞ in. (25.1 cm); Width: 7⅜ in.
(18.7 cm); Depth: 6¼ in. (15.9 cm)
Accession number 78.DI.359

PROVENANCE

[Kraemer et Cie, Paris, 1960s]; Henry Ford
II, Grosse Pointe Farms, Michigan (sold,
Sotheby, Parke, Bernet, New York, Febru-
ary 25, 1978, lot 61); [Partridge (Fine Arts)
Ltd., London, 1978].

EXHIBITIONS

New York, The China Institute in America,
Chinese Porcelains in European Mounts,
October 1980–January 1981, no. 11, illus.

BIBLIOGRAPHY

Wilson, "Acquisitions 1977 to mid 1979,"
no. 9, pp. 45–46, illus.; Wilson et al.,
Mounted Oriental Porcelain, no. 16,
pp. 74–76, illus.; F. J. B. Watson, "Chinese
Porcelains in European Mounts," *Orienta-
tions* 12 (September 1981), no. 9, p. 30.

264. **Pair of Mounted Vases**

Porcelain: Chinese, Kangxi (1662–1722)
Mounts: Paris, circa 1770–1775
Hard-paste porcelain, black ground color;
gilding; gilt-bronze mounts
Vase .1 bears a paper label (torn) underneath
reading *HELIOT FILS. eIII....* Vase .2 is
stamped once with *EM* on the base mount.
Height: 1 ft. 7¼ in. (49 cm); Width: 9¾ in.
(24.7 cm); Depth: 7⅞ in. (20 cm)
Accession number 92.DI.19.1–.2

PROVENANCE

Laurent Heliot, (?) Paris (sold, Hôtel
Drouot, Paris, December 3, 1985, lot 55);
[B. Fabre et Fils, Paris].

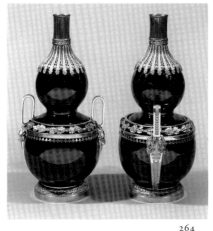

264

BIBLIOGRAPHY
Compagnie des Commissaires-Priseurs de
Paris, *Drouot, 1985–1986, l'art et les enchères*
(Paris, circa 1986), p. 302, illus. p. 210;
"Acquisitions/1992," *GettyMusJ* 21 (1993),
in press, illus.

265. **Mounted Vase**
Porcelain: Chinese, Kangxi (1622–1722)
Mounts: Paris, circa 1785
Hard-paste porcelain, purple ground color;
gilt-bronze mounts
Height: 1 ft. 9⅙ in. (54.2 cm); Width:
10⅝ in. (27 cm); Depth: 9⅞ in. (25 cm)
Accession number 87.DI.137

PROVENANCE
[Michel Meyer, Paris, 1987].

BIBLIOGRAPHY
"Acquisitions/1987," *GettyMusJ* 16 (1988),
no. 74, pp. 178–179, illus.

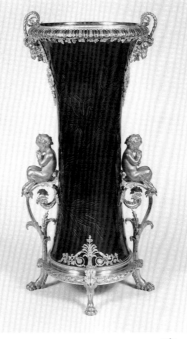

265

266. **Standing Vase**
Porcelain: Chinese, Qianlong (1736–1795),
mid-eighteenth century
Mounts: Paris, circa 1785
Mounts attributed to Pierre-Philippe
Thomire
Hard-paste porcelain, blue ground color;
gilt-bronze mounts; *rouge griotte* marble
Bowl painted underneath with an indistinct
date (?) *1781.*
Height: 2 ft. 7¾ in. (81 cm); Diameter:
1 ft. 10 in. (56.5 cm)
Accession number 70.DI.115

PROVENANCE
(?) Princesse Isabella Lubormirska, Castle
Lancut, Poland; by descent to Count Alfred
Potocki (great-great-grandson of Princess
Isabella Lubormirska), Castle Lancut,
removed 1944; [Rosenberg and Stiebel, Inc.,
New York, 1953]; purchased by J. Paul
Getty, 1953.

BIBLIOGRAPHY
Verlet et al., *Chefs d'oeuvre*, p. 132, illus.;
Getty, *Collecting*, p. 162; Geoffrey de
Bellaigue, *Sèvres Porcelain from the Royal
Collection: The Queen's Gallery* (London,
1979–1980), no. 11, pp. 31–32; D. F.
Lunsingh Schleurleer, *Chinesisches und*

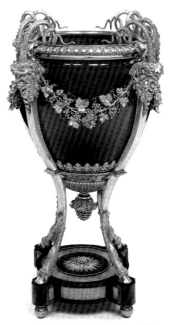

266

japanisches Porzellan in europäischen Fassungen (Braunschweig, 1980), p. 86, illus. p. 308, fig. 275; Michel Beurdeley, *La France à l'encan 1789–1799* (Fribourg, 1981), p. 118, illus.; Wilson et al., *Mounted Oriental Porcelain*, no. 17, pp. 77–81, illus.; Wilson, *Selections*, no. 45, pp. 90–91, illus.; Ottomeyer and Pröschel, *Vergoldete Bronzen*, p. 269, illus. p. 268; *Handbook* 1986, p. 177, illus.; Savill, *Sèvres*, vol. 1, p. 469; n. 10, p. 475; *Handbook* 1991, p. 195, illus.

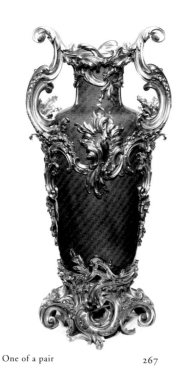

One of a pair 267

267. **Pair of Vases**

Porcelain: Chinese, Kangxi (1662–1722)
Mounts: French (possibly German), circa 1860–1870
Mounts attributed to Bormann
Hard-paste porcelain, blue ground color; gilt-bronze mounts
Height: 1 ft. 11½ in. (59.7 cm); Width: 1 ft. (30.6 cm); Depth: 11⅛ in. (28.2 cm)
Accession number 78.DI.240.1–.2

PROVENANCE

Mrs. Evelyn Saint George, Cam House, London (sold, Sotheby's, London, July 24–25, 1939, lot 81); purchased at that sale by J. Paul Getty.

EXHIBITIONS

Woodside, California, Filoli, on loan, 1979–1991; New York, The Frick Collection, *Mounted Oriental Porcelain*, December 1986–March 1987, no. 44, pp. 116–117, illus.

BIBLIOGRAPHY

Wilson et al., *Mounted Oriental Porcelain*, no. 18, pp. 82–84, illus.; F. J. B. Watson, "Mounted Oriental Porcelain," *The Magazine Antiques* (April 1987), pp. 813–823, illus.

268. **Pair of Vases**

Porcelain: Chinese, Kangxi (1662–1722)
Mounts: Paris, circa 1870–1900
Hard-paste porcelain; polychrome enamel decoration; gilding; gilt-bronze mounts
Height: 1 ft. 10½ in. (57.2 cm); Diameter: 8¼ in. (21.2 cm)
Accession number 78.DI.239.1–.2

One of a pair 268

PROVENANCE

Mme Louis Burat, Paris (sold, Galerie Jean Charpentier, Paris, June 17–18, 1937, lot 55); (sold anonymously, Sotheby's, London, July 1, 1966, lot 38); [Frank Partridge, Ltd., London, 1966]; purchased by J. Paul Getty, 1967.

BIBLIOGRAPHY

Wilson et al., *Mounted Oriental Porcelain*, no. 19, pp. 85–87, illus.

Mounted Hardstones

269. **Vase**

Paris, circa 1760
Bianco e nero antico marble; gilt-bronze
mounts
Height: 1 ft. ½ in. (31.7 cm); Width:
1 ft. 7¾ in. (50.2 cm); Depth: 11⅛ in.
(28.3 cm)
Accession number 79.DJ.183

PROVENANCE
Sold, "Property of a Lady," Christie's, London, December 6, 1979, lot 4.

BIBLIOGRAPHY
Wilson, "Acquisitions 1979 to mid 1980,"
no. 2, pp. 4–5, illus.

269

One of a pair 270

270. **Pair of Vases**

Paris (possibly Italian), circa 1765–1770
After an engraving by Benigo Bossi of a
design by Eunemond-Alexandre Petitot
Porphyry, red marble; gilt-bronze mounts
Height: 1 ft. 3¼ in. (38.7 cm); Width:
1 ft. 4⅛ in. (41 cm); Depth: 10⅞ in.
(27.7 cm)
Accession number 83.DJ.16.1–.2

PROVENANCE
Sir Everard Joseph Radcliffe, 5th Bt. (1884–
1969), Rudding Park, Yorkshire; [Lovice
Reviczky A. G., Zurich, 1982].

EXHIBITIONS
Barnard Castle, County Durham, The
Bowes Museum, *French Art of the Seventeenth and Eighteenth Centuries from
Northern Collections*, July–August 1965,
no. 37.

BIBLIOGRAPHY
Wilson, "Acquisitions/1983," no. 9,
pp. 199–201, illus.; "Acquisitions/1983,"
no. 11, p. 265, illus.; *Handbook* 1986, p. 170,
illus. (one).

271. **Vase**

Paris, circa 1770
Granite; gilt-bronze mounts
Height: 1 ft. 2⅝ in. (37.2 cm); Width:
1 ft. 7 in. (48.2 cm); Depth: 8½ in. (21.6 cm)
Accession number 89.DJ.31

PROVENANCE
(?) Richard, 4th Marquess of Hertford (1800–
1870), rue Lafitte, Paris; (?) Sir Richard
Wallace (1818–1890), rue Lafitte, Paris, by
inheritance; (?) Lady Wallace (died 1897),
rue Lafitte, Paris, by inheritance; Sir John
Murray Scott, rue Lafitte, Paris, until 1912;
(?) Victoria, Lady Sackville, rue Lafitte,
Paris, by inheritance; [(?) Jacques Seligmann, Paris]; Baronne de Gunzburg, avenue Foch, Paris; [Maurice Segoura, Paris].

271

BIBLIOGRAPHY

F. J. B. Watson, *Wallace Collection Catalogues: Furniture* (London, 1956), pl. 120; "Acquisitions/1989," *GettyMusJ* 18 (1990), no. 57, p. 195, illus.

———

272. **Lidded Bowl**

Paris, circa 1770
Porphyry; gilt-bronze mounts
Height: 1 ft. 4 in. (40.6 cm); Width:
1 ft. 4½ in. (41.9 cm); Depth: 9½ in.
(24.1 cm)
Accession number 73.DJ.88

PROVENANCE

I. Rosenbaum, Frankfurt am Main (sold, Parke-Bernet, New York, December 5–6, 1946, lot 309); [Dalva Brothers, Inc., New York, 1973]; purchased by J. Paul Getty.

———

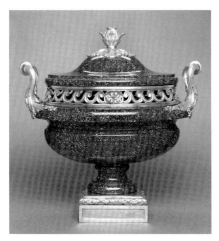

272

273. **Pair of Urns**

Paris, circa 1780
Porphyry; gilt-bronze mounts
Height: 1 ft. 2 in. (35.6 cm); Diameter: 9 in.
(22.9 cm)
Accession number 74.DJ.24.1–.2

PROVENANCE

[Matthew Schutz, Ltd., New York, 1974]; purchased by J. Paul Getty.

———

274. **Pair of Standing Tazzas**

Paris, circa 1785
Jaune foncé marble and (?) *brèche violette*; gilt-bronze mounts
One mount, a replacement, stamped *BY* for the *bronzier* Louis-Auguste-Alfred Beurdeley.
Height: 1 ft. 2⅞ in. (37.8 cm); Width:
9⅝ in. (24.3 cm); Depth: 9⅞ in. (25.2 cm)
Accession number 74.DJ.4.1–.2

PROVENANCE

Napoléon Lannes, 2nd duc de Montebello; Louis-Auguste-Alfred Beurdeley, Paris, by 1882; Alfred-Emanuel-Louis Beurdeley (son of Louis-Auguste-Alfred Beurdeley), Paris (sold, May 19–20, 1899, lot 178); Lindon collection (sold, Sotheby's, London, June 26, 1964, lot 87; [R. L. Harrington, Ltd., London, 1967]; [Dalva Brothers, Inc., New York]; purchased by J. Paul Getty.

———

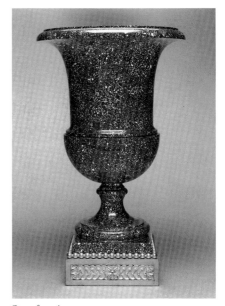

One of a pair 273

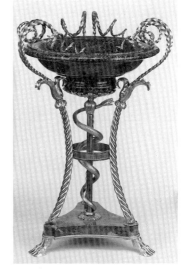

One of a pair 274

275. **Pair of Vases (*jardinières*)**

Paris, circa 1785
Brèche violette; gilt-bronze mounts; brass liners
Height: 8¼ in. (21 cm); Diameter: 7¼ in. (18.5 cm)
Accession number 88.DJ.121.1–.2

PROVENANCE
[Mallett at Bourdon House, Ltd., London, 1988].

BIBLIOGRAPHY
"Acquisitions/1988," *GettyMusJ* 17 (1989), no. 79, p. 144, illus.

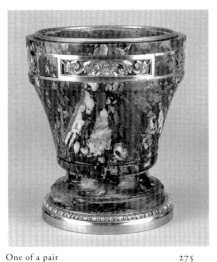

One of a pair 275

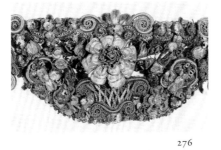

276

Textiles

276. **Length of *Passementerie***

French, circa 1670
Green, orange, and cream silk; wire; paper; parchment
Height: 2 ft. 8¼ in. (81.9 cm); Width: 7¼ in. (18.5 cm); Depth: 1½ in. (4 cm)
Accession number 86.DD.667

PROVENANCE
[Juliette Niclausse, Paris, 1986].

BIBLIOGRAPHY
"Acquisitions/1986," *GettyMusJ* 15 (1987), no. 98, p. 210, illus.

277. **Pair of Embroidered Bed Hangings**

Paris, circa 1690
Design attributed to Daniel Marot
Linen embroidered with silk and wool; linen lining
Panel .1: Height: 11 ft. 2¾ in. (342 cm); Width: 3 ft. ⅛ in. (91.7 cm); Panel .2: Height: 11 ft. 3 ⅙ in. (343 cm); Width: 3 ft. ⅝ in. (93 cm)
Accession number 85.DD.266.1–.2

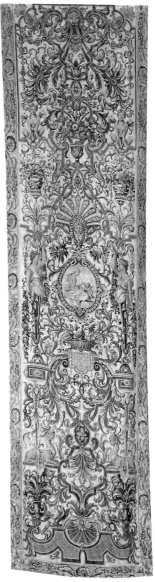

One of a pair 277

PROVENANCE
Lt. Col. A. Heywood-Lonsdale, Shavington
Hall, Salop; [Partridge (Fine Arts), Ltd.,
London, 1985].

BIBLIOGRAPHY
"Acquisitions/1985," *GettyMusJ* 14 (1986),
no. 189, p. 242, illus.; Anne Ratzki-Kraatz,
"Two Embroidered Hangings in the Style
of Daniel Marot," *GettyMusJ* 20 (1992),
pp. 89–106, illus.

278. **Hangings for a Bed**

French, circa 1690–1715
Silk satin, cording, velour, silk embroidery,
damask panels; linen linings
Height: 15 ft. 7⅜ in. (415 cm); Width:
5 ft. 11½ in. (182 cm); Depth: 6 ft. (183 cm)
Accession number 79.DD.3

PROVENANCE
Château de Montbrian, near Messimy,
Aix-en-Provence; [P. Bertrand et Cie, Paris,
1933]; [Gerald C. Paget, London and New
York, 1970s].

EXHIBITIONS
Paris, Salon des Arts Ménagers, Grand
Palais, *L'Exposition rétrospective de la
chambre à coucher*, January–February 1933,
no. 129, illus.; Versailles, Château de Ver-
sailles, Salon de la Guerre, June 1936.

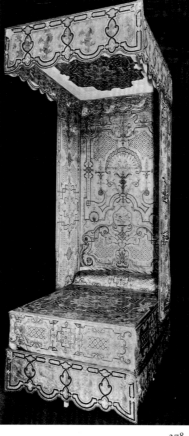

278

BIBLIOGRAPHY
Wilson, "Acquisitions 1977 to mid 1979,"
no. 12, pp. 48–49, illus.; Anne Ratzki-Kraatz,
"A French Lit de Parade 'A la Duchesse'
1690–1715," *GettyMusJ* 14 (1986), pp. 81–104,
illus.

279. **Six Painted Panels**

Paris, circa 1780
Gouache on silk with gold paint
One panel painted with the monograms
MJL and *LSX* of the comte and comtesse de
Provence.
Height: 4 ft. 9 in. (144.8 cm); Width: 7 in.
(17.8 cm)
Accession number 73.DH.89.1–.6

PROVENANCE
Made for Louis-Stanislas-Xavier and Marie-
Josephine-Louise, comte and comtesse de
Provence (sold as part of a set of eight panels
from the "Bureaux des Bâtiments [du Roi],"
July 15, 1794 [27 *messidor, an* II], lot 16112,
for 150 *livres* to *citoyen* Bouchard [informa-
tion: C. Baulez]); Baron Louis de Roth-
schild (sold, Parke-Bernet, New York,
May 13, 1955, lot 165); [Dalva Brothers, Inc.,
New York, 1973]; purchased by J. Paul Getty.

BIBLIOGRAPHY
Wilson, *Selections*, no. 43, pp. 86–87, illus.

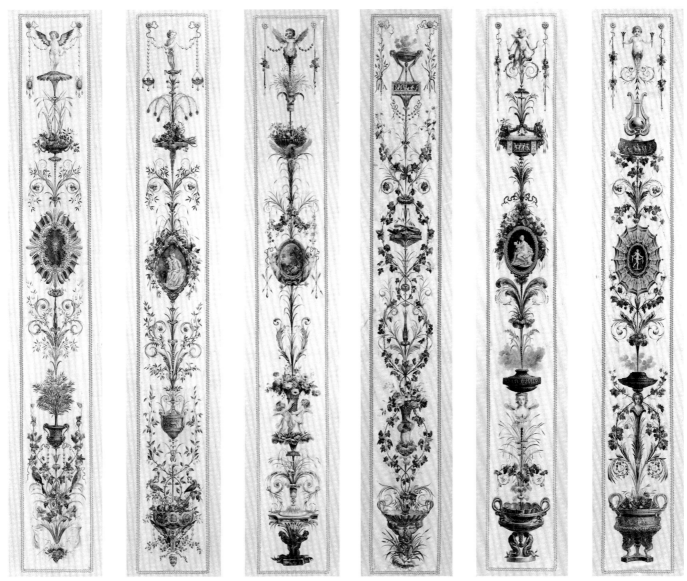

279

280

Carpets and Screens

280. **Carpet**

Savonnerie manufactory, circa 1663
Probably made in the workshops of
Philippe Lourdet
Wool and linen
Length: 21 ft. 11⅜ in. (669 cm); Width:
14 ft. 5 in. (440 cm)
Accession number 70.DC.63

PROVENANCE

Louis XIV, by 1667; Church of Saint-André-
des-Arts, Paris, 1769; (?) Parguez-Perdreau,
Paris, March 1914; [Arnold Seligmann,
Paris, March–June 1914]; George A. Kessler,
June 1914; Mortimer L. Schiff, New York
(sold by his heir John L. Schiff, Christie's,
London, June 22, 1938, lot 77); purchased at
that sale by J. Paul Getty.

BIBLIOGRAPHY

Jules Guiffrey, *Inventaire général du mobilier
de la couronne sous Louis XIV: Tapis* (Paris,
1885–1886), (?) no. 18, p. 378; Verlet et al.,
Chefs d'oeuvre, pp. 134–135, illus.; Pierre
Verlet, *The James A. de Rothschild Collection
at Waddesdon Manor: The Savonnerie* (Fri-
bourg, 1982), p. 174; nn. 5, 11, p. 421; Wilson,
Selections, no. 1, pp. 2–3, illus.

281. **Carpet**

Savonnerie manufactory, before May 3, 1680
Woven under the direction of the Lourdet
family after the design of François Francart
and Baudoin Yvart (*le père?*) according to
the scheme of Charles Le Brun
Wool
Length: 29 ft. 9¾ in. (908.6 cm); Width:
15 ft. 7 in. (472.1 cm)
Accession number 85.DC.515

PROVENANCE

Delivered to the *garde meuble* on May 3,
1680, by "Veuve" Lourdet for Louis XIV,
Galerie du bord de l'eau, Louvre, Paris;
on loan to Pierre-Paul, marquis d'Ossun
(1713–1788), *Ambassadeur Extraordinaire et
Plénipotentiaire de France*, 1759, from

281

circa 1769–1775; [(?) Jacques Seligmann, Paris, 1926]; Mme Jorge Ortiz-Linares (née Graziella Patiño), Paris; by descent to Georges Ortiz, Geneva.

BIBLIOGRAPHY

Pierre Verlet, *The James A. de Rothschild Collection at Waddesdon Manor: The Savonnerie* (Fribourg, 1982), p. 203; 72nd carpet p. 491; nn. 119, 123, p. 430; n. 143, p. 432; n. 149, p. 433; and included as a line drawing in a folding plan of the Galerie du bord de l'eau; "Acquisitions/1985," *GettyMusJ* 14 (1986), no. 187, p. 240, illus.

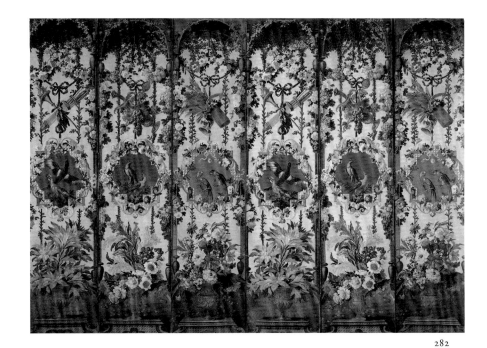

282

282. Pair of Three-panel Screens

Savonnerie manufactory, woven between 1714 and 1740
Woven after designs by Jean-Baptiste Belin [Belain or Blin] de Fontenay and Alexandre-François Desportes
Wool and linen; modern velvet backing; wooden frame
Height: 8 ft. 11¾ in. (273.6 cm); Width: 6 ft. 4⅛ in. (193.2 cm)
Accession number 83.DD.260.1–.2

PROVENANCE

(?) Mme d'Yvon, Paris (sold, Galerie Georges Petit, Paris, May 30–June 4, 1892, lot 673); [Jacques Seligmann, Paris] (sold, Galerie Georges Petit, Paris, March 9–12, 1914, lot 343); [Germain Seligmann, Paris, 1927]; [François-Gérard Seligmann, Paris, by 1960] (sold, Sotheby's, Monaco, June 14–15, 1981, lot 54); [Dalva Brothers, Inc., New York, 1981].

EXHIBITIONS

Paris, Manufacture Nationale des Gobelins, *Tapis de la Savonnerie*, December 1926–January 1927, no. 96; Paris, Bibliothèque Nationale, *Le Siècle de Louis XIV*, February–April 1927, no. 1268; Paris, Musée des Arts Décoratifs, *Louis XIV: Faste et décors*, May–October 1960, no. 774, pl. 52; Richmond, Virginia, *Experts' Choice: One Thousand Years of the Art Trade*, April 22–June 12, 1983, pp. 82–83, illus., lent by Dalva Brothers, Inc.

BIBLIOGRAPHY

Pierre Verlet, *The James A. de Rothschild Collection at Waddesdon Manor: The Savonnerie* (Fribourg, 1982), p. 301; n. 82, pp. 457–458; Wilson, "Acquisitions 1983," no. 2, pp. 180–183, illus.; "Acquisitions/1983," *GettyMusJ* 12 (1984), no. 4, p. 262, illus.; *Handbook* 1986, p. 150, illus. (one) p. 151; Catherine Hamrick, "European Folding Screens: Mirrors of an Enduring Past," *Southern Accents* (April 1990), pp. 30, 32, 34, 38, 40, illus. p. 34; *Handbook* 1991, p. 164, illus. (one), p. 165.

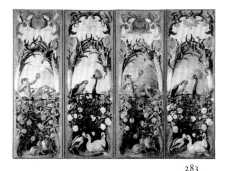

283

283. **Four-panel Screen**

Savonnerie manufactory, woven between
1719 and 1769
Woven after designs by Alexandre-François
Desportes
Wool and linen; modern velvet backing;
wooden frame; brass nails
Height: 6 ft. ⅞ in. (185.1 cm); Width:
8 ft. 6 in. (259.1 cm)
Accession number 75.DD.1

PROVENANCE

The Earl of Caledon, Tyttenhanger Park,
Hertfordshire; [Alexander and Berendt,
Ltd., London, 1973]; private Australian
collection; [Alexander and Berendt, Ltd.,
London, 1975]; purchased by J. Paul Getty.

BIBLIOGRAPHY

Pierre Verlet, *The James A. de Rothschild
Collection at Waddesdon Manor: The Savon-
nerie* (Fribourg, 1982), p. 15; n. 20, p. 467;
Wilson, *Selections*, no. 12, pp. 24–25, illus.

Tapestries

284. **Fragment of a Verdure Tapestry**

French, circa 1630
Wool
Height: 10 ft. 10 in. (330.5 cm); Width:
7 ft. 11½ in. (242.5 cm)
Accession number 69.DD.37

PROVENANCE

Gift of Dr. Albert Best, Los Angeles, 1969.

285. **Tapestry, *The Offering to Bacchus* from the Grotesque Series**

Beauvais manufactory, circa 1685–1730
After a design by Jean-Baptiste Monnoyer
Wool and silk
Height: 9 ft. 5¾ in. (289 cm); Width:
6 ft. 7¼ in. (201 cm)
Accession number 86.DD.645

PROVENANCE

Rothschild collection, Vienna; (anonymous
sale, Christie's, London, June 22, 1939,
lot 159); (sold, Christie's, London, July 1,
1982, lot 3, to [Bernheimer Fine Arts, Ltd.,
London]).

BIBLIOGRAPHY

"Acquisitions/1986," *GettyMusJ* 15 (1987),
no. 99, pp. 210–211, illus.

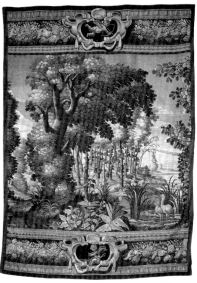

284

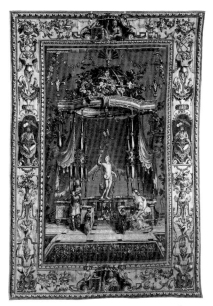

285

286. **Six Tapestries from** *The Story of the Emperor of China* **Series**

Beauvais manufactory, circa 1690–1705
Woven under the direction of Philippe Béhagle after designs by Guy-Louis Vernansal, Jean-Baptiste Monnoyer, and Jean-Baptiste Belin [Belain or Blin] de Fontenay
Wool and silk
All woven with the arms and monogram of the comte de Toulouse.

The Collation:
Signature *VERNANSAL.INT.ET.PU* woven at lower center of scene, in border of carpet.
Height: 13 ft. 10½ in. (423 cm);
Width: 10 ft. 2 in. (310 cm)
Accession number 83.DD.336

The Harvesting of Pineapples:
Woven *BEHAGLE* at lower right.
Height: 13 ft. 7½ in. (415 cm);
Width: 8 ft. 5½ in. (258 cm)
Accession number 83.DD.337

The Astronomers:
Height: 13 ft. 9 in. (419 cm);
Width: 10 ft. 5½ in. (319 cm)
Accession number 83.DD.338

The Emperor on a Journey:
Height: 13 ft. 7½ in. (415 cm);
Width: 8 ft. 4 in. (254 cm)
Accession number 83.DD.339

The Return from the Hunt:
Woven *BEHAGLE* at lower right.
Height: 13 ft. 8½ in. (418 cm);
Width: 9 ft. 6 in. (290 cm)
Accession number 83.DD.340

The Empress's Tea:
Height: 13 ft. 9 in. (419.1 cm);
Width: 6 ft. 3 in. (195 cm)
Accession number 89.DD.62

PROVENANCE
Made for Louis-Alexandre de Bourbon, comte de Toulouse and duc de Penthièvre, as part of a set of ten tapestries in the *Chambre du Roi* and the *Antichambre du Roi* of the Château de Rambouillet in 1718; by descent to his son, Louis-Jean-Marie de Bourbon, duc de Penthièvre; by descent to his daughter, Louise-Marie-Adélaïde de Bourbon; by descent to her son, Louis-Philippe d'Orléans, King of the French (six tapestries from the set sold, Paris, January 25–27, 1852, lot 8); Thérèse d'Albert-Luynes d'Uzès, France (sold in America in 1926); John Thompson Dorrance, Sr., Newport, Rhode Island; by descent to John Thompson Dorrance, Jr.
83.DD.336–340: [Rosenberg and Stiebel, Inc., New York, 1983].
89.DD.62: The Preservation Society of Newport County, Château-sur-Mer, Newport, Rhode Island, 1970s.

EXHIBITIONS
The Preservation Society of Newport, Rhode Island, Château-sur-Mer, 1970s–1989 (89.DD.62 only).

BIBLIOGRAPHY
Montié and de Dion, "Quelques documents sur le Duchépairie de Rambouillet," *Mémoires et documents publiés par la Société archéologique de Rambouillet* 7 (1886), pp. 208, 227; Jules Badin, *La Manufacture de tapisseries de Beauvais depuis ses origines jusqu'à nos jours* (Paris, 1909), p. 13; George Leland Hunter, *The Practical Book of Tapestries* (Philadelphia, 1925), p. 162; Dr. Szokolny, "Vom amerikanischen Kunstmarkt," *Cicerone* 18 (1926), pp. 271–272; Edith Standen, "The Story of the Emperor of China: A Beauvais Tapestry Series," *Metropolitan Museum of Art Journal* 2 (1976), pp. 103–117; Bremer-David, "Acquisitions 1983," no. 1, pp. 173–181, illus.; "Acquisitions/1983," *GettyMusJ* 12 (1984), no. 3, pp. 261–262, illus.; Edith Standen, "The Audience of the Emperor from the series 'The Story of the Emperor of China,'" *European Post-Medieval Tapestries and Hangings in the Metropolitan Museum of Art* (New York, 1985), vol. 2, pp. 461–468; Jacqueline Boccara, "Voyages du grand siècle: Tapisseries de Beauvais, de Bruxelles et des Gobelins," *Les Antiquaires au Grand Palais: XIVe biennale internationale* (Paris, 1988), pp. 112–118; Jacqueline Boccara, *Ames de Laine et de Soi* (Saint-Just-en-Chausée, 1988), p. 306, illus.; "Acquisitions/1989," *GettyMusJ* 18 (1990), no. 54, pp. 193–194, illus.

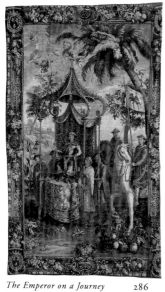

The Emperor on a Journey 286

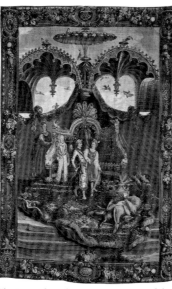

The Return from the Hunt 286

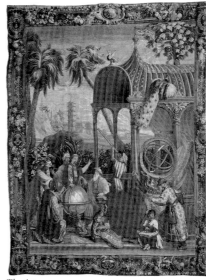

The Astronomers 286

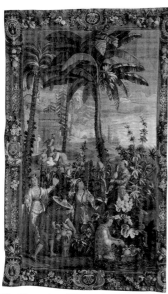

The Harvesting of Pineapples 286

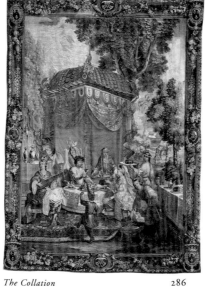

The Collation 286

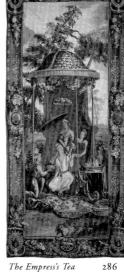

The Empress's Tea 286

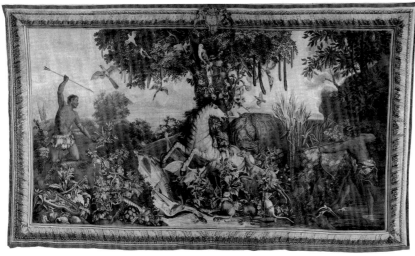

287

287. Tapestry, *Le Cheval Rayé* from the *Anciennes Indes* Series

Gobelins manufactory, circa 1690–1730
After a cartoon by Albert Eckhout and
Frans Post, retouched by Jean-Baptiste
Monnoyer, Jean-Baptiste Belin [Belain or
Blin] de Fontenay, René-Antoine Houasse,
François Bonnemer, and Alexandre-François
Desportes
Wool and silk
Woven with the arms of the Camus de
Pontcarré de Viarmes de la Guibourgère
families.
Height: 10 ft. 10 in. (326 cm); Width:
18 ft. 10 in. (580.2 cm)
Accession number 92.DD.21

PROVENANCE

(?) Jean-Baptiste-Elie Camus de Pontcarré,
seigneur de Viarmes (1702–1775), and his
wife Françoise-Louise Raoul de la Guibour-
gère; by descent to Louis-Jean-Népomucene-
François-Marie Camus de la Guibourgère
(1747–1794); by descent to Alexandre-
Prosper Camus de la Guibourgère (1793–
1853), Château de la Guibourgère, Bretagne;
[Bernard Blondeel, Antwerp, Belgium, 1991].

BIBLIOGRAPHY

"Acquisitions/1992," *GettyMusJ* 21 (1993),
in press, illus.

288. Tapestry Carpet

(?) Beauvais manufactory, circa 1700–1725
Wool and silk
Length: 12 ft. 3 in. (371.5 cm); Width:
8 ft. 1 in. (246.3 cm)
Accession number 86.DC.633

PROVENANCE

(?) Sold, Hôtel Drouot, Paris, May 27, 1910,
one of four sold as lots 131–134; ([?] sold,
Christie's, London, March 6, 1923, lot 629,
as one of a pair); [(?) B. Fabre et Fils, Paris];
Thenadey collection, Paris; [Mayorcas, Ltd.,
London, 1985].

BIBLIOGRAPHY

"Acquisitions/1986," *GettyMusJ* 15 (1987),
no. 100, p. 211, illus.

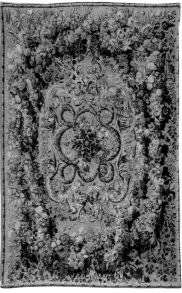

288

289. **Tapestry, *Le Mois de Decémbre,***
Le Château de Monceaux* from
***Les Maisons Royales* Series**
Gobelins manufactory, before 1712
The cartoon painted by François van
der Meulen, Baudrain Yvart *le père*, Jean-
Baptiste Monnoyer, Pierre (Boulle) Boels,
Guillaume Anguier, Abraham Genoels after
designs by Charles Le Brun. Woven under

the direction of Jean de la Croix
Wool and silk
The lower right *galon* bears the woven sig-
nature *I.D.L. CROX*.
Height: 10 ft. 4¼ in. (316 cm); Width:
10 ft. 9 in. (328 cm)
Accession number 85.DD.309

PROVENANCE

Comte de Camondo, Paris (sold, Galerie
Georges Petit, Paris, February 1–3, 1893,
lot 291); Gaston Menier, Paris (sold, Galerie
Charpentier, Paris, November 22, 1936,
lot 111); Baron Gendebien-Salvay, Belgium;
[Vincent Laloux, Brussels].

BIBLIOGRAPHY

Le Journal des arts, January 28, 1893 (Paris);
Maurice Fenaille, *Etat général de la Manu-
facture des Gobelins, 1600–1900* (Paris,
1903–1923), vol. 2, pp. 161–162; Charissa
Bremer-David, "Tapestry 'Le Château de
Monceaux' from the series *Les Maisons
Royales*," *GettyMusJ* 14 (1986), pp. 105–112,
figs. 1a–b; "Acquisitions/1985," *GettyMusJ*
14 (1986), no. 192, pp. 242–243, illus.;
Jacqueline Boccara, *Ames de Laine et de Soie*
(Saint-Just-en-Chausée, 1988), p. 207, illus.
p. 209; Edith A. Standen, "The Jardin des
Plantes: An *Entrefenêtre* for the Maisons
Royales Gobelins Tapestry Series," *Bulletin
du Centre internationale d'études des textiles
anciennes* 68 (1990), p. 49; illus. p. 51, fig. 4;
Handbook 1991, p. 162, illus. p. 163.

290. **Tapestry, *Char de Triomphe***
Gobelins manufactory, 1715–1716
Woven from the cartoon by Baudrain Yvart
le père after a design by Charles Le Brun
Wool and silk
Part of the original backing bears the
inscription *No. 194 Ports. Du Char,/ 6: Sur 3:
au[ne]. de haut/ 2: au[ne] 1/2 de Cours* over
10-6 six pieces 8 520. Woven with the arms
of France and Navarre.

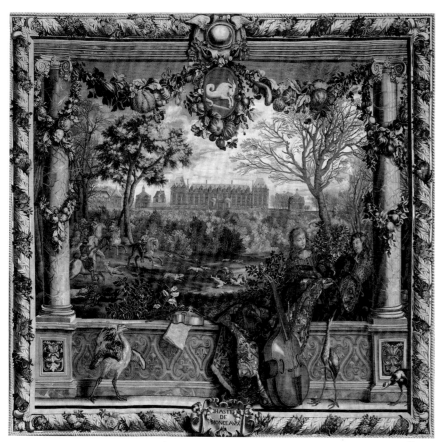

289

Height: 11 ft. 4½ in. (347 cm); Width:
8 ft. 9¼ in. (267 cm)
Accession number 83.DD.20

PROVENANCE
Delivered to the *Garde Meuble de la
Couronne* on October 27, 1717; Mme
Fulco de Bourbon, Patterson, New York;
Michael de Bourbon (son of Mme Fulco
de Bourbon), Pikeville, Kentucky.

BIBLIOGRAPHY
Maurice Fenaille, *Etat général des tapisseries
de la Manufacture des Gobelins* (Paris, 1903),
vol. 2, pp. 16–22; Wilson, *Selections*, no. 8,
pp. 16–17, illus.; Bremer-David, "Acquisi-
tions 1983," no. 3, pp. 183–185, 187, illus.;
"Acquisitions/1983," *GettyMusJ* 12 (1984),
no. 5, p. 263, illus.; *Handbook* 1986, p. 147,
illus.; enlarged detail p. 140.

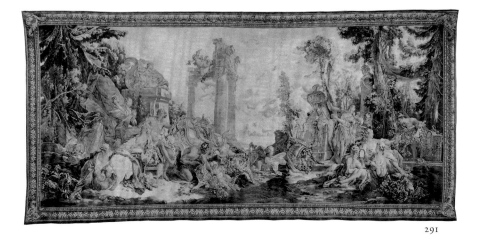

291

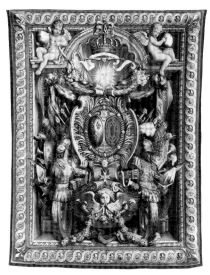

290

291. **Tapestry, *The Loves of the Gods:
Bacchus and Ariadne, Jupiter and
Antiope***
Beauvais manufactory, circa 1722–1749
Woven after paintings by François Boucher
Wool and silk
Height: 12 ft. (366 cm); Width: 24 ft. 9 in.
(754 cm)
Accession number 63.DD.6

PROVENANCE
(?) Royal family of Portugal; Jules Paul
Porgès, Portugal and later Paris; C. Ledyard
Blair; [French and Co., New York, 1937];
purchased by J. Paul Getty, 1937.

EXHIBITIONS
New York, Parke-Bernet Galleries, *French
and English Art Treasures of the United States*,
December 20–30, 1942, no. 241, p. 39.

BIBLIOGRAPHY
M. Vaucaire, "Les Tapisseries de Beauvais,"
Les Arts (August 1902), p. 16, illus.; Jules
Badin, *La Manufacture de tapisseries de
Beauvais depuis ses origines jusqu'à nos
jours* (Paris, 1909), p. 61, illus.; George L.
Hunter, "Beauvais-Boucher's Tapestries,"
Arts and Decoration (March 1919), p. 246;
George L. Hunter, *The Practical Book of
Tapestries* (Philadelphia, 1925), p. 173;
George L. Hunter, "America's Beauvais-
Boucher Tapestries," *International Studio*
(November 1926), pp. 26–28, illus.; Hein-
rich Göbel, *Wandteppiche* (Leipzig, 1923),
vol. 2, part 1, p. 227; Erik Zahle, "François
Boucher's dobbelte billedavaening," *Det
Danske Kunstindustrimuseum: Virksomhed*
3 (1959–1964), p. 68; Madeleine Jarry, "A
Wealth of Boucher Tapestries in American
Museums," *Antiques* (August 1972), p. 224,
fig. 2; Edith Standen, "The Loves of the
Gods," *European Post-Medieval Tapestries
and Hangings in the Metropolitan Museum*

of Art (New York, 1985), vol. 2, pp. 534–543; Edith Standen, "The *Amours des Dieux*: A Series of Beauvais Tapestries After Boucher," *Metropolitan Museum of Art Journal* 19/20 (1986), pp. 63–84, illus. p. 69.

292. **Tapestry, *Chancellerie***

Gobelins manufactory, circa 1728–1730
Woven by Etienne-Claude Le Blond after designs by Guy-Louis Vernansal and Claude Audran
Wool and silk
A fleur-de-lys and *G.ˈLE.ˈBLOND* are woven in lower right corner.
Height: 11 ft. 1 in. (338 cm); Width: 8 ft. 10¼ in. (270 cm)
Accession number 65.DD.5

PROVENANCE

Woven for Germain-Louis Chauvelin, marquis de Grosbois and *Garde des Sceaux* (1685–1762); [(?) French and Co., New York]; Mortimer L. Schiff, New York (sold by his heir John L. Schiff, Christie's, London, June 22, 1938, lot 74); purchased at that sale by J. Paul Getty.

BIBLIOGRAPHY

Maurice Fenaille, *Etat général des tapisseries de la Manufacture des Gobelins* (Paris, 1904), vol. 3, p. 139; Heinrich Göbel, *Wandteppiche* (Leipzig, 1923), vol. 2, part 1, pp. 172–173; Verlet et al., *Chefs d'oeuvre*, p. 133, illus.; Edith Standen, "Portière with the Chauvelin Arms," *European Post-Medieval Tapestries and Hangings in the Metropolitan Museum of Art* (New York, 1985), vol. 1, pp. 361–364.

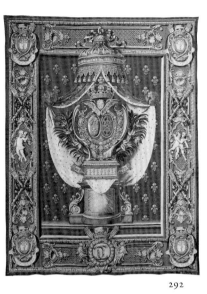

292

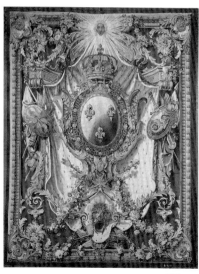

293

293. **Tapestry, *Portière aux Armes de France***

Gobelins manufactory, circa 1730–1743
Woven from a cartoon by Pierre-Josse Perrot, under the direction of Etienne-Claude Le Blond
Wool and silk
A fleur-de-lys, the letter *G*, and part of an *L* [for Le Blond] are woven into the *galon* of the lower right corner.
Height: 11 ft. 10 in. (355 cm); Width: 8 ft. 9 in. (262.5 cm)
Accession number 85.DD.100

PROVENANCE

Richard, 4th Marquess of Hertford, Paris, before 1870; by inheritance to Sir Richard Wallace, Paris, before 1890; by inheritance to Lady Wallace, Paris, 1890; by inheritance to Sir John Murray Scott, Paris, 1897; Victoria, Lady Sackville, Paris, 1912; [M. and Mme Jacques Seligmann, Paris (sold in the late 1940s)]; [François-Gérard Seligmann, Paris, 1953]; private collection; [François-Gérard Seligmann, Paris, 1985].

EXHIBITIONS

Paris, Union Centrale des Beaux-Arts Appliqués à l'Industrie, *Musée rétrospectif*, 1865, no. 5734; Paris, *Exposition d'art français du XVIIIᵉ siècle*, 1916, no. 113., p. 87, illus.

BIBLIOGRAPHY

Maurice Fenaille, *Etat général de la Manufacture des Gobelins, 1600–1900* (Paris, 1903), vol. 3, pp. 310–314; Heinrich Göbel, *Wandteppiche* (Leipzig, 1923), vol. 2, part 1, p. 156; "Acquisitions/1985," *GettyMusJ* 14 (1986), no. 196, pp. 244–245, illus.; *Handbook* 1991, p. 170, illus.; detail illus. p. 154.

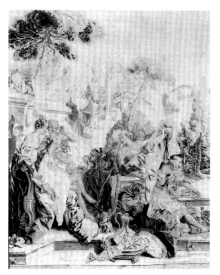

294

294. **Tapestry,** *The Toilet of Psyche*
Beauvais manufactory, circa 1741–1753
Woven after a painting by François Boucher,
under the administration of Nicolas Besnier
and the direction of Jean-Baptiste Oudry
Wool and silk
Signature *BESNIER & OVDRY - A*
BEAVVAIS woven at lower right.
Height: 11 ft. (335 cm); Width: 8 ft. 9 in.
(267 cm)
Accession number 63.DD.2

PROVENANCE
Sir Anthony de Rothschild, London; Henry
Walters, Baltimore (sold by his widow,
Parke-Bernet, New York, April 26, 1941,
lot 739, to [French and Co., New York]);
purchased by J. Paul Getty.

BIBLIOGRAPHY
Madeleine Jarry, "A Wealth of Boucher
Tapestries in American Museums," *Antiques*
(August 1972), pp. 222–231.

295. **Tapestry,** *The Toilet of Psyche*
Beauvais manufactory, circa 1741–1770
Woven after a painting by François Boucher,
under the administration of Nicolas Besnier
and the direction of Jean-Baptiste Oudry
Wool and silk
Signature *BESNIER·ET·OVDRY·A*
BEAUVAIS woven in lower right *galon.*
Height: 9 ft. 4 in. (284.5 cm); Width:
13 ft. 5 in. (409 cm)
Accession number 68.DD.23

PROVENANCE
Rupert Edward Cecil Lee Guinness, 2nd
Earl of Iveagh (1874–1967), Pyrford Court,
Surrey (sold, Christie's, Pyrford Court,
June 4, 1968, lot 206); purchased at that sale
by J. Paul Getty.

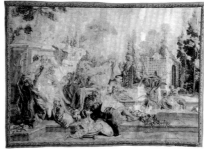

295

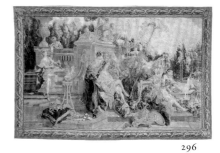

296

296. **Tapestry,** *The Toilet of Psyche*
Beauvais manufactory, circa 1749
Woven after a painting by François Boucher,
under the administration of Nicolas Besnier
and the direction of Jean-Baptiste Oudry
Wool and silk
Height: 10 ft. (305 cm); Width: 15 ft. 6 in.
(472.5 cm)
Accession number 71.DD.470

PROVENANCE
Duc de Gramont, Paris (sold, Galerie
Georges Petit, Paris, May 22, 1925, lot 73);
[Duveen Brothers, London, 1933]; Anna
Thompson Dodge, Rose Terrace, Grosse
Pointe Farms, Michigan (sold, Christie's,
London, June 24, 1971, lot 137); purchased
at that sale by J. Paul Getty.

EXHIBITIONS
London, 25 Park Lane, *Three French Reigns,*
February–April 1933, no. 528, pl. 88; San
Marino, California, The Henry E. Hunting-
ton Library and Art Gallery, January–
July, 1989.

BIBLIOGRAPHY

Jules Badin, *La Manufacture de tapisseries de Beauvais depuis ses origines jusqu'à nos jours* (Paris, 1909), p. 60; Duveen and Co., *A Catalogue of Works of Art of the Eighteenth Century in the Collection of Anna Thomson Dodge* (Detroit, 1933), introduction pp. iii–iv and non-paginated entry, illus.

———

297. **Tapestry,** *The Abandonment of Psyche*

Beauvais manufactory, circa 1750
Woven after a painting by François Boucher, under the administration of Nicolas Besnier and the direction of Jean-Baptiste Oudry
Wool and silk
Signature *f. Boucher* woven at lower left.
Height: 11 ft. 11½ in. (364.5 cm); Width: 9 ft. 2 in. (280 cm)
Accession number 63.DD.3

PROVENANCE

Sir Anthony de Rothschild, London; E. M. Hodgkins, Paris; [French and Co., New York]; purchased by J. Paul Getty, 1937.

BIBLIOGRAPHY

Jules Badin, *La Manufacture de tapisseries de Beauvais depuis ses origines jusqu'à nos jours* (Paris, 1909), p. 60; George L. Hunter, *The Practical Book of Tapestries* (Philadelphia, 1925), pp. 169, 249; Madeleine Jarry, "A Wealth of Boucher Tapestries in American Museums," *Antiques* (August 1972), pp. 222–231.

———

297

298

298. **Tapestry,** *Psyche at the Basketmakers*

Beauvais manufactory, circa 1750
Woven after a painting by François Boucher, under the administration of Nicolas Besnier and the direction of Jean-Baptiste Oudry
Wool and silk
Signature *f. Boucher* woven at lower left and the arms of France and Navarre at the top, center.
Height: 11 ft. 4 in. (345.5 cm); Width: 8 ft. 3 in. (251.5 cm)
Accession number 63.DD.4

PROVENANCE

Edward Cecil Guinness, 1st Earl of Iveagh (1847–1927), London; Walter Guinness, London; [Jacques Seligmann, Paris, by 1931 (inv. no. 1346)]; purchased by J. Paul Getty, 1938.

BIBLIOGRAPHY

Jules Badin, *La Manufacture de tapisseries de Beauvais depuis ses origines jusqu'à nos jours* (Paris, 1909), p. 60; George L. Hunter, *The Practical Book of Tapestries* (Philadelphia, 1925), p. 144; Madeleine Jarry, "A Wealth of Boucher Tapestries in American Museums," *Antiques* (August 1972), pp. 222–231; Geraldine C. Hussman, "Boucher's *Psyche at the Basketmakers*: A Closer Look," *GettyMusJ* 4 (1977), pp. 45–50.

———

299

299. **Tapestry,** *Psyche at Cupid's Palace*
Beauvais manufactory, circa 1750
Woven after a painting by François Boucher, under the administration of Nicolas Besnier and the direction of Jean-Baptiste Oudry
Wool and silk
Height: 10 ft. 11 in. (322.7 cm); Width: 18 ft. 7¾ in. (568.4 cm)
Accession number 63.DD.5

PROVENANCE
Sir Anthony de Rothschild, London; E. M. Hodgkins, Paris; [French and Co., New York]; purchased by J. Paul Getty, 1937.

BIBLIOGRAPHY
Jules Badin, *La Manufacture de tapisseries de Beauvais depuis ses origines jusqu'à nos jours* (Paris, 1909), p. 60; Madeleine Jarry, "A Wealth of Boucher Tapestries in American Museums," *Antiques* (August 1972), pp. 222–231.

300. **Four Tapestries from** *The Story of Don Quixote* **Series**
Gobelins manufactory, 1772–1773
Central narrative panels designed by Charles-Antoine Coypel and the *alentours* designed by Jean-Baptiste Belin [Belain or Blin] de Fontenay, Claude Audran III, François Desportes, and Valade; woven in the workshop of Michel Audran
Wool and silk
DON QUIXOTTE GUERI DE SA FOLIE, PAR LA SAGES [sic]:
Signature *AUDRAN* woven at bottom right corner and with the date *1773* in the *galon*.
Height: 12 ft. 2 in. (371 cm); Width: 12 ft. 10 in. (391 cm)
Accession number 82.DD.66
LE REPAS DE SANCHO, DANS L'ILE DE BARATARIA [sic]:
Signature *AUDRAN* and date *1772* woven in the *galon* and the border at the bottom right corner; also woven with the manufactory mark *G* in the *galon*.
Height: 12 ft. 2 in. (371 cm); Width: 16 ft. 5½ in. (502 cm)
Accession number 82.DD.67
ENTREE DE SANCHO DANS L'ILE DE BARATARIA [sic]:
Signature *AUDRAN* woven at the bottom right corner and with the date *1772* in the *galon*.
Height: 12 ft. 2 in. (371 cm); Width: 13 ft. 9¾ in. (421 cm)
Accession number 82.DD.68
POLTRONERIE DE SANCHO A LA CHASSE [sic]:
Signature *AUDRAN* woven in the bottom right corner and with the date *1772* in the *galon*.

Height: 12 ft. 2 in. (371 cm); Width: 13 ft. 6 in. (411 cm)
Accession number 82.DD.69

PROVENANCE
Given by Louis XVI on August 20, 1786, to Albert and Marie-Christine (sister of Marie Antoinette), Duke and Duchess of Saxe-Teschen, Joint Governors of the Austrian Netherlands; Karl Ludwig Johann Joseph Lorenz, Duke of Teschen, 1822; Albrecht Friedrich Rudolf, Duke of Teschen, 1847; Friedrick Maria Albrecht Wilhelm Karl, Duke of Teschen, Schloss Haltburn, Burgenland, Austria, 1895, removed to London, 1936; Alice Bucher, Lucerne, Switzerland (offered for sale, Sotheby's, London, December 8, 1967, lot 1, bought in); [Galerie Römer, Zurich, 1981] (sold, Sotheby's, Monaco, June 14, 1982, lot 571).

BIBLIOGRAPHY
Maurice Fenaille, *Etat général des tapisseries de la Manufacture des Gobelins* (Paris, 1904), vol. 3, pp. 237ff.; Heinrich Göbel, *Wandteppiche* (Leipzig, 1923), vol. 2, part 1, p. 163; Bremer-David, "Acquisitions 1982," no. 13, pp. 60–66, illus.; Wilson, *Selections*, no. 36, pp. 72–73, illus.; Edith Standen, "The Memorable Judgment of Sancho," *European Post-Medieval Tapestries and Hangings in the Metropolitan Museum of Art* (New York, 1985), vol. 1, pp. 369–375; *Handbook* 1986, p. 172, illus. (82.DD.66 only); Jonathan Bourne and Vanessa Brett, *Lighting in the Domestic Interior: Renaissance to Art Nouveau* (London, 1991), illus. p. 114, fig. 369; *Handbook* 1991, p. 191, illus. (82.DD.68 only).

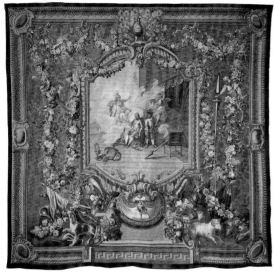

Don Quixote gueri de sa folie 300

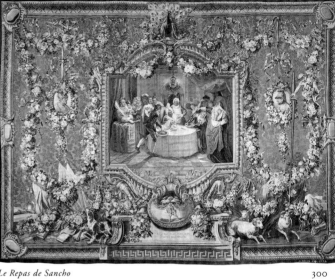

Le Repas de Sancho 300

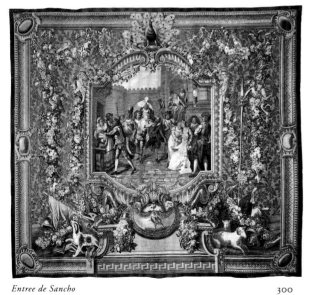

Entree de Sancho 300

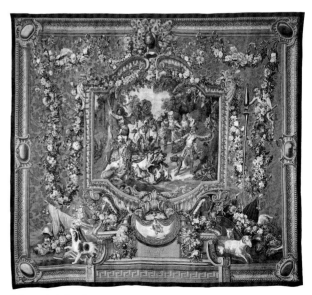

Poltronerie de Sancho 300

301. **Four Hangings from the *Tentures de Boucher* Series**
Gobelins manufactory, circa 1775–1776
Central scenes after paintings by François Boucher; *alentours* after designs by Maurice Jacques and Louis Tessier; woven under the direction of Jacques Neilson
Wool and silk
Diana and Callisto, Vertumnus and Pomona: Signature *neilson. ex.* woven at lower right, and *F.Boucher* in the medallion of *Vertumnus and Pomona*.
Height: 12 ft. 7 in. (383.5 cm); Width: 20 ft. 6 in. (624.8 cm)
Accession number 71.DD.466
Venus on the Waters:
Signature *neilson. ex.* woven at lower right.
Height: 12 ft. 7 in. (383.5 cm); Width: 10 ft. 5 in. (317.5 cm)
Accession number 71.DD.467

Venus and Vulcan:
Signature *neilson, ex.* woven at lower right.
Height: 12 ft. 6 in. (381 cm); Width: 16 ft. (487.7 cm)
Accession number 71.DD.468
Aurora and Cephalus:
Signature *neilson, ex.* woven at lower right.
Height: 12 ft. 6 in. (381 cm); Width: 10 ft. 7 in. (322.5 cm)
Accession number 71.DD.469

PROVENANCE
Given by Louis XVI in 1782 to the Grand Duke Paul Petrovitch (later Czar Paul I) and Grand Duchess Maria Feodorovna of Russia; hung at the Palace of Pavlovsk (near St. Petersburg) until circa 1925 (sold by the Soviet government); [Duveen Brothers, New York]; Norton Simon (sold, Parke-Bernet, New York, May 8, 1971, lot 233); purchased at that sale by J. Paul Getty.

EXHIBITIONS
Pennsylvania, The Allentown Art Museum, *Great Periods of Tapestry*, February 1961.

BIBLIOGRAPHY
Grand Duchess Maria Feodorovna, "Descriptions of the Grand Palace of Pavlovsk, 1795," *Les Trésors d'art en Russie* (St. Petersburg, 1907), vol. 3, 1903, illus.; Maurice Fenaille, *Etat général des tapisseries de la Manufacture des Gobelins* (Paris, 1904), vol. 4, pp. 285–287, illus.; George Leyland Hunter, *The Practical Book of Tapestries* (Philadelphia, 1925), p. 190; Phyllis Ackerman, *Tapestry: the Mirror of Civilization* (New York, 1933), p. 277, pl. 45; Edith Standen, "The Tapestry Room from Croome Court," *Decorative Art from the Samuel H. Kress Collection at the Metropolitan Museum of Art* (London, 1964), p. 52; Madeleine Jarry, "A Wealth of Boucher Tapestries in American Museums," *Antiques* (August 1972), pp. 222–231; Wilson, *Selections*, no. 38, pp. 76–77, illus.; Edith Standen, "Croome Court Tapestries," *European Post-Medieval Tapestries and Hangings in the Metropolitan Museum of Art* (New York, 1985), vol. 1, p. 397.

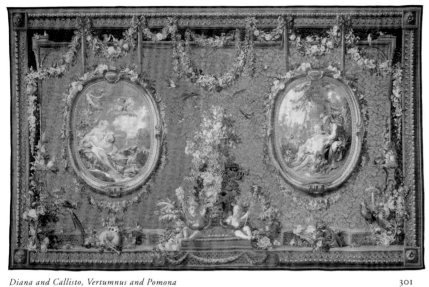

Diana and Callisto, Vertumnus and Pomona 301

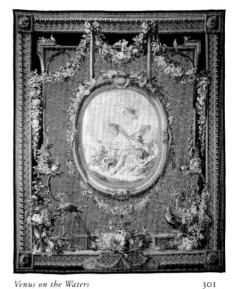

Venus on the Waters 301

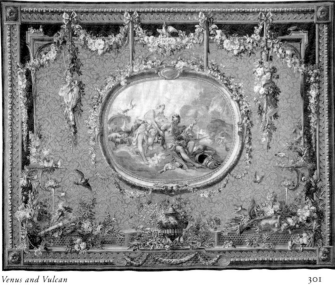

Venus and Vulcan 301

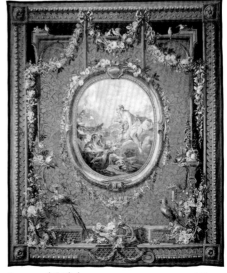

Aurora and Cephalus 301

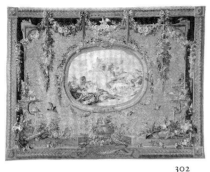

302

302. Tapestry, *Neptune and Amymone* from the *Tentures de Boucher* Series

Gobelins manufactory, circa 1781–1783
Central scene after a painting by François Boucher; *alentour* after designs by Maurice Jacques and Louis Tessier; woven under the direction of Jacques Neilson
Wool and silk
F.Boucher.Pix woven in central oval panel and *neilson éx.* woven in the lower right of the *alentour*.
Height: 12 ft. ¾ in. (368 cm); Width: 15 ft. 6 in. (472.5 cm)
Accession number 73.DD.90

PROVENANCE

One of four tapestries given by Louis XVI in 1784 to Prince Henry of Prussia; Jules Porgès (sold, Galerie Georges Petit, Paris, June 18, 1924, no. 244); (sold, Galerie Charpentier, Paris, May 28, 1954, no. 145); private collection, France, 1957; conte Francesco Castelbarco Albani, Italy (sold, Sotheby's, Palazzo Capponi, Florence, May 22, 1973, lot 79); purchased at that sale by J. Paul Getty.

BIBLIOGRAPHY

Maurice Fenaille, *Etat général des tapisseries de la Manufacture des Gobelins* (Paris, 1904), vol. 4, pp. 285–289, illus.; Hermann Schmitz, *Bildteppiche, Geschichte der Gobelinwirkerei* (Berlin, 1919), p. 304; Stéphane Faniel et al., *French Art of the Eighteenth Century* (Collection Connaissance des arts, New York, 1957), vol. 1, p. 161, fig. c; Edith Standen, "The Tapestry Room from Croome Court," *Decorative Art from the Samuel H. Kress Collection at the Metropolitan Museum of Art* (London, 1964), p. 52; Edith Standen, "Croome Court Tapestries," *European Post-Medieval Tapestries and Hangings in the Metropolitan Museum of Art* (New York, 1985), vol. 1, p. 397.

Decorative Drawings

303. Drawing for a Wall Light

(See entry no. 169)
Paris, circa 1760–1780
Attributed to Contant d'Ivry
Pen and black ink on paper
Inscribed (recto) in ink in the lower right *(S) Girandolle de dessus la chem[inée] [...?]/ de Jeu dans l'Elevation No. 6....* Inscribed (verso) in pencil *Bachelier* and, in ink, below *F. A. Maglin 1902.* Inscribed in pencil on separate rectangles glued to the reverse *lr* and *Thre Van Thulden.* Unidentified watermark.
Height: 10 7/16 in. (26.5 cm); Width: 6¾ in. (17.1 cm)
Accession number 86.GA.692

PROVENANCE

F. A. Maglin, 1902; [François-Gérard Seligmann, Paris].

BIBLIOGRAPHY

"Acquisitions/1986," *GettyMusJ* 15 (1987), no. 105, p. 213, illus.

303

304

304. **Drawing for a Wall Light**

Paris, circa 1775
Attributed to Richard de Lalonde
Pen and black ink with wash on paper
Unidentified watermark.
Height: 11¾ in. (29.9 cm); Width: 8¼ in.
(20.7 cm)
Accession number 79.GA.179

PROVENANCE

Maison Odiot, Paris (sold, Sotheby's,
Monaco, November 26, 1979, lot 609).

BIBLIOGRAPHY

Wilson, "Acquisitions 1979 to mid 1980,"
item B, p. 12, illus.; Ottomeyer and
Pröschel, *Vergoldete Bronzen*, pp. 173–174,
fig. 3.5.3 (here attributed to Jean-Louis
Prieur); Jonathan Bourne and Vanessa Brett,
*Lighting in the Domestic Interior: Renaissance
to Art Nouveau* (London, 1991), illus. p. 110,
fig. 353.

305

305. **Drawing for a Ewer**

Paris, circa 1775–1780
Attributed to Robert-Joseph Auguste
Pen and brown ink with brown and gray
wash on paper
Unidentified watermark.
Height: 1 ft. 3¹³⁄₁₆ in. (40.2 cm); Width:
10¹⁄₁₆ in. (25.6 cm)
Accession number 79.GA.180

PROVENANCE

Maison Odiot, Paris (sold, Sotheby's,
Monaco, November 26, 1979, lot 610).

BIBLIOGRAPHY

Claude Frégnac et al., *Les Grands Orfèvres de
Louis XIII à Charles X* (Collection Connais-
sance des arts, Paris, 1965), p. 194, illus.;
Wilson, "Acquisitions 1979 to mid 1980,"
item B, p. 12, illus.; Savill, *Sèvres*, vol. 1,
p. 469; n. 7, p. 475.

306. **Drawing for Urns and Vases**

Paris, circa 1780
Pen and black ink with gray, black, and
brown wash on paper
Inscribed *Salembier* in pencil, perhaps a
later attribution to Henri Salembier.
Unidentified watermarks.
Height: 1 ft. 8¹³⁄₁₆ in. (52.9 cm); Width:
3 ft. 6¹⁵⁄₁₆ in. (109.5 cm)
Accession number 79.GA.178

PROVENANCE

Maison Odiot, Paris (sold, Sotheby's,
Monaco, November 26, 1979, lot 584).

306

BIBLIOGRAPHY
Wilson, "Acquisitions 1979 to mid 1980,"
item A, p. 11, illus.

———

307. **Drawing for an Inkstand**
Paris, circa 1780
Attributed to Robert-Joseph Auguste
Pen and black ink with blue and yellow
wash on paper
Unidentified watermark.
Height: 1 ft. 5⁵⁄₁₆ in. (44 cm); Width:
1 ft. 3⁵⁄₁₆ in. (38.9 cm)
Accession number 79.GA.181

PROVENANCE
Maison Odiot, Paris (sold, Sotheby's,
Monaco, November 26, 1979, lot 612).

BIBLIOGRAPHY
Wilson, "Acquisitions 1979 to mid 1980,"
item E, p. 16, illus.

———

307

308. **Drawing for a Wine Cooler**
Paris, circa 1785–1790
Attributed to Jean-Guillaume Moitte
Pen and black ink with gray wash on paper
Stamped *J.B.C. Odiot No.* at lower right and
inked *228*. Unidentified watermark.
Height: 1 ft. 2 7/16 in. (36.6 cm); Width:
1 ft. ½ in. (31.8 cm)
Accession number 79.GA.182

PROVENANCE
Maison Odiot, Paris (sold, Sotheby's,
Monaco, November 26, 1979, lot 627).

BIBLIOGRAPHY
Wilson, "Acquisitions 1979 to mid 1980,"
item D, pp. 14–15, illus.

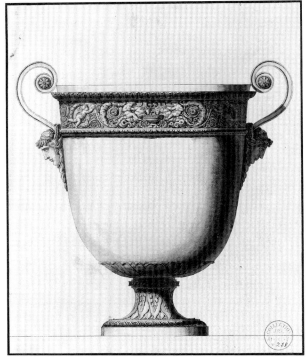

308

Italian
Decorative Arts

✦

Furniture

CASSONI

309. *Cassone*
Milan, second half of the sixteenth century
Walnut, partially gilt
Height: 2 ft. 5⅛ in. (73.9 cm); Width:
5 ft. 5¼ in. (167 cm); Depth: 2 ft. ⅛ in.
(61.3 cm)
Accession number 68.DA.8

PROVENANCE
Earls of Warwick, Warwick Castle; [Frank
Partridge and Sons, Ltd., London]; pur-
chased by J. Paul Getty.

EXHIBITIONS
The Fine Arts Museums of San Francisco,
The Triumph of Humanism, September 29,
1977–January 18, 1978, p. 91, fig. 107; Tulsa,
The Philbrook Art Center, *Gloria dell'arte:
A Renaissance Perspective*, October 26,
1979–January 27, 1980 (Tulsa, 1979), no. 85,
p. 53, illus.

310. *Cassone*
(?) Rome, second half of the sixteenth
century
Walnut, partially gilt
Height: 2 ft. 5⅛ in. (74 cm); Width:
5 ft. 5⅜ in. (166.6 cm); Depth: 2 ft. ¼ in.
(61.8 cm)
Accession number 78.DA.120

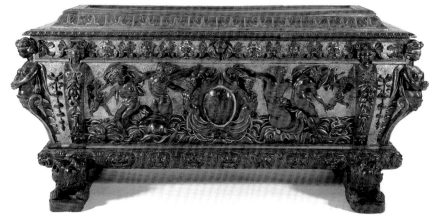

309

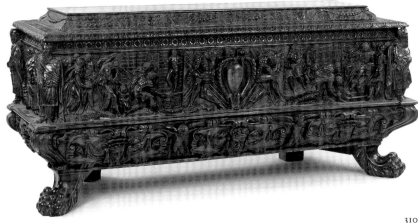

310

PROVENANCE
[H. Blairman and Sons, London, 1963];
purchased by J. Paul Getty for Sutton Place,
Surrey; distributed by the estate of J. Paul
Getty to the J. Paul Getty Museum.

EXHIBITIONS
Tulsa, The Philbrook Art Center, *Gloria
dell'arte: A Renaissance Perspective*, Octo-
ber 26, 1979–January 27, 1980 (Tulsa, 1979),
no. 86, p. 53, illus.

———

311. **Pair of *Cassoni***
Umbria, 155(?)
Attributed to Antonio Maffei
Carved walnut, originally partially gilt
Cassone .1 inscribed on a paper label in a late
seventeenth- or early eighteenth-century
hand *L'arme che si vede nel mezzo della parte
d'avanti di questo cassone è della famiglia
dei Conti di Coccorone e di Antignano detti
[poi?] dei Conti ò dei Comitibus abitanti
in Foligno, esi[stenti?] questi [in?] casa di
Contessa Pressilla moglie del Conte Cesare
Bentivogli seniore, il di cui matrimonio seguì
circa l'[anno] 155[9?] onde è verisimile che
tanto questo quanto l'altro simil cassone
fossero fatti in congiuntura dei loro sponsali
et erano nella maggior parte dorati come può
ancor vedersi da diverse reliquie discoperte
nel ripulirli e son fattuta del celebre scultore
Maffei.*
Cassone .1: Height: 2 ft. 5½ in. (75 cm);
Width: 5 ft. 11½ in. (181.5 cm); Depth (at
top): 1 ft. 11¼ in. (59 cm); Depth (at feet):
3 ft. 6 in. (76.2 cm); *Cassone* .2: Height:
2 ft. 5 in. (73.5 cm); Width: 5 ft. 11⅜ in.
(178.75 cm); Depth (at top): 1 ft. 11¼ in.
(59 cm); Depth (at feet): 2 ft. 5 in.
(73.75 cm)
Accession number 88.DA.7.1–.2

PROVENANCE
Private collection, England; [Same Art,
Ltd., Zurich].

BIBLIOGRAPHY
"Acquisitions/1988," *GettyMusJ* 17 (1989),
no. 87, pp. 147–148, illus.

———

312

312. **Credenza**
Florence, circa 1600–1650
Carved walnut
Height: 3 ft. 9¼ in. (114.93 cm); Width:
6 ft. 7¾ in. (202.56 cm); Depth: 1 ft. 9½ in.
(54.61 cm)
Accession number 78.DA.107

PROVENANCE
[Ugo Bardini, 1960]; purchased by J. Paul
Getty for Sutton Place, Surrey; distributed
by the estate of J. Paul Getty to the J. Paul
Getty Museum.

EXHIBITIONS
Woodside, California, Filoli, on loan,
1983 – 1992.

———

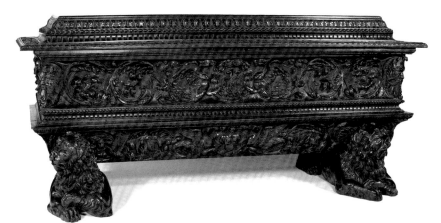

One of a pair

311

313

COMMODES

314. **Commode**
Venice, circa 1745–1750
Painted, gilt, and silvered oak
Height: 2 ft. 8⅛ in. (81.5 cm); Width:
4 ft. 9⅞ in. (147 cm); Depth: 2 ft. ⅝ in.
(62.5 cm)
Accession number 83.DA.282

PROVENANCE
(?) Orsini Family, Italy; (sold, Saint-Malo,
France, 1982) [Didier Aaron, Paris]; (sold,
Sotheby's, London, July 15, 1983, lot 114);
[Alexander and Berendt, London].

BIBLIOGRAPHY
"Acquisitions/1983," *GettyMusJ* 12 (1984),
no. 17, p. 267, illus.; *Handbook* 1986,
p. 191, illus.

313. **Credenza**
(?) Umbria, late seventeenth century (later
remade)
Carved walnut
Height: 3 ft. 10¾ in. (118.74 cm); Width:
4 ft. 1¼ in. (124.46 cm); Depth: 1 ft. 10½ in.
(57.15 cm)
Accession number 78.DA.109

PROVENANCE
[Ugo Bardini, 1960]; purchased by J. Paul
Getty for Sutton Place, Surrey; distributed
by the estate of J. Paul Getty to the J. Paul
Getty Museum.

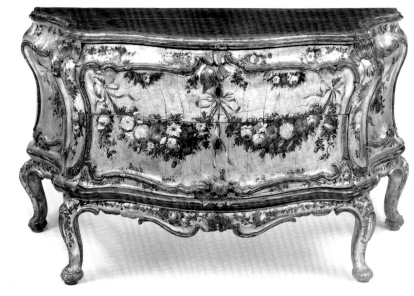

314

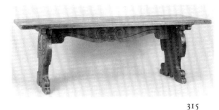

315

TABLES

315. **Table**

Tuscany, sixteenth century
Walnut
Height: 2 ft. 10 in. (86.4 cm); Width:
8 ft. 6 in. (259 cm); Depth: 2 ft. 10 in.
(86.4 cm)
Accession number 78.DA.121

PROVENANCE

[Ugo Bardini, 1963]; purchased by J. Paul
Getty for Sutton Place, Surrey; distributed
by the estate of J. Paul Getty to the J. Paul
Getty Museum.

316. **Octagonal Table**

Northern Italian (possibly Mantua),
circa 1550
Rosso di Verona inlaid with *nero antico* and
cipollina marble
Height: 2 ft. 9¼ in. (84.5 cm); Width (of
top): 3 ft. 9½ in. (115.5 cm)
Accession number 90.DA.33

PROVENANCE

(?) Palazzo Gonzaga, Mantua (exh. cat.,
Stedelijk Museum, 1934); private collection,
the Netherlands, 1934; private collection,
Paris, since 1975; [Alain Moatti, Paris].

EXHIBITIONS

Amsterdam, Stedelijk Museum, *Italiaansche
Kunst in Nederlandsch Bezit*, July 1–Octo-
ber 1, 1934, no. 1008.

317. **Table**

The Veneto, late sixteenth century
Rosso di Verona marble
Height: 2 ft. 7⅞ in. (81 cm); Width:
9 ft. 11⅝ in. (308 cm); Depth: 4 ft. ⅛ in.
(123.5 cm)
Accession number 86.DA.489

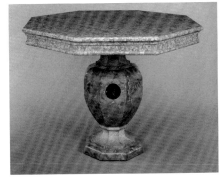

316

PROVENANCE

[Same Art, Ltd., Zurich].

BIBLIOGRAPHY

"Acquisitions/1986," *GettyMusJ* 15 (1987),
no. 117, pp. 217–218, illus.

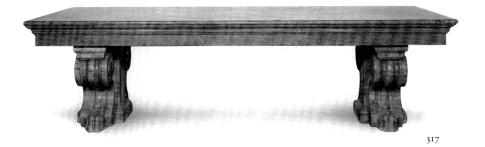

317

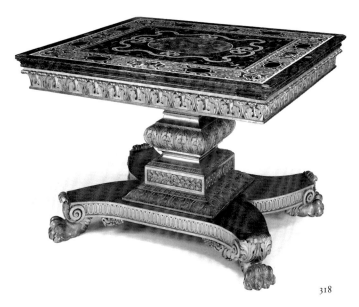

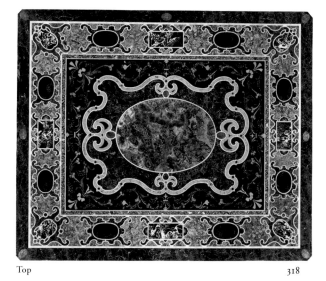

Top 318

318

318. *Pietre Dure* Table

Florence or Rome
Tabletop: circa 1580–1600
Pietre dure and marble mosaic including
breccia di Tivoli (or *Quintilina*), *giallo antico*,
nero antico, *breccia rossa*, *breccia cenerina*,
breccia verde, *broccatello*, *bianco e nero
antico*, serpentine, alabaster *fiorito* and
alabaster *a tartaruga*, lapis lazuli, coral, rock
crystal, and yellow and black jasper
Length: 4 ft. 5¾ in. (136.5 cm); Width:
3 ft. 8½ in. (113 cm);
Base: circa 1825
Carved and gilt wood
Height: 2 ft. 11⅜ in. (89.9 cm)
Accession number 92.DA.70

PROVENANCE

Corsini, Florence, by at least the nineteenth
century; by descent in the Corsini family;
[Same Art, Ltd., Zurich, 1991].

BIBLIOGRAPHY

Leonardo Ginori Lisci, *I Palazzi di Firenze
nella storia dell'arte* (Florence, 1972), vol. I,
p. 152 (reproduces nineteenth-century
archival photograph of object); Alessandra
Guicciardini Corsi Salviati, *Affreschi di
Palazzo Corsini a Firenze 1650–1700* (Florence,
1989), pl. 23 (reproduces same photograph
as above); "Acquisitions/1992," *GettyMusJ* 21
(1993), in press, illus.

319. **Console Table**

(?) Piedmont, circa 1730
Carved and gilt wood with *sarrancolin*
marble top
Height: 2 ft. 10¼ in. (86.9 cm); Width:
6 ft. 5¼ in. (196.2 cm); Depth: 3 ft. 6¾ in.
(78.1 cm)
Accession number 78.DA.118

PROVENANCE

Elsie de Wolfe, New York.

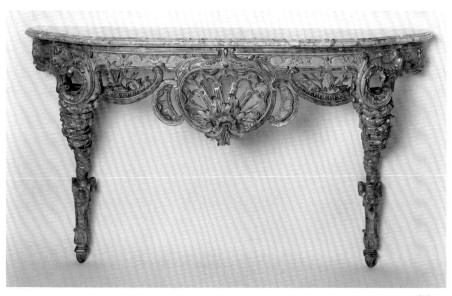

319

PROVENANCE

(?) Baroness Lionel de Rothschild (née Charlotte von Rothschild), Gunnersbury Park, Middlesex; Alfred de Rothschild (1842–1918), Halton, Buckinghamshire, by 1884; by descent to Edmund de Rothschild (b. 1916), Exbury, Hampshire; [Frank Partridge and Sons, Ltd., London, 1972]; [French and Company, New York, on consignment from Frank Partridge and Sons, Ltd., London]; purchased by J. Paul Getty.

BIBLIOGRAPHY

Gillian Wilson, *Decorative Arts in the J. Paul Getty Museum* (Malibu, 1977), no. 49, p. 38, illus.

320. **Center Table**

Top: Florence or Rome, circa 1600–1620
Support: See entry no. 85 under *French Furniture*
Pietre dure and marble mosaic top
Width: 6 ft. 5⅝ in. (197.1 cm); Depth: 5 ft. 3⅛ in. (115.8 cm)
Accession number 72.DA.58

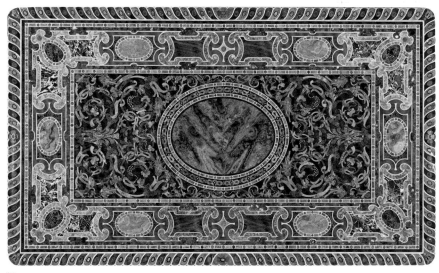

Top

320

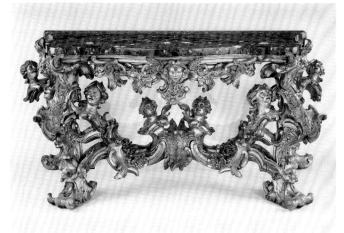

321

322

321. **Side Table**

Rome, circa 1670
Design attributed to Johann Paul Schor,
called Giovanni Paolo Tedesco
Carved and gilt wood
Height: 5 ft. 6 15/16 in. (170 cm); Width:
7 ft. 4½ in. (225 cm); Depth: 2 ft. 9 7/16 in.
(85 cm)
Accession number 86.DA.7

PROVENANCE

Rudolph Hegetschweile, Zurich, since 1947;
[International Patent Trust Reg., Vaduz,
Liechtenstein].

322. **Side Table**

Rome, circa 1720–1730
Gilt pine
Height: 3 ft. 1 in. (93.9 cm); Width: 6 ft. 3 in.
(190.5 cm); Depth: 3 ft. 2 in. (96.5 cm)
Accession number 82.DA.8

PROVENANCE

Private collection, England; Belgian art
market; [Jacques Kugel, Paris, 1981].

BIBLIOGRAPHY

Handbook 1986, p. 188, illus.; *Handbook*
1991, p. 215, illus.

323. **Side Table**

Italian, circa 1760–1770
Carved and gilt-wood base surmounted by
a marble top
Height: 3 ft. 5 5/16 in. (105 cm); Width:
5 ft. ¼ in. (153 cm); Depth: 2 ft. 5 1/8 in.
(74 cm)
Accession number 87.DA.135

PROVENANCE

Private collection, Switzerland; [Danae Art
International, S.A., Panama].

BIBLIOGRAPHY

"Acquisitions/1987," *GettyMusJ* 16 (1988),
no. 79, p. 181, illus.; *Handbook* 1991, p. 216,
illus.

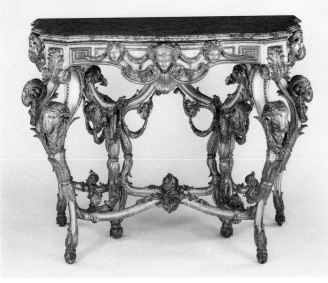

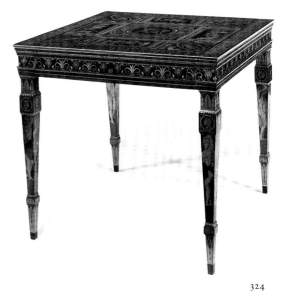

323

324

324. **Table**

(?) Naples, 179(?)

By Francesco Abbiati

Oak, walnut, and poplar veneered with
purplewood, satinwood, ebony, and various
fruitwoods

Signed and dated in the central roundel of
marquetry on the top, *FRANCO ABBIATI /
179(?)*.

Height: 2 ft. ⅝ in. (77.8 cm); Width:
10⁷⁄₁₆ in. (87.5 cm); Depth: 10⁷⁄₁₆ in. (87.5 cm)
Accession number 84.DA.77

PROVENANCE

Private collection, Cleveland, Ohio; [Dalva
Brothers, Inc., New York].

BIBLIOGRAPHY

"Acquisitions/1984," *GettyMusJ* 13 (1985),
no. 254, p. 258, illus.

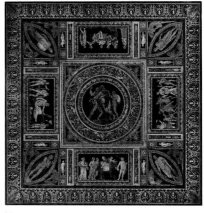

Top

324

SEAT FURNITURE

325. **Side Chair**

Turin, circa 1710–1715
Gilt wood with modern silk upholstery
copying the original silk
Height: 4 ft. 2⅛ in. (118.5 cm); Width:
1 ft. 9⅞ in. (55.6 cm); Depth: 2 ft. 3⅜ in.
(69.5 cm)
Accession number 83.DA.281

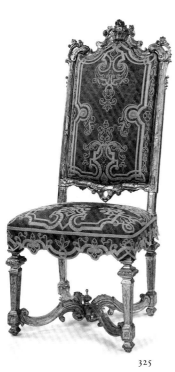

325

PROVENANCE

House of Savoy, Racconigi, Turin; Mrs.
Walter Hayes Burns (née Morgan), North
Mymms Park, Hertfordshire; Major-
General Sir George Burns, North Mymms
Park (sold, Christie's, North Mymms Park,
September 24–26, 1979, lot 215 [one of five]);
[Partridge (Fine Arts), Ltd., London,
1979–1983].

BIBLIOGRAPHY

"Acquisitions/1983," *GettyMusJ* 12 (1984),
no. 16, p. 267, illus.

326. **Set of Four Armchairs**

Venice, circa 1730–1740
Carved, gessoed, and gilt walnut; upholstered
in modern Genoese velvet
Armchair .1: Height: 2 ft. 10¾ in. (137.8 cm);
Width: 2 ft. 9½ in. (85.1 cm); Depth:
2 ft. 10¾ in. (88.3 cm); Armchair .2: Height:
4 ft. 7⅛ in. (140 cm); Width: 2 ft. 9⅞ in.
(86 cm); Depth: 2 ft. 10¼ in. (87.3 cm);
Armchair .3: Height: 4 ft. 6½ in. (138.5 cm);
Width: 2 ft. 9¾ in. (85.8 cm); Depth:
2 ft. 11¾ in. (89.8 cm); Armchair .4: Height:
4 ft. 7¼ in. (140.3 cm); Width: 2 ft. 9⅞ in.
(86 cm); Depth: 2 ft. 9¼ in. (84.5 cm)
Accession number 87.DA.2.1–.4

PROVENANCE

Private collection, England, since the eigh-
teenth century; [Alexander and Berendt,
Ltd., London, 1984].

BIBLIOGRAPHY

"Acquisitions/1987," *GettyMusJ* 16 (1988),
no. 78, pp. 180–181, illus.

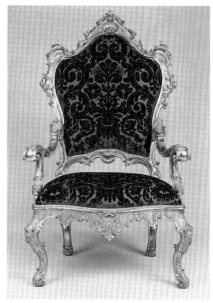

One of four 326

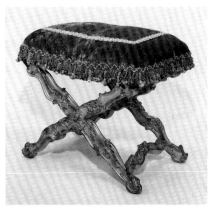

327

327. **Folding Stool**

Turin, circa 1735
Carved and gilt wood
Branded twice with three fleurs-de-lys and
with the letters *FON* for the Château de
Fontainebleau
Height: 1 ft. 4¼ in. (41.1 cm); Width:
2 ft. 3⅛ in. (68.9 cm); Depth: 1 ft. 5⅛ in.
(43.5 cm)
Accession number 74.DA.26

PROVENANCE

Château de Fontainebleau during the nine-
teenth century; [Matthew Schutz, Ltd.,
New York].

EXHIBITIONS

The Detroit Institute of Arts, March 7–
June 13, 1975.

BIBLIOGRAPHY

Gillian Wilson, *Decorative Arts in the J. Paul
Getty Museum*, 1977, p. 33, no. 42, illus.

328. **Daybed**

Turin, designed between 1832–1835
By Filippo Pelagio Palagi (born in Bologna
1775–1860)
Maple inlaid with mahogany
On back of frame, *3421* stenciled in green
paint from Racconigi inventory of 1900
(obscured by upholstery), *Dazio Verificato*
ink stamp, *PPR 3421* incised stamp. On
frame of upholstered seat *Dazio Verificato*
ink stamp, *Racconigi Camera da letto degli
Augusti Sposi* in pencil across front. On
frame structure *37* in ink on part of a label,
a pencil design for inlay.
Height: 2 ft. 1½ in. (80 cm); Width:
7 ft. 4⅛ in. (224 cm); Depth: 2 ft. 3⅛ in.
(69 cm)

Accession number 86.DA.511

PROVENANCE

King Carlo Alberto, Racconigi Palace
(near Turin), until 1922; 1938–1980 in a pri-
vate Swiss collection; [Heim Gallery, Ltd.,
London, 1980].

BIBLIOGRAPHY

"Acquisitions/1986," *GettyMusJ* 15 (1987),
no. 118, p. 218, illus.; *Handbook* 1991, p. 219,
illus.

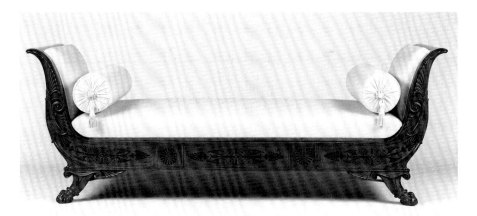

328

Metalwork

329. **Mortar**

Venice, circa 1550
Bronze
Height: 1 ft. 7¼ in. (48.9 cm); Diameter:
1 ft. 11½ in. (59.7 cm)
Accession number 85.SB.179

PROVENANCE
Sold, Sotheby's, London, July 14, 1977,
lot 156; [Rainer Zietz, Ltd., London];
[Rosenberg and Stiebel, Inc., New York];
Barbara Piasecka Johnson, Princeton, New
Jersey; [Rosenberg and Stiebel, Inc., New
York].

BIBLIOGRAPHY
Acquisitions/1985," *GettyMusJ* 14 (1986),
no. 222, p. 254, illus.

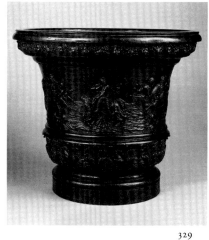

329

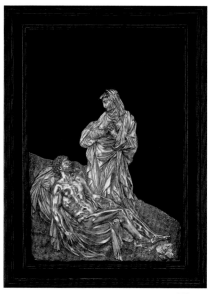

330

330. *Virgin Mourning the Dead Christ*

Venice, 1586–1587
By Cesare Targone
Finely chased *repoussé* gold on obsidian (in
a black nineteenth-century wood frame)
Signed ·*OPUS·CAESARIS·TAR·VENETI*·
below Christ's feet.
Gold Relief: Height: 11⅛ in. (29 cm);
Width: 10¼ in. (26 cm); Obsidian Plaque:
Height: 1 ft. 3⅛ in. (38.5 cm); Width:
10⁷⁄₁₆ in. (26.5 cm)
Accession number 84.SE.121

PROVENANCE
Sir Julius Wernher, Bt. (died 1912); by
descent to Sir Harold Wernher, Bt.; (sold,
Christie's, London, November 16, 1950,
lot 157, to David Black, Sr.); [Bernard Black
(Black-Nadeau, Ltd.), Monte Carlo].

EXHIBITIONS
The Los Angeles County Museum of Art,
"Curator's Choice," December 11, 1978–
February 11, 1979.

BIBLIOGRAPHY
Ulrich Middeldorf, "In the Wake of Gugli-
elmo della Porta," *Connoisseur* (February
1977), pp. 75–84; "Acquisitions/1984,"
GettyMusJ 13 (1985), no. 251, pp. 256–257,
illus.

331. **Basin**

Genoa, 1620–1625
By a Dutch or Flemish artist working in
Genoa after a design by Bernardo Strozzi
Silver
Diameter: 2 ft. 5¾ in. (75.5 cm)
Accession number 85.DG.81

PROVENANCE
(?) Commissioned by the Genoese Doge
Alessandro Giustiniani-Longo di Luca,
1544–1624; Longhi Giustiniani; Giovanna
Musso Piantelli, 1892; [Aetas Antiqua, S.A.,
Panama].

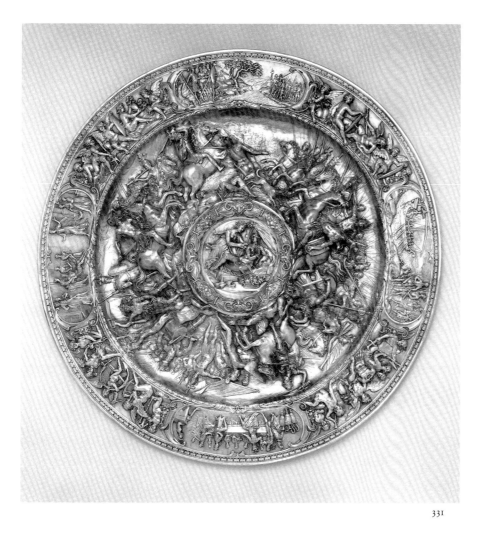

331

EXHIBITIONS

Genoa, *Esposizione artistico archeologico industriale aperta nelle Sale dell'Accademia Linguistica*, 1868, no. 55, p. 115; Genoa, Palazzo Bianco, *Mostra d'Arte Antica*, 1892, no. 86, p. 75; Genoa, Palazzo Spinola and Palazzo Reale, *Genova nell'Età Barocca*, May 2–July 26, 1992; Frankfurt, Schirn Kunsthalle, *Kunst in der Republik Genua*, September 4–November 8, 1992.

BIBLIOGRAPHY

Hugh Macandrew, "A Silver Basin Designed by Strozzi," *Burlington Magazine* 113 (January 1971), pp. 4–11; Ronald W. Lightbown, "A Note on the Silver Basin," *Burlington Magazine* 113 (January 1971), p. 11; Hugh Macandrew, "Genoese Silver on Loan to the Ashmolean Museum," *Burlington Magazine* 114 (September 1972), pp. 611–620; Carl Hernmarck, *The Art of the European Silversmith 1430–1830* (London and New York, 1977), vol. 1, p. 233; *Handbook* 1991, p. 212, illus.; David A. Scott, "Technological, Analytical, and Microstructural Studies of a Renaissance Silver Basin," *Archeomaterials* 5, no. 1 (Winter 1991), pp. 21–45; Franco Boggero and Farida Simonetti, *Argenti genovesi da parata tra cinque e seicento* (Turin, 1992), no. 7, p. 233, pls. 20–23; pp. 132, 135–143.

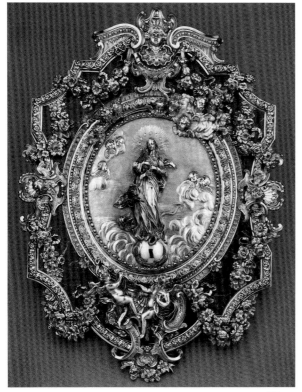

332

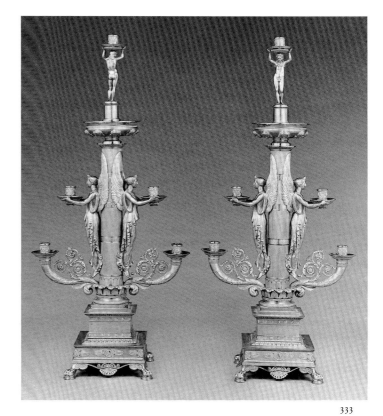

333

332. Wall Plaque

Southern Italian, 1730–1740
By Francesco Natale Juvara
Silver and lapis lazuli
Height: 2 ft. 3⁷⁄₁₆ in. (70 cm); Width:
1 ft. 8½ in. (52 cm)
Accession number 85.SE.127

PROVENANCE

(?)House of Savoy, since its pendant is last
recorded as belonging to a member of that
family (Antonio Morassi, *Antica Oreficeria*
Italiana [Milan, 1936], no. 316); [Siran
Holding Company, Geneva].

BIBLIOGRAPHY

"Acquisitions/1985," *GettyMusJ* 14 (1986),
no. 223, p. 254, illus.; *Handbook* 1991, p. 216,
illus.

333. Pair of Candelabra

Northern Italian, circa 1830–1840
By Pelagio Palagi
Gilt and chased bronze
Height: 2 ft. 11½ in. (90 cm)
Accession number 85.DF.22.1–.2

PROVENANCE

(?)Palazzo Reale, Turin; Jacob Rothschild,
London, 1983; [P. and D. Colnaghi and Co.,
London].

EXHIBITIONS
London, P. and D. Colnaghi and Co., *The Adjectives of History: Furniture and Works of Art 1550–1870*, 1983, no. 47.

BIBLIOGRAPHY
"Acquisitions/1985," *GettyMusJ* 14 (1986), no. 224, p. 255, illus.

———

Ceramics

334. **Jug with Pecking Bird (*boccale*)**
Tuscany, early fifteenth century
Tin-glazed earthenware
Height: 9⅞ in. (25 cm); Diameter (at lip): 3¼ in. (9.5 cm); Maximum Width: 6⅜ in. (16.2 cm)
Accession number 84.DE.95

PROVENANCE
Private collection, the Netherlands; [Rainer Zietz, Ltd., London].

BIBLIOGRAPHY
"Acquisitions/1984," *GettyMusJ* 13 (1985), no. 155, pp. 239–240, illus.; Hess, *Maiolica*, no. 3, pp. 17–19.

———

335. **Two-handled "Oak-Leaf" Drug Jar (*orciuolo biansato*)**
Florence, circa 1420–1440
Tin-glazed earthenware
Marked with a three-runged ladder surmounted by a cross painted on each side and a *P*, possibly intertwined with a backward *C*, below each handle.

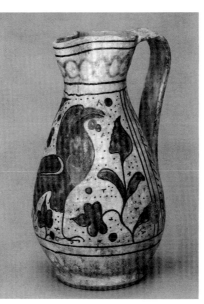

334

335

Height: 1 ft. ¼ in. (31.1 cm); Diameter (at lip): 5⅝ in. (14.3 cm); Maximum Width: 11¼ in. (29.8 cm)
Accession number 85.DE.56

PROVENANCE
Wilhelm von Bode, Berlin; Glogowski, Berlin (sold, Sotheby's, London, June 8, 1932, lot 58); August Lederer, Vienna; Erich Lederer, Geneva.

BIBLIOGRAPHY
Henry Wallis, *Oak-Leaf Jars: A Fifteenth-Century Italian Ware Showing Moresco Influence* (London, 1903), p. 35, illus. p. 9, fig. 7; Wilhelm von Bode, *Die Anfänge der Majolikakunst in Toskana* (Berlin, 1911), pl. 14; Joseph Chompret, *Répertoire de la majolique italienne*, vol. 2 (Paris, 1949), fig. 648; Galeazzo Cora, *Storia della maiolica di Firenze e del contado del XIV e del XV secolo* (Florence, 1973), vol. 1, p. 76; vol. 2, pls. 61–62, 63c; Giovanni Conti, *L'Arte della maiolica in Italia*, 2nd ed. (Milan, 1980), pls. 45–46; Anna Moore Valeri, "Florentine '*Zaffera a Rilievo*' Maiolica: A New Look at the 'Oriental Influence,'" *Archaeologia medievale* 2 (1984), pp. 477–500, fig. 4b; "Acquisitions/1985," *GettyMusJ* 14 (1986), no. 211, p. 251, illus.; Hess, *Maiolica*, no. 5, pp. 23–25; *Handbook* 1991, p. 200, illus.

———

336. **Cylindrical "Oak-Leaf" Jar (*albarello*)**

Florence, circa 1420–1440
Tin-glazed earthenware
Height: 6½ in. (16.5 cm); Diameter (at lip):
3¹³/₁₆ in. (9.7 cm); Maximum Diameter:
4¹³/₁₆ in. (12.2 cm)
Accession number 85.DE.57

PROVENANCE

Ugo Grassi, Florence; August Lederer,
Vienna; Erich Lederer, Geneva.

BIBLIOGRAPHY

John Rothenstein, "Shorter Notices:
Two Pieces of Italian Pottery," *Burlington
Magazine* 85 (August 1944), p. 205, pl. C;
Galeazzo Cora, *Storia della maiolica di
Firenze e del contado del XIV e del XV secolo*
(Florence, 1973), vol. 1, p. 78; vol. 2, fig. 83c;

Giovanni Conti, *L'Arte della maiolica in
Italia*, 2nd ed. (Milan, 1980), no. 48;
"Acquisitions/1985," *GettyMusJ* 14 (1986),
no. 213, p. 251, illus.; Hess, *Maiolica*, no. 6,
pp. 26–27.

———

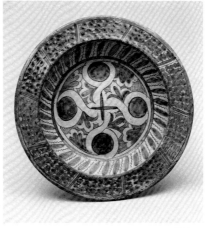

337

337. **Dish (*bacino*)**

Florence, circa 1425–1440
Tin-glazed earthenware
Height: 1¾ in. (4.4 cm); Diameter: 9¹⁵/₁₆ in.
(25.3 cm)
Accession number 84.DE.94

PROVENANCE

E. R. Paget, London; Alfred Pringsheim,
Munich; A. Kauffmann, London; [Rainer
Zietz, Ltd., London].

BIBLIOGRAPHY

Otto von Falke, *Majolikasammlung Pring-
sheim in München* (The Hague, 1914–1923),
vol. 1, p. 4, fig. 4; Galeazzo Cora, *Storia
della maiolica di Firenze e del contado
del XIV e del XV secolo* (Florence, 1973),
vol. 2, no. 50d, pl. 50; "Acquisitions/1984,"
GettyMusJ 13 (1985), no. 152, p. 239, illus.;
Hess, *Maiolica*, no. 4, pp. 20–22.

———

338. **Two-handled "Oak-Leaf" Jar
(*orciuolo biansato*)**

Florence, circa 1425–1450
Tin-glazed earthenware
Marked with a six-pointed asterisk below
each handle.
Height: 1 ft. 3½ in. (39.4 cm); Diameter (at
lip): 7⅝ in. (19.3 cm); Maximum Width:
1 ft. 3¾ in. (40 cm)
Accession number 84.DE.97

PROVENANCE

Contini-Bonacossi, Florence; [Nella Longari,
Milan]; [Rainer Zietz, Ltd., London].

BIBLIOGRAPHY

Galeazzo Cora, *Storia della maiolica di
Firenze e del contado del XIV e del XV secolo*
(Florence, 1973), vol. 1, pp. 83, 457; vol. 2,
pl. 112; "Acquisitions/1984," *GettyMusJ* 13
(1985), no. 157, p. 240, illus.; Hess, *Maiolica*,
no. 7, pp. 28–30.

———

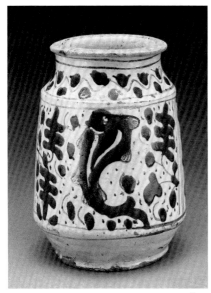

336

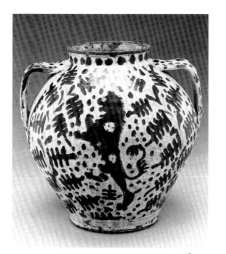

338

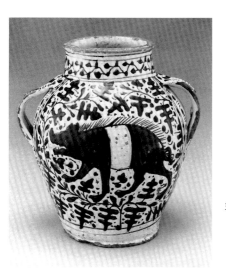

339

339. Two-handled "Oak-Leaf" Drug Jar (*orciuolo biansato*)

Florence, circa 1431
Tin-glazed earthenware
Painted with a copper green and manganese purple crutch on each handle and marked with a six-pointed asterisk surrounded by dots below each handle.
Height: 9⅞ in. (25 cm); Diameter (at lip): 4¹⁵⁄₁₆ in. (12.5 cm); Maximum Width: 9⅝ in. (24.5 cm)
Accession number 84.DE.98

PROVENANCE

Sir Thomas Ingilby, Bt., North Yorkshire (offered for sale, Sotheby's, London, July 2, 1974, lot 261, withdrawn) (sold, Sotheby's, London, April 14, 1981, lot 13); [Rainer Zietz, Ltd., London].

BIBLIOGRAPHY

John Cuadrado, "Prized Pottery Triumphs of the Italian Renaissance," *Architectural Digest* 41 (February 1984), p. 127; "Acquisitions/1984," *GettyMusJ* 13 (1985), no. 158, p. 240, illus.; *Handbook* 1986, p. 182, illus.; Hess, *Maiolica*, no. 8, pp. 31–33.

───────

340. Two-handled Jar (*orciuolo biansato*)

Florence, circa 1432–1450
Tin-glazed earthenware
Marked below each handle with a six-pointed asterisk surrounded by dots.
Height: 6½ in. (16.5 cm); Diameter (at lip): 4⅛ in. (10.5 cm); Maximum Width: 7 in. (17.8 cm)
Accession number 85.DE.58

PROVENANCE

Stefano Bardini, Florence; Elie Volpi, Florence (sold, Jandolo and Tavazzi, Rome, April 25–May 3, 1910, lot 777); (sold, Lempertz, Cologne, May 6, 1953, lot 414); Dr. Bak, New York; (sold, Sotheby's, New York, December 7, 1965, lot 15); August Lederer, Vienna; Erich Lederer, Geneva.

BIBLIOGRAPHY

Galeazzo Cora, *Storia della maiolica di Firenze e del contado del XIV e del XV secolo* (Florence, 1973), vol. 1, p. 80; vol. 2, fig. 107b; "Acquisitions/1985," *GettyMusJ* 14 (1986), no. 212, p. 251, illus.; Hess, *Maiolica*, no. 9, pp. 34–35.

───────

340

341

341. **Cylindrical Jar (*albarello*)**

Florentine area, circa 1440–1450
Tin-glazed earthenware
Height: 7⁵⁄₁₆ in. (18.6 cm); Diameter (at rim):
4⅛ in. (10.5 cm); Maximum Diameter:
4⅝ in. (11.8 cm)
Accession number 84.DE.100

PROVENANCE

Sold, Sotheby's, London, November 22,
1983, lot 194; [Rainer Zietz, Ltd., London].

BIBLIOGRAPHY

"Acquisitions/1984," *GettyMusJ* 13 (1985),
no. 153, p. 239, illus.; Hess, *Maiolica*, no. 11,
p. 39.

342. **Cylindrical Jar (*albarello*)**

Florentine area, mid-fifteenth century
Tin-glazed earthenware
Inscribed marks on underside (graduations?).
Height: 7⅛ in. (18.1 cm); Diameter (at lip):
3¾ in. (9.5 cm); Maximum Width: 5⅛ in.
(13 cm)
Accession number 84.DE.96

PROVENANCE

J. Chompret, Paris (sold, Hôtel Drouot,
Paris, December 15, 1976, lot 19); [Rainer
Zietz, Ltd., London].

BIBLIOGRAPHY

"Acquisitions/1984," *GettyMusJ* 13 (1985),
no. 156, p. 240, illus.; Hess, *Maiolica*,
no. 10, pp. 36–38.

342

343

343. **Two-handled Armorial Jar (*albarello biansato*)**

Florentine area or Umbria, circa 1450–1500
Tin-glazed earthenware
AMA.DIO painted on one side.
Height: 8¾ in. (22.2 cm); Diameter (at
rim): 4½ in. (11.4 cm); Maximum Width:
9³⁄₁₆ in. (23.4 cm)
Accession number 84.DE.99

PROVENANCE

Alfred Pringsheim, Munich (sold, Sotheby's,
London, June 7, 1939, lot 3); [Alfred Spero,
London]; [Rainer Zietz, Ltd., London].

BIBLIOGRAPHY

Otto von Falke, *Majolikasammlung Pring-
sheim in München* (The Hague, 1914–1923),
vol. I, no. II, pl. 8; Mario Bellini and
Giovanni Conti, *Maioliche italiane del
rinascimento* (Milan, 1964), p. 89, fig. A;
"Acquisitions/1984," *GettyMusJ* 13 (1985),
no. 159, p. 240, illus.; Hess, *Maiolica*, no. 12,
pp. 40–42.

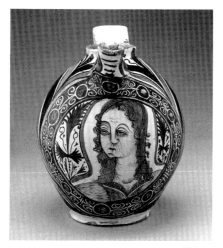

344

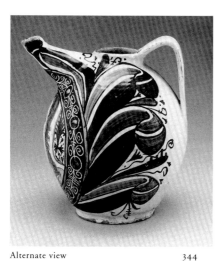

Alternate view 344

344. Jug with Bust Medallion (*brocca*)

Florentine area, circa 1450–1500
Tin-glazed earthenware
Height: 1 ft. 1⅝ in. (34.6 cm); Diameter (at rim): 3⅞ in. (9.8 cm); Maximum Width: 1 ft. 1 in. (33 cm)
Accession number 84.DE.101

PROVENANCE

Savile family, Rufford Abbey, Nottingham (sold, Knight, Frank and Rutley in association with Christie's, London, October 11–20, 1938, lot 879); [Alfred Spero, London]; (sold, Sotheby's, London, December 4, 1956, lot 24); Robert Strauss, London (sold, Christie's, London, June 21, 1976, lot 7); [Rainer Zietz, Ltd., London].

BIBLIOGRAPHY

Christie's Review of the Season 1975 (London and New York, 1976), p. 394; Morley-Fletcher and McIlroy, *European Pottery*, p. 26, fig. 3; "Acquisitions/1984," *GettyMusJ* 13 (1985), no. 154, p. 239, illus.; Hess, *Maiolica*, no. 13, pp. 43–45.

345. Two-handled Cylindrical Jar (*albarello biansato*)

Faenza, circa 1460–1480
Tin-glazed earthenware
Inscribed marks under foot (graduations?).
Height: 9 in. (22.9 cm); Diameter (at lip): 4⁷⁄₁₆ in. (11.2 cm); Maximum Width: 9⅜ in. (23.8 cm)
Accession number 84.DE.102

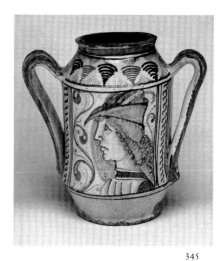

345

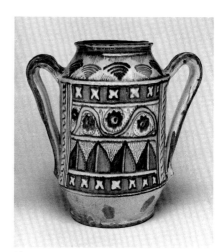

Alternate view 345

PROVENANCE

Sold, Christie's, London, October 3, 1983,
lot 237; [Rainer Zietz, Ltd., London].

BIBLIOGRAPHY

"Acquisitions/1984," *GettyMusJ* 13 (1985),
no. 160, p. 240, illus.; Hess, *Maiolica*,
no. 14, pp. 46–48.

346. **Peacock-pattern Dish**

(?) Faenza, circa 1470–1500
Tin-glazed earthenware
Height: 2½ in. (6.3 cm);
Diameter: 1 ft. 3⅜ in. (39 cm)
Accession number 84.DE.103

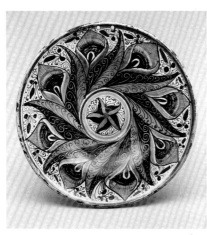

346

347. **Cylindrical Drug Jar (*albarello*)**

Faenza, circa 1480
Tin-glazed earthenware
S. ACETOSITATI CIT[RUS] painted on
banderole label.
Height: 1 ft. ⅜ in. (31.5 cm); Diameter (at
lip): 4⅜ in. (11.1 cm); Maximum Diameter:
4⅞ in. (12.4 cm)
Accession number 84.DE.104

PROVENANCE

Alfred Pringsheim, Munich; (sold, Sotheby's,
London, June 7, 1939, lot 9); Charles
Damiron, Lyons; Paul Damiron; (sold,
Sotheby's, London, November 22, 1983,
lot 212); [Rainer Zietz, Ltd., London].

BIBLIOGRAPHY

Otto von Falke, *Majolikasammlung Pring-
sheim in München* (The Hague, 1914–1923),
vol. 1, no. 22, pl. 15; Emil Hannover, *Pot-*

PROVENANCE

Sir William Stirling-Maxwell, Bt., K.T;
Lt. Col. W. J. Stirling, Keir (sold, Sotheby's,
London, June 18, 1946, lot 79); F. D. Lycett-
Green, Goudhurst, Kent (sold, Sotheby's,
London, October 14, 1960, lot 24); Robert
Strauss, London (sold, Christie's, London,
June 21, 1976, lot 14); [Cyril Humphris,
London]; [Rainer Zietz, Ltd., London].

BIBLIOGRAPHY

Jörg Rasmussen, *Italienische Majolika* (Ham-
burg, 1984), p. 71, n. 1; "Acquisitions/1984,"
GettyMusJ 13 (1985), no. 162, p. 241, illus.;
Hess, *Maiolica*, no. 15, pp. 49–51.

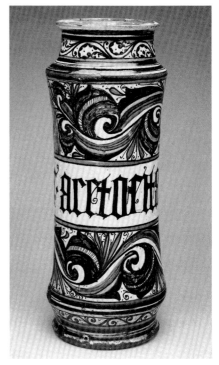

347

tery and Porcelain (London, 1925), fig. 117;
Charles Damiron, *Majoliques italiennes* (pri-
vately printed, 1944), no. 27; "Acquisitions/
1984," *GettyMusJ* 13 (1985), no. 161, p. 241,
illus.; Hess, *Maiolica*, no. 17, pp. 55–57;
Handbook 1991, p. 202, illus.

348

348. **Plate with Saint Peter**

Faenza or (?) Cafaggiolo, circa 1500
Tin-glazed earthenware
Height: 1⅞ in. (4.8 cm);
Diameter: 10¼ in. (27.3 cm)
Accession number 84.DE.108

PROVENANCE

Private collection, Switzerland; [Rainer
Zietz, Ltd., London].

BIBLIOGRAPHY

"Acquisitions/1984," *GettyMusJ* 13 (1985),
no. 170, p. 242, illus.; Hess, *Maiolica*, no. 20,
pp. 64–65.

349. *Ecce Homo*

Faenza or (?) Florentine area, circa 1500
Tin-glazed earthenware
Height: 1 ft. 11¾ in. (60.3 cm); Width: 1 ft.
11½ in. (59.7 cm); Depth: 10¼ in. (26 cm)
Accession number 87.SE.148

PROVENANCE

Private collection, Belgium; (sold, Sotheby's,
London, April 7, 1987, lot 44); [Rainer
Zietz, Ltd., London].

BIBLIOGRAPHY

Burlington Magazine 129 (March 1987), illus.
p. 1; *Il giornale dell'arte*, no. 45 (1987), p. 90,
fig. 50; "Acquisitions/1987," *GettyMusJ* 16
(1988), no. 77, p. 180, illus.; Hess, *Maiolica*,
no. 16, pp. 52–54.

———

349

350. *Alla Porcellana* **Dish (*tondino*)**

Cafaggiolo, circa 1500–1525
Attributed to Jacopo di Stefano di Filippo
([?]1490–after 1576)
Tin-glazed earthenware
Signed on the reverse, *J[acop]o chafagguolo*
or *In chafagguolo* in blue.
Height: 1⅞ in. (4.8 cm); Diameter: 9 9/16 in.
(24.3 cm)
Accession number 84.DE.109

PROVENANCE

Charles Loeser, Torri Gattaia (sold, Sotheby's,
London, December 8, 1959, lot 55); Robert
Strauss, London (sold, Christie's, London,
June 21, 1976, lot 19); [Rainer Zietz, Ltd.,
London].

BIBLIOGRAPHY

Galeazzo Cora and Angiolo Fanfani, *La
maiolica di Cafaggiolo* (Florence, 1982),
p. 66, fig. 48; Morley-Fletcher and McIlroy,

350

European Pottery, p. 44, fig. 1; "Acquisitions/
1984," *GettyMusJ* 13 (1985), no. 171, p. 242,
illus.; Hess, *Maiolica*, no. 21, pp. 66–68.

351

351. Lustered Display Plate with Female Bust (*piatto da pompa*)

Deruta, circa 1500–1530
Tin-glazed earthenware
Inscribed *VIVIS ERO VIV[U]S E
MORTV[U]S ERO VIV[U]S* on the scroll.
Height: 3½ in. (8.8 cm); Diameter:
1 ft. 4⅞ in. (42.8 cm)
Accession number 84.DE.110

PROVENANCE

R. W. M. Walker, London; (sold, Christie's,
London, July 25, 1945, lot 73); Adda col-
lection, Paris; (sold, Christie's, London,
November 20, 1967, lot 87); [Rainer Zietz,
Ltd., London].

BIBLIOGRAPHY

Bernard Rackham, *Islamic Pottery and
Italian Maiolica* (London, 1959), no. 34b,
p. 143, pl. 231; Morley-Fletcher and McIlroy,
European Pottery, p. 52, fig. 7; "Acquisitions/
1984," *GettyMusJ* 13 (1985), no. 172, p. 243,
illus.; Hess, *Maiolica*, no. 22, pp. 69–71.

352. Cylindrical Jar with Lame Peasant (*albarello*)
Cylindrical Jar with Woman and Distaff (*albarello*)

Faenza, circa 1510
Tin-glazed earthenware
Marked on the back of each jar, *B⁰*.
Height: 9¾ in. (24.8 cm); Diameter (at lip):
5⁵⁄₁₆ in. (12.9 cm); Maximum Diameter: Jar .1:
6¼ in. (15.9 cm); Jar .2: 6⅝ in. (16.8 cm)
Accession number 84.DE.112.1–.2

PROVENANCE

J. Pierpont Morgan, New York; Joseph E.
Widener, Elkins Park, Pennsylvania (sold,
Samuel T. Freeman and Co., Philadelphia,
June 20, 1944, lots 326–327); Dr. Bak, New
York (sold, Sotheby's, New York, Decem-
ber 7, 1965, lot 54); Benjamin Sonnenberg,
New York (sold, Sotheby's, New York, June 5,
1979, lot 356); [Rainer Zietz, Ltd., London].

BIBLIOGRAPHY

Bernard Rackham, "A New Chapter in
the History of Italian Maiolica," *Burlington
Magazine* 27 (May 1915), p. 50; *Inventory of
the Objets d'Art at Lynnewood Hall, Elkins
Park, Estate of the Late P.A.B. Widener*
(privately printed, Philadelphia, 1935),

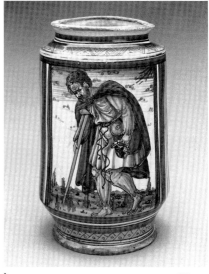

Jar .1 352

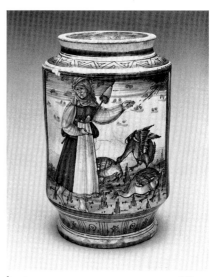

Jar .2 352

pp. 67–68; Mario Bellini and Giovanni Conti, *Maioliche italiane del rinascimento* (Milan, 1964), p. 100, pls. A, C; Jörg Rasmussen, *Italienische Majolika* (Hamburg, 1984), pp. 84, 86; "Acquisitions/1984," *GettyMusJ* 13 (1985), no. 163, p. 241, illus.; Hess, *Maiolica*, no. 24, pp. 75–81.

———

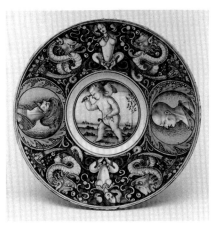

353

353. **Dish with a Cupid on a Hobbyhorse (*tondino*)**

(?) Castel Durante, circa 1510–1520
Tin-glazed earthenware
Height: ¹⁵⁄₁₆ in. (2.4 cm); Diameter: 9¼ in. (23.5 cm)
Accession number 84.DE.116

PROVENANCE
Alessandro Castellani, Rome (sold, Hôtel Drouot, Paris, May 27, 1878, lot 34); Charles Damiron, Lyons (sold, Sotheby's, London, June 16, 1938, lot 60); Robert Strauss, London (sold, Christie's, London, June 21, 1976, lot 22); [Cyril Humphris, London]; [Rainer Zietz, Ltd., London].

BIBLIOGRAPHY
Bernard Rackham, "The Damiron Collection," *Apollo* 25 (1937), p. 256, fig. 7; Joseph Chompret, *Répertoire de la majolique italienne*, vol. 2 (Paris, 1949), pl. 13, fig. 93; *Christie's Review of the Season 1975* (London and New York, 1976), p. 396; Morley-Fletcher and McIlroy, *European Pottery*, p. 66, fig. 3; "Acquisitions/1984," *GettyMusJ* 13 (1985), no. 174, p. 243, illus.; Hess, *Maiolica*, no. 29, pp. 29–31.

———

354. **Dish with a Scene from the *Aeneid* (*coppa*)**

Faenza, circa 1515–1520
Tin-glazed earthenware
Marked on the underside with a crossed circle with a smaller circle in each of the four quarters.
Height: 2⅛ in. (5.4 cm); Diameter: 9¹¹⁄₁₆ in. (24.6 cm)
Accession number 84.DE.106

PROVENANCE
Sold, Sotheby's, London, November 21, 1987, lot 42; [Rainer Zietz, Ltd., London].

BIBLIOGRAPHY
"Acquisitions/1984," *GettyMusJ* 13 (1985), no. 164, p. 241, illus.; Hess, *Maiolica*, no. 18, pp. 58–60.

———

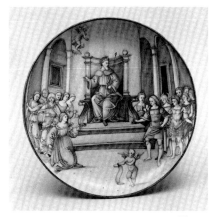

354

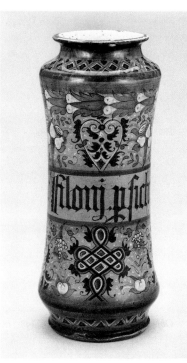

355

355. Cylindrical Drug Jar (*albarello*)

Faenza, circa 1520–1530
Tin-glazed earthenware
FILONIJ P[ER]SICHI painted on the
banderole label.
Height: 1 ft. 2 9/16 in. (37 cm); Diameter (at
lip): 4 15/16 in. (12.5 cm); Maximum
Diameter: 6 1/2 in. (16.5 cm)
Accession number 84.DE.105

PROVENANCE

Stora, Paris; Whitney Warren, New York
(sold, Parke-Bernet, New York, October 7,
1943, lot 448); (sold, Sotheby's, London,
November 22, 1983, lot 197); [Rainer Zietz,
Ltd., London].

BIBLIOGRAPHY

"Acquisitions/1984," *GettyMusJ* 13 (1985),
no. 166, p. 242, illus.; Hess, *Maiolica*, no. 25,
pp. 82–84.

356. Armorial Plate with *The Flaying of Marsyas*

Urbino, mid-1520s
By Nicola (di Gabriele Sbraghe) da Urbino
Tin-glazed earthenware
Height: 2 1/4 in. (5.7 cm); Diameter:
1 ft. 4 5/16 in. (41.4 cm)
Accession number 84.DE.117

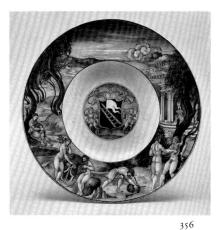

356

PROVENANCE

Ralph Bernal, London (sold, Christie's,
London, March 5, 1855, lot 1767); (sold,
Christie's, London, April 12, 1976, lot 179,
pl. 13); [Rainer Zietz, Ltd., London].

BIBLIOGRAPHY

Morley-Fletcher and McIlroy, *European
Pottery*, p. 65, fig. 8; "Acquisitions/1984,"
GettyMusJ 13 (1985), no. 175, p. 243, illus.;
Hess, *Maiolica*, no. 30, pp. 97–100.

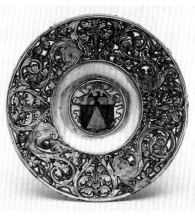

357

357. Lustered Armorial Plate

Gubbio, 1524
Produced in the workshop of Maestro
Giorgio Andreoli
Tin-glazed earthenware
Signed and dated *M⁰ G⁰ 1524* on the
reverse.
Height: 2 7/8 in. (7.3 cm);
Diameter: 1 ft. 3 11/16 in. (39.9 cm)
Accession number 84.DE.111

PROVENANCE

Sold, Sotheby's, London, November 21,
1978, lot 41; [Cyril Humphris, London];
[Rainer Zietz, Ltd., London].

BIBLIOGRAPHY

"Acquisitions/1984," *GettyMusJ* 13 (1985),
no. 173, p. 243, illus.; Hess, *Maiolica*, no. 23,
pp. 72–74.

———

358. **Plate with *Hero and Leander* (*tagliere*)**

Faenza, circa 1525
Tin-glazed earthenware
Marked with a swan on the reverse.
Height: 1½ in. (3.8 cm); Diameter:
1 ft. 5⁵⁄₁₆ in. (44 cm)
Accession number 84.DE.113

PROVENANCE

Henri Gautier, Paris (sold, Hôtel Drouot,
Paris, May 4, 1929, lot 28); George Dur-
lacher, London (sold, Christie's, London,
April 7, 1938, lot 26); Henry S. Reitlinger,
London; Robert Strauss, London (sold,
Christie's, London, June 21, 1976, lot 25);
[Rainer Zietz, Ltd., London].

BIBLIOGRAPHY

Joseph Chompret, *Répertoire de la majo-
lique italienne*, vol. 2 (Paris, 1949), fig. 458;
Christie's Review of the Season 1975 (London
and New York, 1976), p. 397; Morley-
Fletcher and McIlroy, *European Pottery*,
p. 36, fig. 5; "Acquisitions/1984," *GettyMusJ*
13 (1985), no. 165, p. 241, illus.; Hess, *Maio-
lica*, no. 26, pp. 85–87.

———

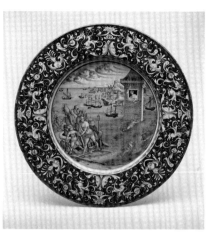

358

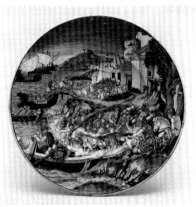

359

359. **Plate with *The Abduction of Helen***

Urbino, 1534
By Francesco Xanto Avelli
Tin-glazed earthenware
Dated and inscribed on the reverse,
*.M.D.XXXIIII / Quest'è 'l pastor che mal
mirò l bel / volto / D'Helena Greca, e, quel
famoso rapto / pel qual fu'l mondo sotto sopra
volto. /* and signed *.Fra[ncesco]:Xa[n]to.
A[velli]./da Rovigo, i[n]/Urbino.*
Height: 2½ in. (6.3 cm);
Diameter: 1 ft. 6⅛ in. (46.1 cm)
Accession number 84.DE.118

PROVENANCE

Sold, Sotheby's, London, November 21,
1978, lot 44; [Rainer Zietz, Ltd., London].

EXHIBITIONS

P. and D. Colnaghi and Co., London,
Objects for a "Wunderkammer," 1981, no. 65,
pp. 124–125.

BIBLIOGRAPHY

Christie's Review of the Season 1975 (London
and New York, 1976), p. 397; "Acquisitions/
1984," *GettyMusJ* 13 (1985), no. 176, p. 243,
illus.; Hess, *Maiolica*, no. 31, pp. 101–103;
Handbook 1986 p. 184, illus.

———

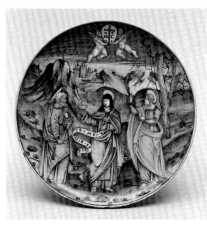

360

360. Dish with Three Saints (*coppa*)

Faenza, circa 1535
By Baldassare Manara
Tin-glazed earthenware
Obverse painted with a shield containing a
holy cross flanked by *M* and *C* below annulets; inscribed on the scroll *PETRE DILIGIS
ME* and signed on the reverse, *Baldasara
Manara fa[e]n[tino]* or *Baldasara Manara
fa[e]n[za]*.
Height: 1½ in. (3.8 cm);
Diameter: 8⁷⁄₁₆ in. (21.5 cm)
Accession number 84.DE.107

PROVENANCE

Stora, Paris; Charles Damiron, Lyons (sold,
Sotheby's, London, June 16, 1938, lot 20);
Paul Damiron (sold, Sotheby's, London,
November 22, 1983, lot 209); [Rainer Zietz,
Ltd., London].

BIBLIOGRAPHY

Charles Damiron, *Majoliques italiennes*
(privately printed, 1944), no. 79; Joseph
Chompret, *Répertoire de la majolique itali-
enne*, vol. 1 (Paris, 1949), p. 77; illus. p. 2,
fig. 500; *Art at Auction: The Year at Sotheby's*
(London, 1983–1984), p. 290; "Acquisitions/
1984," *GettyMusJ* 13 (1985), no. 167, p. 242,
illus.; Hess, *Maiolica*, no. 19, pp. 61–63.

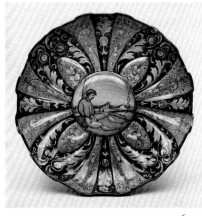

361

361. Molded Dish with an Allegory of Love (*crespina*)

Faenza, circa 1535
Tin-glazed earthenware
Height: 2⅞ in. (7.3 cm);
Diameter: 11 in. (28 cm)
Accession number 84.DE.114

PROVENANCE

Prince Thibaut d'Orléans, Paris (sold,
Sotheby's, London, February 5, 1974,
lot 30); [Rainer Zietz, Ltd., London].

BIBLIOGRAPHY

"Acquisitions/1984," *GettyMusJ* 13 (1985),
no. 168, p. 242, illus.; Hess, *Maiolica*, no. 27,
pp. 88–90.

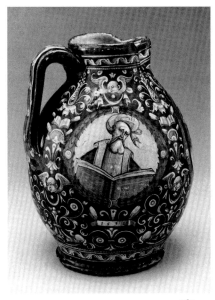

362

362. Jug with *Berettino* Ground (*boccale*)

Faenza, 1536
Tin-glazed earthenware
Dated *1536* on each of four tablets under the
medallions and marked *Elixeo* beside a
bearded and turbaned old man.
Height: 1 ft. ¹³⁄₁₆ in. (32.5 cm); Diameter (at
lip): 5¼ in. (13.3 cm); Maximum Width:
10¼ in. (26 cm)
Accession number 84.DE.115

PROVENANCE

Alessandro Castellani, Rome (sold, Hôtel Drouot, Paris, May 27–29, 1878, lot 230); J. Pierpont Morgan, New York; George R. Hann, Sewickley Heights, Pennsylvania (sold, Christie's, on the Hann premises, Treetops, Sewickley Heights, May 19, 1980, lot 91); [Rainer Zietz, Ltd., London].

EXHIBITIONS

The Metropolitan Museum of Art, New York, 1913–1916.

BIBLIOGRAPHY

"Acquisitions/1984," *GettyMusJ* 13 (1985), no. 169, p. 242, illus.; Hess, *Maiolica*, no. 28, pp. 91–93.

363. ***A Candelieri* Plate**

Venice, circa 1540–1560
Tin-glazed earthenware
Marked on the obverse *.S.P.Q.R.*
Height: 2¼ in. (5.7 cm);
Diameter: 1 ft. 6¾ in. (47.7 cm)
Accession number 84.DE.120

PROVENANCE

Royal collection (see Marryat, below); Robert Strauss, London (sold, Christie's, London, June 21, 1976, lot 52); [Rainer Zietz, Ltd., London].

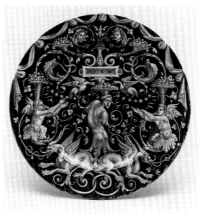

363

BIBLIOGRAPHY

Joseph Marryat, *A History of Pottery and Porcelain* (London, 1857), p. 34, fig. 18; *Christie's Review of the Season 1975* (London and New York, 1976), p. 400; Morley-Fletcher and McIlroy, *European Pottery*, p. 86, fig. 1; "Acquisitions/ 1984," *GettyMusJ* 13 (1985), no. 178, p. 244, illus.; Hess, *Maiolica*, no. 33, pp. 108–111.

364. **Pilgrim Flask and Cover with Marine Scenes (*fiasca da pellegrino*)**

Urbino, circa 1560–1570
Produced in the workshop of Orazio Fontana
Tin-glazed earthenware
Height: 1 ft. 5⅜ in. (44.1 cm); Maximum Width: 11¼ in. (28.6 cm)
Accession number 84.DE.119.a-.b.

PROVENANCE

Thomas F. Flannery, Jr., Winnetka, Illinois (sold, Sotheby's, London, November 22, 1983, lot 160); [Edward Lubin, New York]; [Rainer Zietz, Ltd., London].

BIBLIOGRAPHY

"Acquisitions/1984," *GettyMusJ* 13 (1985), no. 177, pp. 243–244, illus.; Hess, *Maiolica*, no. 32, pp. 104–107.

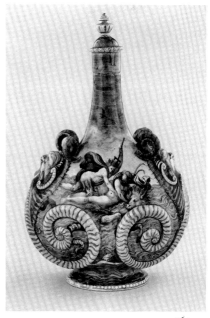

364

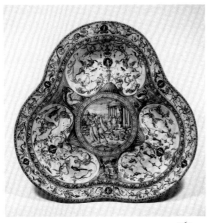

365

365. **Basin with _Deucalion and Pyrrha_ (_bacile trilobato_)**

Urbino, circa 1565–1571
By Orazio Fontana or produced in his
workshop
Tin-glazed earthenware
Height: 2½ in. (6.3 cm);
Diameter: 1 ft. 6¼ in. (46.3 cm)
Accession number 86.DE.539

PROVENANCE

Baron Adolphe de Rothschild, Paris,
between 1870 and 1890; Baron Maurice
de Rothschild, Paris, until 1916; [Duveen
Brothers, New York]; private collection,
Stuttgart; (sold, Reimann and Monats-
berger, Stuttgart, January 1986); [Alain
Moatti, Paris].

BIBLIOGRAPHY

Antiquitäten-Zeitung 25 (1985), p. 611;
"Acquisitions/1986," _GettyMusJ_ 15 (1987),
no. 114, p. 216, illus.; Hess, _Maiolica_, no. 34,
pp. 112–115, illus.; _Handbook_ 1991, p. 206,
illus.

366. **Pilgrim Flask (_fiasca da pellegrino_)**

Florence, the Medici porcelain factory, circa
1575–1587
Soft-paste porcelain
Marked on the underside with the dome of
Santa Maria del Fiore accompanied by _F_; a
mark resembling _3_ scratched under the glaze
and painted with blue glaze; on rim, three
hatch marks inscribed before glaze firing.

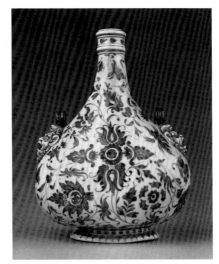

366

Height: 10⅜ in. (26.4 cm); Diameter (at
lip): 1⁹⁄₁₆ in. (4 cm); Maximum Width:
7⅞ in. (20 cm)
Accession number 86.DE.630

PROVENANCE

William Spence, Florence, until 1857; pur-
chased by Alessandro Foresi, 1857; Giovanni
Freppa, Florence; Eugène Piot, Paris (sold,
Hôtel des Commissaires-Priseurs, Paris,
March 19, 1860, lot 82, to Baron Alphonse
de Rothschild, Paris); Baron Edouard de
Rothschild, Paris; Baron Guy and Baroness
Marie-Hélène de Rothschild, Paris.

EXHIBITIONS

Paris, _Exposition rétrospective du Trocadéro_,
1878.

BIBLIOGRAPHY

Albert Jacquemart, "La porcelaine des
Médicis," _Gazette des beaux-arts_ 3 (Decem-
ber 1859), p. 276; Albert Jacquemart and
Edmond Le Blant, _Histoire artistique:
Industrielle et commerciale de la porcelaine_
(Paris, 1862), p. 644, no. 5; Alessandro Foresi,
Sulle porcellane medicee (Florence, 1869),
pp. 15ff., 29, reprint from _Piovani Arlotto_
(July 1859); Alfred Darcel, "Les faïences
français et les porcelaines au Trocadéro,"
Gazette des beaux-arts 18 (November 1878),
p. 762; Baron Jean Charles Davillier, _Les
Origines de la porcelaine en Europe_ (Paris,
1882), no. 29, pp. 39–41, 114–115; Charles de
Grollier, _Manuel de l'amateur de porcelaine_
(Paris, 1914), no. 2309; Seymour de Ricci,
"La porcelaine des Medicis," _Faenza, Museo
Internazionale delle Ceramiche: L'opera d'un
decennio, 1908–1918_ (Faenza, 1918), p. 29,

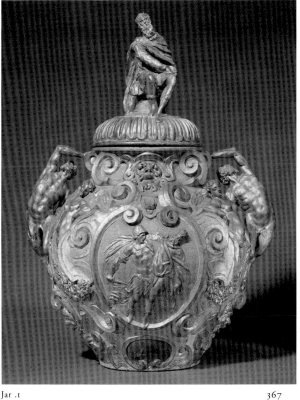

Jar .1 367

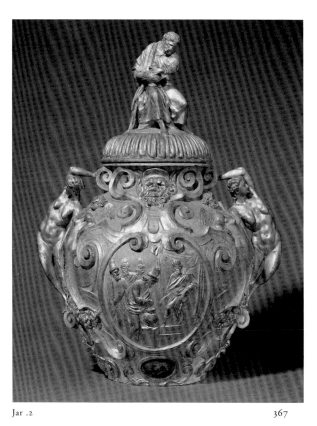

Jar .2 367

no. 22; Giuseppe Liverani, *Catalogo delle porcellane dei Medici* (Faenza, 1936), no. 28, p. 31; Arthur Lane, *Italian Porcelain* (London, 1954), p. 5, pl. 3c; "Acquisitions/1986," *GettyMusJ* 15 (1987), no. 115, pp. 216–217, illus.; Clare le Corbellier, "A Medici Porcelain Pilgrim Flask," *GettyMusJ* 16 (1988), pp. 119–126, illus.; Hess, *Maiolica*, no. 36, pp. 120–123, illus.; *Handbook* 1991, p. 205, illus.

367. **Pair of Drug Jars**
Northern Italian, circa 1580–1590
Painted and gilt terracotta
Height: 1 ft. 11⅜ in. (60 cm)
Accession number 90.SC.42.1–.2

PROVENANCE
Private collection, London; [Siran Holding Company, Geneva].

BIBLIOGRAPHY
"Acquisitions/1990," *GettyMusJ* 19 (1991), no. 57, p. 164, illus.

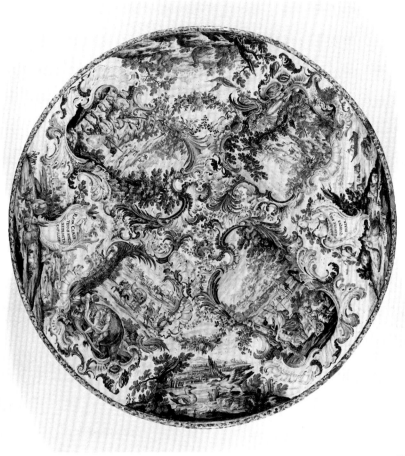

368

368. **Tabletop**

Naples, circa 1760

By Francesco Saverio II Maria Grue

Tin-glazed earthenware

Inscribed on the obverse, in two cartouches, *FLAVA CERES TENUS SPICIS REDEMITA CAPILLOS* and *FORTUNAE SUAE QUISQUE FABER*; signed on the horse's haunch in scene of Europeans hunting a deer, *SG*; and signed on the horse's haunch in scene of Moors hunting ostriches, *FSG*.

Height: 1¼ in. (3.2 cm);

Diameter: 1 ft. 11½ in. (59.7 cm)

Accession number 86.DE.533

PROVENANCE

Earl of Warwick, Warwickshire; (sold, Sotheby's, London, March 4, 1986, lot 24); [Winifred Williams, Ltd., London].

BIBLIOGRAPHY

Jacqueline Guillaumin, "Majoliques tardives: à prospecter," *Connaissance des arts* 419 (1987), p. 12, fig. 4; "Acquisitions/1986, *GettyMusJ* 15 (1987), no. 116, p. 217, illus.; Guido Donatone, "Pasquale Criscuolo e la Maiolica Napoletana dell'Età Rococò," *Centro Studi per la Storia della Ceramica Meridionale: Quaderno* (1988), fig. 1; Hess, *Maiolica*, no. 35, pp. 116–119.

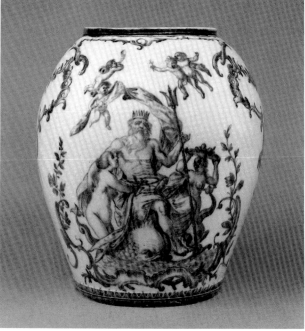

Vase .1 369

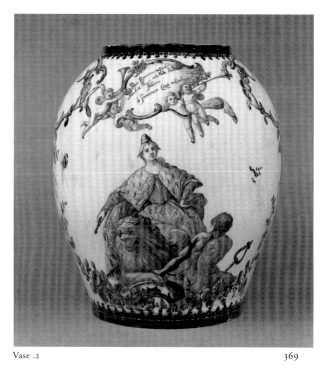

Vase .2 369

369. **Pair of Vases**

Venice, 1769

Produced in the factory of Geminiano Cozzi

Hybrid soft-paste porcelain

One jar inscribed and dated *Primo Esperi-
mento in Grande fatto li 15 Maggio 1769 Nella
Privil[egiata] fabbrica di Geminiano Cozzi
in Canalregio* (First large experiment [in
porcelain] executed May 15, 1769, in the
privileged factory of Geminiano Cozzi in
Cannaregio). This jar also bears the Cozzi
factory mark—an anchor—on one side.

Neptune Vase: Height: 11 13/16 in. (30 cm);
Diameter: 10½ in. (26.7 cm);
Signed Vase: Height: 11¾ in (29.8 cm);
Diameter: 10¾ in. (27.3 cm)
Accession number 88.DE.9.1–.2

PROVENANCE

Sig. Centanini, Venice, by 1889; Edmund de
Unger, Surrey.

BIBLIOGRAPHY

Raffaele Erculei, *Arte ceramica e vetraria*
(Museo Artistico-Industriale, Rome, 1889),
p. 151; Alessandra Mottola Molfino, *L'Arte
della porcellana in Italia* (Milan, 1976),

p. 27; Francesco Stazzi, *Le porcellane
veneziane di Geminiano e Vincenzo Cozzi*
(Venice, 1982), p. 53; "Acquisitions/1988,"
GettyMusJ 17 (1989), no. 85, p. 146, illus.;
Sotheby's Concise Encyclopedia of Porcelain,
David Battie, ed. (London, 1990), pp. 9–10;
Catherine Hess, "'Primo Esperimento in
Grande': A Pair of Vases from the Factory
of Geminiano Cozzi," *GettyMusJ* 18 (1990),
pp. 141–156, illus.; *Handbook* 1991,
p. 217, illus.

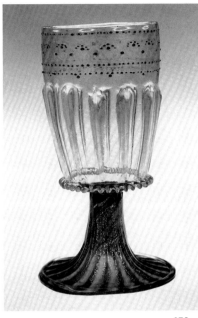

370

Glass

370. **Goblet**

Venice, late fifteenth or early sixteenth
century

Free- and mold-blown soda glass with gild-
ing and enamel decoration

Height: 7 ¼ in. (18.14 cm)

Accession number 84.DK.533

PROVENANCE

Spitzer, Paris (sold, "Objets d'art et de haute
curiositié," Paris, April 17–June 16, 1893,
vol. 2, lot 1977); John Edward Taylor,
London (sold, Christie's, London, July 4,
1912, lot 346); Ruth and Leopold Blumka,
New York.

EXHIBITIONS

New York, The Corning Museum of Glass,
Three Great Centuries of Venetian Glass, 1958,
no. 7, p. 32.

BIBLIOGRAPHY

"Acquisitions/1984," *GettyMusJ* 13 (1985),
no. 181, p. 244, illus.

———

371. **Goblet**

Venice, circa 1500

Free-blown soda glass with gilding and
enamel decoration

Etched in the gilding around the lip,
VIRTUS LAUDATA CRESCIT.

Height: 7 in. (17.8 cm)

Accession number 84.DK.534

PROVENANCE

Ruth and Leopold Blumka, New York.

EXHIBITIONS

New York, The Corning Museum of Glass,
Three Great Centuries of Venetian Glass, 1958,
no. 17, p. 39.

BIBLIOGRAPHY

"Acquisitions/1984," *GettyMusJ* 13 (1985),
no. 182, p. 244, illus.; *Journal of Glass Studies*,
no. 12, p. 101.

———

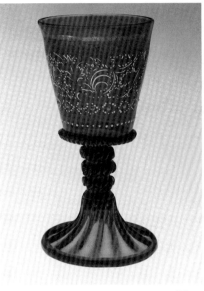

371

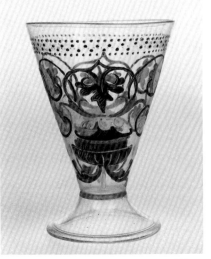

372

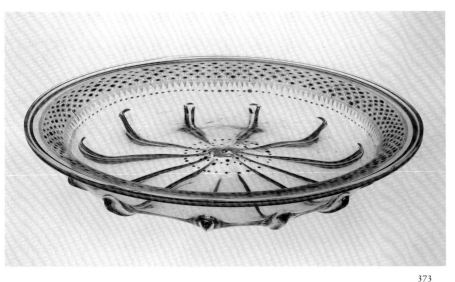

373

374. *Calcedonio* **Footed Bowl (*coppa*)**

Venice, circa 1500
Free-blown chalcedony glass
Height: 4¾ in. (12.5 cm)
Accession number 84.DK.660

PROVENANCE
Fritz Biemann, Zurich (sold, Sotheby's, London, June 16, 1984, lot 48); [David, Inc., Vaduz].

EXHIBITIONS
Düsseldorf, Städtische Kunsthalle, *Meisterwerke der Glaskunst aus internationalem Privatbesitz*, 1968, no. 59; Cologne, Kunstgewerbemuseum, Berlin, Kunstgewerbemuseum, and Zurich, Museum Bellerive, *Sammlung Biemann Ausstellung 500 Jahre Glaskunst*, 1978–1979, no. 43; Lucerne, Kunsthalle, *3000 Jahre Glaskunst von der Antike bis zum Jugendstil*, 1981, no. 661; Venice, Palazzo Ducale, Museo Correr, *Mille Anni di Arte del Vetro a Venezia*, 1982, no. 93.

372. **Goblet**

Venice, sixteenth century
Free-blown soda glass with enamel decoration
Height: 5½ in. (14 cm)
Accession number 84.DK.540

PROVENANCE
Ruth and Leopold Blumka, New York.

BIBLIOGRAPHY
"Acquisitions/1984," *GettyMusJ* 13 (1985), no. 192, p. 246, illus.

373. **Plate**

Venice, early sixteenth century
Free-blown and molded soda glass with gilding and enamel decoration
Height: 1¼ in. (4.5 cm); Diameter: 1 ft. (30.5 cm)
Accession number 84.DK.536

PROVENANCE
Ruth and Leopold Blumka, New York.

BIBLIOGRAPHY
"Acquisitions/1984," *GettyMusJ* 13 (1985), no. 189, p. 245, illus.

374

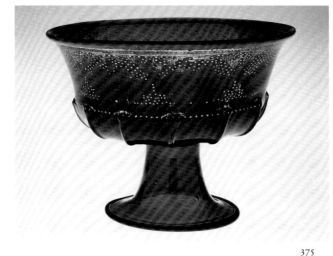

375

376

BIBLIOGRAPHY

J.-C. Gateau, *Die Glaskunst* (Geneva, 1974), pp. 65, 125; Brigitte Klesse and Axel von Saldern, *500 Jahre Glaskunst: Sammlung Biemann* (Zurich, 1978), no. 43, pp. 106–107; "Acquisitions/1984," *GettyMusJ* 13 (1985), no. 184, p. 245, illus.; *Handbook* 1986, p. 183, illus.; *Handbook* 1991, p. 204, illus.

375. Footed Bowl (*coppa*)

Venice, circa 1500
Free- and mold-blown glass with gilding and enamel decoration
Height: 7 in. (17.8 cm); Diameter (at mouth): 9½ in. (24.1 cm)
Accession number 84.DK.535

PROVENANCE

Prince of Liechtenstein, Vaduz; Ruth and Leopold Blumka, New York.

EXHIBITIONS

New York, The Corning Museum of Glass, *Three Great Centuries of Venetian Glass*, 1958, no. 42, p. 57.

BIBLIOGRAPHY

"Acquisitions/1984," *GettyMusJ* 13 (1985), no. 189, p. 245, illus.

376. Footed Bowl with Papal Arms (*coppa*)

Venice, circa 1513–1534
Free-blown soda glass with gilding and enamel decoration
Arms on the interior, in enamel, *or six balls gules* surmounted by a papal miter.
Height: 6½ in. (16.5 cm); Diameter (at mouth): 11¾ in. (29.9 cm)
Accession number 84.DK.655

PROVENANCE

Emile Gavet, Paris (sold, Galerie Georges Petit, Paris, May 31–June 9, 1897, lot 610); (sold, Sotheby's, London, February 23, 1976, lot 175); [David, Inc., Vaduz].

EXHIBITIONS

Venice, Palazzo Ducale, Museo Correr, *Mille Anni di Arte del Vetro a Venezia*, 1982, no. 122.

BIBLIOGRAPHY

"Acquisitions/1984," *GettyMusJ* 13 (1985), no. 187, p. 245, illus.

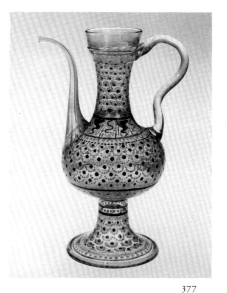

377

377. **Ewer**

Venice, late fifteenth or early sixteenth
century
Free-blown soda glass with gilding and
enamel decoration
Height: 11 in. (27.9 cm)
Accession number 84.DK.512

PROVENANCE

Emile Gavet, Paris (sold, Galerie Georges
Petit, Paris, May 31–June 9, 1897, lot 592);
John Edward Taylor, London (sold, Christie's,
London, July 4, 1912, lot 340); George
Eumorfopoulos, London (sold, Sotheby's,
London, May 28–31, 1940, lot 223); Ruth
and Leopold Blumka, New York.

EXHIBITIONS

New York, The Corning Museum of Glass,
Three Great Centuries of Venetian Glass, 1958,
no. 23, p. 45.

BIBLIOGRAPHY

"Acquisitions/1984," *GettyMusJ* 13 (1985),
no. 179, p. 244, illus.; *Journal of Glass Studies*,
no. 10, p. 101; *Handbook* 1991, p. 202, illus.

———

378. **Pilgrim Flask**

Venice, late fifteenth or early sixteenth
century
Free-blown soda glass with gilding and
enamel decoration
Height: 1 ft. 3 in. (38.1 cm)
Accession number 84.DK.538

PROVENANCE

Ruth and Leopold Blumka, New York.

EXHIBITIONS

New York, The Corning Museum of Glass,
Three Great Centuries of Venetian Glass, 1958,
no. 39, p. 55; New York, The Metropolitan
Museum of Art, The Cloisters, *The Secular
Spirit: Life and Art at the End of the Middle
Ages*, 1975, no. 45, p. 47.

BIBLIOGRAPHY

"Acquisitions/1984," *GettyMusJ* 13 (1985),
no. 180, p. 245, illus.

———

379. **Footed Bowl (*coppa*)**

Venice, early sixteenth century
Free- and mold-blown soda glass with gild-
ing and enamel decoration
Height: 9½ in. (21.4 cm); Diameter (at
mouth): 8¼ in. (21.5 cm)
Accession number 84.DK.511

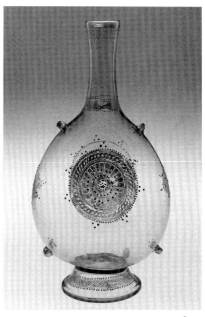

378

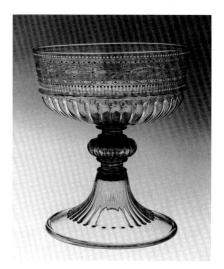

379

PROVENANCE
Prince of Liechtenstein, Vaduz; Ruth and Leopold Blumka, New York.

EXHIBITIONS
New York, The Corning Museum of Glass, *Three Great Centuries of Venetian Glass*, 1958, no. 29, p. 49.

BIBLIOGRAPHY
"Acquisitions/1984," *GettyMusJ* 13 (1985), no. 188, p. 245, illus.; *Journal of Glass Studies*, no. 11, p. 101.

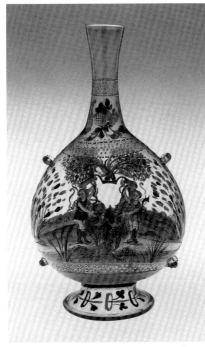

380

380. Pilgrim Flask

Venice, first quarter of the sixteenth century
Free-blown soda glass with gilding and enamel decoration
Height: 1 ft. 5/16 in. (31.3 cm)
Accession number 88.DK.539

PROVENANCE
Hollingworth Magniac, Colworth (sold, Christie's, London, July 2–4, 1892, lot 868); Durlacher, London; Edward Steinkopff, London (sold, Christie's, London, May 22–23, 1935, lot 72); (?) Riddell, London; (?) Alexander von Frey, Paris; private collection, Paris; (sold, Palais Galliera, Paris, November 29–December 3, 1965, lot 157); Ruth and Leopold Blumka, New York.

BIBLIOGRAPHY
Sir John Charles Robinson, *Notice of the Principal Works of Art in the Collection of Hollingworth Magniac, Esq.* (London, 1861), no. 152, p. 82; Acquisitions/1984," *GettyMusJ* 13 (1985), no. 185, p. 245, illus.; *Journal of Glass Studies*, no. 13, pp. 102–103.

381. Double-handled *Filigrana* Vase

Venice, mid-sixteenth century
Free-blown soda glass or *cristallo*, *vetro a retorti*, and *vetro a fili* with applied canes of *vetro a retorti*
Height: 8⅞ in. (22.5 cm)
Accession number 84.DK.654

PROVENANCE
[David, Inc., Vaduz].

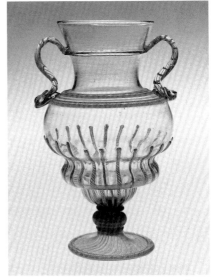

381

BIBLIOGRAPHY
"Acquisitions/1984," *GettyMusJ* 13 (1985), no. 191, p. 246, illus.

382. Ice-glass Situla (*secchiello*)

Venice, 1550–1600
Free-blown soda glass with applied decoration
Height: 4⅜ in. (11.2 cm)
Accession number 84.DK.657

PROVENANCE
[Rainer Zietz, Ltd., London]; [David, Inc., Vaduz].

BIBLIOGRAPHY
"Acquisitions/1984," *GettyMusJ* 13 (1985), no. 198, p. 247, illus.

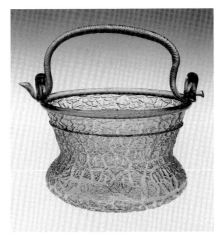

382

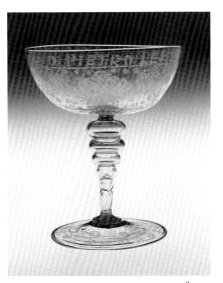

383

383. **Goblet**

(?) Murano, circa 1575–1600
Free-blown soda glass or *cristallo* with
diamond-point etching
Etched around the lip *SIG. DOTTORE D.
LESSIO.*
Height: 6 in. (15.2 cm)
Accession number 84.DK.541

PROVENANCE

E. and A. Silberman, Vienna; Oscar Bondy,
Vienna; Ruth and Leopold Blumka, New
York.

EXHIBITIONS

New York, The Corning Museum of Glass,
Three Great Centuries of Venetian Glass, 1958,
no. 92, p. 90.

BIBLIOGRAPHY

"Acquisitions/1984," *GettyMusJ* 13 (1985),
no. 194, p. 246, illus.; *Journal of Glass Studies*,
no. 31, p. 107.

384. **Standing Covered *Filigrana* Cup**

Glass: Venice, mid-sixteenth century
Mounts: German (Augsburg), circa
1580–1600
Free- and mold-blown soda glass or *cristallo*
and *lattimo*, *vetro a retorti*; silver-gilt mounts
Stamped on the edge of the lip mount, a
pinecone for the city of Augsburg and a tree
on a mount, an unknown maker's mark.
Height: 8 7/16 in. (21.5 cm)
Accession number 84.DK.514

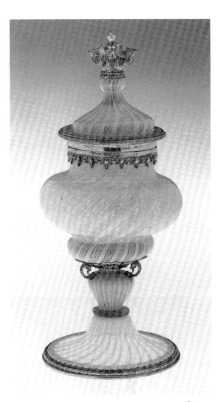

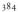

384

PROVENANCE

Ruth and Leopold Blumka, New York.

BIBLIOGRAPHY

"Acquisitions/1984," *GettyMusJ* 13 (1985),
no. 190, p. 246, illus.; *Journal of Glass Studies*,
no. 15, pp. 102–103.

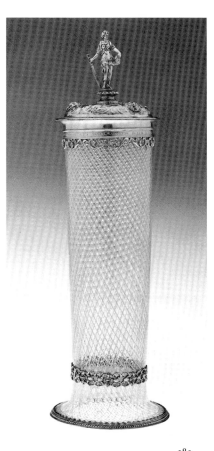

385

385. Covered *Filigrana Pokal*

Glass: Venice, third quarter of the sixteenth century
Mounts: German, circa 1585–1600
Free- and mold-blown soda glass or *cristallo* and *lattimo*, *vetro a reticello* with silver-gilt mounts

Engraved on the lip mount, *–SEI WILLKUMEN MEIN HAUS - SEZ AN UND TRINK AUS - TRAG FRID NIT HINAUS –*. Stamped on the brim of the cover, a pinecone for the city of Augsburg and the monogram *MB*, the maker's mark of Mathaeus Waldbaum (active in Augsburg 1582–1630/32).
Height: 1 ft. ¼ in. (31.3 cm)
Accession number 84.DK.513

PROVENANCE
Ruth and Leopold Blumka, New York.

BIBLIOGRAPHY
"Acquisitions/1984," *GettyMusJ* 13 (1985), no. 193, p. 246, illus.; *Handbook* 1991, p. 208, illus.

386. Umbo *Filigrana* Vase

Venice, late sixteenth century
Free- and mold-blown soda glass or *cristallo* and *lattimo*, *vetro a retorti*
Height: 8⅓ in. (21.6 cm)
Accession number 84.DK.656

PROVENANCE
John Malcolm, Poltalloch (1805–1893);
Col. George Malcolm, Poltalloch (sold, Christie's, London, February 8, 1977, lot 241); [David, Inc., Vaduz].

EXHIBITIONS
Venice, Palazzo Ducale, Museo Correr, *Mille Anni di Arte del Vetro a Venezia*, 1982, p. 31; no. 163, p. 124.

BIBLIOGRAPHY
Johanna Lessmann, "Meisterwerke der Glaskunst aus Renaissance und Barock," *Weltkunst* 47, no. 8 (April 15, 1977), p. 791; "Acquisitions/1984," *GettyMusJ* 13 (1985), no. 194, p. 246, illus.

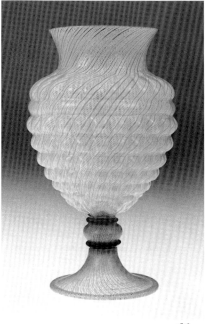

386

387. *Filigrana Kuttrolf*
(?) Venice, late sixteenth or early seventeenth century
Free- and mold-blown soda glass or *cristallo* and *lattimo, vetro a retorti*
Height: 9⅓ in. (24 cm)
Accession number 84.DK.661

PROVENANCE
Fritz Biemann, Zurich; (sold, Sotheby's, London, June 16, 1984, lot 48); [Rainer Zietz, Ltd., London]; David, Inc., Vaduz.

EXHIBITIONS
Düsseldorf, Städtische Kunsthalle, *Meisterwerke der Glaskunst aus internationalem Privatbesitz*, 1968, no. 65, p. 29; Cologne, Kunstgewerbemuseum, Berlin, Kunstgewerbemuseum, and Zurich, Museum Bellerive, *Sammlung Biemann Ausstellung 500 Jahre Glaskunst*, 1978–1979, no. 55, p. 113; Lucerne, Kunsthalle, *3000 Jahre Glaskunst von der Antike bis zum Jugendstil*, 1981, no. 668, p. 159.

BIBLIOGRAPHY
Fritz Biemann, "Der Kuttrolf: Sonderling unter den Glasgefässen," *Keramik-Freunde der Schweiz, Mitteilungsblatt* 76 (April 1968), p. 13, pl. 10; "Acquisitions/1984," *GettyMusJ* 13 (1985), no. 196, p. 247, illus.; *Journal of Glass Studies*, no. 16, pp. 102–103.

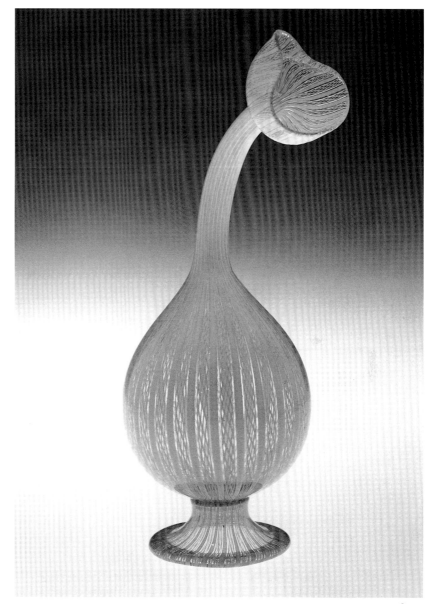

387

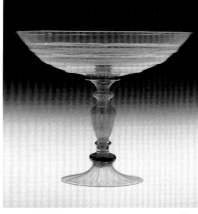

388

388. *Filigrana* **Stemmed Bowl**

Venice or the Netherlands ([?] Antwerp),
circa 1600
Free- and mold-blown soda glass or *cristallo*
and *lattimo, vetro a retorti,* and *vetro a fili*
Height: 3 ¹⁵⁄₁₆ in. (10 cm)
Accession number 84.DK.652

PROVENANCE

Sold, Sotheby's, London, February 23, 1976,
lot 175; [David, Inc., Vaduz].

BIBLIOGRAPHY

Ada Polak, "Venetian Renaissance Glass:
The Problems of Dating *vetro a filigrana,*"
Connoisseur 192, no. 774 (August 1976),
p. 3; "Acquisitions/1984," *GettyMusJ* 13 (1985),
no. 197, p. 247, illus.

389

389. **Horn**

Italian or Netherlandish, late seventeenth
or early eighteenth century
Free-blown glass with *lattimo* and applied
decoration
Height: 1 ft. 7 ¼ in. (40.9 cm)
Accession number 84.DK.565

PROVENANCE

[(?) Rainer Zietz, Ltd., London]; Ruth and
Leopold Blumka, New York.

BIBLIOGRAPHY

"Acquisitions/1984," *GettyMusJ* 13 (1985),
no. 228, p. 252, illus.

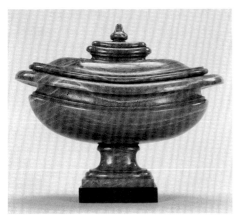

One of a pair 390

Hardstones

390. **Pair of Vases**

Early seventeenth century
Golden alabaster (*alabastro dorato*) with
paragone marble bases
Height (with lid): 1 ft. 2 in. (35.5 cm);
Height (without lid): 9½ in. (24 cm);
Width: 1 ft. 4¾ in. (42.7 cm)
Accession number 92.DJ.68.1–.2

PROVENANCE
Sold, Sotheby's, Monte Carlo, March 3,
1990, lot 70; [Didier Aaron, Paris]; [Same
Art, Ltd., Zurich].

BIBLIOGRAPHY
"Acquisitions/1992," *GettyMusJ* 21 (1993),
in press, illus.

Mosaics

391. *Portrait of Pope Clement VIII*
(Ippolito Aldobrandini)

Florence, 1600–1601
Designed by Jacopo Ligozzi; produced in
the Galleria de' Lavori in *pietre dure* by
Romolo di Francesco Ferrucci, called
del Tadda

Marble, lapis lazuli, mother-of-pearl, lime-
stone, and calcite (some overpainted paper
or fabric cartouches) on a silicate black
stone in original gilt-bronze frame
Height (with frame): 3 ft. 3¹³⁄₁₆ in. (101.7 cm);
Width (with frame): 2 ft. 5⅝ in. (75.2 cm);
Height (without frame): 3 ft. 2³⁄₁₆ in. (97 cm);
Width (without frame): 2 ft. 2¾ in. (68 cm)
Accession number 92.SE.67

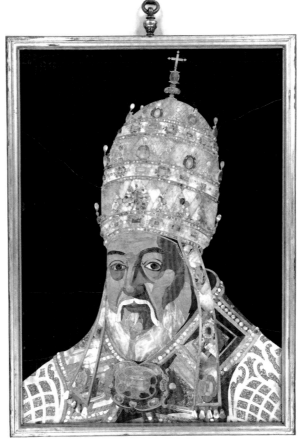

391

PROVENANCE
Given by Grand Duke Ferdinando I de'
Medici to Giovanni Bardi in 1601; Corsini,
Rome, from at least 1853 through 1891;
[Same Art, Ltd., Zurich, 1991].

BIBLIOGRAPHY
Antonio Zobi, *Notizie storiche sull'origine e
progressi dei lavori di commesso in pietre dure
nell'I. e R. stabilimento di Firenze* (Florence,
1853), pp. 184–186; *Guida delle RR. Cappelle
Medicee e R. Opificio delle Pietre Dure in
Firenze*, Edoardo Marchionni, ed. (Florence,
1891), pp. 99–100; Ludwig von Pastor, *The
History of the Popes* (London, 1952), vol. 23,
p. 32; Anna Maria Giusti et al., *Il Museo
dell'Opificio delle Pietre Dure* (Florence,
1978), p. 282; Anna Maria Giusti, *Palazzo
Vecchio: Committenze e collezionismo medicei*
(Florence, 1980), p. 239; "Acquisitions/1992,"
GettyMusJ 21 (1993), in press, illus.

392

392. ***Portrait of Camillo Rospigliosi***
Circa 1630–1640
Attributed to Giovanni Battista Calandra
Mosaic in gilt-wood frame
Inscribed on a paper label attached to the
gilt frame, *Questo ritratto in mosaico del
Balì Camillo Rospigliosi fratello del Papa
Clem.* IX *e di proprietà di mio nipote [Don?]
Giov. Battista Rospigliosi.*
Height (without frame): 2 ft. ⅜ in. (62 cm);
Width (without frame): 1 ft. 7¹⁄₁₆ in.
(48.5 cm)
Accession number 87.SE.132

PROVENANCE
According to its paper label, this work
belonged to the nephew of Giovanni
Battista Rospigliosi (1646–1722); private col-
lection, Zurich; [Danae Art International,
S.A., Panama].

BIBLIOGRAPHY
"Acquisitions/1987," *GettyMusJ* 16, 1988,
no. 88, p. 185, illus.

German
Decorative Arts

✳

Furniture

CABINETS, CASKETS, AND COMMODES

393. **Display Cabinet (*Kabinettschrank*)**
Augsburg, circa 1620–1630
Ebony, pearwood, oak, boxwood, walnut, chestnut, marble, ivory, semiprecious stones, tortoiseshell, snakeskin, enamel, and miniature painting
Height: 2 ft. 4¾ in. (73 cm); Width: 1 ft. 10¹³⁄₁₆ in. (58 cm); Depth: 1 ft. 11¼ in. (59 cm)
Accession number 89.DA.28

PROVENANCE
Private collection, Sweden; [J. Kugel, Paris, since the mid-1970s].

EXHIBITIONS
Paris, *XIVᵉ Biennale des Antiquaires*, September 22–October 9, 1988.

BIBLIOGRAPHY
Dieter Alfter, *Die Geschichte des Augsburger Kabinettschranks* (Augsburg, 1986), no. 23, pp. 69–70, pls. 56–58; "Acquisitions/1989," *GettyMusJ* 18 (1990), no. 58, pp. 196–197, illus.; *Handbook* 1991, p. 213, illus.

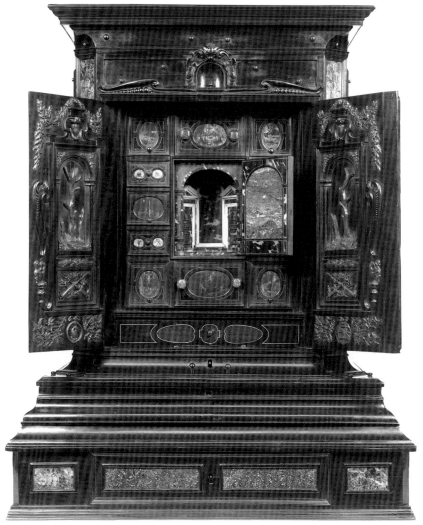

393

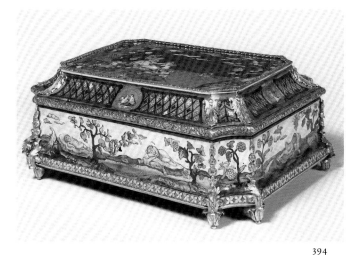

394

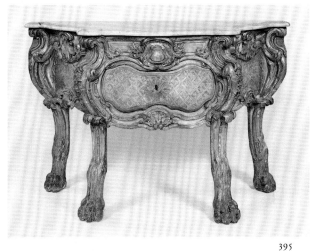

395

394. **Casket**

Southern German, circa 1680–1690
Wood veneered with brass, mother-of-pearl,
pewter, copper, stained and painted horn,
and rosewood; gilt-bronze mounts
One foot stamped with the crowned *C* for
1745–1749.
Height: 5⅛ in. (12.9 cm); Width: 1⅛ in.
(32.1 cm); Depth: 10⅛ in. (26.5 cm)
Accession number 88.DA.III

PROVENANCE

William, 12th Duke of Hamilton, Hamilton
Palace, Lanarkshire, Scotland (sold, Christie's,
London, June 19, 1882, lot 2185, to William
King for £242, 10s); Christopher Becket-
Denison, Esq. (sold, Christie's, London,
June 6, 1885, lot 685); Arturo Lopez-
Willshaw, by 1958 (sold, Sotheby's, Monaco,
June 24, 1976, lot 21); purchased at that sale
by The British Rail Pension Fund.

EXHIBITIONS

Malibu, The J. Paul Getty Museum, on
loan, 1982–1988.

BIBLIOGRAPHY

Stéphane Faniel et al., *Le XVIIIᵉ siècle
français* (Collection Connaissance des arts,
Paris, 1958), p. 206; "Acquisitions/1988,"
GettyMusJ 17 (1989), no. 81, p. 145, illus.

395. **Commode**

Circa 1735–1740
Gessoed, painted, and gilded pine;
marble top
Height: 2 ft. 9 in. (83.8 cm); Width:
4 ft. 6½ in. (138.5 cm); Depth: 1 ft. 9½ in.
(54.5 cm)
Accession number 87.DA.47

PROVENANCE

Michael Taylor, San Francisco (sold, Butter-
field's, San Francisco, April 7, 1987, lot 340).

BIBLIOGRAPHY

"Acquisitions/1987" *GettyMusJ* 16 (1988),
no. 75, p. 179, illus.

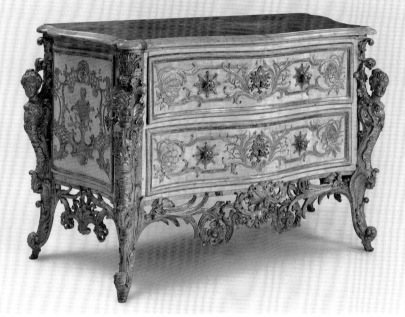

One of a pair 396

396. **Pair of Commodes**

Munich, circa 1745
Carving attributed to Joachim Dietrich;
side panels after engraved designs by
François de Cuvilliés
Gessoed, painted, and gilded pine; gilt-
bronze mounts; *jaune rosé de Brignolles*
marble tops
Height: 2 ft. 8¾ in. (83.2 cm); Width:
4 ft. 1¼ in. (126.4 cm); Depth: 2 ft. ⅜ in.
(61.9 cm)
Accession number 72.DA.63.1–.2

PROVENANCE

(?) Anonymous sale, Christie's, London,

March 1, 1882, lot 165, for 210 guineas;
[Jacques Helft, New York]; Georges Lurcy
(1891–1953), New York (sold, Parke-Bernet,
New York, November 9, 1957, lot 383);
[Frank Partridge, Ltd., London]; Maha-
ranee of Baroda, Paris; [Frank Partridge,
Ltd., London]; purchased by J. Paul Getty.

BIBLIOGRAPHY

Thomas E. Norton, *One Hundred Years of
Collecting in America: The Story of Sotheby,
Parke, Bernet* (New York, 1984), p. 166, illus.
(one); *Handbook* 1986, p. 156, illus. (one);
Handbook 1991, p. 171, illus. (one).

DESKS AND SECRETAIRES

397. **Rolltop Desk**

Neuwied, circa 1785
Attributed to David Roentgen; gilt-bronze
plaque attributed to Pierre Gouthière; some
mounts by François Rémond
Oak veneered with mahogany and burr
amboyna; steel fittings; gilt-bronze mounts
Height: 5 ft. 6¼ in. (168.3 cm); Width
5 ft. 1⅜ in. (155.9 cm); Depth (open):
4 ft. 1⅞ in. (126.7 cm); Depth (closed):
2 ft. 11⅛ in. (89.3 cm)
Accession number 72.DA.47

PROVENANCE

(?) Louis XVI, *cabinet du Roi*, Palais des
Tuileries; later moved to the Château de
Versailles; removed in 1793 to Russia; (?)
Count Iljinski, Castle of Romanova, near
St. Petersburg, 1793–1852; [M. Court, rue de
la Madeleine, Paris, 1857] (sold, M. le comte
de M..., Paris, November 12, 1859, lot 1,
to Migeon) [above information: Patrick
Leperlier]; [(?) Samson Wertheimer, London]
(sold, Christie's, London, March 15, 1892,
lot 637, to Jackson); Count János Pálffy,
Palais Pálffy, Vienna (sold, Glückselig und
Warndorfer, Vienna, March 7, 1921, lot 209,
to Castiglione); Baroness Marie de Reitz,
Vienna; [French and Co., New York, 1960s];
purchased by J. Paul Getty.

EXHIBITIONS

Washington, D.C., The State Department,
on loan, 1960s.

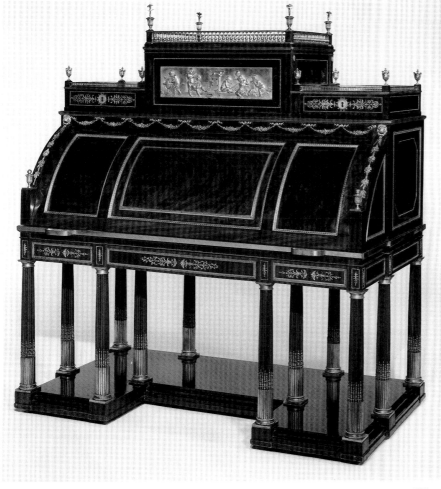

397

BIBLIOGRAPHY

La Gazette de France (October 30, 1857);
Alois C. Riegel, *Der Wiener Congress*
(Vienna, 1898), fig. x; Heinrich Kreisel,
Die Kunst des deutschen Möbels (Munich,
1973), vol. 3, fig. 17; Hans Huth, *Roentgen
Furniture: Abraham and David Roentgen:
European Cabinetmakers* (London and
New York, 1974), illus. 64–68; Josef Maria
Greber, *Abraham und David Roentgen:
Möbel für Europa* (Starnberg, 1980), vol. 2,
figs. 683, 684; Dietrich Fabian, *Die Ent-
wicklung der Roentgen-Schreibmöbel* (Bad
Neustadt, 1982), p. 45, figs. 66–67; Wilson,
Selections, no. 44, pp. 88–89, illus.; Dietrich
Fabian, *Roentgenmöbel aus Neuwied: Leben
und Werk von Abraham und David Roentgen*
(Bad Neustadt, 1986), p. 96, illus. p. 134,
figs. 307–310; *Handbook* 1986, p. 176, illus.;
Pradère, *Les Ebénistes*, illus. p. 417, fig. 514;
Kjellberg, *Dictionnaire*, p. 727; *Handbook*
1991, p. 194, illus.

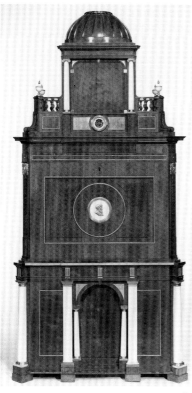

398

398. *Secrétaire*

Berlin, circa 1798–1799
By Johann Andreas Beo; clock movement
by Christian Mollinger
Pine and oak veneered with mahogany,
satinwood, bloodwood, ebony, and king-
wood; white marble; bronze; enameled
metal; gilt-bronze mounts

Clock face painted *Mollinger à Berlin.*
Height: 8 ft. (243.8 cm); Width: 3 ft. 8 in.
(111.8 cm); Depth: 2 ft. (60.9 cm)
Accession number 84.DA.87

PROVENANCE

Purchased by Frederick William III, King
of Prussia (1770–1840), for Schloss Pots-
dam, circa 1802; private collection, Berlin;
Ragaller, Berlin; (sold, Weinmüller, Munich,
May 2–5, 1956, lot 1111); (sold, Weinmüller
[Neumeister], Munich, October 23–24,
1974, lot 861); private collection, Munich;
[Juan Portela, New York].

BIBLIOGRAPHY

Claudia Freytag, *Bruckmann's Möbel-Lexikon*
(Munich, circa 1978), illus. p. 298; Michael
Stürmer, *Handwerk und höfische Kultur
Europäische Möbelkunst in Munich* (Munich,
1982), p. 193, pl. 102; Dietrich Fabian, *Die
Entwicklung der Roentgen-Schreibmöbel*
(Bad Neustadt, 1982), pp. 53–55, figs. 77d–g;
Heinrich Kriesel, *Die Kunst des deutschen
Möbels*, vol. 3 (Munich, 1983), illus. p. 264;
Dietrich Fabian, *Kinzing und Roentgen
Uhren aus Neuwied* (Bad Neustadt, 1984),
p. 147; Wilson, "Acquisitions 1984," no. 5,
pp. 83–88, illus; "Acquisitions/1984,"
GettyMusJ 13 (1985), no. 68, p. 184, illus.;
Dietrich Fabian, *Roentgenmöbel aus Neuwied*
(Bad Neustadt, 1986), p. 312, illus. p. 305,
figs. 724–727.

TABLES

399. **Console Table**

Munich, circa 1730
Design attributed to Joseph Effner; carving
attributed to Johann Adam Pichler
Limewood; Tegernsee marble top
Height: 2 ft. 9¼ in. (86.5 cm); Width:
5 ft. 1½ in. (156 cm); Depth: 2 ft. 1¼ in.
(64 cm)
Accession number 88.DA.88

PROVENANCE

(?) Karl Albrecht (Charles VII, 1697–1745),
Elector of Bavaria, 1726, and Holy Roman
Emperor, 1742, in the Kaisersaal at Kloster
Ettal; Paris (art market or private collection),
1960s; private collection, Germany (sold,
Nouveau Drouot, Paris, December 5, 1980,
lot 99); [Bernheimer Fine Arts, Ltd.,
London, 1988].

BIBLIOGRAPHY

"Acquisitions/1988," *GettyMusJ* 17 (1989),
no. 82, p. 145, illus.

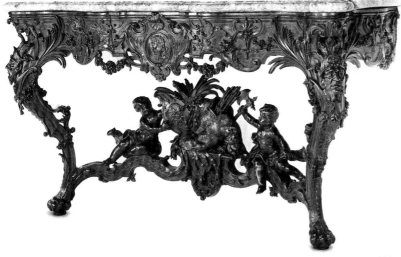

399

400. **Console Table**

Circa 1735–1745

Gessoed and gilded limewood; *brèche d'Alep* top

Height: 3 ft. (91.4 cm); Width: 3 ft. 6¾ in. (108.6 cm); Depth: 1 ft. 9 in. (53.3 cm)

Accession number 85.DA.319

PROVENANCE

Private collection, Germany; [Capricorn Art International S.A., Panama].

BIBLIOGRAPHY

"Acquisitions/1985," *GettyMusJ* 14 (1986), no. 206, p. 248, illus.

400

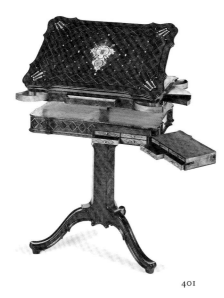

401.

401. Reading and Writing Stand

Neuwied, circa 1760–1765
By Abraham Roentgen
Pine, oak, and walnut veneered with pali-
sander, alder, rosewood, ebony, ivory, and
mother-of-pearl; gilded metal fittings
The tabletop bears the archepiscopal coat
of arms and the monogram *JPC* for Johann
Philipp Churfurst.
Height: 2 ft. 6½ in. (76.8 cm); Width:
2 ft. 4¼ in. (71.7 cm); Depth: 1 ft. 7¼ in.
(48.8 cm)
Accession number 85.DA.216

PROVENANCE
Johann Philipp von Walderdorff, Prince
Archbishop and Elector of Trier; by descent
to Count Emanuel von Walderdorff.

BIBLIOGRAPHY
Heinrich Kreisel, *Die Kunst des deutschen
Möbels-Spätbarok und Rokoko* (Munich,
1970), vol. 2, pp. 294, 428, fig. 992; Hans
Huth, *Roentgen Furniture: Abraham and
David Roentgen, European Cabinetmakers*
(London and New York, 1974), fig. 110;
Josef Maria Greber, *Abraham und David
Roentgen: Möbel für Europa* (Starnberg,
1980), vol. 2, pp. 32–33, pls. 57–58; Dietrich
Fabian, "Entwicklung der Roentgen:
Mehrzwecktische-Funktion, Konstruktion,
Oberflachenschmuck, Einrichtung," *Alte
und moderne Kunst* 174–175 (1981), pp. 18–26,
figs. 14, 14a; Georg Himmelheber, "Abraham
Roentgen and the Archbishop of Trier,"
Antiques 127 (January 1985), pp. 245–259,
fig. 12; "Acquisitions/1985," *GettyMusJ* 14
(1986), no. 207, p. 248, illus.; Dietrich
Fabian, *Roentgenmöbel aus Neuwied* (Bad
Neustadt, 1986), p. 29, illus. p. 33, figs. 11–14;
Handbook 1991, p. 185, illus.

Architectural Woodwork

402. Floor

(?) German, circa 1725
Pine veneered with kingwood, *bois satiné*,
sycamore, tulipwood, and olive
Length: 10 ft. 11 in. (332.7 cm); Width:
9 ft. 11 in. (302.2 cm)
Accession number 78.DH.360.1–.4

One-quarter of floor

402.

PROVENANCE
The Metropolitan Museum of Art, New
York, deaccessioned, 1970; [Dalva Brothers,
Inc., New York, 1970].

BIBLIOGRAPHY
Wilson, "Acquisitions 1977 to mid 1979,"
no. 10, p. 46, illus.

Clocks

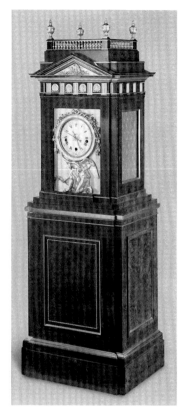

404

403. **Long-case Clock**

Berlin, circa 1755
Painted, silvered, and lacquered oak; gilt
bronze; mirror glass; enameled metal
Dial inscribed *Rehnisch Berlin.*
Height: 8 ft. 3½ in. (252 cm); Width:
2 ft. 5½ in. (76 cm); Depth: 1 ft. 10½ in.
(57 cm)
Accession number 86.DB.695

PROVENANCE
Michael Konig, Munich; [Alexander and
Berendt, Ltd., London, 1985].

BIBLIOGRAPHY
"Acquisitions/1986," *GettyMusJ* 15 (1987),
no. 113, p. 215, illus.

404. **Long-case Musical Clock**

Neuwied, 1784–1786
Case by David Roentgen; the movement by
Peter Kinzing; musical movement by Johann
Wilhelm Weil (Jean Guillaume Weyl)
Oak and mahogany veneered with amboyna;
bronze; gilt-bronze mounts; enamel dial;
glass; blued steel
The movement is inscribed *Roentgen &*
Kinzing à Neuwied. Inside the chest of
bellows is the penciled inscription *Jean*
Guillaume Weyl Fait a Neuwied le 16 May
178 [?] No. 18.
Height: 6 ft. 3½ in. (192 cm); Width:
2 ft. 1½ in. (64 cm); Depth: 1 ft. 9½ in.
(54.5 cm)
Accession number 85.DA.116

PROVENANCE
Edward Joseph, London (sold, Christie's,
London, May 1890, lot 374 to "Payne");
private collection, France; [Aveline et Cie,
Paris, 1984].

BIBLIOGRAPHY
Dietrich Fabian, *Kinzing und Roentgen*
Uhren aus Neuwied (Bad Neustadt, 1984),
no. 51, p. 235; "Acquisitions/1985," *GettyMusJ*
14 (1986), no. 208, p. 249, illus.

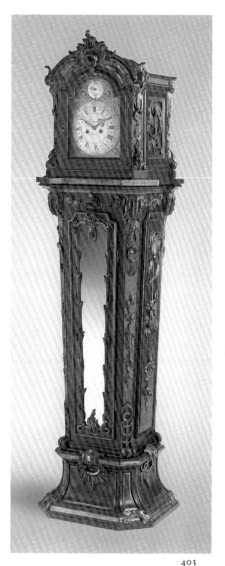

403

Metalwork

405. **Carolingian Reliquary**
Upper Rhine, reconstructed at a later date
of elements attributed to the eighth century
Gilt copper, silver, cabochon hardstones,
and glass pastes
Height: 5⅛ in. (13 cm)
Accession number 85.SE.53

PROVENANCE
Richard von Kauffmann, Berlin; Erich
Lederer, Geneva.

BIBLIOGRAPHY
Otto von Falke, *Die Sammlung Richard von
Kauffmann* (Berlin, 1917), no. 413, pp. 63–64;
"Acquisitions/1985," *GettyMusJ* 14 (1986),
no. 219, p. 253, illus.

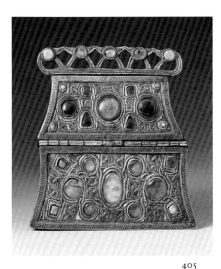

405

406. **Romanesque *Aquamanile***
Lower Saxony (Hildesheim or Magdeburg),
circa 1220
Bronze
Height: 10¼ in. (26 cm)
Accession number 85.SB.55

PROVENANCE
A. Seligmann, Paris; Robert von Hirsch,
Basel (sold, Sotheby's, London, June 22,
1978, lot 206); [David Carritt, London];
Erich Lederer, Geneva.

BIBLIOGRAPHY
Otto von Falke and Erich Meyer, *Bronze-
geräte des Mittelalters*, vol. 1 (Berlin, 1935),
no. 332, p. 53, figs. 309a–b; Vladislav Petro-
vich Darkevich, "Proizvedeniia zapadnogo
khudozhestvennogo remesia v Vostochnoi

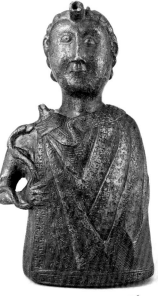

406

Europe: X-XIVvv.," *Arkheologiia SSSR* (1966),
pl. 89; "Acquisitions/1985," *GettyMusJ* 14
(1986), no. 219, p. 253, illus.

407. **Ewer and Basin**
Augsburg, 1583
By Abraham Pfleger I
Parcel-gilt silver with enamel plaques
and engraving
Coat of arms of Pálffy and Fugger families
on basin, base, and cover of ewer.
Ewer: Height: 9⅞ in. (25 cm); Basin:
Diameter: 1 ft. 7⅞ in. (50.5 cm)
Accession number 85.DG.33.1–.2

PROVENANCE
Sold, Christie's, Geneva, November 15, 1984,
lot 606; [David, Inc., Vaduz].

BIBLIOGRAPHY
"Acquisitions/1985," *GettyMusJ* 14 (1986),
no. 220, p. 254, illus.; *Handbook* 1991,
p. 208, illus.

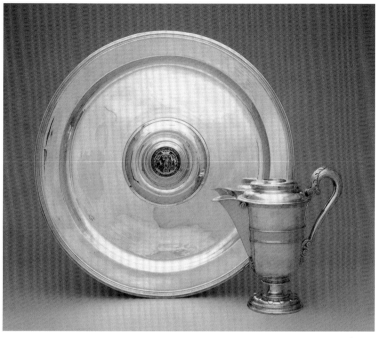

407

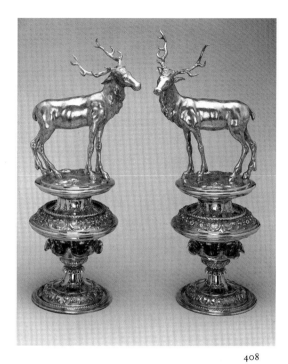

408

408. **Pair of Stags**

Augsburg, circa 1680–1700
By Johann Ludwig Biller the Elder
Gilt silver

Stamped *ILB* on one antler of each model;
ILB and Augsburg mark stamped five times
on each base: (1) on top border of upper rim
of spool; (2) on underside of same; (3) on
top border of lower rim of spool; (4) on
underside of same; (5) on top of border
around foot of base.

Stag .1 (with head bent over proper left
shoulder): Height: 2 ft. 1 in. (63.5 cm);
Width: 11¼ in. (28.5 cm); Depth: 8½ in.
(21.5 cm); Stag .2 (with head bent over

proper right shoulder): Height: 2 ft. 2³⁄₁₆ in.
(66.5 cm); Width: 10⅝ in. (27 cm); Depth:
8⅝ in. (22 cm)
Accession number: 85.SE.442.1–.2

PROVENANCE

Possibly in the collection of King Fer-
nando II, Portugal, by 1882; (sold, Sotheby's,
Geneva, May 15, 1984, lot 66); [Albrecht
Neuhaus, Würzburg].

EXHIBITIONS

(?) Lisbon, *Exposiçào Retrospectiva de Arte
Ornamental,* 1882, vol. 1, no. 57, p. 245;
vol. 2, no. 37.

BIBLIOGRAPHY

Art at Auction: The Year at Sotheby's 1983–1984
(London, 1984), p. 288; *Deutscher Kunst-
handel im Schloss Charlottenburg* (Berlin,
1985), pp. 74–75; "Acquisitions/1985,"
GettyMusJ 14 (1986), no. 221, p. 254, illus.;
Lorenz Seelig, "Jagdliche Motive in der
Goldschmiedekunst des. 16 bis 18 Jahr-
hunderts," *Weltkunst* 59, (February 1989),
p. 234, pl. 2.

Ceramics

MEISSEN

409. **Wine Bottle**
Meissen manufactory, circa 1710–1715
By Johann Friedrich Böttger and modeled
by Johann Donner
Stoneware
Painted underneath with the black Johan-
neum mark *232.* over *R.* and impressed with
the modeler's mark.
Height: 6½ in. (16.5 cm); Width: 4⅜ in.
(11.1 cm); Depth: 3¾ in. (9.5 cm)
Accession number 85.DE.231

PROVENANCE
Augustus the Strong, Elector of Saxony,
Japanese Palace, Dresden (sold, Rudolph
Lepke's Kunst-Auctions-Haus, Berlin,
October 12–14, 1920, lot 59 or 60); [Kate
Foster, Ltd., England, 1985].

EXHIBITION
The Los Angeles County Museum of Art,
September 1987 to present.

BIBLIOGRAPHY
"Acquisitions/1985," *GettyMusJ* 14 (1986),
no. 201, p. 247, illus.

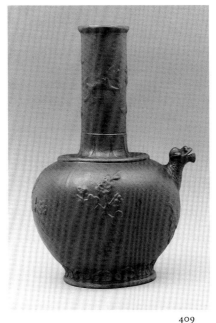

409

410. **Standing Cup and Cover**
Meissen manufactory, circa 1710–1715
Attributed to Johann Friedrich Böttger
Stoneware; silver-gilt mounts
Height: 9⅞ in. (25 cm); Diameter: 4⁵⁄₁₆ in.
(11 cm)
Accession number 85.DI.286

PROVENANCE
[Bent Peter Bronée, Copenhagen].

BIBLIOGRAPHY
"Acquisitions/1985," *GettyMusJ* 14 (1986),
no. 202, p. 247, illus.

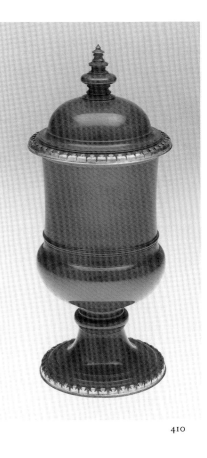

410

411. **Teapot**

Meissen manufactory, circa 1715–1720
Attributed to Johann Friedrich Böttger
Stoneware; silver-gilt mounts and chain
Height: 5½ in. (14 cm); Width: 6 3/16 in.
(15.4 cm); Depth: 4⅞ in. (12.4 cm)
Accession number 85.DI.287

PROVENANCE

[Bent Peter Bronée, Copenhagen].

BIBLIOGRAPHY

"Acquisitions/1985," *GettyMusJ* 14 (1986),
no. 203, p. 247, illus.

———

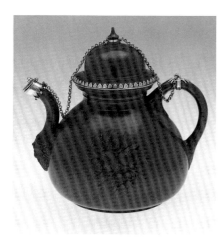

411

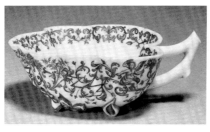

412

412. **Leaf-shaped Dish**

Porcelain: Meissen manufactory, circa
1715–1720
Painted decoration: Breslau, circa 1715–1725
Painting attributed to Ignaz Preissler
Hard-paste porcelain; painted decoration;
gilding
Height: 1 9/16 in. (4 cm); Width: 3¼ in.
(8.3 cm); Depth: 4⅜ in. (11.1 cm)
Accession number 86.DE.541

PROVENANCE

Dr. Marcel Nyffeler, Switzerland (sold,
Christie's, London, June 9, 1986, lot 183).

BIBLIOGRAPHY

Maureen Cassidy-Geiger, "Two Pieces of
Porcelain Decorated by Ignaz Preissler in
the J. Paul Getty Museum," *GettyMusJ* 15
(1987), pp. 35–52, figs. 10a–e; "Acquisitions/
1986," *GettyMusJ* 15 (1987), no. 111, p. 215,
illus.

———

413. **Figure ([?] *Beltrame di Milano*)**

Meissen manufactory, circa 1720
Hard-paste porcelain
Height: 6½ in. (16.5 cm); Width: 2 11/16 in.
(6.8 cm); Depth: 2⅝ in. (6.5 cm)
Accession number 86.DE.542

PROVENANCE

Dr. Marcel Nyffeler, Switzerland (sold,
Christie's, London, June 9, 1986, lot 21).

BIBLIOGRAPHY

"Acquisitions/1986," *GettyMusJ* 15 (1987),
no. 112, p. 215, illus.

———

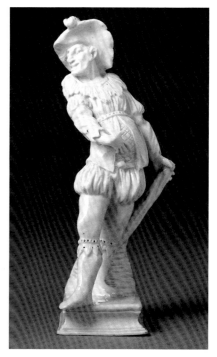

413

414. **Wine Pot**

Meissen manufactory, circa 1725
Painting attributed to the studio of Johann
Gregor Höroldt
Hard-paste porcelain; polychrome enamel
decoration; gilding
Height: 5½ in. (14 cm); Width: 6¹¹⁄₁₆ in.
(17 cm); Depth: 3½ in. (8.9 cm)
Accession number 85.DE.381

PROVENANCE
Private collection, Torquay, England (sold,
Bearne's Auction House, Torquay, May 2,
1984, lot 224); [Winifred Williams, Ltd.,
London].

BIBLIOGRAPHY
"Acquisitions/1985," *GettyMusJ* 14 (1986),
no. 204, pp. 247–248, illus.

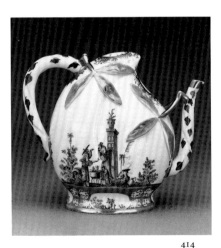

414

415

415. **Bell**

Meissen manufactory, circa 1725–1730
Painting attributed to the studio of Johann
Gregor Höroldt
Hard-paste porcelain, mauve and pale green
ground colors; polychrome enamel decora-
tion; gilding
Height: 3⅛ in. (8.6 cm); Diameter: 2⁷⁄₁₆ in.
(6.5 cm)
Accession number 85.DE.203

PROVENANCE
Erich von Goldschmidt-Rothschild, Frank-
furt am Main; Christoph Hoffman-Frey,
Zurich; [Lovice Reviczky A. G., Zurich].

BIBLIOGRAPHY
"Acquisitions/1985," *GettyMusJ* 14 (1986),
no. 205, p. 248, illus.

416. **Assembled Set of Five Vases**

Meissen manufactory, circa 1730
Painting attributed to Johann Gregor
Höroldt; largest vase molded by Schiefer
Hard-paste porcelain; polychrome enamel
decoration; gilding
Each vase painted under its base with the
blue *AR* monogram of Augustus the Strong,
Elector of Saxony. Largest lidded vase
incised with Schiefer's mark of a cross with
four dots.
Lidded Vase .1: Height: 1 ft. 2¹¹⁄₁₆ in.
(37.3 cm); Width: 9½ in. (24.1 cm); Lidded
Vases .2–.3: Height: 1 ft. ¹¹⁄₁₆ in. (32.2 cm);
Width: 7⅝ in. (19.4 cm); Open Vases .4–.5:
Height: 10⅞ in. (27.6 cm); Width: 7 in.
(17.8 cm)
Accession number 83.DE.334.1–.5

PROVENANCE
Private collection (sold, Sotheby's, London,
March 5, 1957, lot 123); [The Antique
Porcelain Co., London, 1957]; Alamagna
family, Milan, 1961–1982; [The Antique
Porcelain Co., London, 1982].

BIBLIOGRAPHY
Sassoon, "Acquisitions 1983," no. 16,
pp. 217–222, illus.; "Acquisitions/1983,"
GettyMusJ 12 (1984), no. 18, pp. 267–268,
illus.; *Handbook* 1986, p. 153, illus.

416

417. **Pair of Lidded Vases**

Vases: Meissen manufactory, before 1733
Lids: Possibly Meissen porcelain replace-
ments, circa 1760
One vase probably molded by Rehschuck
Hard-paste porcelain; polychrome enamel
decoration; gilding
Each vase painted under its base with the
blue *AR* monogram of Augustus the Strong,
Elector of Saxony; each incised with a cross
under the base; one vase with a simple
cross (probably the mark of the molder
Rehschuck), the other with a cross hatched
at each extension.

Height: 1 ft. 2 in. (35.5 cm); Diameter:
7⅞ in. (20.1 cm)
Accession number 73.DE.65.1–.2

PROVENANCE
Private collection, Zurich (sold, Sotheby's,
London, March 27, 1973, lot 39); purchased
at that sale by J. Paul Getty.

One of a pair 417

Ewer 418

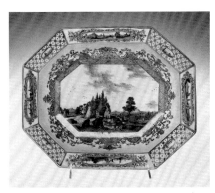

Basin 418

418. **Ewer and Basin**

Meissen manufactory, circa 1740
Painting attributed to the studio of Christian Frederich Herold
Hard-paste porcelain; polychrome enamel decoration; gilding
The ewer and basin are both painted beneath with the crossed swords in blue of the Meissen manufactory; both are impressed with the number 27.
Ewer: Height: 8½ in. (21.2 cm); Width: 8¼ in. (20.6 cm); Depth: 4¼ in. (10.5 cm); Basin: Height: 2⅞ in. (7.3 cm); Width: 1 ft. ½ in. (31.8 cm); Depth: 10 in. (25.5 cm)
Accession number 84.DE.918.1-.2

PROVENANCE

Sir Hugh Smithson, first Duke of Northumberland and Earl Percy (1714–1786); by descent to Algernon Heber-Percy (sold, Christie's, London, October 30, 1967, lot 154); Dr. and Mrs. E. Pauls-Eisenbeiss (sold, Christie's, Geneva, November 12, 1976, lot 197); (anonymous sale, Christie's, London, June 25, 1979, lot 177); private collection, London (sold, Christie's, London, December 3, 1984, lot 275, to [The Antique Porcelain Co., London]).

BIBLIOGRAPHY

Dr. Erika Pauls-Eisenbeiss, *German Porcelain of the Eighteenth Century* (London, 1972), vol. 1, pp. 484–487; "Acquisitions/ 1984," *GettyMusJ* 13 (1985), no. 67, p. 183, illus.

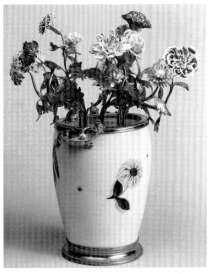

Vase .1 419

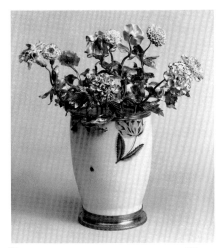

Vase .2 419

419. **Pair of Vases Mounted with Flowers**
Bowls: Meissen manufactory, before 1733
Flowers: French (Vincennes manufactory),
circa 1745–1750
Mounts: French (Paris), circa 1745–1749
Hard-paste porcelain bowls; polychrome
enamel decoration; soft-paste porcelain
flowers; gilt-bronze mounts
Each bowl painted on the base with the
blue *AR* monogram of Augustus the Strong,
Elector of Saxony. Mounts struck with the
crowned *C* for 1745–1749.
Height: 1 ft. 3⅝ in. (39.7 cm); Width:
1 ft. 3⅛ in. (38.3 cm); Depth: 1 ft. 1⅜ in.
(34 cm)
Accession number 79.DI.59.1–.2

PROVENANCE
Consuelo Vanderbilt (Mme Jacques Balsan);
[Matthew Schutz, Ltd., New York].

420. **Group of "Japanese" Figures**
Meissen manufactory, circa 1745
Model by Johann Joachim Kändler
Hard-paste porcelain; polychrome enamel
decoration; gilt-bronze mounts
Any marks that might be under the base are
concealed by the irremovable gilt-bronze
mount.
Height: 1 ft. 5¾ in. (45.1 cm); Width:
11⅝ in. (29.5 cm); Depth: 8⁹⁄₁₆ in. (21.7 cm)
Accession number 83.DI.271

PROVENANCE
Figure group: private European collection
(sold, Sotheby's, London, March 2, 1982,
lot 168); [Winifred Williams, Ltd., London,
1982].
Parasol: Paul Schnyder von Wartensee,
Switzerland; [Winifred Williams, Ltd.,
London, 1982].

BIBLIOGRAPHY
M. A. Pfeiffer, "Ein Beitrag zur Quellenge-
schichte des Europäischen Porzellans,"
*Werden und Wirken: Ein Festgruss für Karl
W. Hiersemann* (Leipzig, 1924), p. 285;
Sassoon, "Acquisitions 1983," no. 17,
pp. 222–224, illus.; "Acquisitions/1983,"
GettyMusJ 12 (1984), no. 19, p. 268, illus.

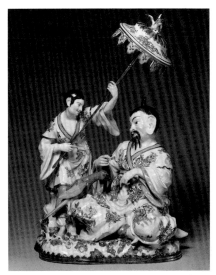

420

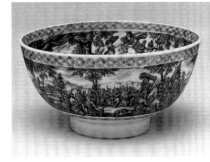

421

421. **Bowl**
Porcelain: Chinese, Kangxi (1662–1722),
circa 1700
Decoration: German (Breslau), circa
1715–1720
Painted decoration attributed to
Ignaz Preissler
Hard-paste porcelain; underglaze blue and
black enamel painted decoration; gilding
Height: 2⅞ in. (7.3 cm); Diameter: 5⅞ in.
(14.9 cm)
Accession number 86.DE.738

PROVENANCE
Octave du Sartel, Paris, before 1881 (sold,
Hôtel Drouot, Paris, June 4–9, 1894,
lot 151); (?) Familie von Parpart, Berlin
(sold, Lepke, Berlin, March 18–22, 1912,
lot 488, pl. 39); Des Nordböhmischen
Gewerbemuseums, Reichenberg (now
Liberec, Czech Republic), 1912; private
collection, Germany; [Kate Foster, Ltd.,
London, 1986].

BIBLIOGRAPHY

Zeitschrift des Nordböhmischen Gewerbe-museums. Neue folge: VII Jahrgang, Reichenberg (No. 3, 1912), p. 95; Gustave E. Pazaurek, *Deutsche Fayence- und Porzellan-Hausmaler* (Leipzig, 1925), vol. 1, p. 214; Maureen Cassidy-Geiger, "Two Pieces of Porcelain Decorated by Ignaz Preissler in the J. Paul Getty Museum," *GettyMusJ* 15 (1987), pp. 35–52, figs. 1a–h; "Acquisitions/ 1986," *GettyMusJ* 15 (1987), no. 110, p. 215, illus.

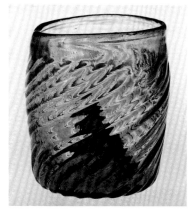

422

Glass

422. Beaker (*Maigelein*)

Lower Rhineland, Hesse or (?) Franconia, first half of the fifteenth century
Mold-blown potash-lime glass
Height: 3 in. (7.5 cm)
Accession number 84.DK.522

PROVENANCE

Leopold H. Seligmann, Cologne (sold, Sotheby's, London, June 30, 1932, lot 35); Baron Maurice de Rothschild, Paris; Alexander von Frey, Paris; Ruth and Leopold Blumka, New York.

BIBLIOGRAPHY

Franz Rademacher, "Die gotischen Gläser der Sammlung Seligmann-Köln," *Pantheon* 8 (1931), pp. 290–294, fig. 3 (lower left); idem, *Die deutschen Gläser des Mittelalters* (Berlin, 1933), pp. 94ff., pl. 24c; "Acquisitions/1984," *GettyMusJ* 13 (1985), no. 200, p. 247, illus.

423. Drinking Bowl (*Maigelein*)

(?) Lower Rhineland or the Netherlands, second half of the fifteenth century
Mold-blown potash-lime glass
Height: 1 15/16 in. (4.9 cm)
Accession number 84.DK.521

PROVENANCE

Leopold H. Seligmann, Cologne (sold, Sotheby's, London, June 30, 1932, lot 33); Karl Ruhman, Vienna; Ruth and Leopold Blumka, New York.

BIBLIOGRAPHY

Franz Rademacher, "Die gotischen Gläser der Sammlung Seligmann-Köln," *Pantheon* 8 (1931), pp. 290–294, fig. 3 (upper left); idem, *Die deutschen Gläser des Mittelalters* (Berlin, 1933), pp. 94ff., pl. 22c; Jaroslave Vavra, *Das Glas und die Jahrtausende* (Prague, 1951), no. 95, pl. 38; "Acquisitions/1984," *GettyMusJ* 13 (1985), no. 199, p. 247, illus.

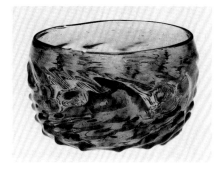

423

424. **Beaker (*Maigelein*)**
(?) Spessart, late fifteenth or early
sixteenth century
Mold-blown potash-lime glass
Height: 3 9/16 in. (9 cm)
Accession number 84.DK.523

PROVENANCE
Alexander von Frey, Paris; Ruth and Leo-
pold Blumka, New York.

BIBLIOGRAPHY
"Acquisitions/1984," *GettyMusJ* 13 (1985),
no. 202, p. 248, illus.

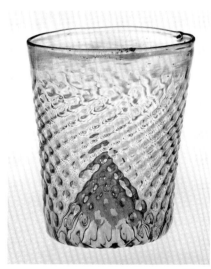

424

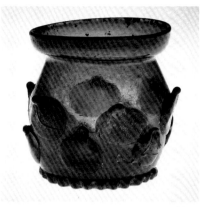

425

425. *Krautstrunk*
Last quarter of the fifteenth century
Free-blown potash-lime glass with applied
decoration
Height: 2 7/15 in. (6.2 cm)
Accession number 84.DK.524

PROVENANCE
Ruth and Leopold Blumka, New York.

BIBLIOGRAPHY
"Acquisitions/1984," *GettyMusJ* 13 (1985),
no. 201, p. 247, illus.

426. **Prunted Beaker**
Late fifteenth or early sixteenth century
Free-blown potash-lime glass with applied
decoration
Height: 3 7/8 in. (9.9 cm)
Accession number 84.DK.526

PROVENANCE
Hohenzollern Museum, Sigmaringen;
Leopold H. Seligmann, Cologne (sold,
Sotheby's, London, June 30, 1932,
lot 24); Kreitz; (sold, Sotheby's, London,
November 10, 1938, lot 56); A. Vecht,
Amsterdam; Alexander von Frey, Paris;
Ruth and Leopold Blumka, New York.

EXHIBITIONS
Amsterdam, Rijksmuseum, *Catalogus van de
Tentoonstelling van oude Kunst uit het bezit
van den internationalen Handel*, 1936,
no. 687.

BIBLIOGRAPHY
Franz Rademacher, "Die gotischen Gläser
der Sammlung Seligmann-Köln," *Pantheon*
8 (1931), pp. 290–294, fig. A (upper right);
idem, *Die deutschen Gläser des Mittelalters*
(Berlin, 1933), p. 113, pl. 45b; "Acquisitions/
1984," *GettyMusJ* 13 (1985), no. 203, p. 248,
illus.

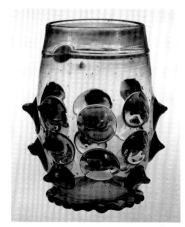

426

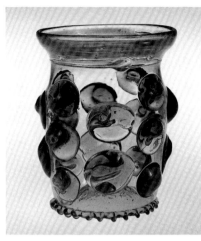

427

427. *Krautstrunk*

(?) Southern German or Swiss, first third of
the sixteenth century
Free-blown potash-lime glass with applied
decoration
Height: 4⅛ in. (10.5 cm)
Accession number 84.DK.525

PROVENANCE

Hohenzollern Museum, Sigmaringen;
Leopold H. Seligmann, Cologne (sold,
Sotheby's, London, June 30, 1932, lot 23);
Alexander von Frey, Paris; Ruth and Leo-
pold Blumka, New York.

BIBLIOGRAPHY

Franz Rademacher, "Die Gläser der Samm-
lung Seligmann-Köln," *Pantheon* 8 (1931),
pp. 290–294, fig. 4 (lower right); idem,
Die deutschen Gläser des Mittelalters (Berlin,
1933), pp. 111ff., pl. 42d; "Acquisitions/1984,"
GettyMusJ 13 (1985), no. 232, p. 253, illus.

428. **Footed Beaker**

Lower Rhineland or southern Netherlands,
first third of the sixteenth century
Free-blown potash-lime glass with applied
decoration
Height: 4¹¹⁄₁₆ in. (11.9 cm)
Accession number 84.DK.532

PROVENANCE

Alexander von Frey, Paris; Ruth and Leo-
pold Blumka, New York.

BIBLIOGRAPHY

"Acquisitions/1984," *GettyMusJ* 13 (1985),
no. 241, p. 255, illus.

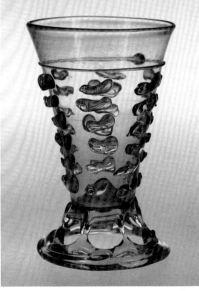

428

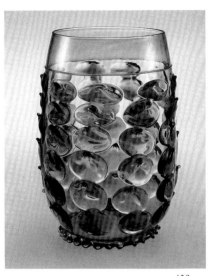

429

429. **Prunted** *Humpen*

First half of the sixteenth century
Free-blown potash-lime glass with applied
decoration
Height: 9¹⁵⁄₁₆ in. (25.2 cm)
Accession number 84.DK.510

PROVENANCE

Hans Graf Wilczek, Burg Kreuzenstein;
Franz Ruhmann, Vienna; Ruth and Leo-
pold Blumka, New York.

BIBLIOGRAPHY

Alfred Walcher-Molthein, "Die deutschen
Renaissancegläser auf Burg Kreuzenstein, I,"
Belvedere 9–10, no. 3 (March 1926), p. 41,
fig. 18; Wolfgang Born, "Five Centuries of
Glass: I, The Franz Ruhmann Collection
at Vienna," *Connoisseur* 101 (January

1938), pp. 12–13, fig. 6; "Acquisitions/1984,"
GettyMusJ 13 (1985), no. 204, p. 248, illus.;
Journal of Glass Studies, p. 100, fig. 8.

430. *Römer* (*Berkemeyer*)

(?) Southern Germany or lower Rhineland
([?]Cologne), first half of the sixteenth
century
Free-blown potash-lime glass with applied
decoration
Height: 5⁵⁄₁₅ in. (13.5 cm)
Accession number 84.DK.527

PROVENANCE

Ruth and Leopold Blumka, New York.

BIBLIOGRAPHY

"Acquisitions/1984," *GettyMusJ* 13 (1985),
no. 237, p. 254, illus.

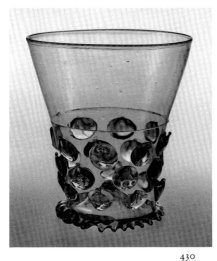

430

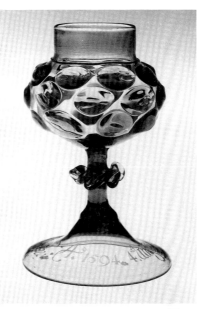

431

431. **Stemmed and Prunted Goblet**

Lower Rhineland ([?]Cologne), first half of
the sixteenth century
Free-blown potash-lime glass with applied
and etched decoration
Etched on the foot, *4 . augustus . was Ick
Out . 100 . Jaer . A 1594 ..*
Height: 5¹¹⁄₁₆ in. (14.4 cm); Diameter (at
mouth): 2⅛ in. (5.4 cm)
Accession number 84.DK.509

PROVENANCE

Ruth and Leopold Blumka, New York.

BIBLIOGRAPHY

"Acquisitions/1984," *GettyMusJ* 13 (1985),
no. 231, p. 253, illus.; *Journal of Glass Studies*,
p. 99, fig. 6.

432. **Ring Beaker**

First half of the sixteenth century
Free-blown potash-lime glass with applied
decoration
Height: 4¾ in. (12.1 cm)
Accession number 84.DK.531

PROVENANCE

Gabriel Pichler, Vienna; acquired by Oscar
Bondy, Vienna, November 29, 1927; Ruth
and Leopold Blumka, New York.

BIBLIOGRAPHY

"Acquisitions/1984," *GettyMusJ* 13 (1985),
no. 240, p. 254, illus.

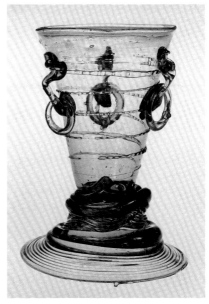

432

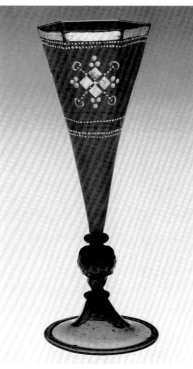

433.

433. **Goblet**

Central German or Bohemian, second half of the sixteenth century
Free- and mold-blown glass with gilding and enamel decoration
Height: 8 in. (20.3 cm)
Accession number 84.DK.550

PROVENANCE

Alexander von Frey, Paris; Ruth and Leopold Blumka, New York.

EXHIBITIONS

New York, The Corning Museum of Glass, *Three Great Centuries of Venetian Glass*, 1958, no. III.

BIBLIOGRAPHY

"Acquisitions/1984," *GettyMusJ* 13 (1985), no. 233, p. 253, illus.

434. **Beaker with the Arms of Schiltl and Portner von Theuern**

Southern German, (?) upper Bavarian, *1586*
Free-blown potash-lime glass with gilding and enamel decoration
Arms, on the center section of one side, in enamel, *per bend azure, a lion passant crowned or, grasping a scimitar, and per bend or, three escuthcheons azure, and gules; crest, out of a coronet or, a demi-lion with the scimitar as in the shield, between two eagles' wings gules, each ensigned with a bend—dexter transformed into a bar—or, charged with three escutcheons azure; on the center section of the opposite side, azure, a fallow deer salient with tail, armed or; crest, a demi-fallow deer salient, as in the shield.* Dated on the side of the vessel, in enamel, *1586.*
Height: 8¼ in. (21 cm)
Accession number 84.DK.554

PROVENANCE

Hans Graf Wilczek, Burg Kreuzenstein; Ruth and Leopold Blumka, New York.

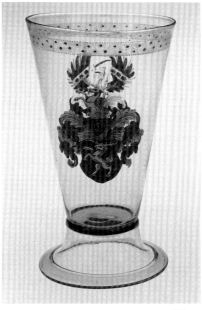

434

BIBLIOGRAPHY

Alfred Walcher-Molthein, "Deutschen Renaissancegläser auf Burg Kreuzenstein II," *Belvedere* 9–10, no. 4 (April 1926), p. 57, fig. 28; "Acquisitions/1984," *GettyMusJ* 13 (1985), no. 205, p. 248, illus.; *Journal of Glass Studies*, no. 25, p. 105.

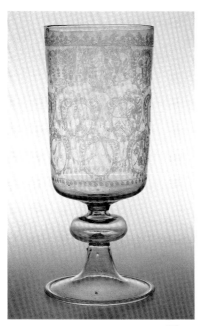

435

435. Goblet with the Arms of Bregenz and of Local Patricians

Southwestern German (Baden), probably the southern Schwarzwald, after 1621–circa 1635

Free-blown potash-lime glass with diamond-point etching

Arms, etched in three rows across the surface of the vessel twenty-one shields, seven per row, several blank, not all numbered, (unnumbered) *a patchwork of pelts, a pale ermine*; (*1*) *a swan with wings open*; (*2*) *quarterly one and four on a mount a lion rampant holding a gem ring and two and three on a pale three bezants*; (*3*) *an ox rampant armed*; (*4*) *a pale three trees*; (*5*) *issuant from a mount vert, a cross between two arms, vested, each*

holding a stone; (*6*) *quarterly one and four, a rose and two and three lozengy in bend sinister*, on an *inescutcheon and a pale* the lettering *SMD in pale, sable*; (*7*) *a gem ring*; (*8*) *an ox rampant armed*; (*9*) *a stag standing in profile*; (*10*) *flanking a tree a goat rampant and a man*; (*11*) as 2; (*12*) as 7; (*13*) *quarterly one and four a bendy with tree and two and three a chevron with three bezants*; (*14*) *a shield tripart the florettes*; (*15*) as 2 and 11; (*16*) *Forstmarke MS*; (*17*) *Hausmark IGH*; (*18*) *a crescent between three mullets*; (*19*) blank; (*20*) blank.

Height: 10¹³⁄₁₆ in. (27.5 cm)
Accession number 84.DK.551

PROVENANCE
Ruth and Leopold Blumka, New York.

BIBLIOGRAPHY
"Acquisitions/1984," *GettyMusJ* 13 (1985), no. 249, p. 256, illus.

436. Tumbler (*Stehaufbecher*)

Central German, Franconian (possibly Fichtelgebirge, Bishofsgrun), or northwestern Bohemian (Falkenau or Kreibitz), 1631

Free-blown potash-lime glass with enamel decoration

Inscribed around the vessel wall, painted in enamel, *Drinckh mich aus undt leg mich nid[er] Steh ich auff so vil mich wider. gib mich deinen / nechsten wider. ich lieb was wein ist obs gleich nicht mein ist. unndt mier nicht wertten khan / so hab ich gliech wol mein vreidt daran. liebt ihr mich wie ich eich nicht mehr veger ich / von eich. vil sint*

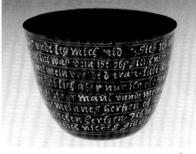

436

lieblich aber nur ihr ehr vreidt mich ich lieb eich aus hertzen / grundt. wollt godt eur maul unndt mein maul war ein mundt. ich lieb eich / noch von grundt meinnes hertzen ob ich so[llt] nicht mitt eich darff schertzn / drink allen valschen hertzen. Ich wolt sie miesten alle ehr hengen. / die mier undt eich nichts ginnen.; at the end of the inscription, dated *1631*.

Height: 2¾ in. (7 cm)
Accession number 84.DK.561

PROVENANCE
Franz Ruhmann, Vienna; Hans Graf Wilczek, Burg Kreuzenstein; Ruth and Leopold Blumka, New York.

BIBLIOGRAPHY
Alfred Walcher-Molthein, "Deutschen Renaissancegläser auf Burg Kreuzenstein II," *Belvedere* 9–10, no. 4 (April 1926), p. 64, fig. 41; Tilde Ostertag, *Das Fichtelgebirgsglas, Beiträge zur Fränkischen Kunstgeschichte* 2 (Erlangen, 1933), pl. 22a; Axel von Saldern, *German Enameled Glass*, p. 149, fig. 266; "Acquisitions/1984," *GettyMusJ* 13 (1985), no. 243, p. 255, illus.

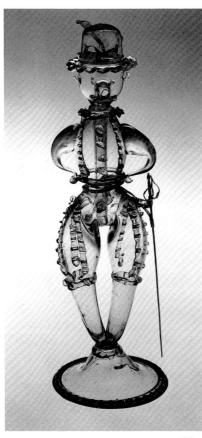

437

437. Joke Glass (*Scherzgefäss*) or Siphon Glass
German or Netherlandish, early seventeenth century
Free-blown potash-lime glass with applied decoration and silver mounts
Height: 1 ft. 1¼ in. (33.7 cm)
Accession number 84.DK.520

PROVENANCE
Ruth and Leopold Blumka, New York.

BIBLIOGRAPHY
"Acquisitions/1984," *GettyMusJ* 13 (1985), no. 239, p. 254, illus.

———

438. *Pattern-molded Humpen*
German or Netherlandish, first half of the seventeenth century
Pattern-molded glass with applied decoration
Height: 6 in. (11.2 cm)
Accession number 84.DK.530

PROVENANCE
Ruth and Leopold Blumka, New York.

BIBLIOGRAPHY
"Acquisitions/1984," *GettyMusJ* 13 (1985), no. 247, p. 256, illus.

———

439. *Römer (Berkemeyer)*
German or Netherlandish, second or third quarter of the seventeenth century
Free-blown potash-lime glass with applied decoration
Height: 7¼ in. (18.5 cm)
Accession number 84.DK.528

PROVENANCE
Snouck Hurgronje, The Hague (sold, Frederick Muller, Amsterdam, July 8, 1931, lot 56); A. Vecht, Amsterdam; Alexander von Frey, Paris; Ruth and Leopold Blumka, New York.

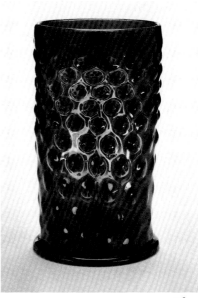

438

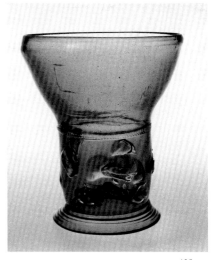

439

EXHIBITIONS
Amsterdam, Rijksmuseum, *Tentoonstelling van oude Kunst uit het Bezit van den internationlen Handel*, 1936, no. 692.

BIBLIOGRAPHY
"Acquisitions/1984," *GettyMusJ* 13 (1985), no. 246, p. 256, illus.

Height: 4 15/16 in. (12.5 cm)
Accession number 84.DK.529

PROVENANCE
Ruth and Leopold Blumka, New York.

BIBLIOGRAPHY
"Acquisitions/1984," *GettyMusJ* 13 (1985), no. 207, p. 248, illus.

Height: 8 9/16 in. (21.5 cm)
Accession number 84.DK.562

PROVENANCE
Ruth and Leopold Blumka, New York.

BIBLIOGRAPHY
"Acquisitions/1984," *GettyMusJ* 13 (1985), no. 209, p. 249, illus.

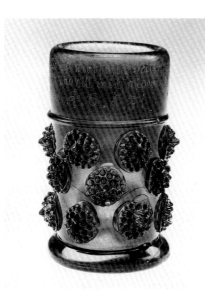

440

440. Thick-walled Beaker

(?) Central German, 1643
Free-blown potash-lime glass with applied decoration
Etched around the lip in diamond-point, *Trinck mich auss und wirff mich Nider / Hebb mich auff und vill mich wider* and dated *Anno 1643*.

441. Satirical Beaker

Northern German, (?) lower Saxony or Braunschweig, 1660
Free-blown potash-lime glass with enamel and applied decoration
Inscribed on the vessel wall, in enamel, *Hilff Gott! wie muss sieh doch der gutte Tilly leyden / Wie kann doch mancher Geld auss seinem schimpfe schneiden / Wie zeucht er doch verbey, wie musser sich doch bücken / Wie drückt ihn doch die Butt auf seinem alten Rücken / Der kaum geheyletist von Puffen, die driegt / Bey Leypsischem confeckt. Der Korb fast uberwiegt / Mehr als er tragen kann. So wandert er geschwinde / Mit sich und seinem Stab in Regen, Schnee und Winde / Doch geht er nicht allein, sein alte Geyss leufst mitte / Und zettert bey ihm her mit eben leisen Tritte / Sie meckert dass sie muss mit dem zu fusse fort / Mit dem sie vor stets fuhr an iede Stell und Ort /*; from Tilly's mouth *O miserere mei*; on the basket *Nimiae Exaction*; on the barrel *Mea Constientia*; on his staff *Unicum et fragile*; from the personification of the wind *Vindicta divina / Vindicta divina*; below the lip, dated *1.6.6.0*; on the bottom, painted in a modern hand, *3822* and *1180*.

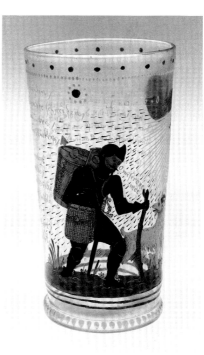

441

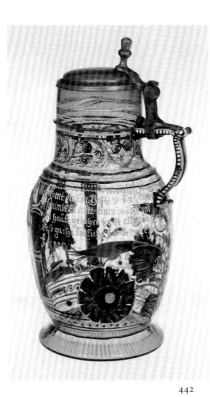

442

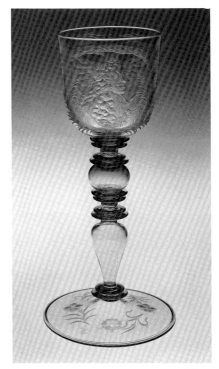

443

the inscription, dated *1671*; on the arcade over the figures, inscribed *Drinckt und est Gott / nich vergest.*
Height: 10¾ in. (27.3 cm)
Accession number 84.DK.563

PROVENANCE
Oscar Bondy, Vienna; Ruth and Leopold Blumka, New York.

BIBLIOGRAPHY
"Acquisitions/1984," *GettyMusJ* 13 (1985), no. 210, p. 249, illus.

443. **Goblet with a Portrait of Emperor Leopold I**
Nuremberg, 1676–1683
By Hermann Schwinger
Free-blown glass with wheel-engraved decoration
Height: 11½ in. (29.6 cm)
Accession number 84.DK.566

PROVENANCE
Viktor Schick, Prague (sold, Sotheby's, London, May 4, 1939, lot 34); Ruth and Leopold Blumka, New York.

BIBLIOGRAPHY
"Acquisitions/1984," *GettyMusJ* 13 (1985), no. 208, p. 249, illus.; *Journal of Glass Studies*, no. 37, p. 109.

442. **Covered Jug**
Thuringia, 1671
Free-blown potash-lime glass with enamel decoration and unmarked pewter mounts
Inscribed around the vessel wall, in enamel, *Wirtt komt die ein Gast so drag ihm fur wass du hast, ist er Erbau und Wohlgemutt / so nimbt er mitt einen drunckt und Brodt ver gutt ist er aber ein schalckin / der hautt geborhn so ist alle gutt thut an ihm verlohrn, Gott behütte und erhalte / Dass gantze lübliche handtwerck der kü[rsch]ner.*; below

444. **Covered Goblet**
Silesia, Schaffgotsch glassworks (Hermsdorf), 1691–1694
By Friedrich Winter
Glass with wheel-engraved, high-relief decoration (*Hochschnittglas*)
Wheel-engraved on the vessel wall above the handle, *Aucun temps ne le change.*
Height: 1 ft. ⅙ in. (31.2 cm)
Accession number 84.DK.568

PROVENANCE
Karl Ruhmann, Vienna; Ruth and Leopold Blumka, New York.

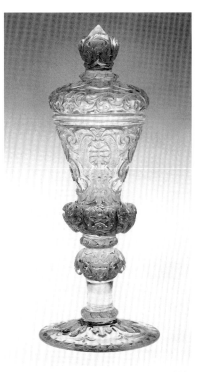

444

BIBLIOGRAPHY
Wolfgang Born, "Five Centuries of Glass: II," *Connoisseur* 101 (March, 1938), p. 121, fig. 1; Ignaz Schlosser, *Das alte Glas: Ein Handbuch für Sammler und Liebhaber* (Brunswick, 1965), 226, pl. 185; Axel von Saldern, "Unbekannte Gläser von Johann Wolfgang Schmidt, Friedrich Winter and Franz Gondelach," *Anzeiger des Germanischen Nationalmuseums* (1970), 110; "Acquisitions/ 1984," *GettyMusJ* (1985), no. 230, p. 253, illus.; *Journal of Glass Studies*, no. 38, p. 109.

Ivory

445. **Covered Goblet**
1631
By Marcus Heiden
Lathe-turned and carved ivory
Marked *MARCUS HEIDEN. COBURGENSIS.FECIT.1631* under base.
Height: 2 ft. 1 in. (63.5 cm)
Accession number 91.DH.75

PROVENANCE
Presumed to have been made for Duke Johann Casmir of Saxe-Coburg and seized by Colonel Giovanni Giovacchino Keller of Schaikaine during the sack of Coburg in 1632; private collection, Germany; [Same Art, Ltd., Zurich, 1990].

BIBLIOGRAPHY
Eugen von Philippovich, *Elfenbein* (Bibliothek für Kunst- und Antiquitätenfreunde, Munich, 1982), vol. 17, p. 422, fig. 372; Klaus Maurice, *Der Drechselnde Souverän, Materialen zu einer fürstlichen Maschinenkunst* (Zurich, 1985), pp. 74, 152, fig. 78.

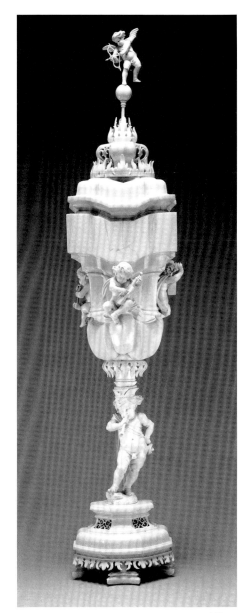

445

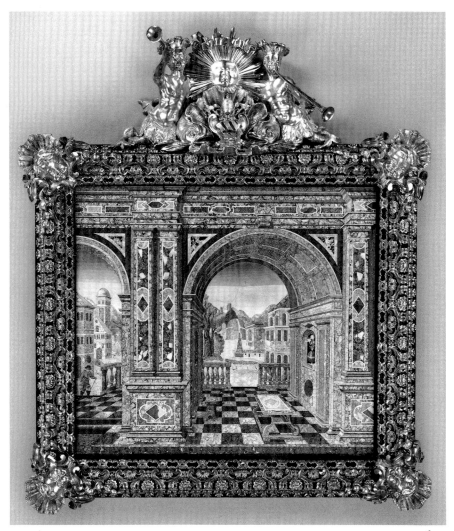

446

Scagliola

446. **Architectural Scene and Frame**
Plaque: Southern German, circa 1630–1670
Produced in the workshop of Blausius
Fistulator
Scagliola
Frame: Italian, circa 1730–1740
Ebonized wood; gilt-bronze mounts
Plaque: Height: 1 ft. 5⅛ in. (43.5 cm);
Width: 1 ft. 7¹¹⁄₁₆ in. (50 cm); Frame:
Height: 2 ft. 4¾ in. (73 cm); Width:
2 ft. 4⅜ in. (67 cm)
Accession number 92.SE.69

PROVENANCE
Corsini family, Florence, by 1730; [Same
Art, Ltd., Zurich, 1991].

BIBLIOGRAPHY
"Acquisitions/1992," *GettyMusJ* 21 (1993),
in press, illus.

Bohemian
Decorative Arts

✵

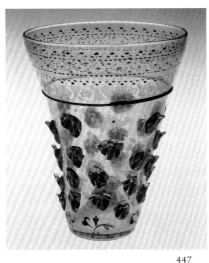

447

Glass

447. **Fragment of a Beaker or Goblet**

(?) Bohemian, 1525–1575
Free-blown soda glass with gilding, enamel, and etched decoration
Height: 8⅝ in. (22 cm); Diameter (at mouth): 7½ in. (19 cm)
Accession number 84.DK.547

PROVENANCE

Robert von Hirsch, Basel (sold, Sotheby's, London, June 22, 1978, lot 256); Ruth and Leopold Blumka, New York.

BIBLIOGRAPHY

The History of Glass, Dan Klein and Ward Lloyd, eds. (London, 1984), p. 74, illus.; "Acquisitions/1984," *GettyMusJ* 13 (1985), no. 211, p. 249, illus.; *Journal of Glass Studies*, no. 22, p. 104.

448. **Goblet**

1576
Free-blown potash-lime glass with enamel and applied decoration
Dated *1576*.
Height: 9 in. (22.9 cm)
Accession number 84.DK.552

PROVENANCE

Prince of Liechtenstein, Vaduz; Ruth and Leopold Blumka, New York.

BIBLIOGRAPHY

"Acquisitions/1984," *GettyMusJ* 13 (1985), no. 234, pp. 253–254, illus.; *Journal of Glass Studies*, no. 23, p. 105.

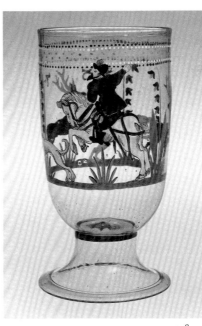

448

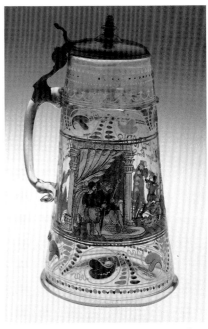

449

449. **Covered Tankard**

1578
Free-blown potash-lime glass with enamel decoration; pewter mounts
Inscribed around central zone of vessel, *Konig . Herodis . Lest . Die / unschuldigen kindlein elendiglich todten*; dated *1578*.
Height: 10⅝ in. (27 cm); Diameter (at base): 5⅞ in. (14.5 cm)
Accession number 84.DK.553

PROVENANCE

Wilczek, Schloss Eisgrub; Ruth and Leopold Blumka, New York.

BIBLIOGRAPHY

Axel von Saldern, *German Enameled Glass* (Corning, 1965), p. 92, fig. 114; "Acquisitions/1984," *GettyMusJ* 13 (1985), no. 220, p. 251, illus.; *Journal of Glass Studies*, no. 24, p. 105.

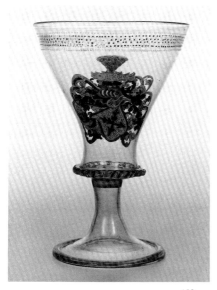

450

450. Goblet with the Arms of Liechtenberg
(?) Southern Bohemian, before 1580
Free-blown soda glass with gilding and enamel decoration
Arms, on the center of the bowl, in enamel, *or two ragged staves in saltire, sable*; the crest, *upon a cushion gules, tasseled or, a fish argent, in front of a panache of peacock's feather proper.*
Height: 9¼ in. (23.5 cm)
Accession number 84.DK.537

PROVENANCE

F. Kieslinger, Vienna; Ruth and Leopold Blumka, New York.

EXHIBITIONS

New York, The Corning Museum of Glass, *Three Great Centuries of Venetian Glass*, 1958, no. 19; New York, The Metropolitan Museum of Art, The Cloisters, *The Secular Spirit: Life and Art at the End of the Middle Ages*, 1975, no. 263.

BIBLIOGRAPHY

"Acquisitions/1984," *GettyMusJ* 13 (1985), no. 186, p. 245, illus.; *Journal of Glass Studies*, no. 14, p. 102.

451. *Stangenglas* with the Arms of Puchner
(?) Northwestern Bohemian or German, Saxon ([?]Erzgebirg), 1587
Free-blown potash-lime glass with enamel decoration
Arms, on the central zone of the vessel wall, in enamel, *tierced per chevron or, in chief sable a lion or, armed and langued gules and in base, azure, on a mount vert a [beech] tree proper*; crest, *lion issuant between two buffaloes' horns, couped dexter azure and or, sinister or and sable, issuant from each flames gules.* Inscribed on upper and lower vessel wall, in enamel, *Auff Gott mein hoffnung / Paulus Puchner Churtz : S : Zeug / meister zu dresden*; around the upper vessel wall, dated *1587.*
Height: 1 ft. ¼ in. (31.2 cm)
Accession number 84.DK.555

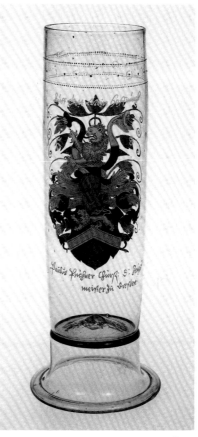

451

PROVENANCE

Ruth and Leopold Blumka, New York.

BIBLIOGRAPHY

Brigitte Klesse and Axel von Saldern, *500 Jahre Glaskunst: Sammlung Biemann* (Zurich, 1978), p. 309; "Acquisitions/1984," *GettyMusJ* 13 (1985), no. 206, p. 248, illus.; *Journal of Glass Studies*, no. 26, p. 106.

452. ***Stangenglas* with the Arms of Hirt and Maier**

(?) Southwestern Bohemian, Böhmer Wald, 1590
Free-blown potash-lime glass and enamel decoration
Arms, *gules, a pale argent, three rosettes gules*; on the opposite side, *azure, a stork argent.* Inscribed on band above the cresting, in enamel, *ALLES ALLES MIT GOTTES HVLF*; below the arms, *HANS HIRT V WEISSENAV FVRST / BRAVNSCHWEIGIS-CHER VND LVNEBVRG / ISCHER RATH VND AGENT AM KAYs / HOFF*; on the opposite side above the cresting, *HIE ZEITLICHS LEID BRINGT D EWIGE FREVD*; below the arms, *MARIA HIRTIN VON WEISSENAU / GEBORNE MAIER IN VON SANT / GILGEN STEIN HAVSFRAV ALLES ALLES MIT GOTTES HVLF*; and just below the upper bands, dated *Patientia Durum Frango 1590.*
Height: 4⅛ in. (10.4 cm)
Accession number 85.DK.214

PROVENANCE
Viktor Schick, Prague; Mrs. Hedwig Schick, Prague (sold, Sotheby's, London, May 4, 1939, lot 17); Ruth and Leopold Blumka, New York.

BIBLIOGRAPHY
L. Fusch, "Die frühen süddeutschen Wappenhumpen," *Münchener Jahrbuch der bildenden Kunst* 12, n.s. (1937–1938), p. 224; p. 226, fig. 6; "Acquisitions/1985," *GettyMusJ* 14 (1986), no. 215, p. 252, illus.

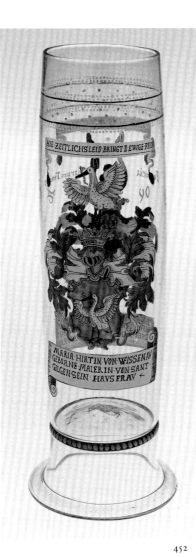

452

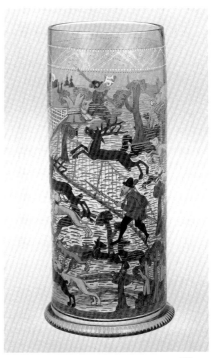

453

453. ***Jagdhumpen***

Bohemian or central German, 1593
Free-blown potash-lime glass and enamel
Dated *1593.*
Height: 11⅜ in. (28.9 cm)
Accession number 84.DK.556

PROVENANCE
Hans Graf Wilzcek, Burg Kreuzenstein; E. and A. Silberman, Vienna; Oscar Bondy, Vienna; Ruth and Leopold Blumka, New York.

BIBLIOGRAPHY
"Acquisitions/1984," *GettyMusJ* 13 (1985), no. 235, p. 254, illus.

454. *Reichsadler Humpen*

(?) Bohemian or (?) central German, 1599
Free-blown potash glass with enamel decoration
Inscribed on the vessel wall below the decorative band, in enamel, *Das heylige Romisch Reich Mit Sampt Seinen gliedern*; on the four heraldic shields along the top of the eagle's dexter wing, *TRIER / COLN / MENTZ / POTESTAT ZV ROM*; on the sinister wing, *BEHEN / PFALTA / SACHSEN / BRANDENBVRG*; on the banderoles attached to each feather and on the bands over the shields in six vertical ranks on the dexter wing, from left to right and top to bottom, *4 BAVRN / COLN / REGENSPVRG / COSENITZ / SALTZBVRG / 4 STETT / AVGSBVRG / METZ / ACH / LVBECK / 4 SEMPER FREIEN / LVNDBVRG / WESTERBVRG / THVSSIS / ALTWALTEN / 4 BVRGGRAVEN / MAIDBVRG / NVRN-BERG / REMECK / STANBERG / 4 MAR-GRAVEN / ERCHERN / BRANDENBVRG / MEISCHEN / BADEN / 4 SEIL / BRVAN-SCHWEIG / BAIRN / SCHWABEN / LVTRING*; and on the sinister wing, *4 VICARI / BRABAND / N. SACHSEN / WESTERBVRG / SCHLEST / 4 LAND-GRAVEN / DVRING / EDELSAS / HESSEN / LEVCHTERBERG / 4 GRAVEN / CLEVE / SAPHOY / SCHWARZBVRG / ZILL1 / 4 RITTER / ANDELAW / WEIS-SENBACH / FRAWENBERG / STVNDECK*

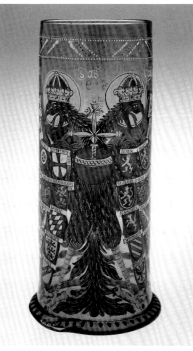

454

/ 4 DORFFER / BAMBERG / VLM / HAGENAW / SLETSTAT / 4 BIRG / MAD-ABVRG / LVTZELBVRG / ROTTENBVRG / ALTENBVRG; below the rim, opposite the eagles, dated *1599*.
Height: 11 9/16 in. (29.9 cm)
Accession number 84.DK.558

PROVENANCE
Ruth and Leopold Blumka, New York.

BIBLIOGRAPHY
"Acquisitions/1984," *GettyMusJ* 13 (1985), no. 236, p. 254, illus.

455. **Beaker**

(?) Northwestern Bohemian, 1599
Free-blown potash-lime glass with enamel decoration
Inscribed and dated *ELIAS . IN . DER / WUSTEN . AN / NO . 1.5.9.9.*
Height: 4 1/2 in. (11.4 cm)
Accession number 84.DK.557

PROVENANCE
A. Vecht, Amsterdam; Lucien Sauphar, Paris; Alexander von Frey, Paris; Oscar Bondy, Vienna; Ruth and Leopold Blumka, New York.

BIBLIOGRAPHY
Axel van Saldern, *German Enameled Glass* (Corning, 1965), p. 446; "Acquisitions/1984," *GettyMusJ* 13 (1985), no. 221, p. 251, illus.

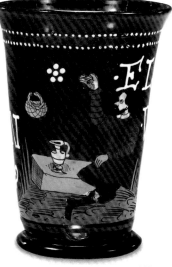

455

456. *Stangenglas*

Southern Bohemian, 1600
Free-blown potash-lime glass with diamond-point etching
Inscribed in the upper paralled bands, *FRISCH AUF JUNG GESEL WOL GEMUNDT GAR WOL / MIR DAS FRIEDELN THUT.* Inscribed over the couple, *Lieb haben und nicht genissenn / Thut manchen gar sehr fer/ driessen /.* Inscription flanking the couple, *Ich aber thut genissen / dass thuet ganz nicht vorfriessen.* Inscribed over the naked woman, *Halte feste kom / men frembde gäste / Frisch auff;* dated *1600* twice on central zone of vessel wall.
Height: 1 ft. 1⁹⁄₁₆ in. (34.5 cm)
Accession number 84.DK.559

PROVENANCE

Richard Leitner, Vienna; Oscar Bondy, Vienna (sold from his collection, June 16, 1922); Ruth and Leopold Blumka, New York.

BIBLIOGRAPHY

Hans Zedinek, "Die Glashütte zu Hall in Tirol," *Altes Kunsthandwerk* 1, no. 3 (1927), pp. 98–117, pl. 89; Wilfred Buckley, *Diamerond Engraved Glasses of the Sixteenth Century with Particular Reference to Five Attributed to Giacomo Verzelini* (London, 1929), p. 16, pl. 31; Erich Egg, *Die Glashütte zu Hall und Innsbruck im 16. Jahrhundert,* Tiroler Wirtschaftsstudien, vol. 15 (Innsbruck, 1962), p. 80; "Acquisitions/1984," *GettyMusJ* 13 (1985), no. 222, p. 251, illus.; *Journal of Glass Studies,* no. 32, p. 108.

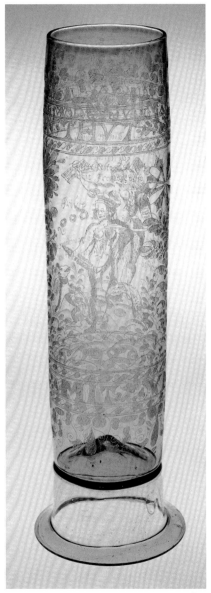

456

457. *Humpen*

Southern German or Bohemian, 1614
Free-blown potash-lime glass with diamond-point etching
Arms, (?) *gules, three swords, a right one in pale, between two others of different shape, hilt and pommel or, together enfiled in a coronet or;* the charges of the shield, repeated. Etched on one side *Daniel Weger 1.6.1.4.,* and on the other side *Fein land ficht du zu mir her / ein. Und lass dein Kürschneri / schen lauffen sein. Mich dunckt du / forcht dich für den streichenn. Drumb wirdt dass / glass am dich Nicht reichenn.* Dated *1614* on central zone of vessel wall.
Height: 10⅜ in. (26.3 cm)
Accession number 84.DK.560

PROVENANCE

Karl Ruhmann, Vienna; Ruth and Leopold Blumka, New York.

BIBLIOGRAPHY

Ignaz Schlosser, *Das alte Glas: ein Handbuch für Sammler und Liebhaber* (Brunswick, 1956), pp. 152, 159, fig. 131; Erich Egg, *Die Glasshütte zu Hall und Innsbruck im 16. Jahrhundert,* Tiroler Wirtschaftsstudien, vol. 15 (Innsbruck, 1962), p. 80; "Acquisitions/1984," *GettyMusJ* 13 (1985), no. 242, p. 255, illus.; *Journal of Glass Studies,* no. 33, p. 108.

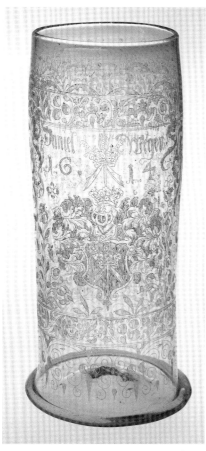

457

458. *Humpen*

Southern Bohemian, 1624–1650
Gray seeded glass with diamond-point
decoration
Height: 4¾ in. (12.1 cm)
Accession number 84.DK.659

PROVENANCE

Fritz Biemann, Zurich (sold, Sotheby's,
London, June 16, 1984, lot 46); [David, Inc.,
Vaduz].

EXHIBITIONS

Lucerne, Kunstmuseum Luzern, *3000 Jahre
Glaskunst von der Antike bis zum Jugendstil*,
1981, no. 705, p. 161, illus.

BIBLIOGRAPHY

Dagmar Hnikova, "Böhmisches Glas,"
Orbis Pictus, vol. 61 (Bern and Stuttgart,
1974); Brigitte Klesse and Axel von Saldern,
500 Jahre Glaskunst: Sammlung Biemann
(Zurich, 1978), p. 15, fig. 12; p. 118, no. 65;
"Acquisitions/ 1984," *GettyMusJ* 13 (1985),
no. 223, p. 251, illus.

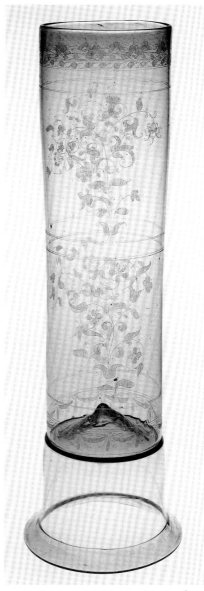

458

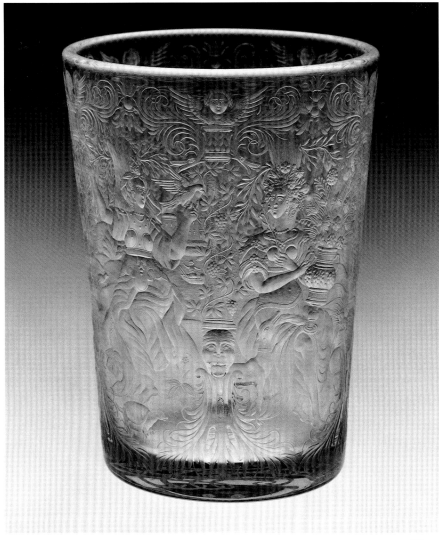

459

459. **Beaker with Personifications of the Senses**
Late seventeenth century
After the Master of the Koula Beaker
Free-blown glass with wheel-engraved decoration
Height: 4¾ in. (12.8 cm)
Accession number 84.DK.567

PROVENANCE
Ruth and Leopold Blumka, New York.

BIBLIOGRAPHY
Olga Drahotava, "Dans le sphère du maître graveur du goblet dit de Koula," *Cristal de Bohëme* (1965), pp. 29–32; "Acquisitions/ 1984," *GettyMusJ* 13 (1985), no. 224, p. 252, illus.

Austrian
Decorative Arts

❖

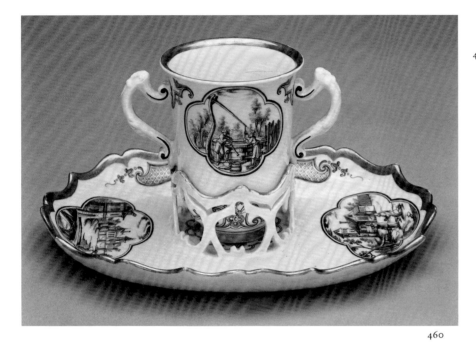

460

Ceramics

460. **Cup and Saucer (*trembleuse*)**
Vienna, Du Paquier manufactory, circa 1740
Hard-paste porcelain, black enamel decoration; gilding
Cup: Height: 2¾ in. (7.1 cm); Width: 3⅝ in. (9.2 cm); Depth: 2⁷⁄₁₆ in. (6.2 cm);
Saucer: Height: 1⅜ in. (3.5 cm); Width: 6 ¹¹⁄₁₆ in.
(17 cm); Depth: 4¾ in. (12.2 cm)
Accession number 85.DE.375.1–.2

PROVENANCE
Sold, Christie's, London, December 5, 1983, lot 177; [Winifred Williams, Ltd., London].

BIBLIOGRAPHY
"Acquisitions/1985," *GettyMusJ* 14 (1986), no. 181, p. 239, illus.

Glass

461. **Umbo Vase**
(?) Tirolean (Hall), circa 1534–1536
(?) Workshop of Wolfgang Vitl
Free- and mold-blown soda glass with gilding and cold enamel decoration
Arms, on rim, in cold enamel, *per fesse argent a demi-wheel gules, and azure a fleur-de-lis argent*; on the opposite side *on a mount or a triple-turreted tower argent.*
Height: 8⁵⁄₁₆ in. (21.1 cm)
Accession number 84.DK.546

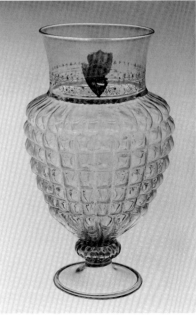

461

PROVENANCE

Wormser, Paris; Ruth and Leopold Blumka, New York.

BIBLIOGRAPHY

"Acquisitions/1984," *GettyMusJ* 13 (1985), no. 218, pp. 250–251, illus.; *Journal of Glass Studies*, no. 28, p. 106.

462. **Covered *Pokal***

Hall, circa 1536–1540

(?) Workshop of Wolfgang Vitl

Free-blown soda glass with applied decoration, gilding, and cold enamel

Arms on one side of the central zone of the vessel canted toward each other, below a bishop's miter, in cold enamel, *two escutcheons, dexter or, a moor's head in profile proper crowned,* and *sinister, quarterly one and four sable a lion or crowned gules* and *two and three lozengy argent and azure.*

Height: 7 ⅝ in. (19.3 cm)

Accession number 84.DK.548

PROVENANCE

Ruth and Leopold Blumka, New York.

EXHIBITIONS

New York, The Corning Museum of Glass, *Three Great Centuries of Venetian Glass*, 1958, no. 59.

BIBLIOGRAPHY

"Acquisitions/1984," *GettyMusJ* 13 (1985), no. 219, p. 251, illus.; *Journal of Glass Studies*, no. 30, p. 107.

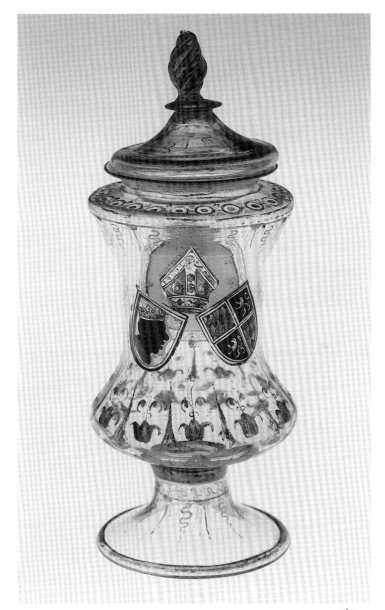

462

463. **Goblet (*Kelchpokal*)**

Hall, circa 1535–1555
Workshop of Wolfgang Vitl or that of
Sebastian Höchstetter
Free- and mold-blown soda glass with
gilding
Height: 7 7/16 in. (18.9 cm)
Accession number 84.DK.542

PROVENANCE

Ruth and Leopold Blumka, New York.

BIBLIOGRAPHY

"Acquisitions/1984," *GettyMusJ* 13 (1985),
no. 212, pp. 249–250, illus.

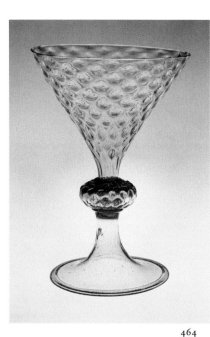

464

464. **Goblet (*Kelchpokal*)**

Hall, circa 1540–1560
(?) Workshop of Sebastian Höchstetter
Free- and mold-blown soda glass with
gilding
Height: 7½ in. (19 cm)
Accession number 84.DK.543

PROVENANCE

Ruth and Leopold Blumka, New York.

BIBLIOGRAPHY

"Acquisitions/1984," *GettyMusJ* 13 (1985),
no. 213, p. 250, illus.

465. **Goblet**

Hall, circa 1540–1560
(?) Workshop of Sebastian Höchstetter
Free- and mold-blown soda glass with
gilding
Height: 10 in. (25.4 cm)
Accession number 84.DK.544

PROVENANCE

Ruth and Leopold Blumka, New York.

BIBLIOGRAPHY

"Acquisitions/1984," *GettyMusJ* 13 (1985),
no. 216, p. 250, illus.

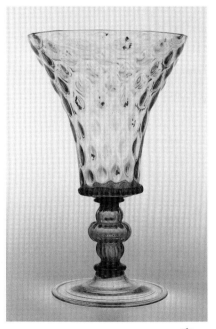

465

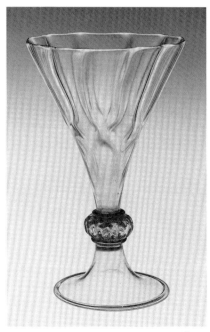

463

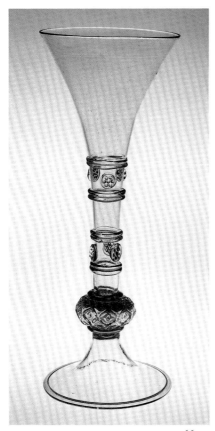

466

466. Goblet (*Trichterpokal*)

Hall, circa 1550–1560
(?) Workshop of Sebastian Höchstetter
Free- and mold-blown soda glass with
applied decoration
Height: 1 ft. 3⅛ in. (38.3 cm)
Accession number 84.DK.545

PROVENANCE

Hans Graf Wilzcek, Burg Kreuzenstein;
Ruth and Leopold Blumka, New York.

BIBLIOGRAPHY

"Acquisitions/1984," *GettyMusJ* 13 (1985),
no. 217, p. 250, illus.; *Journal of Glass Studies*,
no. 27, p. 106.

467. Covered Beaker (*Wilkommglas*)

Hall, circa 1550–1554
(?) Workshop of Sebastian Höchstetter
Free-blown potash glass with etched and
enamel decoration
Arms, on the center of the vessel wall and
repeated on the opposite side, in enamel,
argent a fesse dancetty gules; crest, *on a helf
argent a coronet or and a panache of peacock's
plumes argent and gules*. Inscribed over the
vessel wall with the names or initials of vari-
ous people and dates, in diamond point.
Height: 1 ft. 2⁹⁄₁₆ in. (37 cm)
Accession number 84.DK.515

PROVENANCE

Graf von Trautmannstorff, Schloss Gleichen-
berg bei Graz; E. and A. Silberman, Vienna;
Oscar Bondy, Vienna (acquired in 1932);
Ruth and Leopold Blumka, New York.

EXHIBITIONS

New York, The Metropolitan Museum of
Art, The Cloisters, *The Secular Spirit: Life
and Art at the End of the Middle Ages*, 1975,
no. 279.

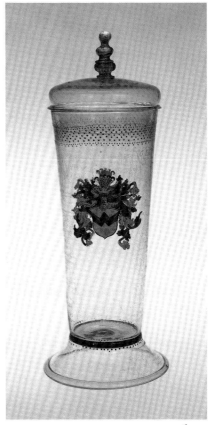

467

BIBLIOGRAPHY

Dr. Oswald Trapp, "Die Geschichte eines
Trappisches Wilkommglas," *Der Schlern* 40
(1966), pp. 120–122; Rainer Rückert, *Die
Glassammlung des Bayerischen National-
museums München* I (Munich, 1982), p. 79;
"Acquisitions/1984," *GettyMusJ* 13 (1985),
no. 214, p. 250; *Journal of Glass Studies*,
no. 21, p. 104.

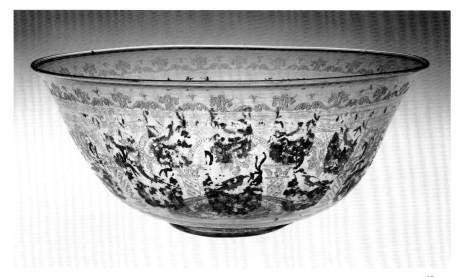

468

468. **Bowl**

Innsbruck, 1570–1591
Royal glassworks, (?) executed by Murano
craftsmen
Colorless soda glass with diamond-point
etching, gilding, and cold enamel decoration
Height: 6⁵⁄₁₆ in. (16 cm)
Accession number 84.DK.653

PROVENANCE
Magdelene Sharpe Erskine, Dunimarle
Castle, Culross, Fife, Scotland (sold,
Sotheby's, London, June 26, 1978, lot 26);
[David, Inc., Vaduz].

BIBLIOGRAPHY
Brian J. R. Blench, letter to the editor, *Journal of Glass Studies* 26 (1984), pp. 155–157;
"Acquisitions/1984," *GettyMusJ* 13 (1985),
no. 215, p. 250, illus.; *Journal of Glass Studies*,
no. 29, p. 107.

English
Decorative Arts

❖

Furniture

CABINETS

469. **Cabinet on Stand**
Circa 1690–1700
Painted, gessoed, and silvered wood;
brass mounts

Cabinet: Height: 2 ft. 8½ in. (82.5 cm);
Width: 3 ft. 1 in. (93.9 cm); Depth:
1 ft. 7½ in. (49.5 cm); Stand: Height:
2 ft. 7¼ in. (79.3 cm); Width: 3 ft. 5¼ in.
(104.7 cm); Depth: 1 ft. 11½ in. (59.6 cm)
Accession number 78.DA.117

PROVENANCE
Mrs. Geoffrey Hart, London; purchased by
J. Paul Getty, 1961.

EXHIBITIONS
London, The Victoria and Albert Museum,
*The Orange and the Rose: Holland and
Britain in the Age of Observation, 1600–1750*,
October 1964–January 1965, no. 220; New
York, The Cooper-Hewitt Museum and
Pittsburgh, The Carnegie Museum, *Courts
and Colonies: The William and Mary Style in
Holland, England, and America*, November
1988–May 1989, no. 107, p. 157, illus.

BIBLIOGRAPHY
R. W. Symonds, "The City of Westminster
and Its Furniture Makers," *Connoisseur* 100
(July 1937), pp. 3–9, illus. pp. 2, 9; R. W.
Symonds, "The Age of Charles II," *Connoisseur* 111 (June 1943), illus. p. 125; Horace
Shipp, "A Home and Its Treasures: Mrs.
Geoffrey Hart's Collection at Hyde Park
Gardens," *Apollo* 62 (December 1955), illus.
p. 181; R. W. P. Luff, "Oriental Lacquer and
English Japan: Some Cabinets from the Collection of Mr. J. Paul Getty at Sutton Place,
Surrey," *The Antique Collector* (December
1962), pp. 256–261, illus. p. 259, fig. 5.

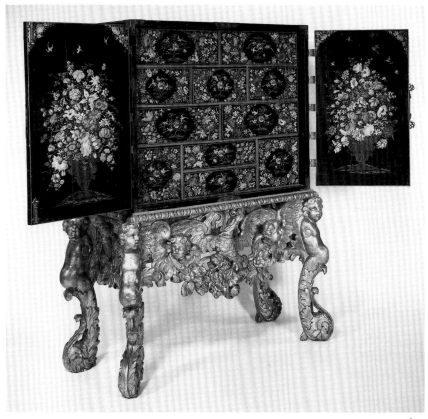

469

SEAT FURNITURE

470. Side Chair

(?) London, late seventeenth century
Gessoed and gilded walnut; modern
upholstery
Height: 3 ft. 10 in. (116.8 cm); Width:
1 ft. 10½ in. (57.1 cm); Depth: 2 ft. 1 in.
(63.5 cm)
Accession number 75.DA.62

PROVENANCE
[Frederick Victoria, Inc., New York]; Nicolas
Landau, Paris; purchased by J. Paul Getty.

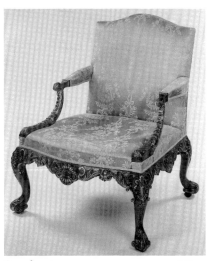

One of a pair 471

471. Pair of Armchairs

London, circa 1740–1745
In the style of William Bradshaw
Gessoed and parcel-gilt pine; modern silk
upholstery
Height: 3 ft. 2½ in. (97.9 cm); Width:
2 ft. 3¼ in. (69.3 cm); Depth: 2 ft. 7⅜ in.
(79.7 cm)
Accession number 78.DA.96.1–.2

PROVENANCE
R. W. Miller (sold, Christie's, London, Janu-
ary 21, 1960, lot 43, to Pallott); [A. Cook,
London]; purchased by J. Paul Getty, 1960.

472. Armchair

London, circa 1750–1760
Walnut with pine and oak; traces of gesso,
paint, and gilding; remnants of original
wool upholstery
Height: 3 ft. 3 in. (99 cm); Width:
2 ft. 1½ in. (64.7 cm); Depth: 2 ft. 1 in.
(63.5 cm)
Accession number 85.DA.120

PROVENANCE
(?) David Garrick, London (1717–1779); an
upholsterer, outside Philadelphia; [Glenn
Randall, New York, 1984].

BIBLIOGRAPHY
"Acquisitions/1985," *GettyMusJ* 14 (1986),
no. 186, p. 240, illus.

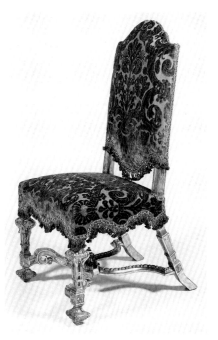

470

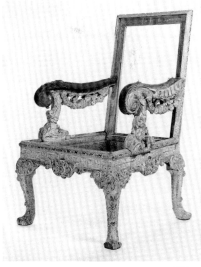

472

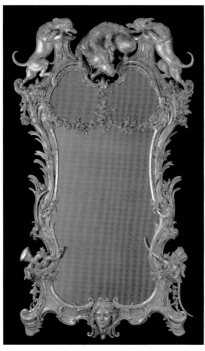

473

Architectural Woodwork and Fixtures

FRAMES

473. **Frame for a Mirror**
London, circa 1740–1745
Attributed to Matthias Lock
Gessoed and gilded pine details on an oak support; mirror glass
Height: 7 ft. (213.3 cm); Width: 4 ft. 2 in. (127 cm)
Accession number 78.DH.243

PROVENANCE
Dukes of Westminster; [Frank Partridge, Ltd., London, 1967]; purchased by J. Paul Getty, 1967.

EXHIBITIONS
The Minneapolis Institute of Arts, on loan, November 1988–present.

Metalwork

474. **Monteith**
London, 1705
By John Rand
Silver
Marked with the maker's stamp of *Ra*; a lion's head erased (the assay mark of London); the figure of Britannia (the standard mark indicating .9583 silver content); the letter *J* (the date letter for 1705). Engraved with an unidentified coat of arms.
Height: 10 in. (25.5 cm); Diameter: 1 ft. 2½ in. (36.8 cm)

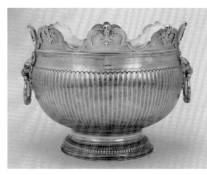

474

Accession number 78.DG.149

EXHIBITIONS
The Los Angeles County Museum of Art, on loan, 1982–present.

475. **Pair of Sugar Castors**
London, 1730
By Paul de Lamerie
Silver-gilt
Bodies and lids marked with the maker's stamp of *L.A.* between an arched crown with a star and a fleur-de-lys (in use around 1720–1732); a lion's head erased (the assay mark of London); the figure of Britannia (the standard mark indicating .9583 silver content); the letter *P* (the date letter for 1730). Castor .1 engraved *1730* and *N⁰2=27-12*; Castor .2 engraved *1730* and *N⁰1=27*; both engraved with Garter coat of arms and the Howard crest.
Height: 9⅜ in. (23.8 cm); Diameter: 3⅞ in. (9.9 cm)
Accession number 78.DG.180.1–.2

PROVENANCE
Dukes of Northumberland; [S. J. Phillips, London]; purchased by J. Paul Getty around 1938.

EXHIBITIONS
The Minneapolis Institute of Art, on loan, 1980–1981; The Los Angeles County Museum of Art, on loan, 1982–1988; London, Goldsmith's Hall, *Paul de Lamerie*, May 16–June 22, 1990, no. 65, p. 109, illus.

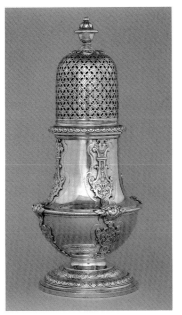

One of a pair 475

Height: 11¼ in. (28.6 cm); Width: 1 ft. 6 in.
(45.7 cm); Depth: 1 ft. ¾ in. (32.4 cm)
Accession number 78.DG.130.1–.2

PROVENANCE
Charles, 4th Duke of Richmond and
Lennox (succeeded 1806, Lord Lieutenant
of Ireland 1807–1813); Dukes of Richmond
and Gordon, Goodwood House, Sussex, by
descent (sold, Christie's, London, July 20,
1938, lot 114); purchased by J. Paul Getty.

EXHIBITIONS
The Minneapolis Institute of Art, on loan,
1980–1981; Williamstown, Massachusetts,
Sterling and Francine Clark Art Institute,
on loan, 1983–1988.

476. **Pair of Lidded Tureens, Liners,
and Stands**

London, 1807
By Paul Storr
Silver
Variously marked with the maker's stamp of
P.S.; a lion passant (the standard mark of
sterling quality); the crowned leopard's head
(the assay mark of London); the Sovereign's
head of George III (the duty mark); and
the letter *M* (the date letter for 1807). Each
tureen engraved with the arms of the Dukes
of Richmond and Lennox and with the
motto *EN LA ROSE LE FLURIE.*

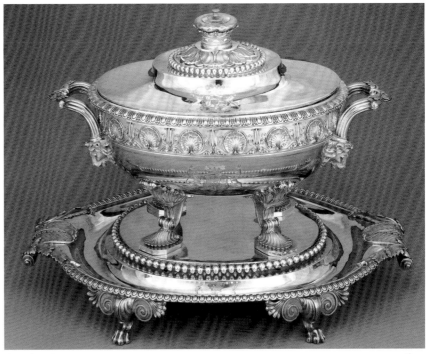

One of a pair 476

Mounted Oriental Porcelain

477. **Pair of Lidded Bowls**

Porcelain: Japanese (Arita), circa 1650
Mounts: English (London), circa 1670
Mounts attributed to Wolfgang Howzer
Hard-paste porcelain, underglaze blue deco-
ration; gilt-metal mounts
Height: 1 ft. 1⁹⁄₁₆ in. (34.5 cm); Width:
1 ft. 3 in. (38 cm); Depth: 10¹⁄₁₆ in. (25.5 cm)
Accession number 85.DI.178.1–.2

PROVENANCE

Joseph Downs, Winterthur, Delaware;
William Heere (sold, Christie's, New York,
October 29, 1983, lot 32); [Aveline et Cie,
Paris].

EXHIBITIONS

New York, The Frick Collection, *Mounted
Oriental Porcelain*, December 1986–March
1987, no. 9, pp. 46–47, illus.

BIBLIOGRAPHY

"Acquisitions/1985," *GettyMusJ* 14 (1986),
no. 185, p. 240, illus.; F. J. B. Watson,
"Mounted Oriental Porcelain," *The Maga-
zine Antiques* 131 (April 1987), pp. 813–823,
illus. p. 823.

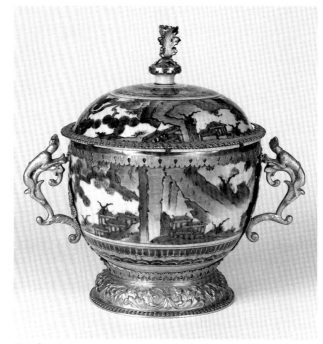

One of a pair 477

Netherlandish
Decorative Arts

✷

Furniture

478. **Display Cabinet (*Toonkast*)**
Flemish (probably Antwerp), early seventeenth century
Walnut and oak veneered with ebony, tortoiseshell, (?) coconut, and ebonized wood
Height: 6 ft. 10¾ in. (210 cm); Width: 5 ft. 2¼ in. (158 cm); Depth: 2 ft. 5⅜ in. (74.5 cm)
Accession number 88.DA.10

PROVENANCE
Prince d'Arenberg, Egmont Palace, Brussels; [Axel Vervoordt, 's Gravenwezel, Belgium].

BIBLIOGRAPHY
"Acquisitions/1988," *GettyMusJ* 17 (1989), no. 86, pp. 146–147, illus.; *Handbook* 1991, p. 209, illus.

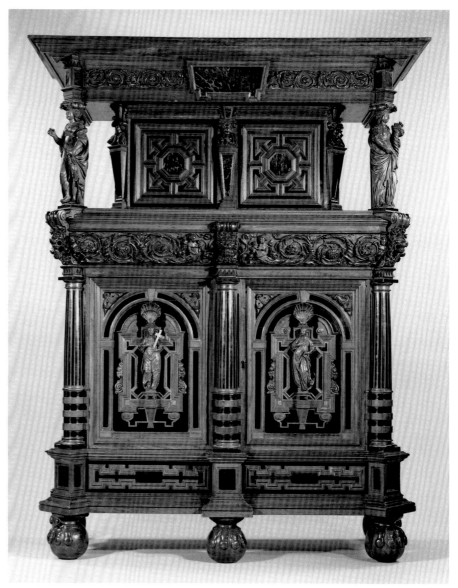

478

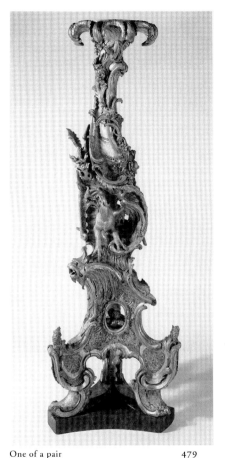

One of a pair 479

479. **Pair of** *Torchères*

Dutch, circa 1740–1750
(?) By the Italian carver, Agostino Carlini
Gessoed, painted, and gilded wood; crushed
glass
Height: 6 ft. 11⅝ in. (212.4 cm); Width:
2 ft. 3 in. (68.6 cm); Depth: 1 ft. 10 in.
(55.9 cm)
Accession number 79.DA.5.1–.2

PROVENANCE
(?) Orangezaal, Royal Palace, Huis ten
Bosch, Holland; Neues Palais, Potsdam,
1895 (purchased in Amsterdam, 1895); dis-
played in the Japis Galerie, 1926; (sold,
Palais Galliera, Paris, December 9, 1963, lot
93); [Fabius Frères, Paris, 1970s].

BIBLIOGRAPHY
Burkhard Meier, *Potsdam Schlösser und
Gärten aufgenommen von der Staatliche
Bildstelle* (Berlin, 1926), fig. 46; Wilson,
"Acquisitions 1977 to mid 1979," no. 13,
pp. 49–51, illus. (one); Marten Loonstra,
*The Royal Palace Huis ten Bosch in a Histori-
cal View* (Zutphen, 1985), p. 75, illus. p. 74.

Metalwork

480. **Chandelier**

Dutch, circa 1645–1675
Brass and oil-gilt wrought iron
Height: approx. 5 ft. (153 cm); Width:
approx. 5 ft. (153 cm)
Accession number 88.DH.62

PROVENANCE
Count Moretus-Plantin, Stabroek, Belgium
(until at least 1930); Count G. della Faille
de Leverghem, Schoten, Belgium (by 1961);
[Axel Vervoordt, 's Gravenwezel, Belgium].

EXHIBITIONS
Antwerp, *Tentoonstelling van Oude Vlaamsche
Kunst* (Exhibition of Old Flemish Art), 1930,
"D 178"; Duerne-Antwerp, Provinciaal

Museum voor Kunstambachten, *Tentoon-
stelling Kunstvoorwerpen uit Verzamelingen
in de Provincie Antwerpen* (Exhibition of
Decorative Arts from Collections in the
Province of Antwerp), 23 April–2 July 1961,
no. 245, p. 34.

BIBLIOGRAPHY
"Acquisitions/1988," *GettyMusJ* 17 (1989),
no. 88, p. 148, illus.

480

Glass

481. **Goblet**

Southern Netherlandish, 1560–1600
Made by a glasshouse in the region of
Chimay, (?) Hainault
Free- and mold-blown glass or *cristallo*
Height: 8½ in. (21.6 cm)
Accession number 84.DK.549

PROVENANCE
Ruth and Leopold Blumka, New York.

EXHIBITIONS
New York, The Corning Museum of Glass,
Three Great Centuries of Venetian Glass, 1958,
no. 115, p. 105.

BIBLIOGRAPHY
"Acquisitions/1984," *GettyMusJ* 13 (1985),
no. 248, p. 256, illus.

482. **Ice-glass Beaker**

Late sixteenth century
Free-blown soda glass with applied
decoration
Height: 8⁷⁄₁₆ in. (21.5 cm)
Accession number 84.DK.564

PROVENANCE
[Rainer Zietz, Ltd., London]; Ruth and
Leopold Blumka, New York.

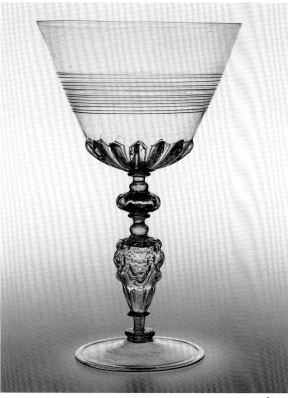

481

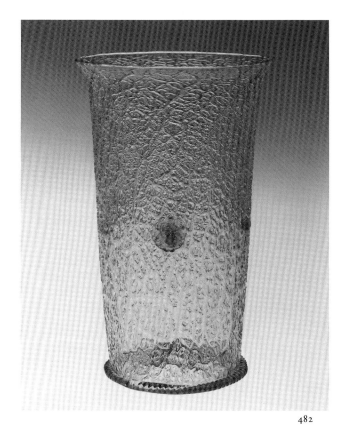

482

BIBLIOGRAPHY
"Acquisitions/1984," *GettyMusJ* 13 (1985),
no. 225, p. 252, illus.

———

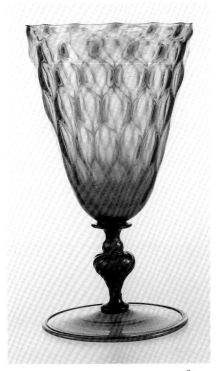

483

483. **Goblet**
Southern Netherlandish or French, late
sixteenth or early seventeenth century
Free- and mold-blown cobalt glass
Height: 8½ in. (21.6 cm)
Accession number 84.DK.517

PROVENANCE
Alexander von Frey, Paris; Ruth and Leo-
pold Blumka, New York.

EXHIBITIONS
New York, The Corning Museum of Glass,
Three Great Centuries of Venetian Glass, 1958,
no. 112, p. 103.

BIBLIOGRAPHY
"Acquisitions/1984," *GettyMusJ* 13 (1985),
no. 238, p. 254, illus.

———

484. **Flute Glass**
Southern Netherlandish, seventeenth
century
Free-blown soda glass or *cristallo* with
diamond-point etching
Height: 1 ft. ⁷⁄₁₆ in. (31.6 cm)
Accession number 84.DK.516

PROVENANCE
Karl Ruhmann, Vienna; A. Vecht, Amster-
dam; Ruth and Leopold Blumka, New York.

BIBLIOGRAPHY
Ignaz Schlosser, *Das alte Glas: Ein Handbuch
für Sammler und Liebhaber* (Brunswick,
1965), p. 210, pl. 161; "Acquisitions/1984,"
GettyMusJ 13 (1985), no. 245, p. 255, illus.;
Journal of Glass Studies, no. 34, p. 108.

———

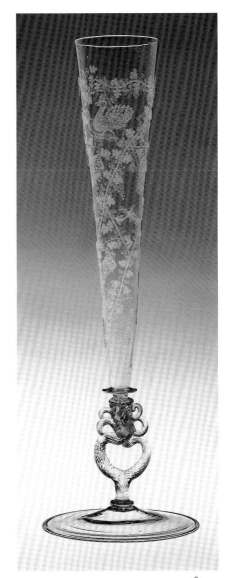

484

485. ***Filigrana* Beaker**

Southern Netherlandish, 1650–1700

Free-blown soda glass or *cristallo* and
lattimo, vetro a fili

Height: 5½ in. (14 cm)

Accession number 84.DK.658

PROVENANCE

[David, Inc., Vaduz].

BIBLIOGRAPHY

"Acquisitions/1984," *GettyMusJ* 13 (1985),
no. 244, p. 255, illus.

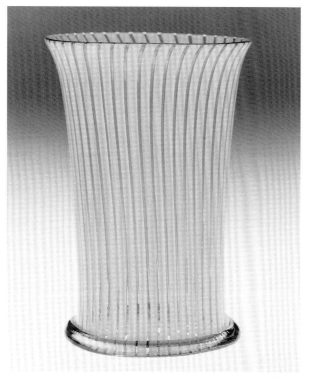

485

Spanish
Decorative Arts

✠

Metalwork

486. **Pair of Candlesticks**

Spanish, circa 1650–1700
Bronze
Height: 5 ft. 8⅞ in. (175 cm) each
Accession number 86.DH.601.1–.2

PROVENANCE

Commissioned by the Counts of Benavente;
(offered for sale, Christie's, London, April 24,
1986, lot 34, withdrawn); [Rainer Zietz, Ltd.,
London].

BIBLIOGRAPHY

"Acquisitions/1986," *GettyMusJ* 15 (1987),
no. 120, p. 219, illus.

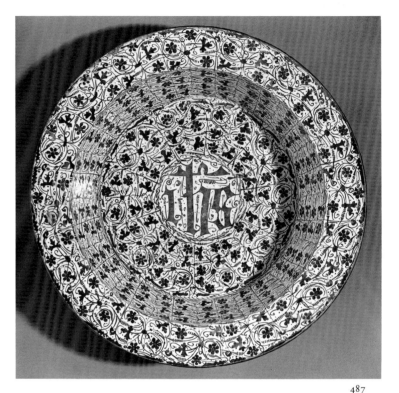

487

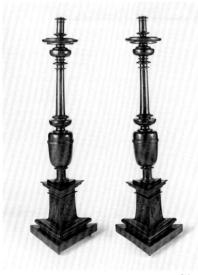

486

Ceramics

487. **Hispano-Moresque Deep Dish**
(*brasero*)

Valencia, mid-fifteenth century
Blue and copper luster-glazed earthenware
Marked *IHS* in the center of the obverse.
Height: 4¼ in. (10.8 cm); Diameter: 1 ft. 7½
in. (49.5 cm)
Accession number 85.DE.441

PROVENANCE

Leonardo Lapiccirella, Florence; (sold,
Christie's, London, July 1, 1985, lot 270);
[Rainer Zietz, Ltd., London].

BIBLIOGRAPHY

Giovanni Conti, *L'Arte della maiolica in
Italia* (Milan, 1973), pl. 8; *Apollo* 122 (1985),
no. 5, p. 405; "Acquisitions/1985," *GettyMusJ*
14 (1986), no. 214, p. 252, illus; Hess, *Maio-
lica*, no. 2, pp. 14–15, illus; *Handbook* 1991,
p. 201, illus.

488. **Tile Floor**

(?) Manises, circa 1425–1450

Tin-glazed earthenware

Speratens and *ne oblyer* inscribed in the hexagonal tiles: a coat of arms, *of barry of six argent and gules*, painted on the square tiles.

Length: 7 ft. 1¾ in. (220 cm); Width: 3 ft. 6⅞ in. (110 cm); Square Tiles: Length: 4⁷⁄₁₆ in. to 4⅞ in. (11.2 to 12.4 cm); Hexagonal Tiles: Length: 8¼ in. to 8⁹⁄₁₆ in. (21 to 21.8 cm); Width: 4¼ in. to 4⅜ in. (10.8 to 11.1 cm)

Accession number 84.DE.747

PROVENANCE

Grassi collection, Florence, before 1920; Ruth and Leopold Blumka, New York.

EXHIBITIONS

Allentown Art Museum, *Beyond Nobility: Art for the Private Citizen in the Early Renaissance*, September 1980–January 1981, no. 122, pp. 115–116.

BIBLIOGRAPHY

Anna Berendsen et al., *Tiles* (London, 1967), p. 76; "Acquisitions/1984," *GettyMusJ* 13 (1985), no. 151, p. 239, illus; Hess, *Maiolica*, no. 1, pp. 12–13.

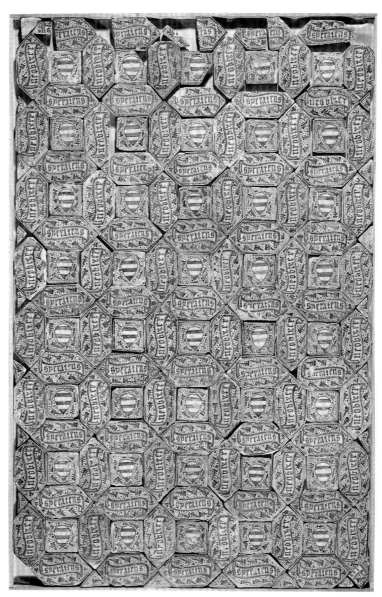

488

Glass

489. **Flask**

Catalonian, nineteenth or twentieth century

Free-blown soda glass with enamel decoration

Inscribed on both sides, in enamel, *IHS / IHS.*

Height: 10¼ in. (20.6 cm)

Accession number 84.DK.518

PROVENANCE

Ruth and Leopold Blumka, New York.

BIBLIOGRAPHY

"Acquisitions/1984," *GettyMusJ* 13 (1985), no. 227, p. 252, illus.; *Journal of Glass Studies,* no. 17, p. 103.

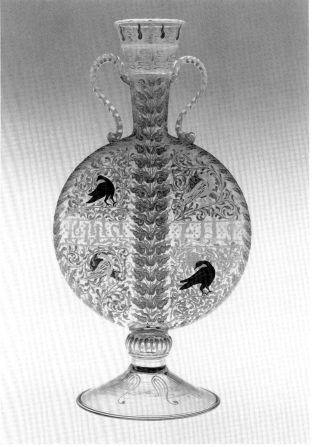

489

CHINESE, JAPANESE, PERSIAN, AND SOUTHEAST ASIAN DECORATIVE ARTS

*

Chinese Ceramics

490. **Garniture of Three Lidded Vases and Two Open Vases**

Chinese, Kangxi (1662–1722)
Hard-paste porcelain, underglaze blue decoration
Lidded Vases: Height: 1 ft. ½ in. (31.8 cm); Diameter: 10¾ in. (27.3 cm); Open Vases: Height: 11⅛ in. (28.3 cm); Diameter: 5 in. (12.7 cm)
Accession number 72.DE.72.I–.5

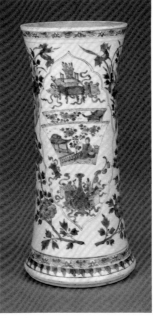

One of two 490

PROVENANCE
Dukes of Northumberland (probably sold circa 1910); [Ralph Chait, New York and London, 1970s]; [Neil Sellin, New York, 1972]; purchased by J. Paul Getty.

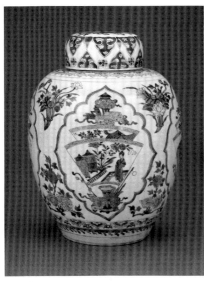

One of three 490

491. **Pair of Lidded Vases**

Chinese, Kangxi (1662–1722)
Hard-paste porcelain, underglaze blue decoration
Height: 1 ft. 5 in. (43.2 cm); Diameter: 10 in. (25.4 cm)
Accession number 72.DE.73.I–.2

PROVENANCE
Dukes of Northumberland (probably sold circa 1910); [Ralph Chait, New York and London, 1970s]; [Neil Sellin, New York, 1972]; purchased by J. Paul Getty.

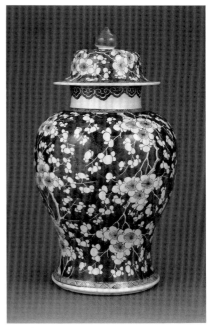

One of a pair 491

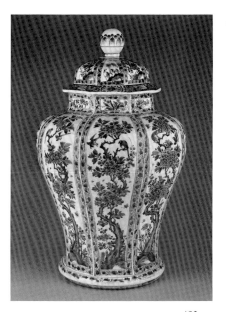

492

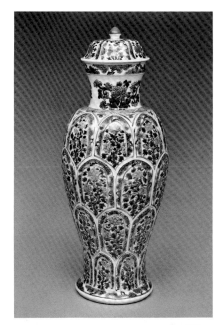

494

493. **Lidded Vase**

Chinese, Kangxi (1662–1722)

Hard-paste porcelain, underglaze blue decoration

Painted underneath with a mark of the Ming reign (Jia Jing, 1522–1566) in underglaze blue.

Height: 11⅞ in. (30.2 cm); Diameter: 4½ in. (11.4 cm)

Accession number 85.DE.414

PROVENANCE

[Spink and Son, Ltd., London].

BIBLIOGRAPHY

"Acquisitions/1985," *GettyMusJ* 14 (1986), no. 183, p. 239, illus.

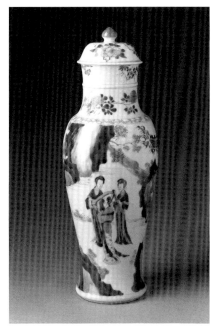

493

492. **Lidded Vase**

Chinese, Kangxi (1682–1722)

Hard-paste porcelain, underglaze blue decoration

Height: 1 ft. 11½ in. (59.7 cm); Diameter: 1 ft. 2¾ in. (37.5 cm)

Accession number 86.DE.629

PROVENANCE

[Spink and Son, Ltd., London].

BIBLIOGRAPHY

"Acquisitions/1986," *GettyMusJ* 15 (1987), no. 97, p. 210, illus.

494. **Lidded Vase**

Chinese, Kangxi (1662–1722)

Hard-paste porcelain, underglaze blue decoration

Painted underneath with a leaf in underglaze blue.

Height: 1 ft. 5½ in. (44.5 cm); Diameter: 8½ in. (21.6 cm)

Accession number 85.DE.46

PROVENANCE

[Spink and Son, Ltd., London, 1985].

BIBLIOGRAPHY

"Acquisitions/1985," *GettyMusJ* 14 (1986), no. 182, p. 239, illus.

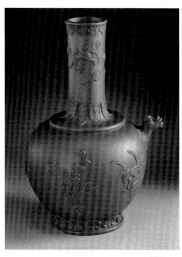

495

495. **Wine Bottle (*kendi*)**

Chinese, Kangxi (1662–1722)
Stoneware
Height: 7⅞ in. (20.1 cm); Width: 5⅝ in.
(14.3 cm); Depth: 4¹⁵⁄₁₆ in. (12.5 cm)
Accession number 85.DE.232

PROVENANCE

[Kate Foster, Ltd., London].

EXHIBITIONS

The Los Angeles County Museum of Art,
September 1987–present.

BIBLIOGRAPHY

"Acquisitions/1985," *GettyMusJ* 14 (1986),
no. 184, p. 239, illus.

496. **Pair of Lidded Vases**

Chinese, Yongzheng, circa 1730
Hard-paste porcelain, polychrome enamel
decoration
Each vase bears a label, pasted within the
lip, printed with *FONTHILL HEIRLOOMS*
and with the inventory number *670/3*.
Height: 2 ft. ¾ in. (62.9 cm); Diameter:
1 ft. 1 in. (33 cm)
Accession number 72.DE.62.1–.2

PROVENANCE

Alfred Morrison, Fonthill House, Wiltshire;
John Greville Morrison, Lord Margadale
of Islay, Fonthill House, by descent (sold,
Christie's, London, June 5, 1972, lot 29);
purchased at that sale by J. Paul Getty.

497. **Figure of an Elephant**

Chinese, Qianlong (1736–1795)
Hard-paste porcelain, polychrome enamel
decoration; gilding
Height: 1 ft. 9¾ in. (55.2 cm); Width:
1 ft. 1½ in. (34.2 cm); Depth: 10 in. (25.4 cm)
Accession number 72.DE.61

PROVENANCE

George Christie (sold, Christie's, London,
June 5, 1972, lot 24); purchased at that sale
by J. Paul Getty.

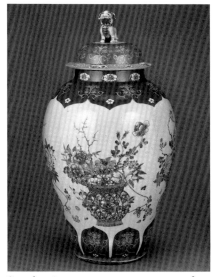

One of a pair 496

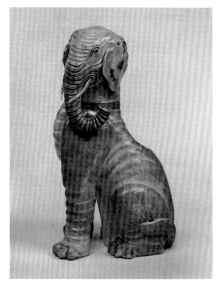

497

Chinese Textiles
(for Italian export)

498. **Wall Hanging**
Chinese, late seventeenth to early eighteenth
century
Silk brocade
Length: 11 ft. 10 in. (360.5 cm);
Width: 7 ft. 4¾ in. (225.5 cm)
Accession number 87.DD.37

PROVENANCE
Private German collection; [Rainer Zietz,
Ltd., London].

BIBLIOGRAPHY
"Acquisitions/1987," *GettyMusJ* 16 (1988),
no. 87, p. 185, illus.

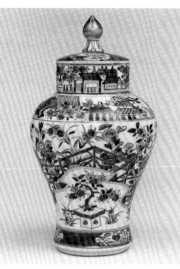

One of three 499

Japanese Ceramics

499. **Garniture of Three Vases**
Japanese (Arita), first half of the eighteenth
century
Hard-paste porcelain, underglaze blue
decoration; polychrome enamel; gilding
Vase .1: Height: 1 ft. ⅝ in. (32.1 cm);
Diameter: 7 in. (17.8 cm); Vase .2: Height:
1 ft. ⅝ in. (32.1 cm); Diameter: 7⅛ in.
(18 cm); Vase .3: Height: 1 ft. ¾ in. (32.4 cm);
Diameter: 7 in. (17.8 cm)
Accession number 87.DE.26.1–.3

PROVENANCE
[Spink and Son, Ltd., London, 1986].

BIBLIOGRAPHY
"Acquisitions/1987," *GettyMusJ* 16 (1988),
no. 76, p. 179, illus.

Persian Carpets

500. **Carpet**
Herat or Isfahan, late sixteenth century
Wool
Length: 25 ft. 10¼ in. (788 cm); Width:
10 ft. 3¼ in. (313 cm)
Accession number 78.DC.91

PROVENANCE
Hagop Kevorkian (sold, Sotheby's, London,
December 5, 1969, lot 20); purchased at that
sale by J. Paul Getty.

EXHIBITIONS
New York, The Metropolitan Museum of
Art, *Collection of Rare and Magnificent
Oriental Carpets* (1966), no. 5, pl. 3.

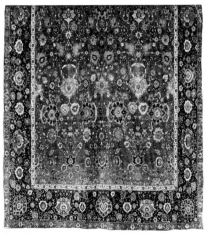

Detail 500

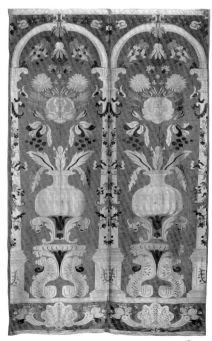

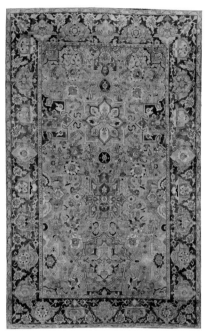

501

501. "Polonaise" Carpet

Kashan, circa 1620
Silk with metallic thread
Length: 9 ft. 1 in. (277 cm); Width: 5 ft. 7 in.
(170 cm)
Accession number 68.DC.6

PROVENANCE

Baron Adolphe de Rothschild, Paris (sold,
Palais Galliera, Paris, March 18, 1968, lot 104);
purchased at that sale by J. Paul Getty.

Southeast Asian Furniture

502. Set of Twelve Chairs (five armchairs and seven side chairs)

(?) Dutch colonial from Indonesia or Sri
Lanka (Ceylon), circa 1680–1720
Ebony and ebonized wood, some details
inlaid with ivory
Armchairs: Height: 3 ft. 6 in. (106.7 cm);
Width (at front): 2 ft. (61 cm); Width
(at back): 1 ft. 8 in. (50.8 cm); Depth:
1 ft. 7 7/16 in. (49.4 cm); Side Chairs: Height:
3 ft. 4 in. (101.6 cm); Width: 1 ft. 9 3/4 in.
(55.2 cm); Depth: 1 ft. 6 11/16 in. (47.5 cm)
Accession number 92.DA.24.1–.12

PROVENANCE

(?) Thomas Thynne, 1st Viscount
Weymouth, Longleat Castle, Wiltshire,
circa 1700; Marquess of Bath, Longleat
Castle, Wiltshire, circa 1700; (sold,
Christie's, London, November 17, 1988, lot
75); [Rainer Zietz, Ltd., London].

BIBLIOGRAPHY

"Acquisitions /1992" *GettyMusJ* 21 (1993),
in press, illus.

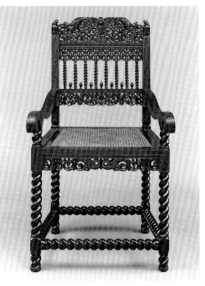

One of five 502

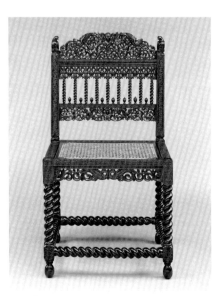

One of seven 502

INDEXES

❖

INDEX OF MAKERS

The following index includes the names of makers and artists. Please note that references are to entry numbers, not page numbers.

INDEX OF PREVIOUS OWNERS

The following index includes the names of private owners and dealers. Named residences are also listed. Please note that references are to entry numbers, not page numbers.